DICTIONARY OF 20TH CENTURY ART

DICTIONARY
OF 20TH
CENTURY
ART

Edited by

Bernard S. and Shirley D. Myers
Editors, *McGraw-Hill Dictionary of Art*

McGraw-Hill Book Company

New York St. Louis San Francisco Düsseldorf Johannesburg
Kuala Lumpur London Mexico Montreal New Delhi Panama
Paris São Paulo Singapore Sydney Tokyo Toronto

Most of the articles in this book have been derived from
the *McGraw-Hill Dictionary of Art.*

Library of Congress Cataloging in Publication Data

Myers, Bernard Samuel
 Dictionary of 20th century art.

 Based on the McGraw-Hill dictionary of art.
 Includes bibliographies.
 1. Art, Modern—20th century—Dictionaries. 2. Art
—Dictionaries. I. Myers, Shirley D., joint author. II.
Title.
N6490.M89 703 74-4200
ISBN 0-07-044220-7

1234567890 MUBP 7987654

PREFACE

Although each period in the history of the world's civilization has its own value and its own interest, the art of our own time has an understandably greater and more immediate appeal for the general reader as well as for the student. The present *Dictionary of 20th Century Art* has been prepared in response to this interest.

Derived from the Editors' five-volume *McGraw-Hill Dictionary of Art,* this new book has as its aim the coverage of the major painters, sculptors, graphic artists, and architects of the twentieth century. Beginning with the principal movements and men of the pre-World War I era from about 1905 on—that is, fauve, expressionist, cubist, futurist, and so on—it goes on to the major post-World War I figures and schools, continues into the period during and after World War II, and comes up into our own day with the proponents of abstract expressionism, color field, hard edge, Op, Pop, minimal, conceptual, and other forms of artistic expression.

Clearly, the greatest number of entries are biographies (with characterizations of the style represented), but there are a sufficient number of general "school" articles, for example, abstract expressionism, to place these individuals within their proper time and place. Since developments in the contemporary art field move as rapidly as they do, we have added new material on indi-

vidual artists as well as art movements in order to make the book as current as possible.

In our effort to produce a handy reference book, we have necessarily provided illustrations of the works of major artists of our time. As a general rule of thumb, every artist for whom we offer a special bibliographical reference will also be illustrated.

For the reader who is interested in going further in depth on any subject, we have gathered an entirely new and focused bibliography grouped under General Works, Major Movements, and Principal Artists. These references are almost all in the English language and reflect the most serious as well as the most current books that deal with the leading artists and art movements of the century.

For the reader who is looking for a summary of the life and work of a modern artist, for the date of a particular work or the museum in which it is kept, or for the meaning of a specific type of artistic expression, the *Dictionary of 20th Century Art* in its various aspects will prove of considerable help.

B. S. M.
S. D. M.

New York, 1974

DICTIONARY OF 20TH CENTURY ART

AALTO, HUGO ALVAR HENRIK. Finnish architect, industrial designer, and city planner (1898–). He was born in Kuortane, studied architecture, and graduated from the Teknillinen Korkeakoulu, Helsinki (1921), traveled in Sweden and western Europe (1921–23), and began private practice in Jyväskylä (1923). In 1924 he married Aino Marsio, his collaborator until her death in 1949.

The office building for the newspaper *Turun-Sanomat* in Turku (1928–30) was his first completed mature work and the first to receive attention outside Finland. The library at Viipuri (designed 1927; completed 1935; destroyed) was an ingeniously planned building in two main blocks, one for library activities, the other containing an auditorium. The lecture hall had a vigorously undulating wooden ceiling, designed primarily for acoustical reasons, which formed an expressive and influential space. The Tuberculosis Sanitarium in Paimio (1929–33), along with such works as the Bauhaus building by Gropius (1925–26), is one of the major large-scale buildings of the 1920s and the first important application of new architectural principles to a hospital.

The Villa Mairea, Noormarkku (1938–39), is a large vacation house built for the Gullichsens, founders of the Artek Company, the manufacturers and distributors of Aalto's birch plywood furniture. Its open plan is meticulously zoned into controlled spaces for varied activities; its detailing and construction were so conscientiously executed that the house still retains its original freshness. In the cellulose factory at Sunila (1936–39; 1951–54) Aalto designed the industrial and residential structures for a factory village. Beginning with a communal core, the design developed over the years into an orderly and human industrial community.

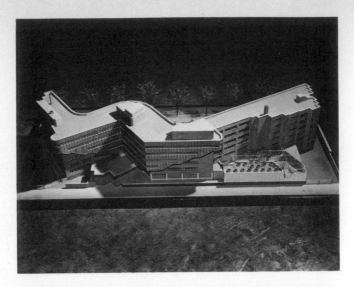

Alvar Aalto, Baker Dormitory, Massachusetts Institute of Technology (1947–48). Cambridge, Mass.

While teaching at M.I.T., he built for that institution one of his finest structures—and his principal work done in the United States—Baker House Dormitory (1947–48). A new interpretation of the dormitory is given by the massive undulating form, coiled beside the Charles River to provide maximum view and ventilation for each inhabitant. Executed in red brick interspersed with clinkers, this masterpiece is prophetic of some of his recent work, such as the House of Culture in Helsinki (1955–58). In 1967–70 he designed a three-level library for the Benedictine abbey at Mt. Angel, Ore.; the plan has the appearance of an open fan affixed to a rectangular base. Finlandia Hall, Helsinki (completed 1971), designed as a center for concerts and congresses, displays a marble exterior that encloses an interior design of pale natural wood tones with black accents.

Aalto was one of the first architects outside Germany, France, and Holland to master the new architecture. In his work he combines the sensuous wood tradition of Finland with the rational industrial tradition of western Europe, resulting in some of the finest art produced in our time. THEODORE M. BROWN

ABSTRACT EXPRESSIONISM. Name generally given to a broad movement in painting that appeared after World War II in New York City and by a decade later had become an international expression. Actually, the term could apply and was applied to the nonobjective paintings of Kandinsky as early as 1911. Abstract expressionism is characterized by a lack of representation and by an emotional approach to concept and execution, an approach that is essentially expressionist. The movement is often called the "New York school" or "action painting." *See* KANDINSKY, WASSILY.

Abstract-expressionist art results from the fusion of various influences, notably surrealism, synthetic cubism, and neoplasticism. Some artists favored aspects of one or more of these diversified art movements and rejected others. Thus, abstract-expressionist art is characterized by considerable variety. One finds included under that broad heading such diverse figures as Jackson Pollock, Mark Rothko, Franz Kline, Robert Motherwell, Adolph Gottlieb, Willem de Kooning, Barnett Newman, Clyfford Still, Bradley Walker Tomlin, Hans Hofmann, Philip Guston, William Baziotes, and Richard Pousette-Dart.

Arshile Gorky is often included with the above painters, but actually his art developed before theirs, and Gorky died in 1948 before the abstract-expressionist concept was recognized as such. *See* GORKY, ARSHILE.

As important as Gorky in the acceptance of abstract painting in the United States is Hans Hofmann. Many of his students became prominent artists, particularly in the mid-1950s and later. Hofmann provided the nucleus of an audience for advanced art. His own art and his message of a vitalized surface with "push-pull" characteristics had a strong influence on American abstract painting. *See* HOFMANN, HANS.

In general, abstract expressionists found in the various forms of cubism pictorial ideas relating to structure and to the integrity of the surface of the picture. In surrealism they found the power of psychic improvisation as a means of discovering a personal mythology and stimulating a release of latent imagery.

Abstract expressionism began to lose much of its momentum in the late 1950s. Abstract impressionism, neo-Dada, and the return of the figure in the early 1960s at first

appeared to be denials of abstract expressionism, but each employs elements and techniques found in the earlier art.

See DE KOONING, WILLEM; GOTTLIEB, ADOLPH; KLINE, FRANZ; MOTHERWELL, ROBERT; POLLOCK, JACKSON; ROTHKO, MARK; TOMLIN, BRADLEY WALKER. See also BAZIOTES, WILLIAM; GUSTON, PHILIP; NEWMAN, BARNETT; POUSETTE-DART, RICHARD; STILL, CLYFFORD.

ROBERT REIFF

ABSTRACTION-CREATION GROUP. International group of sculptors and painters dedicated to geometric abstraction, active in Paris from 1932 to 1936. Its members included Gabo, Pevsner, Mondrian, Vantongerloo, Herbin, and Nicholson. The group held exhibitions and issued an annual publication, *Abstraction-Création*. See GABO, NAUM; MONDRIAN, PIET; NICHOLSON, BEN; PEVSNER, ANTOINE; VANTONGERLOO, GEORGE.

ACTION PAINTING, see ABSTRACT EXPRESSIONISM.

ADLER, JANKEL. Polish-born painter (b. Tuszyn, near Lodz, 1895; d. Aldebourne, England, 1949). Adler studied at the Düsseldorf Academy and later worked in Paris with S. W. Hayter. His art reveals the influence of various periods of Picasso, of Paul Klee, and of surrealism, yet it has been modified to create a lyrical style of its own. He worked primarily with the figure and was at his best when evoking the Jewish life of his native Polish community. Among his best paintings are *King David* (1945; New York, Bernard Collection) with its rich colors and boldly expressed forms and *Two Rabbis* (1942; New York, Museum of Modern Art). A rather eclectic but competent artist, he exerted some influence on American and British painting.

AFRO (Afro Basaldella). Italian abstract painter (1912–). He was born in Udine and now lives in Venice, where he first studied art. He had his initial one-man exhibition in Milan when he was twenty. He painted portraits, landscapes, and still lifes and did some murals. After World War II he turned to abstraction and gained an international reputation. In 1952 he exhibited at the Venice Biennale with a group of painters who called themselves "The Eight." They declared their independence of any precon-

ceived ideas or program except to follow their instincts.

Afro's abstractions derive from Braque's still-life painting. His forms have lost all reference to specific objects in nature. They appear most often as autonomous, light-suffused areas of warm color, freely brushed on and loosely linked together.

AFRO-AMERICAN ART, *see* BLACK ART: UNITED STATES.

AGAM, YAACOV. Israeli painter (1928–). He studied at the Bezalel Art School in Jerusalem and went to Paris in 1951, where he now lives and works. He has exhibited since 1953, and in 1963 won the Award for Artistic Research at the São Paulo Bienal. Agam attempts to express movement and the constant transformation of reality, in terms of time and space and relationship with the viewer, in works that he calls "contrapuntal," "sliding," and "transformable" paintings. His contrapuntal paintings have corrugated surfaces that present a changing panorama of geometric forms as the viewer moves past the paintings. One such work, *Jacob's Ladder* (1964), a ceiling painting 197 feet long, was installed in the National Convention Center in Jerusalem. Agam has also created stage sets.

ALBERS, JOSEF. American painter, graphic artist, designer, and educator (1888–). Born in Bottrop, Germany, Albers studied at the Royal Art School, Berlin (1913–15), the School of Applied Arts, Essen (1916–19), and the Art Academy, Munich (1919–20). His earliest work was representational, somewhat influenced by cubism and German expressionism.

He went to study at the Bauhaus, Weimar (1920–23), and remained to teach there and at Dessau and Berlin (1923–33). Both as student and as teacher (he was director of the glass and furniture workshops and eventually of the wallpaper department) Albers was concerned with the interrelationships in the fine and applied arts. He worked experimentally with a variety of materials to discover their intrinsic design and structural possibilities. He used fragments of glass to form collages (*Rhenish Legend*, 1921; collection of the artist) and stained-glass windows with geometric designs. He designed furniture for mass production, including a chair (1926), which has been called

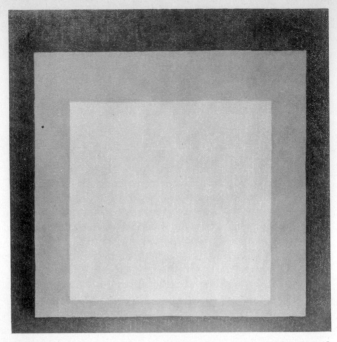

Josef Albers, *Stele and Lawn* (1967). Oil on composition board, 24″ x 24″. Whitney Museum of American Art, New York.

"the first modern chair in bent laminated wood." Rejecting all expressionism and emotionalism in art, as well as any clear-cut distinction between art and design, he used commercial methods to create geometric designs with architectural references on commercially produced "flashed" glass (*Factory*, 1925; collection of the artist).

The first of the Bauhaus teachers to leave Nazi Germany, Albers went to the United States to teach at Black Mountain College in North Carolina (1933–49). He gave special courses and seminars at Harvard University (1936, 1941, and 1950), and was the chairman of the Department of Art at Yale University (1950–60) and later professor emeritus.

In his painting and graphic work Albers creates spatial illusions that can be read in a number of ways. The paintings are primarily concerned with color relationships, usually within a very rigid geometric framework, for example,

the *Variants on a Theme* series (1942 ff.; Hartford, Wadsworth Atheneum). The *Homage to the Square* series (1949 ff.; New York, Museum of Modern Art and Metropolitan Museum) uses a structure of three or four squares superimposed upon one another with the bottom, side, and top margins in a 1:2:3 ratio. Each color square reacts with the others, reciprocally affecting the apparent hues, sizes, and spatial relationships. Value contrasts are not exploited, and Albers uses a large variety of commercial pigments to avoid mixing colors. RUTH GILBERT

ALBRIGHT, IVAN LE LORRAINE. American painter (1897–). Albright was born in Chicago and studied in Nantes, Chicago, Philadelphia, and New York. He served as surgical artist for the Army during World War I. His paintings are a collective *memento mori* in which the corruption of matter and the decay of age are reproduced with a painstaking fidelity to surface detail and a seemingly moralizing purpose. By toplighting his subjects he achieves a hallucinatory, surrealistic glow, which further increases the intensely emotional effect of his paintings. His famous *That Which I Should Have Done I Did Not Do* (1941; Art Institute of Chicago) is an apt assemblage of things funereal.

ALECHINSKY, PIERRE. Belgian painter (1927–). Alechinsky studied in his native Brussels and first began to exhibit in 1945. In 1949 he formed the influential expressionist CoBrA group with the Dane Asger Jorn and the Dutchmen Karel Appel and Corneille. Alechinsky settled in Paris after a trip to Japan in 1955 and began to write widely on art and poetry. His work draws on the associationism of Klee and the northern expressionist tradition, particularly of Ensor, but also on the art of the insane, children, and primitives. He creates a lyric frenzy of violent brushstrokes, high-keyed colors, and linear movement, using some figural elements. *See* CoBrA.

ALSTON, CHARLES. American easel painter, muralist, sculptor, illustrator, and teacher (1907–). Born in Charlotte, N.C., he studied at Columbia University (B.A., M.A.). Alston has taught at The City College, New York, and at the Art Students League of New York; he has also given courses at the Museum of Modern Art and the New School

for Social Research. Among his private pupils are the well-known black artists Jacob Lawrence and Romare Bearden. As a muralist he is related to the tradition of the American 1930s. His murals since the 1940s include those at Harlem Hospital, New York, and the Golden State Mutual Insurance Company of Los Angeles. He has been an important easel painter since the 1950s, his style showing a poetic primitivism, the figures often endowed with small heads and sculpturally rounded forms. Profoundly concerned with the racial problems of our time, Alston reveals in his work a deep compassion for the sufferings of all people and at the same time a preoccupation with the mystery and beauty of the surrounding world.

AMIET, CUNO. Swiss painter (1868–1961). Born in Solothurn, he studied in Munich from 1886 to 1888 and in Paris with Bouguereau and at the Académie Julian. In 1892 he went to Pont-Aven, where his contacts with Bernard, Seguin, and Sérusier influenced his work toward less realistic color and flatter, more decorative composition. Amiet met Hodler in Switzerland in 1893, and their friendship is reflected in *Richesse du soir* (1899; Solothurn Museum), in which firm drawing is dominant over color. But Amiet's native interest in color soon reasserted itself, and his painting after 1905 is similar to that of the Fauves but independent of them. He contributed one woodcut to the 1907 Brücke portfolio but was otherwise unaffected by the Dresden group.

ANGUIANO, RAUL. Mexican painter and printmaker (1915–). Anguiano was born in Guadalajara; his early studies were with Vizcarra and Ixca Farías. In 1934 he went to Mexico City and became a founder of the Taller de Gráfica Popular. He traveled in Cuba, in the United States, and in Europe, and has held various positions, such as governmental inspector for education in the arts, instructor in drawing and painting at the Esmeralda School, and professor at the summer school of the National University of Mexico. Anguiano was an artist-member of the 1949 expedition to Bonampak, and from drawings he made at the site came numerous oils, tempera paintings, and lithographs. He has had one-man shows in Mexico City, Paris, and San Francisco, and was the prize winner at the winter

Salón de la Plástica Mexicana and the recipient of the Orozco Award from his native state of Jalisco. Anguiano paints using a somber realist technique, occasionally verging on surrealism and especially related to Indian physical types. JOSEPH A. BAIRD

ANUSZKIEWICZ, RICHARD. American painter (1930–). Born in Erie, Pa., he studied at the Cleveland Institute of Art (1948–53) and with Albers at Yale University (1953–55). His works, which were in the forefront of the Op Art phenomenon, create strong and shifting optical and sensory effects with tightly controlled geometric webs and subtly sliding color patterns.

APPEL, KAREL. Dutch abstract painter (1921–). Born in Amsterdam, he has lived in Paris since 1950. He studied at the Royal Academy in Amsterdam and was a founder-member of a Dutch experimental group, which became part of the CoBrA group. In 1951 he became associated with the Art Informel group. In 1958 he painted murals for the Dutch Pavilion at the Brussels World's Fair and for the UNESCO Building in Paris.

Appel's heavily textured canvases with their waves of swirling forms in bright contrasting colors are charged with an elemental and explosive energy that recalls the last paintings of Van Gogh. Appel's automatist procedures often induce the suggestion of primordial creatures and masklike faces.

ARCHIPENKO, ALEXANDER. American sculptor (b. Kiev, 1887; d. New York, 1964). He studied painting and sculpture in the Kiev School of Art from 1902 to 1905. His first work in sculpture dates from 1903. He studied and exhibited in Moscow between 1905 and 1908. Arriving in Paris in 1908, he occasionally attended the Ecole des Beaux-Arts and also studied in the museums. Archipenko's first important exhibition was held in 1910 in Berlin as well as in The Hague. During that year he became aware of the work of the cubists and began to adapt their ideas to his sculpture by occasionally employing transparent materials as well as concave forms where convex shapes are to be found in the body (*Pregnancy*, 1911).

He opened an art school in Paris in 1912. In the same

year he exhibited with the cubists and the Section d'Or and also introduced hollows where solids are found in the body. *Woman* (1912) and *Woman Combing Her Hair* (1915), both in the Museum of Modern Art, New York, are examples of this innovation. His work was included in the New York Armory Show of 1913 and exhibited at Herwarth Walden's gallery in Berlin with the Berlin Sturm group. His sculptures of this time tended toward somewhat geometricized volumes; among these works were *Gondolier* (1914), *Geometric Statue* (1913), *Head Constructed with Crossing Planes* (1913), and wood reliefs such as the Medrano figures. His work was widely exhibited in Europe in 1919.

Archipenko opened a school in 1921 in Berlin, where he remained until 1923, when he founded still another school in New York. He became an American citizen in 1928. Archipenko taught at the University of Washington in 1935–36 and joined Moholy-Nagy's New Bauhaus in 1937. In 1939 he returned to New York and again opened a school. ALBERT ELSEN

ARMITAGE, KENNETH. English sculptor (1916–). He studied at the College of Art in Leeds and at the Slade School in London. His career was interrupted by six years of military service in World War II. Armitage has had one-man exhibitions in London at Gimpel Fils and in New York at Schaeffer Galleries, Inc., and Rosenberg Gallery. In 1955 he was represented in the New Decade showing at the Museum of Modern Art in New York. Although his style is generally abstract, he makes subjective reference to the human figure, as in *Standing Group* and *Seated Group Listening to Music* of the early 1950s, both in bronze, sheetlike relief, though freestanding. His *Figure Lying on Its Side* (1957) projects the helplessness of a stricken, abused human form.

ARMORY SHOW, THE. Art exhibition held in 1913, so called in general usage because of its location in the 69th Regiment Armory in New York City. The Armory Show was the first massive presentation in the United States of avant-garde European and American painting, sculpture, and graphics.

ARMS, JOHN TAYLOR. American etcher and draftsman (1887–1953). Born in Washington, D.C., he studied architecture at the Massachusetts Institute of Technology and practiced that profession with the firm of Carrère and Hastings and with his own firm of Clark and Arms until his service with the United States Navy during World War I.

In 1914 he had begun to etch as a vocation and, later, after studies with David Gregg, Ross Turner, Felton Brown, and Despradelle, he became one of the foremost etchers of medieval buildings, especially of French cathedrals. *Lace in Stone, Rouen* (1927) is his best-known plate, an excellent example of his skilled draftsmanship, remarkable control of architectural detail, and acute vision, as well as of the desire to express his deep love of the Gothic cathedral. GUSTAV VON GROSCHWITZ

ARP, JEAN (Hans). French sculptor, painter, graphic artist, and poet (1887–1966). He was born in Strasbourg and from 1905 to 1907 studied at the Weimar Academy; in 1908 he was at the Académie Julian in Paris. He founded the Moderner Bund with other artists during his stay in Weggis, Switzerland (1909–12). In 1912 he took part in the second Blaue Reiter exhibition in Munich, where he met Delaunay and Kandinsky. In Berlin in 1913, he contributed to *Der Sturm* and participated in the first Herbstsalon. In 1914 he was in Cologne, where he met Max Ernst, and then in Paris, where he met Picasso, Modigliani, and Apollinaire. He was in Zurich from 1915 to 1916 and became a founder of the Dada movement. During this period he also composed abstract collages, according to "the laws of chance," and tapestries with Sophie Taeuber, whom he was to marry in 1921.

Arp participated in the Dadaist demonstrations in Cologne (1919–20) with Max Ernst. From 1922 to 1926 he lived in Paris, visiting Hannover in 1923, and contributing to *Merz*. During 1925 he published *Der Pyramidenrock* in Zurich. He also published with Lissitzky an avant-garde anthology, *Les ismes de l'art*. In 1926 he made his home in Meudon, near Paris. In that year he participated with Breton in a surrealist demonstration. In 1927–28, with Sophie Taeuber-Arp and Van Doesburg, he created mural

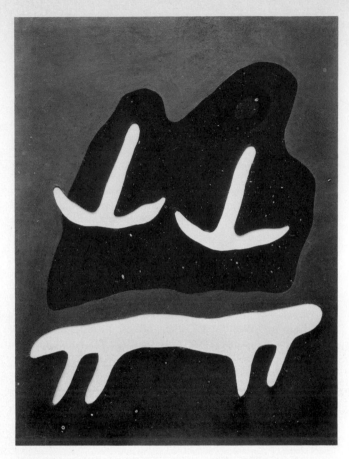

Jean Arp, *Mountain, Table, Anchors, Navel* (1925). Oil on cardboard with cutouts, 29⅝″ x 23½″. Museum of Modern Art, New York.

decorations for the Aubette Restaurant and Bar in Strasbourg, which has since been destroyed. In 1930 he made his *papiers déchirés*, and his poems were translated into French by the surrealists. By 1940 he was a refugee in Grasse, where he worked in collaboration with his wife, Sonia Delaunay, and Magnelli. In 1942 he returned to Zurich, where his wife died.

In 1949, in the United States, Arp published *On My*

Way and was commissioned in 1950 to do mural reliefs for Walter Gropius's Graduate Center at Harvard University. In 1952 he visited Italy and Greece and published *Dreams and Projects.* In 1953–54 he executed a mural relief, *Berger de Nuage,* for the University Center in Caracas. By 1958 he had completed a large copper relief for UNESCO headquarters in Paris. A large retrospective showing of his work was held at the New York Museum of Modern Art in 1958.

Although interested primarily in sculpture from 1932 on, Arp was also very active in the creation of collages. These may be abstractly biomorphic, suggesting primordial forces, or figural, with literal subjects such as forks, eggs, and navels. Flat pattern, curvilinear contours, and pure bright color are emphasized. Arp's contribution consisted of raising the creative practice of free association, chance, and automatism to a high level in sculpture. He brought wit and insight into man's relation to nature and achieved a maximal expressiveness with elementary forms.

ALBERT ELSEN

ART DECO. Decorative style developed primarily in the applied arts and architecture, although it appeared also in sculpture and painting, from about 1920 to 1940. Originally known as *art moderne* in France and "modernistic art" in the United States, Art Deco was a reaction against Art Nouveau with its exaggerated curves and asymmetrical forms. In contrast to the functionally oriented Bauhaus industrial design or the International Style architecture, Art Deco in industrial design or architecture is concerned with colorful and decorative patterns rather than function. The Cincinnati Terminal of 1933, with its mock functionalism and its use of fashionable and decorative materials such as carved linoleum, exotic woods, and onyx in a curious kind of industrial-plus-decorative mixture, typifies the structures in this style.

ART NOUVEAU. Decorative style that flourished on the Continent from about 1890 for a little more than a decade. This style was applied to nearly all art forms from furniture, jewelry, flatware, posters, and typography to sculpture, painting, and architecture. It is characterized by the domination of a fluid, melodious, undulating line or contour to which forms, textures, and even colors submit. The

line is often described as a "whiplash" because it is ser-
pentine and turns upon itself in sudden and unexpected
ways. The line, some artists thought, was expressive of an
elemental life force, and, therefore, the style belonged to
no period and stood outside history. Art Nouveau may be
seen in paintings and graphics by Toulouse-Lautrec, Vuillard,
and Vallotton, in the interior designs of Henry van de Velde,
and in the glass by Lalique and Tiffany.

ASHCAN SCHOOL. Group of American painters led by
Robert Henri (1865–1929) in protest against the vitiated
academic art prevalent in public and dealers' tastes at the
turn of the 20th century. The Ashcan school won its un-
complimentary name at the hands of critics who were ap-
palled by its down-to-earth, socially conscious subject mat-
ter and its generally boldly realistic style. Its membership
included the group known as "The Eight," and the whole
Ashcan circle is sometimes mistakenly referred to by that
designation. The members were, in addition to Henri, John
Sloan, George Luks, Everett Shinn, William Glackens, Ar-
thur B. Davies, Ernest Lawson, and Maurice Prendergast,
who exhibited as "The Eight" only once, at the Macbeth
Gallery in New York (Feb. 1908), and George Bellows,
Edward Hopper, Eugene Higgins, Jerome Myers, and Glenn
Coleman. The names of Rockwell Kent, Leon Kroll, Board-
man Robinson, and Gifford Beal are sometimes added to
this list, but they were not actually central to the principles
of the Ashcan association. *See* EIGHT, THE.

Known also as "the revolutionary black gang," the Ash-
can school derived from, and to a significant extent re-
mained affiliated with, the late-19th-century American tra-
dition of newspaper graphic reporting. Of The Eight, Sloan,
Shinn, Luks, and Glackens were illustrator-cartoonists of a
political-social attitude strongly liberal in outlook (Sloan
was a consulting editor for the *Masses*, an important outlet
for Ashcan graphic work).

The Ashcan school was more radical in its choice of
themes than in its conceptual and technical achievements,
but its significance as a collective, independent organizing
force in early-20th-century American art was profoundly
effective. Aside from the finer canvases and prints by cer-
tain of its members, the Ashcan school and especially those
men who comprised The Eight cleared the way for the

avant-garde exhibitions of later decades. *See* BEAL, GIFFORD
REYNOLDS; BELLOWS, GEORGE WESLEY; COLEMAN, GLENN
O.; DAVIES, ARTHUR BOWEN; GLACKENS, WILLIAM JAMES;
HENRI, ROBERT; HOPPER, EDWARD; KENT, ROCKWELL;
KROLL, LEON; LAWSON, ERNEST; LUKS, GEORGE BENJAMIN;
MYERS, JEROME; PRENDERGAST, MAURICE BRAZIL; ROBINSON,
BOARDMAN; SHINN, EVERETT; SLOAN, JOHN.

<div align="right">JOHN C. GALLOWAY</div>

ASSEMBLAGE. Term first used by the French painter
Jean Dubuffet to distinguish his own works, in which pieces
of paper and other objects are pasted together, from collages
of the 1912–20 period by Picasso, Braque, and others. It
has been used to describe all such conglomerate works of
real objects and fragments since the development of such
collages as Kurt Schwitters's Merz constructions, the Dada
readymades of Duchamp, and the mysterious, surrealistic
box constructions of Joseph Cornell.

The term has been used more specifically, however, to
designate an overwhelming trend in the art of the 1950s
and 1960s, particularly in the United States. This move-
ment reintegrates art and environment by assembling ob-
jects of everyday experience, usually in three-dimension-
al structures or arrangements, in varying ways. Effects
are often satirical, stultifying, or even violent. The sculp-
tures of John Chamberlain and Richard Stankiewicz use
car and machine parts; the painting-constructions of Rob-
ert Rauschenberg and Jasper Johns use charismatic and
hypnotic images from popular culture; the assemblages of
Jean Tinguely are self-destroying machines. *See* DUBUFFET,
JEAN; DUCHAMP, MARCEL; JOHNS, JASPER; RAUSCHENBERG,
ROBERT; SCHWITTERS, KURT; STANKIEWICZ, RICHARD;
TINGUELY, JEAN.

ATL, DR. (Gerardo Murillo). Mexican painter (1877–
1964). Born in Guadalajara and a pioneer of the Mexican
renaissance, Atl (Aztec name assumed ca. 1907) preached
revolt as a student, teacher, and director at the Academy
of San Carlos. His ardent nationalism evinced itself in an
exhibition of specifically Mexican art (1910), in a two-
volume work on the popular arts (1922), and in numerous
pictorial studies of volcanoes.

The best landscapist since Velasco, Atl painted expres-

sive scenes in "Atl-color" (wax crayons). During the Mexican civil war he rallied artists to Carranza's side. Later, in 1922, he did frescoes in Atl-color for the former Convent of SS. Peter and Paul. In later life he became a wanderer and recluse.

AUBERJONOIS, RENE. Swiss painter, theater designer, and graphic artist (b. Yverdon, 1872; d. Lausanne, 1957). He studied in Dresden and London and in Paris with Luc Olivier Merson and Whistler. Auberjonois's early paintings show a reserved use of postimpressionist devices applied to the figures and interiors that, with landscapes, constitute his subject matter. His mild use of cubistic treatment reveals the prime importance of the recognizable figure in his work. His later paintings, at times symbolic in feeling, are quietly composed, loosely brushed, and textured in style, and are often of theater or circus subjects.

AULT, GEORGE COPELAND. American painter (b. Cleveland, Ohio, 1891; d. Woodstock, N.Y., 1948). He went to London in 1899; there he studied at the Slade School and St. John's Wood School of Art. He returned to the United States in 1911. Despite ventures into surrealism and the paintings of landscape in upstate New York, Ault is best known for his association with the precisionist (cubist realist) style. To the sharp contours, immaculately painted planes, and geometric vision of the style Ault added, in his cityscapes, an individual element of mystery and poetry, as, for example, in *Sullivan Street Abstraction* (1928; New York, Zabriskie Gallery).
See also CUBIST REALISM.

AUTOMATISM. A form of modern art related to surrealism and not dissimilar to doodling, as its aim is to allow the creative unconscious expression through uncontrolled movements of the hand. Automatism is limited to painting and drawing, and some of Masson's freer drawings, for example, can be included in this category. *See* MASSON, ANDRE.

AVERY, MILTON. American painter (b. Altmar, N.Y., 1893; d. New York City, 1965). In 1905 Avery's family moved to Hartford, Conn. Though he studied art briefly

there, he was largely self-taught. In 1935 he had his first one-man show at the Valentine Gallery in New York. He spent summers in Europe, Vermont, Maine, Florida, and Provincetown. He won many awards, and in 1960 he was given a retrospective exhibition at the Whitney Museum of American Art in New York. His daughter, March, was a frequent subject of his paintings. He favored landscapes, particularly seashores, with and without figures. His bold, rudimentary forms, often willfully distorted, are thinly painted in piquant, appealing color. They recall Matisse and project an image of quiet well-being and tenderness.

B

BACON, FRANCIS. English painter (1910–). Born in Dublin, Ireland, Bacon first exhibited in London in 1949, revealing an original talent that invited comparison with the fantastic work of Fuseli and Goya. Almost entirely self-taught, Bacon uses a fluid technique to express his images of horror, anger, and excitement. His canvases are thinly painted; his motifs combine memories of earlier paintings, films (the screaming nurse from *Potemkin*), newspapers, and newsmagazines. Particularly successful are his variants on the Velázquez portrait of Pope Innocent X, where the figure, desperate and raving, becomes a vehicle for the painter's anguished visions. Though his output is limited, examples of his work are found in many American and European museums.

BACON, PEGGY. American illustrator, caricaturist, printmaker, and painter (1895–). Born in Ridgefield, Conn., daughter of two artists, she has lived in Maine. As a student at the New York School of Fine and Applied Art and the Art Students League, she studied with Jonas Lie, John Sloan, George Bellows, and K. H. Miller. Her illustrations are found in sixty books. She is the author of sixteen books, one of satirical verse, *Cat-Calls* (1935), and stories for children.

BAIZERMAN, SAUL. American sculptor and teacher (b. Vitebsk, Russia, 1889; d. New York City, 1957). He came to New York in 1910, enrolling in the National Academy of Design and in the Beaux-Arts Institute from 1911 to 1920. He accidentally discovered the technique of hammered metal in 1920 and seriously developed it after 1926. His large copper sheets beaten on both sides were first ex-

hibited in 1938. He taught in his own school from 1934 to 1941. The human form was the sole carrier of his sentiments about nature, music, and peace. He achieved a unique fusion of relief and sculpture in the round through his series *The City and Its People* (begun in the 1920s), *Lyric Poem* (1949), *Exuberance* (1931–39), and *Slumber* (1948; New York, Whitney Museum).

BALLA, GIACOMO. Italian painter (b. Turin, 1871; d. Rome, 1958). As a teacher of Boccioni and Severini about 1900 and as a practitioner of the futurist style not only during the 1910s but after 1920, Balla contributed both to the origins and to the culmination of an important modern movement.

He studied briefly in Paris but was principally self-taught, being strongly influenced by French neoimpressionism. Balla developed from the theories and works of Seurat and Signac a divisionist method of his own, which, after he joined the futurist circle, he applied to the central futurist idea of simultaneous movement of forms in space. Already an established artist by 1909, when Marinetti issued the first futurist manifesto (Balla had exhibited, for example, in the Düsseldorf International Exhibition of 1904), he was old and influential enough to act as counselor to certain of his younger colleagues.

Balla's best-known canvas is probably *Dynamism of a Dog on a Leash* (1912; New York, private collection), although this interesting work is not, in fact, fully relevant to the core of his aesthetic. Balla, unlike certain futurists, was more deeply concerned with the abstract factors of rhythm, light, and color than with the synthesis of those qualities as they derived from machines. His principal works, in fact, bear such titles as *Girl and Balcony* (1912; artist's estate), *Swifts: Paths of Movement + Dynamic Sequences* (1913; New York, Museum of Modern Art), and *Study for Mercury Passing under the Sun* (1914; Winston Collection). Even in canvases of nominally machine subjects, for example, *Automobile Speed + Lights + Noises*, Balla concentrated upon the abstract values of velocity, illumination, and sound rather than upon the mechanical forms that yielded those qualities.

Balla, who first exhibited with the futurists in 1912 after

signing the 1910 "Technical Manifesto of Futurist Painters," frequently worked in this controversial style until the 1930s; and as late as 1951 he was instrumental in an effort to rejuvenate futurism along its 1909 to 1915 lines. *See also* FUTURISM.

JOHN C. GALLOWAY

BALTHUS (Klossowski de Rola). French painter of Polish descent (1908–). Born in Paris, he has lived near Autun. Both his parents were painters. He spent his youth in England and Switzerland and knew Rilke. Largely self-taught, he was influenced first by Bonnard, then by Courbet and Derain. Balthus had his first one-man show in Paris in 1943. His portraits of Miró and Derain (both New York, Museum of Modern Art) are frequently reproduced. A favorite theme consists of adolescents, stultified and transfixed by boredom or introspection, as they daydream, sleep, play cards, or turn the pages of a book in a late afternoon light in a middle-class drawing room. Belonging to no school or group, Balthus's art is frequently associated with such neoromanticists as Tchelitchew and Bérard.

BARLACH, ERNST. German sculptor, graphic artist, and dramatist (b. 1870, Wedel, Holstein; d. Rostock, 1938). From 1888 to 1889 he was a student at the Hamburg School of Applied Arts. He studied sculpture at the Dresden Academy as a master pupil of Robert Diez from 1891 to 1895. Barlach lived in Paris from 1895 to 1897, briefly attending the Académie Julian, and published a book on decorative sculpture, *Figure Drawing*. Between 1897 and 1901 he lived in Paris, Altona, Hamburg, and Berlin, after which he lived in seclusion in Wedel. He had cast some ceramic works in Altona.

Barlach's first exhibition of ceramics and drawings was held in Berlin in 1904. In 1904–05 he taught ceramics at Hoehr. From 1905 to 1909 he lived principally in Berlin, exhibiting in 1906 the small bronze, *Expellees*. From August to September of 1906 he visited his brother in Kharkov, Russia. This trip to southern Russia led to early sculptures of peasants. In 1907–09 he became a member of the Berlin Secession and contracted with Paul Cassirer for all his work. He lived in Florence in 1909 and settled permanently in Güstrow in 1910. He saw brief military

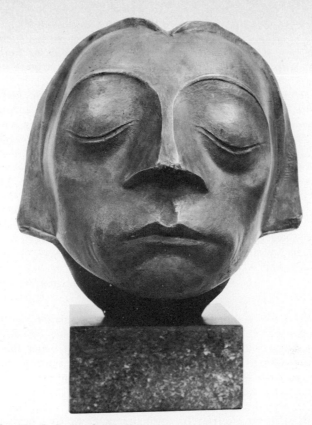

Ernst Barlach, *Head* (Detail, War Monument, Gustrow Cathedral, 1927). Bronze, 13½" high. Museum of Modern Art, New York. Gift of Edward M. M. Warburg.

service during 1915 and 1916, and in 1918 was elected to the Berlin Academy of Fine Arts. His plays *Poor Cousin* and *Dead Day* were performed in 1918–19. In 1921 he received his first war memorial commission and did the *Mater Dolorosa* for the Nikolai Church in Kiel. In 1927 he did the Güstrow memorial, *The Hovering One.* He published his autobiography, *A Self-told Life,* in 1928, and also did the Magdeburg Cathedral memorial. In 1930 he began work on *The Community of the Holy Ones* for St. Catherine's Church in Lübeck, of which three figures were ultimately finished. In 1931 his work was shown at the

Museum of Modern Art, New York. During the Nazis' rise to power, Barlach's work was condemned as "degenerate" art. Several of his memorials were removed, as were 381 works from public collections, and in 1936 a book of his drawings was burned.

Of his sculptures, the Museum of Modern Art, New York, owns *Singing Man* (1928) and *Head of Güstrow Memorial* (1927); the Busch-Reisinger Museum, Cambridge, Mass., has *Seated Girl* (1908) and *Crippled Beggar* (1930); Cranbrook Academy, near Detroit, owns *Man Drawing a Sword* (1911); and the Hamburg Art Gallery has *Man in a Stock* (1918). Under the influence of late medieval art, Barlach revived serious interest in wood carving in modern sculpture and contributed humane images of suffering. He was a proto-expressionist who strongly combined social realism with a visionary approach. His art had a strong influence on American sculptors of the 1930s who were socially conscious.

ALBERT ELSEN

BARLACH AS GRAPHIC ARTIST

Barlach's graphic work shows a preoccupation with humanity's sufferings. Yet the people he creates, usually frail beggars and outcasts, seem to aspire to a better fate rather than to give vent to despair. Barlach's introverted, forlorn souls become ennobled through their misery.

Barlach's activity as a printmaker did not begin until 1910, after he was forty. In 1910–12 his first lithographs were made to illustrate his own drama *Dead Day*, which deals with a mother who loses her child. Here the sgraffito is most agitated, and the figures, though bulky as in his sculpture, nonetheless seem devoid of weight. A work of World War I, his charcoal *Anno Domini MCMXV Post Christum Natum* shows an emaciated Christ tempted before a landscape dotted with crosses marking countless graves. He continued to illustrate his own plays, with thirty-four lithographs for *Poor Cousin* in 1919 and twenty woodcuts for *The Foundling* in 1922, many of which show a predilection for grotesquerie.

Barlach also illustrated works of other writers. He made woodcuts for Goethe's witch-haunted Walpurgisnacht scene from *Faust* and lithographs for several of Goethe's poems. In the late 1920s he made woodcut illustrations for Schiller's *Ode to Joy*. These evoke a spontaneity and lightness

unusual for the medium and rarely found in his sculpture.

From 1927 on, largely because of concentration on major sculpture programs, he worked less with graphic media and seemed content for the most part to rework earlier themes. But *Die Wandlungen Gottes* of 1928, a set of seven woodcuts, shows Barlach still searching for new forms. The plate depicting God resting from His labors, typical of the series, features short incisive strokes rather than the broad contrasts usually found in the medium.

Over a thousand of Barlach's drawings still exist, and these show a variety of expressions. A pen-and-ink study of a nude beggar of 1928 is spontaneously and sketchily rendered, but the charcoal drawings of both single figures and of groups, which become more frequent after the late 1920s, are done in a far more static, occasionally almost dry manner. In the drawings, again and again, his penchant for grotesquerie is evident.

<div style="text-align: right">ABRAHAM A. DAVIDSON</div>

BASKIN, LEONARD. American sculptor and printmaker (1922–). He was born in New Brunswick, N.J., and apprenticed at an early age to the sculptor Maurice Glickman (1937–39). He studied at the New York University School of Architecture and Allied Arts (1940–41), the Yale University School of Art (1941–43), the New School for Social Research (until 1949), the Académie de la Grande Chaumière, Paris (1950), and the Accademia delle Belle Arti, Florence (1951). He was awarded a Tiffany fellowship for sculpture in 1947 and a Guggenheim fellowship for printmaking in 1953. Since then Baskin has been teaching printmaking and sculpture at Smith College in Northampton, Mass.

His large woodcuts are impressive and original in concept. *Man of Peace* and *Everyman* (83 in. high) are among his best. He is among the very finest designers of woodcuts of the present day. Baskin has also made some excellent wood engravings, some of which he has used to illustrate books that he has printed on his private Gehenna Press.

<div style="text-align: right">GUSTAV VON GROSCHWITZ</div>

Baskin as sculptor. In his development as a sculptor Baskin has evolved a unique figure style of monumental, anonymous-appearing shapes, working in bronze, wood, and relief. His figures seem to be subject to the same

forces, whether they are portraits of great artists or poets (*Blake*, 1955; *Barlach Dead*, 1959), pompous sentinels (*Laureate Standing*, 1957), or universal symbols (*Hanged Man*, 1956; *Man with Owl*, 1960). Both as a sculptor and a printmaker, Baskin has been concerned with the humanistic and craft traditions.

BAUHAUS. German school of design, founded in 1919 by Walter Gropius at Weimar. The existing Weimar Art Academy was merged with the Weimar Arts and Crafts School into Das Staatliche Bauhaus Weimar. Because of the city's hostile cultural climate, the school was moved in 1925 to a new building in Dessau. Political pressures caused Gropius to resign as director in 1928, and he was succeeded by Hannes Meyer, who headed the school until 1930. Mies van der Rohe was director until 1933. The Bauhaus moved to temporary quarters in Berlin in 1932 and was closed by the Nazis in 1933. Its program was transplanted to the United States when Josef and Anni Albers joined the faculty at Black Mountain College, in North Carolina, in 1933; László Moholy-Nagy established the New Bauhaus in Chicago in 1937; Walter Gropius and Marcel Breuer joined the faculty at Harvard in 1938; and Mies van der Rohe was appointed head of the architectural school of the Armour Institute, Chicago, in 1939. *See* ALBERS, JOSEF; BREUER, MARCEL LAJOS; GROPIUS, WALTER; MIES VAN DER ROHE, LUDWIG; MOHOLY-NAGY, LASZLO.

Several assumptions conditioned Bauhaus educational policy: (1) the designer must master the machine because it is his main medium; (2) all forms of design must recognize this fact and develop their aesthetic criteria accordingly; (3) all creative works are interdependent; (4) all industrial productions are, of necessity, collaborative works; and (5) the designer must have a thorough practical, as well as theoretical, knowledge of his field.

The Bauhaus building has become a 20th-century classic of immense influence on subsequent architecture, ranging from domestic to industrial buildings. The educational program of the Bauhaus has had an incalculable impact on art education and on the approach to design problems throughout the Western world.

THEODORE M. BROWN

BAUMEISTER, WILLI. German abstract painter (1889–1955). He was born in Stuttgart, and lived and taught there until his death. He studied with Adolf Hoelzel, the noted color theorist, and had his first one-man show in 1912 in Zurich. At that time Baumeister was influenced by Cézanne. He was never associated with the German expressionist movement but rather with constructivist and neo-plastic art such as that of Schlemmer, Ozenfant, Léger, and Le Corbusier. He painted his first abstract works in 1919. In 1928 Baumeister began to teach at the Frankfurt am Main School of Arts and taught there until the Nazis called his art "degenerate" and dismissed him.

By 1937 he employed ideograms and biomorphic shapes suggesting certain primordial and prehistoric signs. These forms recall those in Sumerian hieroglyphics and Aztec carvings, as well as the art of Ernst, Klee, and Miró.

BAYER, HERBERT. American graphic artist and exhibition designer (1900–). Born in Haag, Austria, Bayer studied architecture in Austria and Germany, and in 1921 entered the Bauhaus to study painting under Kandinsky. In 1938 he went to the United States, where his work for such companies as John Wanamaker, J. Walter Thompson, and the Container Corporation of America rapidly enhanced his reputation as a graphic artist. He also became known in the United States for his original museum installations, including the Museum of Modern Art's Bauhaus show (1938), "Road to Victory" (1942), and "Airways to Peace" (1943). In the 1950s he designed a number of buildings for the Institute for Humanistic Studies, near his home in Aspen, Colo. In painting, his earlier works were related to surrealism. Later abstractions are often based upon the weather as well as upon other natural phenomena.

BAZAINE, JEAN. French abstract painter (1904–). He was born in Paris, where he has worked. He studied sculpture and earned a degree in literature before turning to painting in 1924. Bonnard and Gromaire expressed admiration for Bazaine's art in 1934 at his first one-man show. In 1941, during the German Occupation, Bazaine helped found the Salon du Temps Présent along with Manessier, Estève, Lapicque, Singier, and Le Moal. The

Art Museum in Bern gave him a retrospective exhibition in 1958. He has designed many stained-glass windows (three for the church at Assy), and has executed a large mosaic for the UNESCO Building in Paris.

His oils are abstractions based on contemplation of nature. He combines bright, often Fauve-like color with intimations of atmosphere and shimmering light in a shallow, essentially cubist space.

BAZIOTES, WILLIAM. American painter (b. Pittsburgh, 1912; d. New York City, 1963). One of the first post-World War II action painters of the New York abstract-expressionist group, Baziotes was earlier influenced by cubism and surrealism. He studied at the National Academy of Design from 1933 to 1936 and worked with the Federal Art Project until 1941. His first one-man show was held in 1944 at the Art of This Century Gallery in New York. Baziotes has been represented in many outstanding annuals and international exhibitions, including the Museum of Modern Art's Fifteen Americans, in New York, and its European traveling collection, the New American Painting; the São Paulo, Brazil, Bienal; the Carnegie International in Pittsburgh; the Whitney Museum of American Art's Annuals and its New Decade show; and others. His painting has been significant to the widespread acknowledgement of the action style since the late 1940s.

BEAL, GIFFORD REYNOLDS. American painter and graphic artist (b. New York City, 1879; d. there, 1956). He studied with William Merritt Chase and at the Art Students League with Frank DuMond and George Bridgeman. His early works were realistic urban genre subjects, but he later turned to colorful and more decorative seascapes and holiday and circus scenes.

BEARDEN, ROMARE. American painter (1914–). Born in Charlotte, N.C., he was educated at New York University and in 1936–37 worked under George Grosz at the Art Students League in New York. At that time he became friendly with Charles Alston as well as other figures on the black cultural scene. In 1940 he began to work in tempera on brown paper, devoting himself to Southern scenes. That year also he came to know such painters as Stuart Davis, Paul

Burlin, and Walter Quirt, who respected his work and who undoubtedly affected him to some extent.

Bearden's work before this was reminiscent of Ben Shahn and of Mexican muralism, but he soon developed the powerfully poetic and dynamic style that distinguishes his paintings. By the 1960s, as seen in *The Prevalence of Ritual* series (exhibited in his one-man show at the Museum of Modern Art, 1971), his previous contacts and influences had been absorbed into the expressionist-cubist style which marks his contribution to the artistic humanism of our time. Dealing invariably and representationally with the problems of people (generally his own black people), Bearden has brought together a remarkable sense of decorative and emotive color with a feeling for organization of the picture surface itself, into a series of elegies on the works and days of black America. BERNARD S. MYERS

BECKER-MODERSOHN, PAULA, *see* MODERSOHN-BECKER, PAULA.

BECKMANN, MAX. German painter (b. Leipzig, 1884; d. New York, 1950). He studied at the strongly conventional Weimar Academy of Art and was influenced by the painting and theories of Hans von Marées. Visits to Paris in 1903 and Italy in 1904 introduced him to the stimulus of Rembrandt, Piero della Francesca, and other baroque and Quattrocento masters; but Beckmann was not at that time deeply attracted to postimpressionist art (he found some interest in Cézanne slightly later). Moving to Berlin late in 1904, he soon acquired semblances of the German impressionist style of Max Slevogt and Lovis Corinth. He won an important prize in 1906 and in that year was admitted to the Berlin Secession, a prestigious group that in 1892 had organized in a spirit of liberal protest but that had gradually come to represent the old guard.

It appears that Beckmann was not especially progressive in attitude until shortly before World War I, although he did resign from the Secession in 1911 so that he might work independently of programmatic influences. The drive to discover his own personal vision—to make reality visible, as he later put it—began at this time, and Beckmann felt it throughout his career. World War I brought him into the German army as a medical corpsman, and the

Max Beckmann, *Departure* **(1932–33). Oil on canvas; triptych; center panel 84¾″ x 45⅜″; side panels each 84¾″ x 39¼″. Museum of Modern Art, New York.**

shattering horror of the spectacle of the dying and dead provided Beckmann involuntarily with the core of his later nightmarish imagery. He became gravely ill in 1915 and convalesced in Frankfurt am Main, where he managed to continue drawing and engraving. He also seriously restudied German late medieval art and found inspiration in Stoss and Grünewald. In 1916 he was made professor of painting at the Frankfurt Academy. During the rest of the war, Beckmann matured greatly in both concept and technique.

His paintings and prints following 1918 gradually became free from the Berlin impressionist brushwork and steadily acquired the bold, spatially compressed, and harshly delineated forms that were thereafter to distinguish his style. He also developed the complex and often completely enigmatic symbolism that characterizes most of his important figure compositions. Many of Beckmann's themes after about 1920 project sadistic, hazardous situations in which bodily discomfort or outright pain is explicitly depicted and their sources are allegorically or symbolically suggested. In 1921 Beckmann wrote four plays, none of them actually being performed; but the act of writing them very likely increased his feeling for disturbing visual imagery.

Beckmann's paintings and prints of the middle 1920s have been identified by some critics with the Neue Sachlichkeit (New Objectivity) style, a hard, socially conscious realism then practiced by George Grosz, Alexander Kanoldt, Otto Dix, and other artists who painted the spectacle of economic disaster and human depravity that was widespread in postwar Germany. Beckmann, however, only briefly shared the rather overspecific aims of this group and continued to seek the symbolic reality of his own peculiar vision. Nonetheless, certain of his Neue Sachlichkeit paintings and graphics are as bitingly expressive as are those of Grosz.

The late 1920s yielded many fine still lifes, portraits, and city landscapes as well as figure compositions. Beckmann's frequent stops in Paris kept him conversant with new developments in color and spatial handling. His style, with its closely grouped, tensely placed shapes and its strange conjunction of strong linear definition and painterly surfaces, became one of the most distinctive in modern German painting. During the 1930s his color became more resonant, sometimes almost glaring in its combinations of clear blues and greens, brilliant reds, and acid yellows. By now his reputation was internationally established, and he had won an important prize at the 1929 Carnegie International in Pittsburgh. During 1931 and 1932 he exhibited at the Basel Kunsthalle and at the Galerie de la Renaissance and the Galerie Bing in Paris.

The Nazi government after 1933 proscribed Beckmann's art, like that of most avant-garde artists in Germany, as "degenerate"; and he had to quit his professorship in Frankfurt, at first seeking refuge in Berlin, still a more sophisticated center of culture than most of its sister towns. He turned for a time to sculpture during 1934 and 1935, meanwhile finishing the renowned triptych *The Departure*. Beckmann left Germany for Amsterdam in 1937, no longer able to endure the political and psychological disaster then overtaking his country. He won first prize at the Golden Gate International in 1939 and made major book illustrations in 1943 while still a refugee in Holland. Beckmann went to the United States in 1947. In 1948 he taught painting at Washington University in St. Louis, then at the Brooklyn Museum School after settling in New York in 1949. He had just completed the last of his nine allegorical triptychs, *The Argonauts*, when in 1950 he died.

Beckmann's principal oil paintings include *Young Men by the Sea* (1905; private collection), *Self-Portrait* (1912; private collection), *The Street* (1913; artist's estate), *Christ and the Adulteress* (1917; St. Louis, City Museum), *The Night* (1919; Berlin, former State Museums), *Family Picture* (1920; New York, Museum of Modern Art), *View of Genoa* (1927; St. Louis, May Collection), and *Double Portrait* (1941; Amsterdam, Municipal Museum). The triptychs are *Departure* (1932–35), *Temptation* (1936), *Acrobats* (1939), *Perseus* (1941), *The Actors* (1942), *Carnival* (1943), *Blindman's Bluff* (1945), *The Beginning* (1949), and *The Argonauts* (1950). Beckmann was more productive as a graphic artist before 1925 than later. His lithograph *David and Bathsheba* (1911), the woodcuts *Woman with a Candle* (1920), *Before the Mirror* (1923), and *Charnel House* (1923), and the drypoints *Adam and Eve* (1917) and *Kasbek* (1923) are characteristic.

It is paradoxical that Beckmann, never closely linked to any of the definitive expressionist groups in Germany, is one of the major expressionists of this century. The complex and deeply personal symbolism of most of his mature works is so immediately overwhelming that it tends to obscure the far more significant stylistic uniqueness of Beckmann's art. The sheer drama of his structure and color as well as his forceful use of disquieting, extrapictorial sensations—chiefly the imagery of sounds, as in brass horns and drums—serve to identify Beckmann as an original, leading contributor to expressionism.

JOHN C. GALLOWAY

BEERBOHM, MAX. English caricaturist (1872–1956). Some of his collected works have appeared in *A Book of Caricatures of Twenty-five Gentlemen* (1896), in *Caricatures* (1907), and in *Fifty Caricatures* (1913). His subjects were usually drawn from contemporary men of letters, such as Henry James, Aldous Huxley, and George Bernard Shaw. His approach is humorous and whimsical, rather than cruelly satirical. Beerbohm has defined the perfect caricature as that which "on a small surface, with the simplest means, most accurately exaggerates to the highest point, the peculiarities of a human being, at his most characteristic moment, in the most beautiful manner."

BEHRENS, PETER. German architect (1868–1940). He worked near Berlin. Although at first affiliated with Art Nouveau, by the early 1900s his personal style was closely related to that of Olbrich. In this manner Behrens designed in terms of symmetrical cubic blocks with flat planar surfaces. Although he built a variety of structures, both residential and commercial, his most important work was in the industrial field. An outstanding example is the AEG Turbine Factory, begun in 1909, which illustrates his classicizing but forward-looking use of concrete and steel, directly expressed, with no applied ornament, and on a monumental scale. His German Embassy Building in Leningrad recalls his factory work and the romantic classical style. In the 1920s he became a professor at the Vienna Academy. His later work was more academic and traditional.

BELL, LARRY. American painter and sculptor (1939–). A native of Chicago, Bell studied at the Chouinard Art Institute in Los Angeles. At first influenced by abstract expressionism, he then turned to shaped canvases and minimal box constructions, highly finished, which look through to a shifting world of geometric images. In 1965 he was one of the American representatives at the São Paulo Bienal.

BELLING, RUDOLF. German sculptor (1886–). His early works, marked by expressionist influence, were widely exhibited in Berlin, where he was born and where he also executed public sculptures. About 1916 Belling was influenced by Archipenko and cubism. His works of the early 1920s, such as the helmetlike *Sculpture* (1923), relate closely to the constructivist aesthetic and are carried out in highly finished metals. They are also related distantly to Dada forms and to the recent Neo-Dada constructions of New York artists. Belling left Germany during the Nazi ascendancy and has lived in Istanbul; his style has changed to a more traditional expression. Belling's art is interesting for its historical change from expressionist beginnings and its assimilation of cubist, then constructivist qualities, and for its adaptation to popular display objects (doll-like figurines) in Berlin and Paris.

BELLOWS, GEORGE WESLEY. American painter and lithographer (b. Columbus, Ohio, 1882; d. New York City, 1925). In 1904 he went to New York, where he studied with Robert Henri and Kenneth Hayes Miller. For Bellows, success and official recognition came early; despite his youth he was elected an associate of the National Academy in 1909 and an academician in 1913.

His early works were done in a strong, loosely painted style, and many were Ashcan subjects of urban genre, for example, the painting of boys diving from a pier, *Forty-Two Kids* (1907; Washington, D.C., Corcoran Gallery), or the crowded street scene called *Cliff Dwellers* (1913; Los Angeles County Museum). In the same period he painted fluid and skillful landscapes such as *Up the Hudson* (1908; New York, Metropolitan Museum) or *Floating Ice* (1910; New York, Whitney Museum). Perhaps his most popular paintings were his early prizefight scenes; Bellows's interest in realism and in the depiction of violent movement and his vigorous early painting style are readily apparent in *Stag at Sharkey's* (1909; Cleveland Museum of Art) and *Both Members of This Club* (1909; Washington, D.C., National Gallery).

In 1916 Bellows began to make lithographs. He eventually produced nearly 200 prints with a wide variety of subjects ranging from the Rembrandt-influenced *Edith Cavell* (1918) to the dramatic *Billy Sunday* (1923). His lithographs as well as his drawings exhibit his mastery of draftsmanship and tonality.

At about the same time as his interest in lithography developed, Bellows became involved with a more theoretical approach to painting. He studied Jay Hambidge's ideas of "dynamic symmetry" and geometric composition and took up the problem of a restricted palette. The result was stronger composition and a relatively tighter style, applied mostly to portraits and landscapes, which, although carefully worked out, was sometimes dull. The difference is clear when the vivid and slashing prizefight pictures of 1909 are compared with his formally polished *Dempsey and Firpo* (1924; Whitney Museum). Despite the theorizing, some of Bellows's late portraits are among his finest paintings, for example, *Eleanor, Jean, and Anna* (1920; Buffalo, N.Y., Albright-Knox Art Gallery) and another triple portrait, *Emma and Her Children* (1923; Boston,

Museum of Fine Arts). The most famous of Bellows's late figures is the little girl of *Lady Jean* (1924; New York, Stephen C. Clark Collection).

JEROME VIOLA

BELLUSCHI, PIETRO. Italo-American architect (1899–). Born in Ancona, he spent most of his youth in Rome; after three years in the Italian army, he attended the University of Rome, receiving a doctor of engineering degree in 1922. He attended Cornell University as an exchange scholar in 1923, and after receiving a civil engineering degree he joined the architectural firm of A. E. Doyle in Portland, Ore., in 1925. He served as its head designer from about 1927 and acquired the firm in 1943. Later he became dean of architecture and planning at the Massachusetts Institute of Technology. As an architect, Belluschi is a master of simple, almost primitive, forms in wood; he has built notable religious, commercial, and residential works on both coasts. The Equitable Building in Portland, Ore. (1948), is his most important single work.

BENOIT, RIGAUD. Haitian painter (1911–). A self-taught artist and a prominent member of a group connected with the Centre d'Art in his native Port-au-Prince since the 1940s, he participated in the decoration of the Episcopal Church there, painting scenes of the Nativity and the Marriage at Cana. His colorful, crowded scenes of Haitian life are structured in interlocking patterns of flat planes. A strange symbolism sometimes appears, and much of his later work tends toward hieratic formalism.

BENSON, FRANK WESTON. American painter and etcher (b. Salem, Mass., 1862; d. there, 1951). He studied art at the school of the Boston Museum of Fine Arts (1880–83) and at the Académie Julian in Paris (1883–85). Benson began to make etchings in 1912, chiefly of wild fowl, and within a few years his work was well known. He received many awards, among them the Clark prize, National Academy of Design (1891), a silver medal at the Exposition Universelle, Paris (1900), and a gold medal at the Philadelphia Sesquicentennial (1926). His etchings and drypoints of birds, especially ducks, achieved great popularity. He

depicted birds in flight with extraordinary skill, and at the same time the prints were carefully designed decorations.

BENTON, THOMAS HART. American painter (1889–). He was born in Neosho, Mo., and worked as a newspaper illustrator. He then studied at the Art Institute of Chicago and in Paris, where he was briefly influenced by synchromism and cubism. Benton's early work, mostly symbolic groups, shows the strong concern for the rhythmic composition of figures that was to remain part of his style. His interest in American subjects, which began about 1920, culminated in his murals of contemporary American life for the New School for Social Research (1931) and the Whitney Museum of American Art (1932). These, together with the works of Grant Wood and John Steuart Curry, crystallized the regionalist painting of the 1930s. In Benton's later paintings of rural subjects the rich and brilliant color does not compensate for the increased stylization of the forms.

BERARD, CHRISTIAN. French painter, theatrical designer, and illustrator (b. Paris, 1902; d. there, 1949). Bérard studied at the Académie Ranson, where he came under the influence of the Nabi group, particularly Edouard Vuillard and Maurice Denis, and, in 1924, at the Académie Julian. In 1926 Bérard participated in an exhibition at the Galerie Drouet in Paris along with other artists, including Eugene Berman and the recently arrived Pavel Tchelitchew. This loose association of poetic painters became known variously as the "neohumanists" or the "neoromantics."

Bérard's paintings of this period derive from the poignant, lonely figures of Picasso's Blue Period, but their heightened pathos and emotionality are more personal. The dark, dull palette of *Promenade* (1928; New York, Museum of Modern Art), for example, is in keeping with the gloominess of the figures. The concern for the human form and the subjective representation of reality were part of the neoromantic reaction against abstraction. This aspect of Bérard's work is perhaps best expressed in his well-known portraits, such as *Jean Cocteau* (1928; New York, Mu-

seum of Modern Art), with its hypnotic intensification of the sitter's personality.

Bérard began his career as a stage designer with the bleak, atmospheric sets for Sauguet's ballet *La nuit*, produced in Manchester and London in 1930. Among his subsequent theatrical designs were Cocteau's *La voix humaine* and *La machine infernale* in 1930 and 1934, settings for the Ballets Russes' productions of *Cotillon* and *Mozartiana* in 1932, very successful sets and costumes for Giradoux's *La folle de Chaillot* in 1945, and collaboration with Cocteau on the film *La belle et la bête* in 1946. Some of the gentle fantasy that marks Bérard's stage decorations can be seen in the *Mozartiana* (1933).

<div style="text-align: right">JEROME VIOLA</div>

BERGHE, FRITZ VAN DEN. Belgian painter (b. Ghent, 1883; d. there, 1939). He was associated with the second Laethem-Saint-Martin school and studied drawing and painting at the Ghent Academy. He began as an impressionist, but during and after a stay in Holland from 1914 to 1922 his paintings became expressionist in nature, of a vague cubist derivation with cylindrical figures and block forms, as in *La Vie* (1924; Antwerp, Fine Arts Museum). After 1927 the element of personal fantasy became stronger in his work, which seems related more to such artists as Bosch and Ensor than to orthodox surrealism.

See also LAETHEM-SAINT-MARTIN SCHOOL.

BERMAN, EUGENE. Russian-American painter and stage designer (1899–1972). He was born in St. Petersburg, Russia, and later lived in New York City. Berman's family encouraged his early interest in art, and he studied painting with a number of individuals, one of whom was a Palladian architect. Berman traveled to Germany, Switzerland, and France before 1918, when the Revolution in Russia caused him to leave for Paris. There he attended the Académie Ranson along with his brother Leonid and with Christian Bérard. Pierre Bonnard was their teacher.

Berman visited Italy in 1922 and was enchanted with the country, returning there frequently in later life. At about this time he began to paint the kind of subject for which he is best known: melancholy deserted streets and

courtyards of baroque buildings. In 1926 his brother and he, along with Bérard and Pavel Tchelitchew, exhibited as a group at the Galerie Drouet. It was on this occasion that these artists became known as "neoromantics." The term signifies a reaction to the constructivism of synthetic cubism and a reliance on instinct and the senses for direction. The dreamlike, lyrical quality of many neoromantic paintings suggests the influence of Picasso's Blue Period and of surrealism.

Berman's work began to sell; he exhibited regularly in Paris and traveled in the early 1930s to Italy, Spain, and France. In 1937 he settled in the United States. In 1952 he designed the interior for the theater at the Ringling Museum, Sarasota, Fla., and the sets and costumes for the New York Metropolitan Opera production of Verdi's *La Forza del Destino*. He also designed the productions for their *Rigoletto* and *Don Giovanni* and, in 1959, the sets for the television performance of Menotti's opera, *Amahl and the Night Visitors*.

Berman turns to Italy for inspiration and features elements from Neapolitan and Ischian scenery as seen late in the afternoon. Broken columns, classical urns, crumbling walls, and isolated, hooded figures like apparitions cast long shadows against a deep landscape. Perspective is often forced to give impressions of longing and flight, melancholy and nostalgia. Berman frequently enriches the surfaces of his paintings with washes and spatter to suggest the patina of age. ROBERT REIFF

BERTOIA, HARRY. American sculptor (1915–). Born in San Lorenzo, Italy, he went to the United States in 1930 and studied in Detroit. After several years in California, Bertoia moved to Barto, Pa., where he still works. He has designed furniture, and is a consultant to Knoll Associates. His characteristic sculptures since the 1950s have been large, abstract metallic "screens," executed in combinations of steel, bronze, chrome, and copper. Most of them are intended to serve as decorations in residential or commercial interiors, but one is used as the reredos in the chapel at the Massachusetts Institute of Technology, Cambridge, Mass. A monumental example (1954) of such essentially rectangular, flat, perforated sculptures is in the Manufacturers Hanover Trust Company in New York City. Bertoia was represented by a similar work, *Screen Sculpture*, in

the United States Pavilion at the Brussels International Exposition in 1958. His style is generally abstract and geometric and is related to industrial design.

BIDDLE, GEORGE. American painter, sculptor, and graphic artist (1885–1973). He was born in Philadelphia and studied at the Pennsylvania Academy of Fine Arts and in Paris and Munich. Biddle was active in the artistic projects of the Works Progress Administration and did illustrations for socially oriented magazines in the 1930s. Biddle's painting style is realistic as, for example, in the portrait *William Gropper* (1937; Philadelphia Museum of Art), with some distortions for emotional effects in his social genre subjects. His later work was mostly American genre scenes, at times satirical in point of view. Biddle executed murals for the Department of Justice Building in Washington, D.C., and for the Supreme Court Building in Mexico City.

BIGAUD, WILSON. Haitian painter (1931–). A virtuoso painter of Biblical and regional scenes, Bigaud trained at the Centre d'Art in his native Port-au-Prince. His primitivistic style emphasizes rich and decorative effects, drama, and movement, particularly in genre scenes.

BILL, MAX. Swiss sculptor, architect, and designer (1908–). Bill is also famous as a painter and writer on art. Born at Winterthur, he studied at the School of Arts and Crafts in Zurich and at the Dessau Bauhaus. Since the mid-1920s he has lived mainly in Zurich, where he has practiced architecture since the 1930s. He was active as a member of the Abstraction-Création group in Paris during the 1930s, and more recently he directed the Hochschule für Gestaltung at Ulm, Germany. Bill's sculptural style, which is completely nonfigural, is generally constructivist in aesthetic. It is closely allied with the architectural and industrial design principles that were emphasized by most Bauhaus teachers during the 1920s. He often uses cement or white plaster in his sculptures; the shapes are made of tin and are curvilinear and intertwined, as in *Tripartite Unity* (1948). The artist's principal contribution has been his exploitation and perpetuation of Bauhaus formulas dating from the 1920s. JOHN C. GALLOWAY

BISHOP, ISABEL. American painter and etcher (1902–). She was born in Cincinnati, Ohio, and studied in Detroit, with Kenneth Hayes Miller at the New York Art Students League, and at the New York School of Applied Design. She continued Miller's predilection for Fourteenth Street subjects, particularly involving working girls. Her painting technique, derived from Rubens's sketches, involves a judicious mixing of media and produces a rich combination of delicate luminosity and expressive shadow. Her chiaroscuro is especially evident in pensive paintings of female nudes, such as *Nude* (1934; New York, Whitney Museum); her fine technique is equally visible in such figures as *Two Girls* (1935; New York, Metropolitan Museum) and *Subway Scene* (1957–58; Whitney Museum).

BISSIER, JULIUS. German painter (b. Freiburg im Breisgau, 1893; d. Ascona, Switzerland, 1965). Bissier was a graphic artist and textile designer as well as a painter. He became an abstractionist, and between 1934 and 1946 his work was reminiscent of Chinese characters. After 1946 he devoted himself to colored monotypes and miniatures.

BISSIERE, ROGER. French painter (1888–1964). Born in Villeréal, Bissière studied in Bordeaux and was an influential teacher at the Académie Ranson in Paris from 1925 to 1938, when he became blind. In 1945 his sight was restored, and his paintings were again exhibited successfully. Bissière is best known for his abstractions, based remotely on nature, which are characterized by overall design and rich color.

BLACK ART: UNITED STATES. This art began to appear in the 19th century. Some of the portraits by Joshua Johnston (1770–1830) are close to those by Rembrandt Peale. William Bannister (1828–1901) painted marines and landscapes; and Edmonia Lewis (1845–90) sculpted neoclassical figures in Rome. Henry Ossawa Tanner (1859–1937) gained a degree of international recognition for his portraits and genre scenes.

In the 20th century the self-taught Horace Pippin (1888–), working in a primitive vein, has done a *John Brown* series. Irony and social commentary appear in the work of Norman Lewis (1909–), and the contemporary painter Jacob Lawrence (1917–) sometimes

makes use of the cubist idiom. Among those working in the most advanced styles, Daniel Larue Johnson (1938–) creates wood and metal constructions painted in vibrant color patterns. *See* LAWRENCE, JACOB; PIPPIN, HORACE.

See also BEARDEN, ROMARE; THOMPSON, BOB; WOODRUFF, HALE.

BLANCH, ARNOLD. American painter, illustrator, and graphic artist (1896–1968). He was born in Mantorville, Minn., and studied in Minneapolis and with Kenneth Hayes Miller, John Sloan, and Robert Henri. His early works were realistic landscapes, figures, and still lifes, for example, *Kingston, N.Y.* (1928; New York, Whitney Museum). In the 1930s he painted slightly expressionistic farm scenes and social subjects, such as the large-stroked and indignant *Carolina Low Country* (1939; Brooklyn Museum). In the late 1940s he produced sketchily painted fantasy scenes reminiscent of Weber and Chagall. His more recent works, lyrical and higher in color, show a tendency toward abstraction in the fragmentation of forms.

BLAUE REITER, DER, *see* EXPRESSIONISM.

BLOOM, HYMAN. American expressionist painter (1913–). Born in Brunoviski, Lithuania, Bloom settled in Boston in 1920. After studying with Denman Ross at Harvard (1929–32), he contributed, during the 1930s, to the Federal Art Project.

His expressionism is concerned with metamorphosis. His themes are drawn from the Old Testament, séances, corpses, the aged, beggars, animals, and nature. The *Female Corpse (Back View)*, 1947, reveals sumptuous, jewellike colors that recall Rouault, Soutine, and Chagall. Characteristically Bloom upends and flattens his forms and builds compositions through revolving abstract designs. Visionary images emerge from his introspective and spiritualized world.

BLUE RIDER, THE (Der Blaue Reiter), *see* EXPRESSIONISM.

BLUME, PETER. American painter (1906–). He was born in Smorgonie, Russia, and went to the United States

in 1911. He studied at the Educational Alliance Art School (1919–24) and at the Art Students League and the Beaux-Arts Institute of Design. Although he is often linked with surrealism, the disturbing juxtaposition of seemingly unrelated things that Blume's paintings often display is, at least partially, a function of the piece-by-piece construction of his pictures and their sometimes fanciful or polemic nature. A meticulous craftsman, Blume does countless studies for the single large painting that he produces every few years.

His early work was allied to the clean volumes and sharp planes of the precisionists. To this he soon added an involvement with cubistic spatial composition, as in *The Bridge* (1928; Sherman Oaks, Calif., Collection of Mr. and Mrs. Martin Janis). Blume first aroused critical interest with *Parade* (1930; New York, Museum of Modern Art), which shows a workman holding a suit of medieval armor on a pole against a precisionistically rendered factory background. As in most of his work, the unusual combination produces a vague conceptual reference—past versus present, reality versus fantasy, and so on—rather than a definite iconography. In 1934 his *South of Scranton* (1931; New York, Metropolitan Museum) was awarded first prize at the Carnegie International amid much public comment, both pro and con. The negative response was largely caused by the painting's alogical construction, a composite of various things seen on an automobile trip through Pennsylvania presented with extraordinary detail. Ambiguity of interpretation was continued in *Light of the World* (1932; New York, Whitney), thought by some to be a complex allegory on the role of the museum in the modern world.

The greatest uproar of Blume's career was caused by *The Eternal City* (1934–37; New York, Museum of Modern Art), rejected by the 1939 Corcoran Biennial as too controversial. For once, the meaning of Blume's painting was clear and specific, a vehement condemnation of the Fascist regime in Italy. Scattered vignettes showing aspects of Italian life under totalitarian rule are dominated by the acid-green head of a jack-in-the-box Mussolini, the whole painted with minute exactitude. Though somewhat less obvious in meaning, *The Rock* (1949; Art Institute of Chicago) is clearly concerned with man's rebuilding of a ruined world and thus exhibits the humanistic thread constantly underlying his paintings. JEROME VIOLA

BLUMENSCHEIN, ERNEST LEONARD. American painter (b. Pittsburgh, 1874; d. Albuquerque, N.M., 1960). Blumenschein studied in Cincinnati and Paris. In 1898 he went to Taos, N.M., and was one of the founders of the art colony there. His work, mostly tightly painted landscapes, often included Indian subjects.

BOCCIONI, UMBERTO. Italian futurist sculptor and painter (b. Reggio di Calabria, 1882; d. Verona, 1916). Boccioni visited Rome in 1898, meeting Severini and Balla. He was influenced by the neoimpressionist technique of the latter and of Seurat and Signac, whose works he saw in Paris in 1902. He traveled to Russia in 1904 and settled in Milan in 1908. In Milan Boccioni was brought into the futurist circle by Filippo Tommaso Marinetti and became one of the strategists of the movement as well as its only distinguished sculptor. The "Technical Manifesto of Futurist Painters" of April, 1910, and the "Futurist Sculptors' Manifesto" of 1912 were framed by him. He was thereafter, with Marinetti, the principal theoretician of the group.

Boccioni's theories were considerably in advance of his time and even of his own remarkably original sculpture and painting. He advocated in 1912 the use of a motor to mobilize planes or lines where needed, and although he never used such a device in his bronzes and plaster works, the idea was carried out independently several years later by the constructivists. It has been used in the 1960s.

Simultaneous or sequential movement of planes in space was an obsession with Boccioni, as it was with most futurist painters. It is significant that this artist's best-known monuments do not, however, depend so much upon themes of the machine as do those of many of his colleagues. His bronzes, *The Mother* (1911; Rome, National Gallery of Modern Art), *Synthesis of a Human Dynamism* (1912; New York, Museum of Modern Art), and the renowned *Unique Forms of Continuity in Space* (1913; New York, Museum of Modern Art), are still much closer to the human figure in its traditional role as a subject than to machine aesthetic. There is also a distinctively baroque quality in such sculptures. It should be noted that Boccioni anticipated the Dadaist and constructivist adaptation of nontraditional substances such as glass in combination with other materials.

The nonmachine factor is also apparent in Boccioni's

paintings. *The City Rises* (1910; New York, Museum of Modern Art), *The Forces of a Street* (1911; Switzerland, private collection), *Elasticity* (1912; Milan, Jucker Collection), and *Charge of Lancers* (1915; Milan, private collection) show action that, no matter if fragmented and repetitively rhythmic in conformity to futurist theory, is directly indebted to human, muscular energy.

Although the matter remains conjectural, Boccioni, who visited Paris in 1911 during the great phase of analytic cubism, very likely found stimulus and clarification as well in the works of Picasso and Braque; and it is as likely that Marcel Duchamp and Picabia, and perhaps Raymond Duchamp-Villon as well, felt that their ideas were confirmed by the Italian's sculptures, eleven of which were shown in Paris in 1913. Boccioni is clearly one of the most gifted of the futurists, and he is also one of the original sculptors of his time.

See also FUTURISM.

<div align="right">JOHN C. GALLOWAY</div>

BOHROD, AARON. American painter and graphic artist (1907–). He was born in Chicago and studied at the Art Institute of Chicago and in New York with John Sloan, Boardman Robinson, and Kenneth Hayes Miller. Bohrod has painted circus scenes but is best known for the American realism of his farm scenes and urban genre subjects, for the most part painted around Chicago, for example, *Chicago Street* (1939; New York, Whitney Museum). His successful lithographs of the 1930s and 1940s deal with similar subjects.

BOMBOIS, CAMILLE. French primitive painter (1883–). He was born in Vénary-les-Laumes on the Côte d'Or and has lived in Paris. He passed his childhood on a barge; when he was twelve he left school to work on a farm and later became an exhibition wrestler in a circus. By 1907 he was working nights running a newspaper press in Paris; during the day he painted. By 1922 he was painting full time. Like Rousseau, Bombois visited the Louvre to study the old masters. He showed his pictures in a nonjury open-air exhibition. These were seen by the poet Noël Bureau, who wrote an enthusiastic article about Bombois that brought the artist to the attention of such influential col-

lectors as Florent Fels and Wilhelm Uhde. He was represented in the 1938 exhibition, "Masters of Popular Painting," which was held at the Museum of Modern Art in New York.

With the discovery of Rousseau and the increased enthusiasm for his art, such primitives as Camille Bombois, Séraphine and Louis Vivin found an appreciative audience for their work. Without formal training, Bombois had begun to draw as a means of diversion when he was only sixteen. When he began to paint seriously as a full-time occupation, he defined forms in such a manner as to emphasize mass and solidity. To do this, he reduced detail, discarded all atmospheric effects, and strengthened the sharpness of contours. Colors are bright, positive, and local.

Bombois has painted a variety of subjects, from portraits to the nude female figure. His most characteristic works, however, are street scenes with figures. His pictures have a disarming, beguiling sincerity, the vigor and freshness of an innocent view of the world, and yet they also have agility, a fine and subtle sense of design.

ROBERT REIFF

BONNARD, PIERRE. French painter (b. Fontenay-aux-Roses, near Paris, 1867; d. Le Cannet, 1947). After preparatory training for the study of law (1885–88), Bonnard entered the Ecole des Beaux-Arts in Paris. By 1889 he had determined to become a painter. He became an associate of the Nabis group after its founding in that year and, with Edouard Vuillard, later was termed an "intimist" on the basis of an appealing treatment of quiet, gracious themes, most of them domestic.

Bonnard's early style is marked by his admiration of Gauguin and the immediate influence of Sérusier, as in *The Review* (1890; Switzerland, private collection), with its flat shapes of bright, clear color and regularly patched but controlled touch. That the painting is based on Bonnard's own experience in the military service at Bourguin (1890), where he undoubtedly participated in just such an exercise as that shown in *The Review*, is indicative of his preference for readily available themes and of his constant search for elements of beauty in ostensibly dull subjects.

Bonnard's participation in the Salon des Indépendants and the first group show of the Nabis at the Galerie Le

Pierre Bonnard, *The Breakfast Room* (ca. 1930–31). Oil on canvas, 63¼″ x 44⅛″. Museum of Modern Art, New York.

Barc de Boutteville, both in 1891, met with favorable critical response. *The Terrasse Family* of 1892, a group portrait less vibrantly toned than *The Review* and suggestive of early works by Renoir and Degas in its handsome light-dark contrasts, shows a sympathy with impressionism that was to remain characteristic of Bonnard's finest canvases even after his color became far more sensuous.

Between 1891 and 1894 Bonnard made several lithographic posters of Parisian scenes and night life for *La Revue Blanche* and, sponsored by Ambroise Vollard, published a series of twelve lithographs. Bonnard developed a friendship during these years with Toulouse-Lautrec, and the influence of that postimpressionist may be seen, though not obviously, in his prints and drawings. The abiding guideline of impressionism, however, continued to be evident in Bonnard's canvases of 1895, when he gave his first one-man show at Durand-Ruel's, and in his Salon des Indépendants and Salon d'Automne entries of 1901 and 1903, respectively.

Bonnard in 1904 illustrated Jules Renard's *Histoires naturelles* and gave another one-man show (Bernheim-Jeune's), his subjects being chiefly intimate studies of women and interiors. These works and their increasingly glowing, reposeful color anticipated the fully matured style of Bonnard's Salon d'Automne and Salon des Indépendants canvases of 1905 and such characteristic interiors as *The Checkered Tablecloth* (1911; Winterthur, Hahnloser Collection). After that time Bonnard devoted his uniquely refined taste and instinctive gifts as a colorist to the exploitation of an already manifest aesthetic. His admiration of the impressionists in general and of Renoir and Degas in particular, his earlier assimilation of the shape-conscious composition of Gauguin, Sérusier, and Denis, and his interchange of influences of color harmonies and dissonances with the Fauves all conjoined to resolve in Bonnard a peculiarly enduring and beauty-conscious attitude. A canvas such as *After the Shower* (1914; New York, private collection) with its intimate study of a woman resting in a spacious interior is of the same reassuring handsomeness of tone and seemingly informal structure as his compositions of the 1930s and 1940s. A masterpiece among his numerous studies of the nude is the *Figure before a Fireplace* (1917; Saint-Tropez, Musée de l'Annonciade), delightful for its pale tonalities of pinks, blues, and yellows but, for all the ostensible casualness of its structure, soundly organized with vertical and horizontal rhythms.

Bonnard traveled extensively between 1912 and 1920, a productive period that yielded, besides scores of sensuously toned landscapes and interiors, the illustrations for Gide's *Prométhée mal enchainé. Farm at Le Cannet* (1923; Paris, private collection) is a testimonial to Bonnard's gift for

imparting both breadth and intimacy to a single effort. The 1925 *Hahnloser Family*, an informal composition of a portrait group in a sailboat, discloses Bonnard's competence to handle a sweeping, rapidly brushed arrangement in which big elements, as the sail, are played against smaller forms. Among the finest of the many splendid canvases of the 1920s is *Luncheon* (1927; New York, Museum of Modern Art) with its two figures relaxed at a table, its light painted with striking luminosity and tenderly defining a still life of sensuously textured fruit.

The works of the 1930s reveal a persistent youthfulness in Bonnard's conception of color. An increasing sensuousness and freedom of touch obtain in *The Breakfast Room* of about 1931 with its light-saturated, caressingly painted surfaces and in the 1932 *Corner of the Dining Room at Le Cannet* (Paris, National Museum of Modern Art), an arrangement of clear red, yellow, and orange notes restrained by carefully spaced areas of white and pink.

Bonnard's style lacks the avant-garde stridency that might be expected of a contemporary of the Fauves Matisse and Rouault. It has been remarked that Bonnard's chief legacy to modern art is his establishing, through the great popularity of his canvases among collectors, a respectably vigorous French good taste. However, this artist was a bolder colorist in his late years than he was in the late 1890s, and his composition became increasingly liberated as he grew older. Moreover, not a few abstract expressionists, whose overall aesthetic is radically more powerful than Bonnard's, have paid respect to the works in which he more inventively uses color and chooses to relate each form of his composition to the total two-dimensionality of the format.

JOHN C. GALLOWAY

BONTECOU, LEE. American sculptor (1931–). She was born in Rhode Island, and her youth was spent in Nova Scotia. She studied with Hovannes and Zorach at the Art Students League in New York in the early 1950s. A Fulbright grant enabled her to travel in Italy and Greece in 1957 and 1958. She received an award at the Corcoran Biennial of American Art in 1963. Bontecou's mature style is unquestionably among the most individual of those of younger American sculptors; moreover, it is without close European parallel. Her medium is best defined as

relief construction of welded steel and wire covered with unprimed, brownish-stained canvas. A stitched effect in the joining of hollowed, projected ovals lends a provocative texture. Her works in the Museum of Modern Art in New York (1959) and the Albright-Knox Gallery in Buffalo (1960–61) are characteristic.

BORDUAS, PAUL-EMILE. Canadian painter (b. 1906; d. Paris, 1960). After studying in Montreal, he worked under Maurice Denis and was influenced by André Breton. He led the "Automatistes" group of Montreal and was an exponent of nonobjective painting.

BORGLUM, GUTZON. American sculptor (1867–1941). Born in Idaho, Borglum studied painting and sculpture in San Francisco and in Paris, where he exhibited at the official Salon. Soon after 1900 he settled in New York and turned almost exclusively to sculpture, making a group of apostles for St. John the Divine Cathedral in New York. Among his best-known sculptural portraits are the equestrian *Sheridan* in Washington; a bust, *Christian IX*, in Denmark; *Lincoln* in Newark, N.J.; and the head of *Lincoln* at the Capitol rotunda in Washington, D.C. The last work curiously combines an almost excessive detail of facial wrinkles and blemishes with a squared-off short back of the head. Presumably the sculptor thought it would be viewed chiefly from the front, but this is unfortunately not the case.

As Borglum's popular fame grew, he became the planner of increasingly large sculptural projects. One of these was *The Wars of America*, a monument in bronze, for the city of Newark. The monument is a paradox of sculptural composition. At its central apex rear two horses whose heads are roughly parallel; they are accompanied by an essentially static progression of civilian and military figures. Borglum's last and most ambitious design was the dominating composition of the heads of four American presidents, Washington, Jefferson, Lincoln, and Theodore Roosevelt, on the side of a cliff at Mount Rushmore, S.Dak.

JOHN C. GALLOWAY

BOUCHE, LOUIS. American painter (1896–1969). Born in New York City, he studied in Paris with Jean-Paul

Laurens and in New York with DuMond. Bouché painted murals until 1932, then began painting more formally arranged compositions. His later works were colorful genre scenes of New York.

BOURDELLE, EMILE ANTOINE. French sculptor, painter, draftsman, and teacher (b. Montauban, 1861; d. Paris, 1930). Before going to Paris in 1885, he studied with Maurette at the Toulouse School of Fine Arts. In the Paris Ecole des Beaux-Arts, he began his studies with Falguière, then worked with Dalou, and, finally, in 1896, with Rodin. From 1909 until his death, Bourdelle taught, and his studio became the famous school La Grande Chaumière. His *Monument to the Dead of 1870* (1902) is in Montauban, at the Ingres Museum; *Hercules* (1909; replica in the Metropolitan Museum, New York) is in the Paris National Museum of Modern Art; while several works such as *Selène* (1917) and *Eloquence* (1917) are in the Paris Bourdelle Museum. He was gifted in portraiture and occasionally produced a lyrical feminine form, but his strongest contribution may have been his writings and teachings.

BOURGEOIS, LOUISE. American sculptor (1911–). Born in Paris, she studied at the Ecole des Beaux-Arts, at the Académie de la Grande Chaumière, at the Académie Julian, and with Léger. Her sculpture is represented in the Museum of Modern Art and the Whitney Museum of American Art in New York and in distinguished private collections. Louise Bourgeois's style is strongly totemic and abstract.

BRANCUSI, CONSTANTIN. Romanian sculptor (b. Pestisani Gorj, near Târgu-Jiu, 1876; d. Paris, 1957). He was apprenticed to a carpenter and cabinetmaker before a scholarship sent him to the Bucharest Academy of Fine Arts, where he studied from 1898 to 1902. His exact study of the male anatomy, *Antinoüs Flayed*, was subsequently used at the Bucharest Medical School. Arriving in Paris in 1904, he entered the studio of Antonin Mercié at the Ecole des Beaux-Arts. Rodin admired his work in 1906, but Brancusi declined the invitation to work for him. In these early Paris years of poverty he met Modigliani and between 1909 and 1910 instructed him in carving.

Constantin Brancusi, *Fish* (1930). Gray marble, 21″ x 71″. Museum of Modern Art, New York. Lillie P. Bliss Bequest.

Brancusi's personal style emerged in the *Sleeping Head* series, begun in 1906, as well as in *The Kiss* sculptures of 1908, one of which served as a gravestone for a friend in the Montparnasse Cemetery. His introduction to primitive sculpture was probably through the French painters. This contact is felt in the series of wooden sculptures that began about 1914 and include *Prodigal Son* (1914), *Sorceress* (1916), *Chimera* (1918), and *Adam and Eve* (1921). In his search for shapes that would convey the essence of a theme, Brancusi produced forms that are utterly purified in outline.

He exhibited at Stieglitz's Photo-Secession Gallery, New York, in 1914. When he exhibited his *Princess* (1916) in 1920 in Paris, it was rejected as obscene. The phallic motif was strong throughout Brancusi's work. Between 1926 and 1928 he was involved in litigation against the U.S. Bureau of Customs over the question of whether or not his *Bird in Space* was a work of art. Aided by American art critics and dealers, he won his case. In 1937 he returned to Târgu-Jiu and erected his steel *Endless Column*, 98 feet high,

along with a table and seats and his *Archway of the Kiss*. That same year he was invited to India for an ill-fated project to build a Temple of Deliverance for meditation. He spent the remainder of his life in Paris.

The greatest collection of his work is that of Walter and Louise Arensberg in the Philadelphia Museum of Art. It includes *Prometheus* (1911), *The New-Born* (1915), *Sculpture for the Blind* (1924), *The Kiss* (1908), and *The Princess* (1916), among others. The New York Museum of Modern Art owns a version of *Bird in Space* (1919), a vertical expression of the vision of soaring flight; *Fish* (1930); and *Maïastra* (1912). The finest of the 20th century's monolithic sculptors, Brancusi enriched the scope and depth of sculptural symbolism and, through the ambivalent nature of his elementary forms, was able to suggest the mystical unity of all life. His aesthetic has had an incalculable impact upon design in many fields outside sculpture.

ALBERT ELSEN

BRANGWYN, SIR FRANK. English painter, muralist, designer, and printmaker (b. Bruges, 1867; d. 1956). Apprenticed to William Morris from about 1882 to 1884, he then went to sea, traveled extensively, painted marine subjects, and made sketches to which he referred in later etchings and lithographs. Printmaking provided a means of relaxation between commissions for public works. Among the themes of his etchings are marine subjects, landscapes, architectural monuments, and figure compositions. His lithographs, which include a series of posters made during World War I, display powerful draftsmanship. He also worked forcefully in woodcut. A member of many societies, he was given the first one-man show (1952) of a living artist ever awarded by the Royal Academy.

BRAQUE, GEORGES. French cubist painter (b. Argenteuil-sur-Seine, near Paris, 1882; d. Paris, 1963). He was a major pioneer of modern art. The son of a commercial decorator, Braque was brought up in the presence of the materials of the interior-designing craftsman: synthetic graining papers, imitation veined marbles, substances for producing textured finishes. His father was also a skillful

Georges Braque, *Guitar* **(1913–14). Oil on canvas with pasted paper, pencil, and chalk, 39¼″ x 25⅝″. Museum of Modern Art, New York. Lillie P. Bliss Bequest.**

amateur painter and imparted to his son a curiosity about a career in the fine arts.

Braque's first lessons in drawing and painting came at

a local art school in Le Havre, where the family had moved in 1893. He attended the Ecole des Beaux-Arts in Paris in 1902, working briefly under Bonnat; then he transferred to the Académie Humbert. He set up his own studio in 1904. His canvases of 1905–06, especially landscapes done at Collioure, La Ciotat, and L'Estaque, are ostensibly Fauvist in style and were shown at the time with other Fauve paintings at the Salon des Indépendants in Paris; but a close study of these brightly colored works discloses that Braque almost from the outset felt the need to structure his forms into a firm arrangement rather than depend altogether upon exciting color and staccato brushwork. His *Large Nude* of 1908, begun in 1907 (Paris, Cuttoli Collection), anticipates the early cubist aesthetic of the better-known *Landscape at L'Estaque* and *Houses at L'Estaque*.

For Braque 1907 was a crucially significant year. He sold several canvases from the Salon des Indépendants exhibition; he made a contract with Kahnweiler for handling his work; he saw the great Cézanne posthumous show, which was to confirm and clarify what he had begun; and he met Picasso, with whom he was straightway to formulate the cubist style, perhaps the most influential style of the 20th century.

Cézanne's late, powerfully composed landscapes, along with the vigorous planes and masses of African Negro sculpture, stimulated both Braque and Picasso in their search for a new conception of painting. Braque's aforementioned landscapes and his studies of women and still lifes dating between 1908 and late 1909 define the mode called early cubism. Documents of this phase include his *View of La Roche-Guyon* (1908–09) and *Head of a Woman* (1909). His *Violin and Palette* (1909–10; New York, Guggenheim Museum) marks the transition between Braque's early cubism and that remarkable period of his and Picasso's development known as analytic cubism.

Braque's analytic-cubist compositions of 1910–11 are among the most cogent examples of the style, and his and Picasso's works from those years were to exert a remarkably stimulating influence upon much later modern art. By giving deeply personal interpretation to Cézanne's stratagem of seeking in nature the cube, cylinder, and other solid geometric forms, Braque developed an aesthetic which in effect enabled the spectator to see from many points of view the various surfaces of his still-life and figure sub-

jects: he brought toward the frontal plane of his objects the zones that normally belong to the sides and back. Thus he, in collaboration with Picasso, "analyzed" the totality of natural forms in space. It should be noted that these two early masters of modern art used a limited, even severe palette as they founded a revolution in form and space; such paintings as Braque's *Violin and Pitcher* (1910; Basel, Art Museum) and *Man with a Guitar* (1911; New York, Museum of Modern Art) are carried out in subdued grays, tans, and greens rather than in the brilliant Fauvist hues of 1905–06.

Braque and Picasso, the actual pioneers of cubism, did not participate in the controversial exhibitions of 1911–13 arranged by their followers. Nevertheless, cubism soon won international recognition, if not popular acceptance, through exposure in Berlin, New York, London, Russia, and elsewhere; and Braque was famous among avant-garde artists everywhere before World War I began.

Braque appears to have preceded his friend Picasso in the inventing of *papiers collés* and collages, canvases that combine painted forms with added shapes of paper or other decorative substances. With the advent of those cubist forms in 1912 the "synthetic" phase of this revolutionary style occurred. Imitation wood graining and veneers of imitation wallpaper and marble reminiscent of Braque's father's decorating materials began to appear in the still lifes of 1912–14. Letters and numerals cut from journals were often pasted into context with painted shapes.

World War I scattered the cubists, many of them, like Braque, going to the front lines. Discharged from the army in 1916, Braque returned to Paris to develop independently. From 1917 to the early 1920s Braque's style became flatter and more variegated in color. *The Table* of 1918 (Philadelphia Museum of Art), with its browns, greens, and brightly dotted passages, is characteristic. Works by Braque and Picasso with such spotted areas are sometimes called "rococo" cubist in style, the allusion being to the tiny ornamental forms of French 18th-century decorative arts.

From the mid-1920s until the close of his career Braque concentrated on exploiting the method for which he had already established the guidelines. His work became increasingly inventive in composition (he was one of the most ingenious of modern designers of picture space) and

subtler in color relationships. The splendid *Table* of 1928 (Washington, D.C., Phillips Collection) and various figure compositions of the same period show Braque's great mastery of organization of drawing, texture, tone, and shape. This style was compatible with ballet sets designed by Braque during the 1920s.

The 1937 *Woman with a Mandolin* (New York, Museum of Modern Art) typifies Braque's preoccupation with more complex spatial settings and greater diversity of content that mark many works of the late 1930s and the 1940s. Large, contrasting forms of dark sometimes appear against light areas of modulated greens, tans, or grays. Increasingly bright color appears in canvases of the 1950s, brilliant large sections of red, for example, being placed near lesser accents of strong green, as is illustrated in *The Echo* (1956).

Braque continued to paint actively until the end of his life. He was also a prolific printmaker, especially in the lithographic medium, and at various times produced sculpture. He was honored by many retrospectives and included in important international showings, such as the Biennale in Venice, where in 1948 he won first prize. He is represented in almost every distinguished public collection in the world.

See also CUBISM.

<div align="right">JOHN C. GALLOWAY</div>

BREUER, MARCEL LAJOS. Hungarian-American architect and industrial designer (1902–1970). Born in Pécs, he was educated at the Bauhaus in Germany from 1920. Breuer became a master of carpentry at the school. He left the Bauhaus in 1928 to enter private practice in Berlin, at which time he traveled extensively in Spain, North Africa, Greece, Germany, Switzerland, and England. He worked in England with F. R. S. Yorke (1935–37), then immigrated to the United States (1937) to join Walter Gropius as an architectural partner and as an instructor at Harvard University. He was in partnership with Gropius until 1941 and continued to teach until 1946 when he moved to New York, where he conducted an international practice.

While at the Bauhaus Breuer absorbed the basic 20th-century principle that art and technology are one, an assumption that has been fundamental to his work ever since.

During these years he experimented with many design innovations, such as modular unit cabinets and steel furniture, and he executed several interiors that incorporated his furniture. In 1921 he designed an armchair with a sticklike wooden frame and canvas seat and back, reminiscent of Gerrit Rietveld's red-blue chair of 1918. In 1925 Breuer designed the first metal furniture, a chair constructed of continuously bent steel tubing. After the Bauhaus moved to Dessau in 1925 he designed many of the furnishings and interiors of its new buildings.

During his years in Berlin, Breuer executed a few interiors and designed some unexecuted but influential projects such as the Haselhorst housing, multistory apartment slabs (1928). In 1932 he built his first complete house, for the Harnischmacher family. Located at Wiesbaden, it was a three-story modular steel-framed building with concrete and stucco finish, furnished with Breuer's modular furniture, which easily accommodated itself to the architecture. The design, a successful fusion of the rational and the aesthetic, was a combination that formed the basis of his subsequent architectural works. His next building was commissioned in 1933 by the Swiss art historian Dr. Siegfried Giedion. It is a group of three small apartments in the Dolderthal near Zurich. Working with Alfred and Emil Roth, Breuer articulated one of the most decisive and lucid statements about new architectural forms, living spaces, and the relationship of architecture and nature of the decade. The building stands in excellent condition, in contrast with most of the work of the 1930s, which rapidly deteriorated.

Breuer helped Gropius establish a design program at Harvard of such vast influence that virtually every architectural school in the United States today follows Harvard's lead. Gropius and Breuer designed many homes in New England (including Breuer's own house in Lincoln, Mass., in 1939), which combine Bauhaus discipline with local materials and forms. The house Breuer designed for the Museum of Modern Art in New York, and erected in the Museum's garden in 1949, helped establish his reputation and promoted a better understanding of quality contemporary architecture in this country. In recent years Breuer has designed buildings for colleges, including Vassar (1949) and Sarah Lawrence (1951), and for business, including De Bijenkorf in Rotterdam (1958, with Elzar). The largest

of his works is the UNESCO headquarters in Paris, which he built with Pier Luigi Nervi and Bernard Zehrfuss. Breuer created a dramatic design for the new Whitney Museum of American Art (opened 1966) in New York City. In 1968 he received the gold medal of the American Institute of Architects.

Breuer's work is particularly expressive of and relevant to the 20th century. Throughout his career Breuer maintained a judicious balance between the technological requirements of the program and the aesthetic needs of the inhabitants. THEODORE M. BROWN

BRIDGE, THE (Die Brucke), see EXPRESSIONISM.

BROOKS, JAMES. American painter (1906–). Born in St. Louis, he lives in New York State. From 1923 to 1925 he studied at Southern Methodist University in Dallas and from 1927 to 1930 at the Art Students League in New York. He worked on the Federal Art Project of the late 1930s; his style was influenced by cubism. In 1949 he had a one-man show at the Peridot Gallery. His paintings have been included in important annuals at the Museum of Modern Art and the Whitney Museum of American Art in New York and in the Carnegie Internationals in Pittsburgh since 1952. A leading action painter, he was awarded the first prize at the Art Institute of Chicago in 1958.

BROWNE, BYRON. American painter (b. Yonkers, N. Y., 1907; d. New York City, 1961). At twenty-one, he was the youngest artist to win the Hallgarten prize at the National Academy, New York, where he studied. He was a founder-member of the American Abstract Artists and had more than twenty-five one-man shows. His art followed no consistent direction. At times it was representational, but more often it was abstract, in the form of a personal kind of synthetic cubism.

BRUCE, PATRICK HENRY. American painter (b. Virginia, 1880; d. New York City, 1937). He studied with Robert Henri and with Matisse in Paris, where he had settled by 1907. A pioneer American abstractionist, Bruce became affiliated with the orphists and exhibited abstractions with Delaunay at the 1914 Salon des Indépendants. Bruce's

earlier paintings, for example, *Composition II* (ca. 1918; New Haven, Conn., Yale University Art Gallery, Société Anonyme Collection), were related to the early abstractions of Picabia. Bruce's later works were based on still-life forms that were simplified to a generalized geometric shape, as in *Painting* (ca. 1930; New York, Whitney Museum).

BRUCKE, DIE, see EXPRESSIONISM.

BUFFET, BERNARD. French painter (1928–). Born in Paris, Buffet took evening courses in drawing in 1943. The following year he studied at the Ecole des Beaux-Arts and then worked alone. In 1947 the Galerie des Impressions d'Art devoted a small but unsuccessful exhibition to his work. After exhibiting in various salons, Buffet began to develop a personal style (1948). He achieved recognition when, together with Lorjou, he was awarded the Prix de la Critique at the Galerie St-Placide. There was strong critical approval of his socialist realism, which expressed the pathos and violence associated with the anguish and anger of postwar youth.

Buffet continued to carry his *misérablisme* to a high degree of intensity; it became the latest version of expressionism. The Galerie Drouant-David organized several exhibitions of Buffet's work: *La Passion* (1952), *Landscapes* (1953), *Nudes* (1954), *War* (1955), *The Circus* (1956). In 1957 the Galerie David et Garnier presented a series of Buffet's canvases having as subject matter the monuments of Paris (for example, *La Cité*). Treated in a typically Buffet manner, the forms are very flat, with predominating lines mostly in black.

In 1958 the Galerie Charpentier organized a retrospective exhibition of fourteen years of Buffet's work. In the same year he painted the décors for Françoise Sagan's *Le Rendez-vous manqué* and illustrated Cyrano de Bergerac's *Le Voyage dans la lune*. In 1959 an important retrospective exhibition took place at Knokke, Belgium. Buffet exhibited his series of landscapes of New York City. In 1962 he painted for the chapel of the Château d'Arc a series of large canvases devoted to the Passion of Christ.

In his still lifes, portraits, and landscapes, such as *Descent from the Cross* (1948; Paris, Maurice Garnier Collection), Buffet's forms, especially his nudes, are always thin and drawn out. ARNOLD ROSIN

BUFFINGTON, LEROY S. American architect (1847–1931). Trained in his native Cincinnati, Ohio, he practiced in St. Paul and Minneapolis, Minn., after 1871. His wrongly won fame rested on the claim that he invented the technique of skeleton construction in 1880, four years before the erection of William Le Baron Jenney's Home Insurance Building in Chicago, usually considered the first modern structure built on a skeleton frame. Buffington took out a patent on his "invention" in 1888, but it has been demonstrated that he knew little about this technique before reading an article by Jenney published in 1885 in the *Sanitary Engineer*. To his credit, however, is the fact that he successfully publicized this method of construction. As a designer, he was an eclectic and a traditionalist.

BUNSCHAFT, GORDON, *see* SKIDMORE, OWINGS, AND MERRILL.

BURCHFIELD, CHARLES. American painter (1893–1967). Born in Ohio, Burchfield was a distinguished contributor to American art. His style, fundamentally realistic, is marked by a highly personal romanticism, which, in his water colors (1916–20), at times was tinged by surrealism of a nonorthodox character. His outstanding works include *Church Bells Ringing* (*Rainy Winter Night*, 1917; Art Institute of Chicago), *Night Wind* (1918; New York, Museum of Modern Art), *February Thaw* (1920; Brooklyn Museum), and *The Four Seasons* (1949–60; Champaign, University of Illinois, Krannert Art Museum). In recent works Burchfield has often reinterpreted his older themes, sometimes actually reworking papers dating back to the 1920s. His paintings have been included in many leading annuals (Chicago, Art Institute; New York, Museum of Modern Art; Pittsburgh, Carnegie Institute; and others) and in one-man shows (New York, Museum of Modern Art; Pittsburgh, Carnegie Institute; Cleveland School of Art; New York, Whitney Museum of American Art; New York, Rehn Gallery).

JOHN C. GALLOWAY

BURLIN, PAUL. American painter and graphic artist (1886–1969). He was born in New York City and studied at the National Academy of Design in New York, and in

London. He first worked as a magazine illustrator and exhibited four drawings at the 1913 Armory Show. Even before the Armory Show, Burlin's paintings showed some knowledge of contemporary artistic developments in Europe, for example, *Figure of a Woman* (1912; Collection of Edwin Harris, Jr.). For Burlin, as for other American artists, the Armory Show was the decisive introduction to modern styles, not fully to be absorbed until years later. In 1913 Burlin traveled to the American Southwest, where he stayed until 1920. He was greatly impressed by the art and decoration of the Indians and painted their portraits with a primitivistic vigor that flowered in his later career.

He lived in Paris (1921–32), sharing a studio for a while with Albert Gleizes, the cubist painter. Although Burlin was influenced by cubism, he never embraced it as a complete theory of painting, probably because his own artistic personality was more volatile than analytic. In the 1930s he was involved with a sort of social realism that was more concerned with private emotion than with overt propagandizing, as in the desolate landscape *The Ghost City* (1936; New York, Whitney Museum). But by the end of the decade he had discarded socially oriented subject matter in favor of a more personal style and choice of themes.

From the 1940s on, Burlin's paintings are strongly expressionistic, in both color and treatment. Many are of symbolic, mythological, or poetic subjects: the Blakean animal, crowned with three stars, of *Tiger, Tiger, Burning Bright* (1941–42; Northfield, Minn., Carleton College); or the sensuous abandon of the female angel-centaur-goat of *Fallen Angel* (1943; New York, Museum of Modern Art). His figures became less mythological but more abstract: *Young Man Alone with His Face* (1944; Whitney Museum) in part is remotely related to primitive art and to Picasso, but such elements as the formal distortions and the clashing color show Burlin moving away from the immediately recognizable.

By the 1950s he was painting in a style related to abstract expressionism: large shapes of rich color joined to smaller shapes by excited calligraphic lines, often with a loosely faceted shallow space and a thickly worked surface, for example, *Red, Red—Not the Same* (1959; Whitney Museum). These later paintings, the result of a slowly developing abstraction, are the logical climax of Burlin's artistic career.

In 1965 the National Institute of Arts and Letters presented him with the Waite Award "for continuing achievement and integrity in his art."

JEROME VIOLA

BURLIUK, DAVID. American painter (1882–1967). He was born in Kharkov, Russia, and studied in St. Petersburg, Odessa, Munich, and Paris. He exhibited with the Neue Künstlervereinigung in Munich (1910) and with Der Blaue Reiter (1911–12). In 1922 he went to the United States after spending some time in Japan. For several years Burliuk painted in personally named variations on cubism and futurism. With the exception of a group of symbolic paintings dating mostly from the 1930s, the bulk of his work thereafter was brightly colored, thickly painted expressionistic figures, landscapes, still lifes, and genre subjects much influenced by the style of Van Gogh.

BURRA, EDWARD. English painter (1905–). Born in London, Burra studied at the Royal College of Art. He has designed scenery and costumes for ballet. He was a member of Unit One and exhibited with the surrealists in London in 1936. Burra usually works in water color over a detailed drawing. His paintings of the 1920s and early 1930s were satirical treatments of urban genre subjects with strongly modeled figures and a certain violence of expression, as in *Harlem* (1934; London, Tate Gallery). In his later work, affected by the Spanish Civil War and subsequent events, fantasy has given way to symbolism but they still have a strong sense of the grotesque, as in *Soldiers* (1942; Tate).

BURRI, ALBERTO. Italian painter (1915–). Born in Città di Castello, Burri was first a doctor and began to paint full time only after World War II. Since 1947 he has had one-man shows throughout Europe and the United States; his work has appeared in all the major international exhibitions. Influenced at first by Klee and Wols, he turned to complete abstraction and exhibited with Capogrossi and Colla at the Fondazione Origine in Rome in 1951. His characteristic works since then—using old materials such as burlap, charred wood, and iron sheets—are collages of

a new type, in which the materials are the picture rather than the elements of built-up composition; they resist and deny illusion, overpowering us in their reality.

BUTLER, REGINALD COTTRELL. British sculptor, architect, and industrial technologist (1913–). Born in Buntingford, Hertfordshire, he worked as an architect and industrial designer (1936–50) and was a village blacksmith in Sussex (1941–45). During 1944 he seriously took up sculpture and had his first show in London in 1949. In 1950 he was appointed a teacher at the Slade School of Art, where he continues to instruct. He was the Grand Prize winner in the International Sculpture Exhibition for *The Unknown Political Prisoner* (1954), The New York Museum of Modern Art owns the model for that work; it also owns *Oracle* (1952). *Boy and Girl* (1950) is in the collection of the British Arts Council, and *Woman* (1949) is in the Tate Gallery, London. Butler's contribution lies in his tough-minded, open-metal armatures of the human body and in his imaginative hybrid forms.

CALDER, ALEXANDER. American sculptor, engineer, and illustrator (1898–). Born in Philadelphia, he trained as a mechanical engineer (1919) at Stevens Institute of Technology, Newark, N.J., and worked at engineering jobs (1919–22). He took up drawing under Clinton Balmer at a public night school in New York. Calder studied at the Art Students League in New York (1923–26) and did free-lance work for the *National Police Gazette* (1924–26). In 1926 he had his first exhibition of paintings, his *Animal Sketching* was published, and he did his first wood carving, *Flattest Cat*. In that year he went to Paris, where he met José de Creeft, and there continued to sculpture in wood.

Alexander Calder, *Big Red* (1959). Sheet metal and steel wire, 114″ long. Whitney Museum of American Art, New York. Gift of Friends of the Whitney Museum.

In 1927 Calder began his famous miniature circus and animated toys that attracted leading figures in the Paris art world. They were exhibited in the Salon des Humoristes in 1927. Probably inspired by his circus sketches for the *Police Gazette*, his mechanical circus contained seminal ideas for his later work. His first wire sculpture, *Josephine Baker* (1926), was directly influenced by it. Returning to New York in 1927, Calder had his first one-man show at the Weyhe Gallery in 1928. He made wood sculpture during this time and went to Wisconsin to supervise the manufacture of toys based on his models. He returned to Paris in 1928 for eight months and exhibited his works. He did his first jewelry while in Berlin.

During 1930, in Paris, he contacted Miró, Léger, and Mondrian, and the latter influenced Calder to work on abstract painting for a short period. His first abstract constructions, "stabiles," date from 1930. He became a member of the Abstraction-Création group. In 1931 he published illustrations for the *Fables of Aesop* and made his first "mobile," *Dancing Torpedo Shape*, employing a hand crank. In 1932 he made his first wind mobile, *Calderberry Bush*. Marcel Duchamp gave the name "mobile" to Calder's work.

In 1933 he purchased a farm in Roxbury, Conn., where he has lived and worked ever since. He designed a mercury fountain (1937), a water ballet (1939), and stage settings (1935, 1936) and did several mobiles for architectural settings, such as the Cincinnati Terrace Plaza Hotel (1946). The New York Museum of Modern Art owns *Lobster Trap* and *Fish Tail* (1939), *Whale* (1937), and *Wall Constellation With Red Object* (1943). Mr. and Mrs. José Luis Sert own *El Corcovado* (1951), and Nelson Rockefeller owns *Siny* (1942). Calder's importance rests on his witty shape making and on the mobilizing of sculpture in space. His art has unlocked new areas of experience for the sculptor and created new opportunities for relating sculpture and architecture. His largest work, *Man* (1967), is a 70-foot high stabile created to dramatize "Man and His World," the theme of Montreal's Expo 67.

ALBERT ELSEN

CALLAHAN, KENNETH. American painter (1906–). He was born in Spokane, Wash., and studied at the University of Washington. He traveled and studied in England,

Italy, France, and Mexico from 1926 to 1928. Callahan became interested in the forces of nature while working as a fire lookout. Many of his earlier paintings, apart from those specifically concerned with the scenery and logging industry of the Northwest, are personal symbolic interpretations of the moods and powers of nature. His later works become more definitely mystical as the result of his attempt to fuse man and nature, which appears mostly in landscape elements.

CALLERY, MARY. American sculptor (1903–). Born in New York, she attended public school in Pittsburgh and studied at the Art Students League in New York and with Lautchausky in Paris. In the 1950s her work appeared in one-man shows at the Buchholz Gallery in New York; at the Galerie Maeght and the Galerie Cahiers d'Art in Paris; at the Knoedler Art Galleries in New York; at Margaret Brown's in Boston; and at the Chicago Art Club. She was represented in the United States Pavilion at the Brussels International Exposition in 1958. Callery's sculptures, usually carried out in metals, are personal, semiabstract interpretations of human and animal figures, usually in groups. They are especially effective as court or fountain pieces.

CAMPENDONK, HEINRICH. German painter and graphic artist (b. Krefeld, 1889; d. Amsterdam, 1957). After studying with the Dutch artist Thorn-Prikker in Krefeld, Campendonk assisted in the painting of murals in the Cathedral at Osnabrück. In 1911 Marc and Kandinsky invited him to Sindelsdorf, and this association led to his inclusion in the first Blue Rider (Der Blaue Reiter) exhibition later in the year. Campendonk's paintings show the strong influence of both the ideas and the styles of the Blue Rider artists: the generally cubistic approach, the color theories of Kandinsky and Delaunay, and, especially, the animal mysticism and translucent, intersecting planes of Marc (for example, *Springendes Pferd*, 1911; Saarbrücken, Saarland Museum).

While Campendonk included animals in his pictures, his true subject matter was the life of the peasant in the world of nature, depicted in a primitivistic manner recalling Rousseau and also stylistically reminiscent of icons and folk art.

For a while, he even worked in the peasant technique of painting on glass, for example, *Phantasie auf Braun*, or *Sitzender Akt* (ca. 1912; Amsterdam, Stedelijk). His treatment of forms is related to that of Marc but is usually somewhat harder and more angular, as in *Das gelbe Tier* (1914; The Hague, Gemeentemuseum) or the Chagall-like *Hirtin mit Tieren* (1918; München Gladbach, State Museum). The influence of Chagall resulted in pictures in which rustic subjects were treated in a lyrical, fantastic, almost mystical manner (for example, *Weiblicher Akt mit Kuh*, ca. 1923; Wuppertal, Municipal Museum). Somewhat later, his work showed a greater use of the devices of synthetic cubism, as in *Red Still Life with Fish* (1928; Krefeld, Kaiser Wilhelm Museum).

JEROME VIOLA

CAMPIGLI, MASSIMO. Italian painter (1895–1971). A native of Florence, Campigli began to paint according to the rules outlined in *L'Esprit nouveau*. His style is similar to that of the cubists but is more reminiscent of Etruscan and Roman painting than of Braque and Picasso. Campigli was sensitive to metaphysical painting, and his composition and lyricism recall the work of Carrà. His figures are as impersonal as death masks. He was very fond of the female figure, which he juxtaposes in space regardless of proportion, as in *On the Balcony* (1953). His women, shaped like amphorae, have an earthly and universal quality and are never lacking in grace. Although for many years he lived in Paris, Campigli remained unaffected by abstract and neorealistic art and continued to paint the poetical world of his dreams.

CARR, EMILY. Canadian painter (1871–1945). She lived in Victoria and studied painting in San Francisco, London, and Paris. The subject matter of her paintings derives principally from Pacific Coast Indian motifs and the British Columbia forests. After 1936 she wrote several autobiographical books.

CARRA, CARLO. Italian painter (b. Quargnento, 1881; d. Milan, 1966). Carrà was trained as a decorator and in 1900 he worked on the decorations for the International Exhibition in Paris. He studied in Milan at the Brera Academy. In 1909 he joined the futurists and signed the first

futurist group manifesto. In 1915 he composed an article for a futurist manifesto and advocated "total painting," in which color, sound, and smells would be combined. In 1915 he met Giorgio de Chirico, and, under his influence, became an active participant in the "metaphysical school." It is generally thought that he did his best work at this time. By 1920 he had associated himself with the Valori Plastici movement and in 1924 with the Novecento, a group favoring figurative art. Between World War I and World War II he taught at the Brera Academy and had a profound influence on Italian art.

Carrà's futurist paintings have cubist characteristics and, as such, show little indication of movement. He combined views of a single subject, such as a female nude or a boxer, simultaneously and favored neutral colors, such as ivory whites and ambers. Carrà was the first in his group to criticize futurism.

In his next phase of development, as a painter of *pittura metafisica*, he was second in importance only to De Chirico. Like the master, Carrà represented a new vision of nature rather than a new manner of painting, as he had in futurism. He evoked feelings of nostalgia and apprehension by showing deserted streets, fragments of sculptures, ancient ruins, mannequins, and still lifes composed of fish, geometric forms, biscuits, and the like in a late afternoon light, which causes long shadows to be drawn. The titles of many of his paintings, such as *The Hermaphrodite Idol*, are drawn from classical sources.

After World War I, during the early 1920s, he found his ideal in Giotto. Combining Giotto's directness and compression with innovations in color derived from Cézanne, Seurat, and Derain, Carrà developed a personal manner.

ROBERT REIFF

CAVALLON, GIORGIO. American painter (1904–). He was born in Sorio, Italy, and went to the United States in 1920. He studied at the National Academy of Design, in New York, worked with Charles Hawthorne in Provincetown, and with Hans Hofmann, and has been an exhibiting member of American Abstract Artists since 1936. Cavallon has been a highly personal practitioner of neoplasticism, animating the rigidity of that style with lyrical deviations in form and color. The slightest, and generally

earliest, deviation was a gentle shift away from the strict right angle, accompanied by a complicated color range and a not quite precise delimitation of the many rectangular shapes. In the later 1950s fuzzier contours, fewer rectangular forms, and a subtle use of white pigment produced a warmly luminous, floating effect. In Cavallon's most recent paintings the neoplastic grid is loosely divided into irregular areas, some hardly more than scribbles, of rich, light-filled color.

CHADWICK, LYNN. English designer and sculptor (1914–). He was born in London and was trained as an architect. Early influences, from González toward metal sculpture and from Calder toward sculpture in motion, resulted in a series of mobiles from 1947 on, for example, *The Fish Eater* (1950–51; London, Collection of the Arts Council of Great Britain). His next works were of thin sheets, singly or combined with armatures or other materials, as in *The Inner Eye* (1952; New York, Museum of Modern Art), where a lump of glass is suspended in a vaguely human framework of iron and wire. Chadwick's recent sculptures, such as *Moon of Alabama* (1957; artist's collection), are enclosed forms of welded iron.

CHAGALL, MARC. Russian painter (1887–). Born in Vitebsk, Russia, Chagall has lived mainly in Paris since 1910. His style, while reflective of cubist, surrealist, and expressionist affinities, is distinctly personal. His contribution to early modern painting and printmaking has been of the first order.

Chagall studied briefly with a local artist in Vitebsk and, in 1908, studied at the academy in St. Petersburg. In 1910 he went to Paris, where he met the poets Max Jacob, Blaise Cendrars, and André Salmon and the painters Modigliani, Delaunay, La Fresnaye, and other cubists and independents.

The complexities of Chagall's aesthetic are apt to be obscured somewhat by the whimsical, fantastic subject matter. It does not detract from Chagall's uniqueness of expression, however, to attribute to cubism an early and formative influence upon this gifted Russian. His *Half Past Three* (*The Poet*, 1911; Philadelphia Museum of Art) is

Marc Chagall, *Birthday* (*L'anniversaire*; 1915). Oil on cardboard, 31¾″ x 39¼″. Museum of Modern Art, New York. Lillie P. Bliss Bequest.

a testimonial to cubist structure, although Chagall has refuted the programmatic orthodoxy of the French manner and substituted a sensitive adaptation of his own; moreover, his color is altogether original. The impact of cubist structure and spatial handling continues in his *I and My Village* (1911) and *Over Vitebsk* (1916; both New York, Museum of Modern Art). Thereafter his style becomes increasingly unique and the cubist aspects operate less evidently.

Apollinaire introduced Chagall to Herwarth Walden, the German publisher and dealer, in Berlin in 1914. This resulted in Chagall's first one-man show in the same year. He returned to Russia to marry, and after the revolution of 1917 he was appointed commissar of fine arts for Vitebsk and founded an art school there. He designed murals for the Moscow Jewish Theater in 1922 and then left for Paris by way of Berlin, where he remained long enough to make engravings as illustrations for a book.

The poet Cendrars was responsible for Chagall's meeting the dealer Ambroise Vollard. A commission for engraved

illustrations for Gogol's *Dead Souls* followed (these were not published until 1949, although Chagall had completed them long before).

Chagall's first retrospective exhibition was given at the Galerie Barbazange-Hodebert, Paris, in 1924. His style became increasingly romantic and devoted to fantastic narratives during the middle 1920s. *The Jewish Wedding* (1926; New York, Museum of Modern Art), a gouache-and-chalk composition, discloses another tendency of Chagall's expression: his persistent, refreshing summoning of folk memories of his Russian origin. His first New York show dates from 1926. In 1927 he undertook the illustration of La Fontaine's *Fables*, completing the 100 plates in 1930. In 1931 he traveled to Palestine and Syria to study themes for Biblical engravings, another Vollard commission. *The Arabian Nights*, *Daphnis and Chloë*, and Boccaccio were also illustrated as a result. Chagall's own book, *Ma vie*, was published in 1931.

Chagall by now had become internationally famous, and a large retrospective in 1933 at the Basel Art Museum increased his prestige. He was disquieted, however, by political developments in Europe during the early 1930s, and the increasingly severe persecutions and threat of war led him to paint religious works of a darkly exciting kind. His apprehensions were aggravated by a visit to Poland in 1935.

First prize in the 1939 Carnegie International, Pittsburgh, was given to Chagall, and in 1941 he settled in the United States at the invitation of New York's Museum of Modern Art. At first rejuvenated by the new environment, he was to be deeply saddened by the death of his wife in 1944. Before returning to Paris in 1946, he completed the sets for Stravinsky's *Firebird* and other theatrical designs.

Chagall had retrospective shows in 1947 in Paris, Amsterdam, and London, and was represented at the 1948 Venice Biennale. In 1949 he worked in Vence, especially with ceramics. In that year he also painted an important canvas, *The Red Sun*, an allegory invoking memories of his late wife and rich with strikingly colored imagery referring once again to the Russian folk fantasy, which is so much an aspect of his art.

The 1950s brought additional honors to Chagall, not the least of which was the commission from the architect

Joseph Neufeld and the Women's Zionist Organization of America to design twelve stained-glass windows for the synagogue of the Hadassah-Hebrew University Medical Center near Jerusalem. These windows were exhibited in Paris and New York before being installed in Israel in 1962. In 1967 and 1968 a triptych of tapestries designed by Chagall was woven at the Gobelins factory. The triptych, representing *The Creation, The Exodus,* and *Entry into Jerusalem,* was ordered by André Malraux, French Minister of Cultural Affairs, for presentation to the Israeli parliament.

JOHN C. GALLOWAY

CHARLOT, JEAN. Mexican painter (1898–). Born in Paris of French-Mexican ancestry, Charlot studied at the Ecole des Beaux-Arts. He reached Mexico in 1921 and became a pioneer of the mural movement. Late in 1922 he completed his first Mexican mural, *Fall of Tenochtitlán,* for Mexico City's new Preparatory School. After helping Diego Rivera decorate the auditorium of this school, Charlot collaborated with him and others in frescoing the two courts of the Ministry of Education (1923). Dismissed from this venture, Charlot turned temporarily to easel painting. In 1928–29 he served the Carnegie expedition at Chichén Itzá, Yucatán, where contact with the ancient Maya intensified his admiration for primitive art.

His chief production in the United States comprises three murals in Athens, Ga., for the Fine Arts and School of Journalism buildings (1941–42 and 1943–44, respectively) at the University of Georgia and for the McDonough Post Office (1941–42). In 1955 Charlot frescoed Psalm 22 for the Church of Christ the Good Shepherd, Lincoln Park, Mich. He executed murals for the Waikiki Beach branch of the Bishop National Bank as well as for the Hawaiian Village Hotel in 1956. He has also won fame as a pioneer of color lithography.

As an artist, Charlot has achieved a sophisticated blend of primitive and modern elements. He refines and simplifies forms into basic cubes and cylinders evocative of either Léger and Picasso or Toltec and Aztec sculpture. Typically, saw-cut Indian masks and streamlined shapes are combined in formal unions within interlocking, tightly or-

ganized designs. Charlot, however, is more than a formalist; he has striven also to discover appropriate aesthetic solutions to problems of modern religious art.

JAMES B. LYNCH, JR.

CHERMAYEFF, SERGE. American architect, designer, and educator (1900–). He was born in the Caucasus, Russia, and educated at Harrow School, Cambridge, England. From 1933 he practiced architecture with Eric Mendelsohn in England, where they collaborated on the De La Warr Pavilion at Bexhill (1934–35). Chermayeff, who has taught and practiced architecture in the United States since 1940, is a professor of architecture at Yale University.

CHIRICO, GIORGIO DE. Italian painter (1888–). He was born of Italian parents in Volos, Greece, and studied at a technical school in Athens. In 1905 he went to Italy and painted after Botticelli, Uccello, and other Quattrocento masters. De Chirico studied in 1909 with Hackl at the Munich Academy of Fine Arts and was influenced by the styles of Böcklin and Klinger. He lived in Florence in 1910 and began his unique, compelling series of landscapes with figures or antique statuary and the architecture of Italian city squares. One of the earliest of these haunting, shadow-ridden canvases is the 1910 *Enigma of an Autumn Night*. The same melancholy and evocative green tonality continues in 1911 works such as the *Enigma of the Hour* (Milan, private collection), the 1913 *Soothsayer's Recompense* (Philadelphia Museum of Art), and the 1914 *The Melancholy and Mystery of a Street* (private collection). It is remarkable that De Chirico, who was fully aware of the dynamic futurist movement in Italy, with its derision of Italy's antiquarian glories, and was similarly abreast of cubist activities in Paris, remained singularly free from influence of either aesthetic. He was, in fact, almost the only major European painter of the 1910s to avoid those sources, and this despite his knowing Picasso, the poets Paul Guillaume and Max Jacob and other cubist affiliates, and certain of the futurists.

No little of De Chirico's pervasive unearthly effect results from his bringing together elements which are illogically related in time—a modern clock and a locomotive

Giorgio De Chirico, *The Evil Genius of a King* **(1914–15). Oil on canvas, 24″ x 19¾″. Museum of Modern Art, New York.**

in a medieval architectural setting which also contains a late classical statue, for example. Such arrangements are made more enigmatic by the plunging lines of perspective and the shadows that cut across them from inconsistent angles. The nostalgic atmosphere—or curiously vacuum-like space—of the 1910–14 "city square" canvases is rarely matched in its intensity by any of the surrealist efforts of the 1920s and later which were strongly influenced by De Chirico's style.

In 1915 De Chirico shifted his themes to include man-nequin figures and a bizarre span of still-life objects—

biscuits and toys, for example. De Chirico's dreamlike imagery and much of the quality of his earlier technique persisted during the years 1915–25, his so-called Metaphysical Period. Thereafter the uniqueness of his style waned, and soon after 1930 he strangely converted to an academic and uninspired program. A quasibaroque flair has marked most of the portraits he began painting in 1933. He disclaimed his fine early works. See PITTURA METAFISICA.

De Chirico remains one of the most original artists of his time on the strength of his 1911–14 canvases; and the surrealists, with whom he exhibited in 1925 without fully committing himself to the movement, owe much to his visionary temperament.

JOHN C. GALLOWAY

CHRISTO (Christo Javacheff). Bulgarian-born artist (1935–). He trained at Sofia Fine Arts Academy and studied theater design in Prague. After working in Geneva and Paris, he went to New York in 1964. Christo is best known for his "packages," which consist of various aspects of reality isolated or packaged in an ambiguous, mysterious, and often paradoxical way. Along the waterfront in Cologne, he placed a canvas covering over a stockpile of oil drums, calling it a temporary monument (1961). His 1962 wall of oil drums in Paris, temporarily closing off the Rue Visconti, became a kind of Iron Curtain with reference to the Berlin Wall. The contents of Christo's packages are generally concealed, as in the *Four Store Fronts* of 1964–65 in which these unused, unenterable elements take on mystery, even a sinister quality. His most famous "wrapping" was the short-lived *Valley Curtain* of 1972 over Rifle Gap in Colorado. This quarter-mile-wide curtain completely filled the valley and extended over Route 325 with a hole provided for cars to drive through.

C.I.A.M. (Congres Internationaux d'Architecture Moderne). International organization of Europe's leading modern architects, first assembled at the Château de la Sarraz, Switzerland, in June, 1928. It aimed to consolidate the gains of the 1920s; to further explore problems of environmental design; and to propagate the objectives of the new architecture. Among its early organizers were Siegfried Giedion, Le Corbusier, Ernst May, Victor Bourgeois, Walter

Gropius, and others, who subsequently took little part in its proceedings. The organization eventually split and was disbanded in 1959. *See* GROPIUS, WALTER; LE CORBUSIER.

CLAVE, ANTONI. French painter (1913–). Born in Barcelona, Clavé studied at the Barcelona School of Fine Arts. He lives in Paris. Clavé's work underwent a long evolution to reach a very personal style of predominant blacks, reds, and whites, as in *Nature morte aux pastèques* (1936; Paris, Fuentes Collection). He has designed theater décor and has illustrated several books, among them Mérimée's *Lettres d'Espagne*, Rabelais' *Gargantua*, and Pushkin's *The Queen of Spades*. In all his work there is a characteristically Catalonian excitement and vivacity. Clavé was awarded the Prix de la Gravure (1954), the prize of the São Paulo Bienal (1957), the Hallmark Prize, and the UNESCO Prix de la Gravure. His work is on exhibition at the National Museum of Modern Art, Paris. In October–November, 1958, a large Clavé exhibition was held at Arthur Tooth & Sons, London.

COBRA. Group of artists and critics formed in Paris in 1948. The name derives from the cities of the three countries from which the artists originated: Copenhagen (Co), Brussels (Br), and Amsterdam (A). Among the founding members were Jorn, Appel, and Corneille; later Atlan, Alechinsky, Dubuffet, and Pedersen joined. Like the abstract expressionists in the United States, the CoBrA artists were interested in the direct expression of creative energy, in art as a piece of reality. The human figure, although wildly distorted by violent brushstrokes and color in most of the work of the group, remains the central image. The artists of CoBrA worked together on murals, were given exhibitions in Amsterdam, Liège, and Paris, and published a magazine. The group disbanded in 1951 but had a great impact on the subsequent art of northern Europe. *See* ALECHINSKY, PIERRE; APPEL, KAREL; CORNEILLE; DUBUFFET, JEAN; JORN, ASGER.

COLEMAN, GLENN O. American painter and graphic artist (b. Springfield, Ohio, 1887; d. Long Beach, N.Y., 1932). Coleman first studied painting at the Industrial Art

School in Indianapolis and worked as a newspaper illustrator. He went to New York in 1905, studied with William Merritt Chase, Robert Henri, and Everett Shinn, and, only partly under their influence, was drawn to realistic subjects of urban genre. His own economic difficulties, his interest in socialism, and his concern for the lives of the poor also led him in the same direction. Many of his earlier drawings were published in *The Masses*. More than the other painters of the Ashcan group, however, Coleman depended on the picturesque qualities and atmosphere of his scenes, combined with a sentimental emphasis on local elements. Even in his most realistic work the figures are often seemingly less interesting than the charmingly ramshackle streets in which they move, as in *The Mews* (1926; Washington, D.C., Phillips Collection), or the street corners and elevated station of *Downtown Street* (1926; New York, Whitney Museum).

COLLAGE, *see* PAPIERS COLLES.

CONCEPTUAL ART. A broad category covering a variety of works of the 1960s and '70s in which the concept is more important than the actual realization. It is marked by a shift from art as an object to art as an idea; and matter gives way to time, energy, and motion. There are several conceptual, or "dematerialized," forms of activity. One of these involves actions performed in the past and documented in the present by photographs, notes, and other forms such as blueprints. An example is Robert Smithson's photo-records of past experiences in nature. Richard Long also undertakes documentation projects. Another conceptual method locates the body in space, for instance, a room, and takes place in the present tense. Accordingly, Klaus Rinke's *Mutation, Upper Body Gesture* (1972) is a progressive series of photos demonstrating successive body gestures. A third group, the so-called Art Language group, regards the first two methods as reactionary. Its concern is with the nature of art itself rather than with any type of material form.

CONCRETE ART. Term coined by Theo van Doesburg as an alternate to abstract art; he published a journal called *Concrete Art*. Today the term is seldom used.

CONSTRUCTIVISM. Movement and style of art that originated in Russia with the constructions, especially reliefs carried out in modern industrial materials, of Vladimir Tatlin, El Lissitzky, and Alexander Rodchenko beginning in 1913. In that year Tatlin created the first assembled works in abstract forms (Picasso and other cubists had begun high reliefs of the collage technique, and Boccioni in 1912 advocated the utilization of untraditional substances such as hair, glass, and cardboard). Tatlin exhibited them in 1915 as free, geometric constructions in space. While Tatlin and his colleagues were conversant with cubism through slightly earlier exhibitions in Moscow, the combination of essentially geometric abstraction and industrial materials assembled into abstract form was original and was immediately to influence Naum Gabo and his brother Antoine Pevsner, who, although they joined the constructivist movement in 1917 and issued a renowned manifesto in 1920 setting forth the principles of the style, were not in fact the pioneers of the association. Other artists who with Gabo and Pevsner helped to win acceptance of constructivism outside Russia were the Hungarian László Moholy-Nagy and, although his style belongs also to other phases of geometric abstraction, Josef Albers. *See* ALBERS, JOSEF; GABO, NAUM; LISSITZKY, LAZAR; MOHOLY-NAGY, LASZLO; PEVSNER, ANTOINE; RODCHENKO, ALEXANDER; TATLIN, VLADIMIR EVGRAFOVICH.
See also BILL, MAX.

COOK, HOWARD. American painter, muralist, printmaker, and illustrator (1901–). Born in Springfield, Mass., he studied at the Art Students League, New York City, and was awarded a Guggenheim fellowship in 1932. He has traveled extensively throughout the world and has continually experimented with different techniques. His early work is realistic and fully modeled; his later work in collage is almost completely abstract.

CORBETT, HARVEY WILEY. American architect (b. San Francisco, 1873; d. New York City, 1954). As early as the 1920s Corbett was a protagonist of the skyscraper. His firm of Corbett, MacMurray, and Harrison designed Rockefeller Center, New York. In the 1940s the war in Europe, with its bombings, altered the direction of his work away

from skyscrapers, but in 1949 he returned to his early interests, proclaiming the City of the Future with great blocks of skyscrapers. In his exploitation of the New York zoning laws of 1925, he evolved the idea of the "envelope" to maintain light for adjoining buildings. In 1926 he urged cities to develop easy access to airports. His Bush Terminal Office Building (built in 1923) was one of New York's earliest modernistic structures. The base of his Metropolitan Life addition (1930–50) was so designed that with its setbacks it could have been carried 2,000 feet high.

CORINTH, LOVIS. German painter (b. Tapiau, East Prussia, 1858; d. Berlin, 1925). He attended the Gymnasium and art school in Königsberg, and in 1880 began study under Von Löfftz at the Munich Academy of Art. After completing his program in 1884, he visited Paris and worked with Bouguereau and Fleury at the Académie Julian. Corinth was influenced by various artists—among them Rubens, Millet, Manet, and Jongkind—and finally by expressionism, all of which combined in his style to form German impressionism, despite the ostensible roughness or heavy spontaneity of many of his paintings and prints. He left Munich for Berlin in 1900, and, associated with two other masters of late impressionism, Max Slevogt and Max Liebermann, he became one of the most influential painters in Germany.

As a member of the prestigious Berlin Secession, however, Corinth sided with that once-liberal group against the rising pressures of the new expressionist movements. He succeeded Liebermann in the presidency of the group in 1911; but he lost the election in 1913, when the dealer Paul Cassirer and a majority of liberals took the leadership and formed the "Free Secession."

Corinth came to recognize the artistic strength of the expressionists he had once stubbornly opposed, and certain of the Brücke artists evidently returned the admiration. His late style grew more colorful, at times showing an affinity with expressionism yet not fully approaching it. His last pictures are among his finest; the *Walchensee Landscapes*, done in the years just preceding his death in 1925, are characteristic. His graphic works also reflect a certain liberation of style, their restless transitions of light and dark possessing an expressive force. His *Apocalypse* (1921;

lithograph) and *Adam and Eve* (1923; color lithograph) are examples. Corinth stands as a transitional figure between an academic impressionism, which he had begun to transcend at the time of his death, and expressionism, which he did not altogether reach.

JOHN C. GALLOWAY

CORNELL, JOSEPH. American artist (1903–). Cornell was represented in the first American exhibition of the surrealists, at Julien Levy's gallery in New York (1932), and was associated with surrealist artists and writers during the 1930s and 1940s. His work has some affinity with surrealism and Dada, particularly with Marcel Duchamp, but is unique, consistent, and deeply personal. In his characteristic works, objects and cut-out pictures are arranged in small, stage-like boxes, which appear as microcosmic universes of poetic associations.

COSTA, LUCIO. Brazilian architect, historian, and city planner (1902–). With Oscar Niemeyer and Affonso Reidy, he inaugurated Brazil's modern architecture in their designs for the Ministry of Health and Education Building in Rio de Janeiro (1937–42). In other works, Costa's imaginative manipulation of ceramic screens to reduce sun glare is a hallmark of his style. His fan-shaped plan for Brasilia (1957) is his best-known work.

COUBINE, OTHON. French painter, sculptor, and graphic artist (1883–). He was born in Boskovice, Czechoslovakia, and studied in Prague and Antwerp. He traveled in France and Italy and settled in Paris in 1905. At the beginning of his career Coubine was influenced by the early forces in modern art, Van Gogh, Fauvism, and cubism. His mature style, however, has been a form of classical naturalism in which the subject, somewhat simplified, is painted with a structural solidity approaching monumentality. Coubine has painted portraits, figures, and still lifes but is best known for his landscapes.

COVARRUBIAS, MIGUEL. Mexican draftsman and painter (1904–57). Born in Mexico City, Covarrubias began his career as a caricaturist and achieved success in the old *Vanity Fair* and *The New Yorker*. Through Adolfo Best-

Maugard, he became interested in various art forms; this interest led to a lifelong enthusiasm for ethnology and archaeology, especially that of Mexico, and to an extraordinary collection of pre-Conquest art, later willed to the Mexico City National Museum of Anthropology.

Widely traveled, especially in more exotic regions, Covarrubias wrote and illustrated books on Bali, the Isthmus of Tehuantepec (*Mexico South*), and so on. His archaeological studies produced a monumental work (*The Eagle, the Jaguar, and the Serpent*) on pre-Conquest Mexico. It was left unfinished but was later published.

JOSEPH A. BAIRD, JR.

COX, JAN. Belgian painter and graphic artist (1919–). He was born in The Hague and studied in Antwerp and Ghent. He was a founding member of La Jeune Peinture Belge (Brussels, 1945) and a member of L'Art Contemporain group (Antwerp, 1949). He went to the United States in 1956. Cox is primarily concerned with the human form, and his most recent works are mystically symbolic, nearly surreal figure compositions.

CRAWFORD, RALSTON. American precisionist painter (1906–). He was born in Saint Catherines, Ontario, Canada, and lives in New York City. His family settled in the United States when he was four, at which time he was naturalized. He attended high school in Buffalo, N.Y., and was a sailor before studying at the Otis Art Institute in Los Angeles. In 1927 he worked for Walt Disney. He later studied at the Pennsylvania Academy of Fine Arts, Columbia University, and the Barnes Foundation. He had his first one-man show in 1939 in New York City. Crawford has taught at several schools, among them the Art School of the Brooklyn Museum and the University of Minnesota, and is currently a professor at Hofstra College, Hempstead, N.Y. In 1961 he had an exhibition of color lithographs at the Nordness Gallery in New York. Crawford depicts cityscapes, emphasizing hard edges and planes, often reducing values to two or three tones.

CUBISM. The cubist movement had its early development in the works of Picasso and Braque between 1907 and 1910 and, still under their leadership, underwent salient

growth until 1914 with significant contributions by Juan Gris, Robert Delaunay, Fernand Léger, and Jacques Villon. Other painters, among them Albert Gleizes, Jean Metzinger, Auguste Herbin, Roger de La Fresnaye, Louis Marcoussis, Henry Le Fauconnier, André Lhote, André Derain, Marcel Duchamp, and Francis Picabia, in one or another measure adopted the cubist method before World War I. Some of them continued it, with individual modifications (as was the case with Picasso and Braque), into the 1960s. Cubism, rivaled only by the abstract expressionism of the German Blue Rider (Blaue Reiter) movement, has asserted the most penetrating influence imparted by any modern style upon post-World War I art. *See* BRAQUE, GEORGES; DELAUNAY, ROBERT; DERAIN, ANDRE; DUCHAMP, MARCEL; GLEIZES, ALBERT; GRIS, JUAN; LA FRESNAYE, ROGER DE; LE FAUCONNIER, HENRI; LEGER, FERNAND; LHOTE, ANDRE; MARCOUSSIS, LOUIS; METZINGER, JEAN; PICABIA, FRANCIS; PICASSO, PABLO; VILLON, JACQUES.

See also ARCHIPENKO, ALEXANDER; DUCHAMP-VILLON, RAYMOND; LAURENS, HENRI; LIPCHITZ, JACQUES.

CUBISM, FLAT-PATTERN. Term coined by R. H. Wilenski to apply to the paintings of synthetic cubism, in which spatial recession is denied by the organization of line, shape, and color. It originated between 1911 and 1914, with the introduction of collage and the emphasis on surface by Picasso and Braque, and culminated in the austere, architectural compositions of Ozenfant's purist still lifes.

CUBIST REALISM. American artistic movement of the 1920s known variously (and sometimes pejoratively) as immaculatism, precisionism, and sterilism. It arose primarily from experiments with abstraction shortly after the Armory Show by such artists as Charles Demuth and Charles Sheeler. Artists of the cubist realist group shared a common point of view more than a specific technical style. Basically cubist in approach, they organized industrial and architectural scenes or landscape and natural forms into impersonally handled, implicitly abstract compositions of simplified and geometric volumes, clean edges, and sharp images. *See* DEMUTH, CHARLES; SHEELER, CHARLES.

While the formal means of the movement derived mostly

from cubism and purism, cubist realism, in choice of and attitude toward its subjects, is also related to the general 1920s reaction against abstraction, as seen in such a movement as the German New Objectivity. Among the other painters who worked in this manner are George Ault, Ralston Crawford, Preston Dickinson, Georgia O'Keeffe, Niles Spencer, and Joseph Stella. *See* AULT, GEORGE COPELAND; CRAWFORD, RALSTON; DICKINSON, PRESTON; O'KEEFFE, GEORGIA; SPENCER, NILES; STELLA, JOSEPH.

CUEVAS, JOSE LUIS. Mexican draftsman and printmaker (1933–). He was born in Mexico City. Self-taught and precocious, Cuevas was given a one-man show at twenty. The greater part of his output, line drawings and wash drawings, explores social ills in the corrosive manner of Goya, Daumier, and Orozco. His typical themes involve inmates of hospitals, lunatic asylums, and brothels, and are usually done in India ink and gum arabic. Among the finest drawings by Cuevas are illustrations for a book on Kafka. Strongly expressionist, his art emphasizes hallucinatory distortions of form, suggestive linear rhythms, and disquieting conjunctions of light and shadow.

CURRY, JOHN STEUART. American painter, lithographer, and illustrator (b. Dunavant, Kan., 1897; d. Madison, Wis., 1946). He studied in Kansas City and Chicago and at the Art Students League in New York and the Russian Academy in Paris. Curry painted realistic farm and rural subjects, often of an anecdotal nature. His *Baptism in Kansas* (1928, New York, Whitney Museum) won him prominence and helped establish the subject matter of American regionalist painting of the 1930s. In 1932 he traveled with the Ringling Brothers circus, painting the animals and entertainers, as in the glowing red *Flying Codonas* (1932; Whitney Museum). Thereafter he again concentrated on the Middle Western scene, for example, *Wisconsin Landscape* (1940; New York, Metropolitan Museum).

DADA. Movement in literature and the visual arts founded in Zurich, Switzerland, in February, 1916, by a brilliant and ironic group of international artists, including the Rumanians Tristan Tzara and Marcel Janco, the Germans Richard Huelsenbeck and Hugo Ball, the Alsatian Jean (Hans) Arp, and others. These individuals centered their activities at the Cabaret Voltaire, where Huelsenbeck and certain of the others served beer and doubled as musicians and dancers. *See* ARP, JEAN.

The Dadaists were unified by a collectively antimilitarist, antiaesthetic attitude, impelled in part by the horrors of World War I but also, in the more professional sense, by boredom with cubism and other current modern styles as well as traditional art and literature in general. The review bearing the name of this movement specialized in what might be called a remarkably articulate inarticulateness—poems and articles of antilogical content that were sometimes hilarious, sometimes biting.

The Zurich venture had in fact been anticipated by the independent activities of the French painters Marcel Duchamp and Francis Picabia after 1912 and, in 1915 or before, by the Americans Man Ray and Walter Arensberg, all of whom contributed to New York exhibitions and publications during World War I. Closer in spirit to the Zurich variety of Dada, however, was the Cologne association formed in 1919 by Max Ernst and Johannes Baargeld in collaboration with Arp. Arp and Ernst produced a series of collages known as *Fatagaga*, and one of their exhibitions was so controversial that it was closed by the police. *See* DUCHAMP, MARCEL; ERNST, MAX; PICABIA, FRANCIS; RAY, MAN.

Other 1919 Dada manifestations took place concurrently in Hannover, where Kurt Schwitters invented *Merzbilder* (junk pictures); in Paris, where André Breton, Louis Ara-

gon, and Philippe Soupault were editing *Littérature* and were joined by most of the original Zurich group; and in Berlin, where Huelsenbeck published *Der Dada.* Arp worked independently as a painter and sculptor of increasingly abstract reliefs. A unifying principle, in addition to the antilogical character of the literature and art produced by the various individuals, was the group action of deliberately upsetting public behavior. *See* SCHWITTERS, KURT.

It is often alleged that Dada was a nihilistic, destructive movement, but it should be understood that many gifted artists advocated Dada. Among them were some of the most distinguished practitioners of surrealism and abstract art. The surrealist movement could hardly have developed without the collective and individual contributions of Dada. Further, the spirit of the Dadaists never completely disappeared, and the so-called Neo-Dada art of the late 1950s and 1960s in New York, including certain varieties of the "arts of assemblage," especially junk sculpture and some pop art, sustain the tradition.

JOHN C. GALLOWAY

DALI, SALVADOR. Spanish painter, writer, book illustrator, stage designer, movie producer, and jewelry designer (1904–). Dali entered the art school of San Fernando Academy, Madrid, at age seventeen and was expelled in 1926. His student work was concerned with the cubist movement. About 1923, he became interested in the metaphysical aspects of works by Chirico and Carrà. Exhibitions of his work at Barcelona (1925) and Madrid (1926) aroused public attention because of his application of precise and serene draftsmanship to what has been called a new mythology of the Mediterranean.

He visited Picasso in Paris in 1928 as a self-styled cubist. The impact of Picasso's collages, Breton's theory of surrealism, Miró's biomorphic forms, and Tanguy's vast spaces caused Dali to reorient his artistic purpose.

His exploits have always received lavish publicity, and he has enjoyed great public attention. His abundant publications (*The Secret Life of Salvador Dali, Fifty Secrets of the Art of Magic,* and so on), purporting to reveal or explain the "real Dali" or the "true significance" of his art, are couched in impressively rich philosophical terminology, which he garbles in a species of abracadabra.

Persistence of Memory (1931; New York, Museum of

Salvador Dali, *Illumined Pleasures* (1929). Oil and collage on composition board, 9⅜″ x 13¾″. Museum of Modern Art, New York (Sidney and Harriet Janis Collection).

Modern Art) follows the Freudian inspiration of surrealism in depicting a hallucinatory dream world of painfully clear objects irrationally juxtaposed and individually deformed in an ensemble pregnant with hidden meanings. Dali put forward his so-called paranoiac method in an endless proliferation of enigmatic images within images, such as the *Apparition of Face and Fruit Dish* (1931; Hartford, Wadsworth Atheneum).

Dali has since sought external inspirations for subject matter. *Atomic Leda and Swan* is his ambiguous response to the atomic age; the *Sacrament of the Last Supper* (1955; Washington, D.C., National Gallery) is a religious theme interpreted with the artist's own metaphysical symbolism.

<div style="text-align: right">EILEEN A. LORD</div>

DASBURG, ANDREW MICHAEL. American painter (1887–). He moved from Paris to the United States at an early age. He studied with Kenyon Cox and Birge Harrison at the Art Students League and with Robert Henri. Dasburg was one of the early group of American painters interested in European abstraction. The Armory Show impelled him toward cubism, which remained the dominant

source of his style, despite brief experiments in about 1916 with orphism and synchronism. He later became more representational in manner but still retained a formally simplified approach to his subjects, particularly landscapes of the American Southwest.

DAVIDSON, JO. American sculptor (1883–1952). He studied at the Art Students League in his native New York City and at the Ecole des Beaux-Arts in Paris. Davidson's purpose was to create portraits of the outstanding personalities of the 20th century. A friendly and persuasive personality, he succeeded in making busts or figure portraits of more than 300 internationally recognized persons, including Tito, Gandhi, Franklin D. Roosevelt, Shaw, Gide, Pershing, Gertrude Stein, Gertrude Vanderbilt Whitney, Einstein, Chaplin, and Ben-Gurion. He worked in various media—terra cotta, marble, bronze. Davidson's portraits are, at their best, straightforward and interpretative of the personality of the sitter. Typically, he works in a basically naturalistic style, often with suppressed or exaggerated detail as he felt best fitted the character of his subject.

DAVIE, ALAN. British painter (1920–). He was born in Grangemouth, Scotland, and studied at the Edinburgh College of Art. He traveled and studied in France, Switzerland, Italy, and Spain in 1948–49. From a study of Klee in Switzerland, Davie learned that painterly means could be combined with ideas or symbols. His discovery of Jackson Pollock's symbolic paintings at the 1948 Venice Biennale gave him the technique. Davie's abstract paintings of the early 1950s stress geometrical elements of rich color and a vague symbolic meaning. In his recent work the symbolic imagery of forms with a ritualistic reference has become stronger.

DAVIES, ARTHUR BOWEN. American painter, graphic artist, sculptor, and tapestry designer (b. Utica, N.Y., 1862; d. Florence, 1928). He studied at the Chicago Academy of Design, worked in Mexico as a draftsman from 1880 to 1882, and then studied further at the Art Institute of Chicago and the Gotham Art Students School and the Art Students League in New York. With the financial help of William Macbeth and Benjamin Altman he went to

Italy in 1893. He was a member of The Eight. As president of the Association of American Painters and Sculptors, Davies was the instrumental organizer of the 1913 Armory Show, which was a monument to the catholicity of his taste and to the wide range of his social contacts.

Davies's early paintings were landscapes, such as *Along the Erie Canal* (1890; Washington, D.C., Phillips Collection). His travels in Europe resulted in a variety of influences—lyrical Pompeian painting, Giorgione, the Pre-Raphaelites, Puvis de Chavannes, Marées, and Whistler—which, at his best, he assimilated with the more American romanticism of Ryder, as, for example, in *Every Saturday* (ca. 1896; Brooklyn Museum) or the more Venetian *Dancing Children* (1902; Brooklyn Museum). In the early 1900s, he began painting idyllic landscapes in which ethereal women, mythological figures, or unicorns move gracefully against a delicate background of rocks, trees, and water: for example, *Unicorns* (1906; New York, Metropolitan Museum) or *Leda and the Dioscuri* (1905; Art Institute of Chicago). The classical, friezelike arrangement of the figures is particularly evident in such a work as *Crescendo* (1910; New York, Whitney Museum). Davies's refined intellectuality produced such faint allegories as *The Jewel-bearing Tree of Amity* (ca. 1912; Utica, Munson-Williams-Proctor Institute) as well as his later (1922) involvement with Gustav Eisen's theories of inhalation in Greek art.

JEROME VIOLA

DAVIS, STUART. American painter (b. Philadelphia, 1894; d. New York City, 1964). He studied with Robert Henri in New York from 1910 to 1913 and worked for *Harper's Weekly* and *The Masses.* A pioneer modernist, he exhibited five water colors at the Armory Show of 1913. The paintings he saw there, particularly those of the postimpressionists, were decisive in turning Davis away from realism toward a greater abstraction.

Such paintings as *Multiple Views* (1918) and *Yellow Hills* (1919; both New York, Downtown Gallery) are related to Gauguin and Van Gogh, but the water color *Cigarette Papers* (1921; private collection) shows what was to become the dominant influence of synthetic cubism. In these works, along with illusionistic painted textures, he

Stuart Davis, *Owh! in San Pao* (1951). Oil on canvas, 52¼″ x 41¾″. Whitney Museum of American Art, New York.

introduced words not as cubist elements of reality but as a part of the total abstract structure of the picture. The famous *Eggbeater* series (1927–28) carried the surface disposition of generalized forms to a further degree, and when Davis went to Paris in 1928, he applied similar techniques to the painting of street scenes. For example, in *Place Pasdeloup* (1928; New York, Whitney Museum), the few remnants of traditional perspective are lost against the flat planes of bright color. After returning to the United States, he continued in this synthesizing style.

In 1933 Davis joined the Federal Art Project and later

painted two murals for the WPA. Meanwhile his work had become almost totally abstract. In *Bass Rocks No. 1* (1939; Wichita Art Museum), the motif was reduced to lines set against areas of contrasting color. Naturalistic elements became completely subordinate to the needs of overall design. Davis's colors are bright and jumpy but calculated in effect, as seen, for example, in *Hot Stillscape for Six Colors* (1940; private collection), where areas of warm colors are dominant but not enough so as to form a spatial recession.

In 1944 Davis was given a retrospective show at the Museum of Modern Art in New York; subsequently he won many major prizes, the last of which was the 1964 gold medal for the best oil painting, given by the Pennsylvania Academy of Fine Arts. In the latter part of his career, Davis's works show a tendency toward straight-edged forms, though fewer in number than previously, combined with a bolder compositional use of words. He retained little of the social realism of his early days except for his general exuberance and the bits of everyday American life that found their way into his paintings as words or shapes.

Though based on cubism and the machine stylizations of Léger, Davis's paintings have a freshness of approach and a sense of humor completely his own, perhaps due to jazz, which was a constant source of his inspiration. Davis thought of his art as an integral part of the dynamic American scene and considered all his pictures, including those painted in Paris, as referential to that scene.

JEROME VIOLA

DE CREEFT, JOSE. American sculptor (1884–). Born in Guadalajara, Spain, he was apprenticed at the age of twelve to a bronze foundry in Barcelona. He went to Paris (1905), where he studied at the Académie Julian and worked as a stonecutter. He went to the United States in 1928. Although an early exponent of direct handling of materials (he exhibited a "ready-made" of found objects in Paris in 1925), he is best known as a carver. His works exhibit solidity of form, often expressed in rounded volumes, and a sense for whimsical detail.

DE DIEGO, JULIO. American painter (1900–). Born in Madrid, he was trained to be a stage designer. He is

mostly self-taught as a painter. De Diego went to the United States in 1924. He is best known for a series of semiabstract, symbolic war paintings, done during World War II (for example, *The Portentous City*, 1942–43; New York, Metropolitan Museum of Art). His most recent works deal with the destruction of the Spanish Armada.

DEGENERATE ART. Nazi Germany's epithet for all individualism in 20th-century art. In an attempt to destroy both the creation and appreciation of modern art, the state confiscated thousands of works from public museums and exhibited them viciously in Munich in 1937 as examples of degeneracy, pacifism, and non-Aryanism. The art of Cézanne, Gauguin, Braque, and Picasso as well as of most German expressionists was included.

DEHN, ADOLF. American painter and lithographer (1895–1968). He was born in Waterville, Minn., and lived in New York City. In 1914 he studied at the Minneapolis Institute of Fine Arts. Encouraged by the sale of his drawings, he went to New York, where he studied with Boardman Robinson. In 1921 he went abroad for seven years and was influenced by George Grosz and Julius Pascin. He exhibited his water colors for the first time in 1938. In 1939 and 1951 he received Guggenheim grants; he was awarded several prizes. Dehn taught summer sessions at the Colorado Springs Fine Arts Center. In 1946 he visited Haiti. Combining vigorous texture and an athletic line with delicacy of tone, Dehn poked fun at Sunday painters, café society, habitués of Negro night clubs, and earnest prelates, and presented the landscapes of Minnesota, Haiti, Colorado, and other places with lyrical affection.

DEINEKA, ALEXANDER. Russian painter, graphic artist, and teacher (1899–). He was born in Kursk and studied at the Kharkov Art School and at the Moscow Vkhutemas from 1921 to 1924. Since 1924 Deineka has been an important graphic artist and illustrator for various periodicals, especially *The Atheist at the Bench*. He is also known for his patriotic posters, including the famous "We must ourselves become specialists." While Deineka's subjects are mostly standard scenes of Soviet realism—peasants, factories, and Russian history—his style is influ-

enced by the emphasized silhouette and flat treatment of his illustrations and graphic work.

Willem de Kooning, *Woman and Bicycle* **(1952–53). Oil on canvas, 76½″ x 49″. Whitney Museum of American Art, New York.**

DE KOONING, WILLEM. Dutch-born American painter (1904–). A major abstract expressionist, he is a leader in the action group. Born in Rotterdam, he studied at the Rotterdam Academy of Fine Arts and then worked for a decorating firm. In 1926 he went to the United States. He did free-lance commercial art and murals during the late 1920s and early 1930s; he was with the Federal Art Project in 1935; and he collaborated with Fernand Léger on a mural for the French Line. De Kooning shared a studio with Arshile Gorky. De Kooning's earliest abstractions date from about 1930, but his greatest development occurred in the mid-1940s.

By about 1945 De Kooning had become a strong influence among avant-garde painters and a few critics in New York. He became internationally famous soon after his first one-man show at the Egan Gallery in 1948. His *Woman* series of 1952–55, for which there are prototypes in the late 1940s, won astonishingly wide critical and popular attention. In 1958 he reinvestigated the nonobjective manner he had tentatively used about 1930 and had carried further in black-and-white enamel canvases in 1948. His violently brushed, brilliantly colored abstract expressionist paintings and collages of the late 1950s and early 1960s established him as a major contemporary artist. He has sometimes reverted to the *Woman* theme since 1962. He has taught at Black Mountain College and Yale University.

De Kooning has had one-man shows at the Sidney Janis Gallery, Boston Museum of Fine Arts School, Venice Biennale, and São Paulo Bienal. His works have been included in major group and international shows in New York (Museum of Modern Art; Whitney Museum of American Art), Pittsburgh (Carnegie International), Venice, and São Paulo. JOHN C. GALLOWAY

DELAUNAY, ROBERT. French painter (b. Paris, 1885; d. Montpellier, 1941). He was a cubist and a founder of orphism in 1911–12. *See* ORPHISM.

He studied theater design in 1902 and worked with the decorator Ronsin. Delaunay painted part time in Brittany and was influenced by the work of the Pont-Aven group. He carried out independent research in the color theories of Helmholtz, Chevreul, and the neoimpressionists.

Robert Delaunay, *Eiffel Tower* **(1926). Transfer lithograph, 24¼″ x 17¾″. Museum of Modern Art, New York. Abby Aldrich Rockefeller Fund.**

He was also influenced by Cézanne and Near Eastern decorative art.

The color of Delaunay's 1905 still lifes anticipates that of his later cubist works, but his first major paintings date from 1909–10, when he completed his famous series of *Cathedrals* and *Cities.* His *St-Severin* (1909; Philadelphia Museum of Art) and *Eiffel Tower* (1910; Basel, Art Museum) are documents of Delaunay's own early cubist

style and reveal a strongly personal resolution of structural and spatial problems. An active member of the cubist circle after 1910, Delaunay was admired by the Munich Blue Rider group and exhibited his *City of Paris* (Paris, National Museum of Modern Art) in their 1911 exhibition. His principal concerns in 1910 and 1911 were dynamic movement —a kind of "simultaneity" not unrelated to futurist aesthetic—and color based upon delicate interpretations of the spectrum. Color became Delaunay's chief interest in 1912, when he produced his *Windows* (*Simultaneous Windows*) series.

He visited Berlin in 1913 and held a one-man show at Herwarth Walden's Der Sturm Gallery. Delaunay's essay *Sur la lumière* was translated by Paul Klee (an admirer of Delaunay) and published in *Der Sturm*. Delaunay's *Homage to Blériot* (Paris, private collection), an orphist work into which the artist introduced literal symbols of aeronautics, was done in 1914. From 1915 to 1920 he lived in Spain; he designed sets for the Diaghilev ballet *Cléopâtre* in 1918. Delaunay's home was a meeting place for the Parisian Dadaists after his return in 1921.

The Galerie Paul Guillaume held a retrospective of his work in 1922. In 1924 Delaunay undertook his *Runners* series and, in 1930, the *Multicolored Disks* (a restatement of his 1912 orphist aesthetic). He was instrumental in founding the first Réalités Nouvelles exhibition in 1939.

Delaunay's orphist development of the cubist style was a major contribution to 20th-century art, and his work was influential upon many artists. With his *Windows* and *Disks* works of 1912, he was one of the early practitioners of abstract art in France. JOHN C. GALLOWAY

DELVAUX, PAUL. Belgian painter (1897–). He was born in Antheit and studied classics in Brussels. After switching to painting, he spent three years working at the Brussels Academy under Montald. His early work was influenced by the Belgian expressionists Permeke and Smet. Traveling through Italy and France, he discovered Chirico and surrealism, met Magritte, and became a surrealist about 1935. The strange atmosphere of his paintings is induced by nude women and clothed men wandering among classical ruins or down long streets, isolated, yet on some mysterious errand, as in *Phases of the Moon* (1939; New York, Museum of Modern Art).

Charles Demuth, *Daisies* (1918). Watercolor, 17¼″ x 11⅜″. Whitney Museum of American Art, New York.

DEMUTH, CHARLES. American water-colorist (b. Lancaster, Pa., 1883; d. there, 1935). Sickly and lame as a boy, he was encouraged by his family to develop his interest in art. His father was a talented amateur photographer, and his aunt and grandmother were water-color-

ists. He studied at the School of Industrial Art in Philadelphia, and at the age of twenty-two entered the Pennsylvania Academy of Fine Arts to study under Marin's teacher, Thomas Anschutz. Demuth spent the year 1909 in Paris, where he saw Rodin's water colors, Japanese prints, and the art of Cézanne and Toulouse-Lautrec. He finished his studies in Philadelphia and in 1914 returned to Paris, where he saw and was influenced by the cubist art of Gleizes and Metzinger. In 1915, in New York City, he came to know Marcel Duchamp, who became a lifelong friend. Demuth joined the gallery of Alfred Stieglitz in New York City. His most productive years were those between 1914 and 1920. Developing diabetes in 1920, he retired to his home town and spent summers from 1930 to 1934 in Provincetown, Mass.

His best-known water colors are those he did from 1914 on of tender spring flowers, acrobats, vaudeville entertainers, café and bar scenes, and illustrations of such stories and plays as Zola's *Nana*, Henry James's *The Turn of the Screw*, and Wedekind's *Erdgeist*. The illustrations were freely developed and were not meant for publication. The figure studies are imbued with a nervous energy and a winsomeness. He favored a fragile, often pulsating pencil line, which moved independently of the movements of the figures and the folds of their costumes. Filmy washes and stains of color complement rhythms rather than define form. In his flower studies, Demuth emphasized delicacy, evanescence, and succulence. He often removed all trace of brushstrokes and obtained a mottled texture by blotting up washes of water color. He turned to tempera in 1919, when he did most of his architectural landscapes. Among these is his abstraction of a Wrenlike church steeple in a manner that recalls Feininger. He reduced forms to facets of light and used intersecting diagonals to suggest shafts of light and shadow. In 1920 he turned to oil paint to compose several studies of factories and other industrial sites. These last works link him with such precisionist artists as Preston Dickinson and Charles Sheeler. *See also* CUBIST REALISM. ROBERT REIFF

DERAIN, ANDRE. French Fauvist painter (b. Chatou, 1880; d. Garches, 1954). Following his regular education at the Collège Chaptal, Derain took painting classes at the Académie Carrière (1898) and the Académie Julian (1904)

André Derain, *London Bridge* **(1906). Oil on canvas, 26″ x 39″. Museum of Modern Art. Gift of Mr. and Mrs. Charles Zadok.**

in Paris. He was a brilliant student, and in 1905 the dealer Ambroise Vollard, introduced to him by Matisse, bought almost all his works and gave him a contract. In that year Derain also participated in the controversial Fauvist show at the Salon d'Automne and at the Galerie Berthe Weill, which in 1906 purchased several of his pictures.

Derain's Fauvist style of 1905–07, which he exemplified in a prolific series of landscapes done during visits to the south of France and London, was the most vigorous phase of his career. His painting is characterized by brilliant (sometimes pure) color, rapid and broken brushwork, and almost spontaneous composition. His 1906 landscapes and occasional portrait studies are among the most typical Fauvist pictures (*London, Big Ben,* New York, Robert Lehman Collection; *Hyde Park,* Paris, private collection; *Landscape at Collioure*) and relate his style closely to that of Friesz, Matisse, and Vlaminck.

Derain received a contract from Kahnweiler in 1907. During that year and 1908 he met frequently with Picasso, Braque, and other cubist painters and poets. He came under their influence and that of Cézanne, whose 1907 posthumous exhibit had impelled him to restudy the problems of structure and space. His *Still Life with Two Jugs* (1910; Paris, private collection) is a major document of this period of influence.

In 1912 Derain began what is called his "Gothic period," in which he combined cubist and neoclassic manners, especially in figure compositions and portraits (*The Two Sisters*, 1914, Copenhagen, State Museum of Fine Arts; *Portrait of Paul Poiret*, 1915, Grenoble, Museum of Painting and Sculpture; *The Drinker*, 1913–14, Tokyo, Kabutoya Gallery). In 1918 he gave his first one-man show at the Galerie Paul Guillaume. After this his style became increasingly neoclassic, and the earlier Fauvist spontaneity and the more immediate influences of cubism disappeared. His *Pierrot and Harlequin* (1924; Paris, private collection) is characteristic. Derain received the first prize at the Carnegie International in Pittsburgh in 1928 for *La Chasse*. His painting did not undergo a significant change of direction after the 1920s.

He was also prolific as an illustrator and a stage designer. As early as 1902 he illustrated books by Vlaminck, and in 1909 he did drawings for Apollinaire's *L'Enchanteur pourrissant*. After World War I he illustrated works by Breton, Dalize, Salmon, Reverdy, Rabelais, and others. His stage décor included designs for Diaghilev, Poulenc, and Roland Petit. Derain also produced a number of sculptures, especially in 1939.

One of the most prolific and talented of the French Fauves, Derain made a significant contribution, particularly between 1905 and 1912, to early modern painting.

JOHN C. GALLOWAY

DESPIAU, CHARLES. French sculptor (b. Mont-de-Marsan, 1874; d. Paris, 1946). In 1891 he went to Paris and worked under Hector Lemaire at the Ecole des Arts Décoratifs and then with Barrias at the Ecole des Beaux-Arts. Despiau began to exhibit in 1902. Rodin invited him to join his atelier, and he was the master's collaborator from 1907 until 1914. A trip to Germany during the Occupation of World War II was criticized by his countrymen. He followed the quiet pursuit of a gentle, almost classical, art. His *Paulette* (1907) and *Young Girl from Landes* (1909) are in the Paris National Museum of Modern Art, and *Mme Schulte* and *Assia* (1938) are in the New York Museum of Modern Art. His best work is in the sensitive feminine portrait. The limited success of his art rests on nuance and understatement.

DE STIJL. Dutch purist art movement ("stijl," pronounced "style"; de Stijl means "the Style"). It involved painters, sculptors, designers, and architects whose works and ideas were pooled and disseminated through the periodical *De Stijl* between 1917 and 1931. Its editor, Theo van Doesburg, was the initiator and coordinator of the group. *See* DOESBURG, THEO VAN.

The movement began on June 16, 1917, with the first issue of the periodical. The founders and contributors to the first number were the painters Piet Mondrian, Vilmos Huszar, Bart van der Leck, and Gino Severini; the architects J. J. P. Oud, Jan Wils, and Robert van't Hoff; the sculptor George Vantongerloo; and the poet A. Kok. They were joined later by others, including the architect Gerrit Rietveld. *See* LECK, BART VAN DER; MONDRIAN, PIET; OUD, JACOBUS JOHANNES PIETER; RIETVELD, GERRIT THOMAS; SEVERINI, GINO; VANTONGERLOO, GEORGE.

Design principles based upon the most astringent minimum of artistic means eventually evolved. Colors were reduced to the primaries and white, gray, and black; form was limited to the rectangle; and composition was based upon the asymmetrical arrangement of perpendicularly oriented planes, flexible space loosely defined by all these visual elements.

De Stijl was fundamentally an aesthetic, not a materialistic, movement that aimed to create a universal form language which could be manipulated independently of the personal emotions of the artist. It made a major contribution to modern art by introducing this language to the Bauhaus, where the aesthetic was combined with the practical, seen, for example, in the work of Marcel Breuer. *See* BAUHAUS.

Because of de Stijl's objective quality and social orientation, its principles were immediately applicable to the needs of a modern democratic-technological society. Since the 1920s a de Stijl aesthetic has so completely permeated our man-made environment that it is an integral part of virtually all quality graphic, industrial, and architectural design. THEODORE M. BROWN

DI CHIRICO, GIORGIO, *see* CHIRICO, GIORGIO DE.

DICKINSON, PRESTON. American painter (b. New York City, 1891; d. Spain, 1930). He studied with Ernest Law-

son at the Art Students League. Between 1910 and 1915 he was in Europe, mostly Paris, studying paintings in museums.

Dickinson's early work was influenced by Japanese prints and by Cézanne; elements of Oriental principles of pattern and design remained an important aspect of his style for most of his later career. However, his personal use of late Cézanne and early cubist formal treatment involved emotional depiction more than aesthetic analysis. This approach is evident in a city scene, one of his favorite subjects, the later *Old Quarter, Quebec* (1927; Washington, D.C., Phillips Collection), in which buildings and sky are fragmented into strong patterns.

In the early 1920s Dickinson was associated with the precisionist, or cubist realist, style in American painting. But unlike such a precisionist as Sheeler, whose forms are at least theoretically inherent in the subject, Dickinson used industrial and urban shapes as the starting point for exercises in pure painting. The shifting planes and ambiguous space of *Industry* (before 1924; New York, Whitney Museum) or *Factory* (1924; Columbus Gallery of Fine Arts) owe more to cubist technique than to the abstract beauties of modern machinery. *See* CUBIST REALISM.

<div align="right">JEROME VIOLA</div>

DIEBENKORN, RICHARD. American painter (1922–). Diebenkorn was born in Portland, Ore. He attended Stanford University in Palo Alto, Calif., and the University of California before studying and teaching at the California School of Fine Arts in San Francisco. He was deeply influenced by David Park as well as by Clyfford Still, Mark Rothko, and Hassel Smith. The freedom of brushstroke and the color relationships of his early abstract expressionist paintings were incorporated into the new figurative style that he evolved from 1955 onward. Simple interior settings with landscape views and figures are reworked repeatedly in terms of broad perspective patterns of brushstroke and modulations of color.

DILLER, BURGOYNE. American abstract painter (b. New York City, 1906; d. there, 1965). He studied at Michigan State College, at the Art Students League in New York City, and, briefly, with Hans Hofmann. He first worked

as an expressionist, then turned to Cézanne and to cubism, before committing himself to neoplasticism. In 1934 he became a disciple of Mondrian, the first in the United States. In addition to one-man gallery shows in New York City, he was represented in the New York Museum of Modern Art's 1951 exhibition of American abstract art. He was a member of the American Abstract Artists.

DINE, JIM. American painter (1935–). He studied at the University of Cincinnati, the Boston Museum of Fine Arts School, and Ohio University. He lives in New York City. His work appeared in the Venice Biennale of 1964. The ambiguities between art and reality that appear in the work of Jasper Johns are taken up in a more direct and aggressive way by Dine. Pictures drawn on the canvas, objects, such as tools, hung from the canvas, and the canvas itself are played against each other in a startling and often humorous manner.

DINWIDDIE, JOHN EKIN. American architect (1902–59). He was born in Chicago and studied architecture at the University of Michigan. After working as an architectural designer in New York City (1927–30), he went into private practice in San Francisco (1930–53), where he executed a number of homes. From 1953, he was dean of the School of Architecture at Tulane University.

DIX, OTTO. German painter (1891–1969). He was born in Untermhausen and lived in Hemmenhofen, West Germany. His father was a railway worker. Dix was an apprentice to a decorative painter for four years before studying under Richard Müller at the Dresden School of Arts and Crafts. From 1914 to 1918 he served in the army. He returned to Dresden and then went to Düsseldorf to study. From 1922 to 1925 he taught at the Düsseldorf Academy. In the 1920s he acquired his reputation as a critic of society and of war and published *War* (*Der Krieg*, 1924), a series of 50 etchings. In 1927 he was given a professorship at the Dresden Academy but was dismissed in 1935 by the Nazis and forbidden to exhibit. He was jailed in 1939 in Dresden allegedly for plotting against the life of Adolf Hitler. Toward the end of World War II he was a prisoner of the French. When the war ended

he returned to his post at the Dresden Academy, only to move to West Germany shortly afterward.

Before 1920 Dix had painted in a variety of styles, from impressionism and a Hodler-like decorative abstraction to cubism and finally, as an expression of anarchic revolt, to Dada. In the mid-1920s he and George Grosz were leaders in the Neue Sachlichkeit (New Objectivity) movement, a reaction against all that was lyrical, personal, and mystic in expressionism although it retained many expressionist techniques. Artists turned to contemporary themes and to a treatment relatively more realistic. The brutalities of gas and trench warfare had horrified Dix, and he revealed them with unrelenting intensity in his pictures. He found the graphic clarity of such German romantics as Runge and the hyperrealism of Cranach and Hans Baldung-Grien and of contemporary primitives sympathetic to his need for power of statement, and he imitated them.

In his well-known *Parents of the Artist* (1921; Basel, Public Art Collections), he combines tortured, nervous contours with sickly color to create an effect of exaggerated realism that both fascinates and repels. *The Procuress* (color lithograph, 1923) recalls Grosz in the quality of its satire and in its bitterness. His portrait of Dr. Mayer-Hermann (1926) in the Museum of Modern Art, New York, is merciless in its blunt naturalism. After World War II Dix rejected his veristic approach for a personal interpretation of religious themes in a manner that is decidedly expressionist and reminiscent of Nolde.

<div align="right">ROBERT REIFF</div>

DOBELL, SIR WILLIAM. Australian portraitist (1899-1970). He became widely known in 1944, when his right to win an award was challenged unsuccessfully in the courts by a faction of academic painters. This affair became a landmark in the history of Australian art; because of it, Dobell was considered the nominal leader of the modern art movement in Australia. His works, which display sharp cynicism, are not advanced in terms of contemporary art trends but are greatly influenced by Hogarth, Renoir, Gainsborough, and other masters. In 1948 Dobell received further awards for portraiture and landscape painting; he was knighted in 1966.

Theo van Doesburg, *Simultaneous Counter Composition* (1929–30). Oil on canvas, 19¾″ x 19⅝″. Museum of Modern Art, New York (Sidney and Harriet Janis Collection).

DOESBURG, THEO VAN (C. E. M. Kupper). Dutch abstract painter, writer, and critic (b. Utrecht, 1883; d. Davos, Switzerland, 1931). As a young man Van Doesburg trained to be an actor, but turned to painting by 1900. He made a living selling pictures he copied from those in the Rijksmuseum. In 1913 he published a volume of poems called *Full Moon.* He became interested in the modern art movement and wrote articles about it and about the art of Asia.

By 1916 he had begun to render naturalistic representations, such as landscapes and cows, into their geometric counterparts. He maintained that this was an attempt to achieve total harmony through reduction to forms that were universal and timeless. In 1917 he wrote an article on Mondrian, who read it and sought out its author. Soon afterward Mondrian and Van Doesburg joined with Bart

van der Leck, the architects Rietveld, Oud, and Wils, and the sculptor Vantongerloo to form the de Stijl group and to publish an influential review of the same name. It came out in 1917 and went through eighty-seven issues until 1931, the year Van Doesburg died.

De Stijl was noted internationally, largely through the propagandizing efforts of Van Doesburg, who traveled throughout the Continent lecturing. In 1921 he met Mies van der Rohe and Le Corbusier, and from 1921 to 1923 Van Doesburg taught at the Bauhaus in Weimar. In 1923 he organized a comprehensive exhibition of de Stijl art in Paris. That same year, under the name of J. K. Bonset, Van Doesburg participated in the Dada movement in Holland and helped publish a journal, *Mechano*. With the entry of new members such as El Lissitsky and Jean Arp into de Stijl, there was a relaxation and broadening of the original precepts, which led Mondrian to break with the group in 1925. By 1924 Van Doesburg coined the term "elementarism," and he explained its ideas in a manifesto in *De Stijl* in 1926 and later, in 1930, in a magazine, *Art concret*, which he published under the name Aldo Camini with Jean Hélion. In 1928 Van Doesburg collaborated with the Arps in designing L'Aubette, a restaurant in Strasbourg.

His art, like Mondrian's, developed from cubism. Limiting himself to primary colors, black, and white, and to horizontal and vertical rhythms, Van Doesburg sought to purge his art of all that was chance, personal, and fantastic. He sought an ethic that expressed honesty, clarity, discipline, purity, and constructiveness, an art that was self-sufficient and complete in itself and not an interpretation of something else. Unlike Mondrian, he did not employ a grid; and although by 1924 he used a freer geometry and made the diagonal an essential part of his art, his aesthetic philosophy remained fundamentally unchanged.

ROBERT REIFF

DOMELA (Domela-Nieuwenhuis), CESAR. Dutch sculptor and painter (1900–). He was born in Amsterdam and studied in Berlin and Switzerland. Domela began as a painter and exhibited abstract paintings with the Berlin November Group in 1923. In 1924 he went to Paris, where he met Van Doesburg and Mondrian and became a member of de Stijl. Domela's early geometric works are more close-

ly related to Van Doesburg's elementarism (in the use of the diagonal) than to Mondrian's more austere neoplasticism. By 1930, influenced by Gabo and Pevsner, Domela was making constructions in glass, metal, and other materials. He participated in the Cercle et Carré (1930), Abstraction-Création, and the Salon des Réalités Nouvelles. He has had many one-man shows in Paris for his sculptures, which have also been shown at the Municipal Museum (Stedelijk), Amsterdam. His works combine pure form with curvilinear suggestions of Art Nouveau, displaying highly finished surfaces in the metal and stone abstractions. His later sculptures, also nonobjective and composed of various substances, are of rhythmic, Arp-like, biomorphic shapes.

DONGEN, KEES VAN (Cornelius Theodorus Marie van Dongen). Dutch painter (1877–1968). He was born in Delfshaven. As an adolescent he painted and drew realistic works and was soon influenced by the French impressionists. In 1897 he settled in Paris and made sketches for several satirical papers. A habitué of Montmartre life, he responded enthusiastically to Fauvism, for he was a natural colorist. He juxtaposed tones in wide parallel bands with little concern for depth. His already brilliant style was perfectly suited to his vigorous sensualism, achieving richness with direct, simple, and concentrated means. Eager to experience sensations, Van Dongen cared little for drawing and composition. Typical of this period is *Reclining Nude* (1904–05), a daring work of colors contrasted to obtain the desired effect. Van Dongen was also a member of the German expressionist group Die Brücke.

At the end of World War I Van Dongen was the fashionable portraitist of Parisian society. He made few concessions to his sitters, neither flattering them nor concealing their physical or moral flaws. He created the "Van Dongen" type, the princess of the international set, thin, pallid, with red lips, scantily clad in transparent tulle and adorned with glittering jewels. Yet his vision remained that of a strong personality and an incomparable colorist. His interpretations of Anatole France, the Countess de Noailles (Amsterdam, Municipal Museum), and the politician Charles Rappoport are pitiless. Among his paintings of Parisian life is *Aux Champs-Elysées* (1920; private collection). He became a French citizen in 1929.

When Van Dongen turned to landscape, he painted for

pleasure, without artifice or any display of virtuosity, employing a few direct and telling forms reduced to the essential. Unfortunately, these moments of freedom were rare. ARNOLD ROSIN

DOVE, ARTHUR GARFIELD. American painter (b. Canandaigua, N.Y., 1880; d. Centerport, N.Y., 1946). After graduating from Cornell University in 1903 Dove became a magazine illustrator, a job at which he worked periodically until 1930, when the patronage of Duncan Phillips enabled him to become a full-time painter. In 1908 he went to France for almost two years.

At his first one-man show, in 1912 at Stieglitz's gallery, Dove exhibited the Paris-oriented canvases he had painted in Europe, but he also included ten abstract oils that he had done in 1910. They are like the first abstractions of Kandinsky, which were painted at almost exactly the same time. But Dove seldom used abstraction as an end in itself. His paintings are based on an image of reality, often a landscape or an aspect of the weather, purified of nonessential detail and composed on the picture surface, but always present. This is readily seen in his work up to 1920, for example, *Plant Forms* (1915; New York, Whitney Museum), in which simplified vegetable shapes plainly reveal their natural origin.

In the 1920s Dove became concerned less with arranging organic forms and more with the power of color and form to produce a visual equivalent to an experience or a feeling. *Fog Horns* (1929; private collection), with concentric circular shapes of resonant color set in a seascape, re-creates the dull sound of horns in a foggy harbor. To the same period belong Dove's constructions, witty arrangements of materials that represent a crystallization of a subject's personality or outstanding features.

Dove's later paintings became increasingly abstract and were often restricted to geometric forms. Even limited means, however, were sufficient for Dove to express his lyric delight in the oneness of man with the forces of nature. Though influenced by the synchromists in his color, Dove is almost unique in modern American art in his ability to fuse, consistently and successfully, an abstract mode of expression and a personal, nearly mystical, view of the world.

JEROME VIOLA

DRYSDALE, GEORGE RUSSELL. Australian regional painter (1912–). He was born in England, but received his early training at the George Bell School, in Melbourne. Later he studied in London and Paris. He is an outstanding and penetrating interpreter of the vast Australian outback and its inhabitants. His figures are highly stylized and elongated.

DUBLE, LU. American sculptor (1896–1970). Born in Oxford, England, Lu Duble studied at the Art Students League, the National Academy of Design, and the Cooper Union Art School, all in New York City. She also studied under Archipenko, De Creeft, and Hofmann. In 1937–38 she was awarded a Guggenheim Fellowship. She instructed at Bennett College in Greensboro, N.C., and at the Dalton School in New York.

DU BOIS, GUY PENE. American painter (b. Brooklyn, 1884; d. Boston, 1958). He was a student of Chase, Henri, and Miller and went to Paris in 1905 to study with Steinlen. On his return he wrote for various newspapers and magazines. Du Bois's early paintings were dark genre scenes in the realist Ashcan spirit. Gradually his figures became more tightly painted and assumed a solidly sculptural, simplified form, for example, *Opera Box* (1926; New York, Whitney Museum). His subject was the social life of the rich, which he treated satirically. In the 1930s he began to paint portraits and figures in an academic style. He wrote several monographs on American artists.

DUBUFFET, JEAN. French painter (1901–). A native of Le Havre, he went to Paris in 1928. He studied briefly at the Académie Julian but was mainly self-taught. Dubuffet developed a visionary approach to art. For several years he was forced to give up painting in order to provide for his family, and he became a wine dealer. He resumed his art in 1940, using extraordinary mixtures of ashes, sand, and cinders bound by a congealing thick varnish. The resultant clotted crust is engraved or incised with line. Dubuffet's style is called *l'art brut*, or "raw art;" and he consciously invents antiaesthetic, quasisurrealist images. Scrawls and childlike figures populate his brown-toned, densely pigmented compositions. Typical canvases are *Eyes*

Closed (1954; New York, Pierre Matisse Gallery) and *Paris Montparnasse* (1961; Paris, private collection).

Dubuffet in 1948 founded the Société de l'Art Brut and assembled hundreds of crude works by prisoners, fortunetellers, and the insane. He has been represented in one-man shows at the Galerie Rive Gauche and the Galerie Drouin in Paris, the Pierre Matisse Gallery and the Museum of Modern Art in New York, and elsewhere; and has exhibited at the Venice, Pittsburgh, and other major internationals. Dubuffet's art, impossible to classify precisely, relates to French *tachisme*, Dada-surrealism, and expressionism. JOHN C. GALLOWAY

DUCHAMP, MARCEL. French painter (1887–1968). He was born in Blainville, Normandy, and was the brother of the artists Suzanne Duchamp, Jacques Villon, and Raymond Duchamp-Villon. As a youth he attended school in Rouen. After moving to Paris, he worked as a librarian at the Bibliothèque Ste-Geneviève and, with some training at the Académie Julian, taught himself to paint. Duchamp's strongest early influence was Cézanne, as is revealed in such early canvases as *Chapel at Blainville* (1904) and *Portrait of the Artist's Father* (1910), both in the Philadelphia Museum of Art, Arensberg Collection.

A certain brilliance attended Duchamp's efforts from the very first; and a notable independence of intellect kept him from aligning himself totally with any programmatic movement. He and Francis Picabia, whose aims resembled his own, worked in 1911 and 1912 in a method closely related to analytic cubism. Duchamp's renowned *Nude Descending a Staircase II* (Arensberg Collection) also implies, although not distinctly, a connection with Italian futurism. In any case, his deeper purposes were antirepresentational, despite the fact that the titles of his works were meaningful to him and were often lettered on the picture surface.

By 1913 Duchamp was clearly prefiguring the Swiss-based Dada movement of 1916. His paintings became increasingly whimsical in character and sometimes depicted curious and useless machines (*Chocolate Grinder No. 1*, 1913); in 1915 and 1916 he arrived at the use of unconventional materials and techniques, as in *Water Mill within Glider* (Arensberg Collection), in which he used oil paint combined with wire on a lunette-shaped glass sheet.

Marcel Duchamp, *Bicycle Wheel* **(1951). Assemblage, 50½"
high. Museum of Modern Art, New York (Sidney and Harriet
Janis Collection).**

In 1916 Duchamp also created his astonishing "ready-
mades," satirically formed assemblages of such everyday
items as combs, shovels, balls of twine, and bicycle wheels.
This style, with notable variants and with occasional re-
gressions to compositions on glass (which he sometimes

cracked for special effects), continued into the early 1920s. He signed some works "Rrose Sélavy," a word play on "arroser c'est la vie" (to water, that's life).

Duchamp's personal and professional activities in connection with Dada and abstract art were central to the ultimate acceptance of both by a large audience. The *succès de scandale* of his *Nude Descending a Staircase* and its sale along with that of his other three entries in the controversial New York Armory Show of 1913 had prepared the way for Duchamp's visiting the United States two years later. With Man Ray, Picabia, and Alfred Stieglitz, Duchamp founded the review *291*, followed in 1917 by his journal *The Blind Man* and *Rong-Wrong*. He and Katherine S. Dreier founded the important Société Anonyme in New York in 1920, the year in which he exhibited his notorious *L.H.O.O.Q.*, the Mona Lisa with a mustache and beard. In those high days of Dada, Duchamp's verbal as well as painterly lucidity marked him as one of the international leaders of the movement, even while he remained a singularly independent personality.

True to his own Dadaist vow to annihilate painting, Duchamp in 1923 ceased working on his *Bride Stripped Bare by Her Bachelors, Even* (Philadelphia Museum of Art, Dreier Bequest) and turned to chess, writing a study of the game in 1926, and to experiments in optical theory and occasional organization of surrealist exhibitions and publications. Among these was a surrealist show, the 1947 International at the Galerie Maeght in Paris, where he designed two special rooms.

Duchamp had spent most of his life after 1915 in New York City. He was a constant influence upon younger artists, more because of his presence than because of his activities; and yet his existence long kept alive the unrestrictive, liberating tradition of Dada.

See also DADA.

JOHN C. GALLOWAY

DUCHAMP-VILLON, RAYMOND. French sculptor, cubist architect, and physician (b. Damville, 1876; d. Cannes, 1918). He was the brother of Jacques Villon and Marcel Duchamp. After studying medicine for three years, he became a sculptor in 1898. Exhibiting frequently in Paris salons, he joined with the cubists in 1912. His design for a cubist house dates from that year. His work was in the

New York Armory Show of 1913. During service in World War I he contracted blood poisoning and died.

The Museum of Modern Art, New York, owns a cast of his great *Horse* (1914) and *Lovers* (1913), the Yale University Art Gallery, New Haven, has *Seated Woman* (1914), and the Guggenheim Museum, New York, has *Cat* (1913). Duchamp-Villon was one of the first to evolve the modern sculptural metaphor.

DUFY, RAOUL. French painter and decorator (b. Le Havre, 1877; d. Forcalquier, Basses-Alpes, 1953). He studied art first in Le Havre. In 1892 he met Georges Braque and Othon Friesz, fellow art students. He admired Boudin and Delacroix. By 1900 he had gone to Paris to study at the Ecole des Beaux-Arts and felt the impact of the art of the impressionists, of Van Gogh, and of Cézanne. He exhibited for the first time at the Salon des Indépendants in 1903, and three years later he had his first one-man show. By 1904 he was painting harbor scenes

Raoul Dufy, *The Palm* (1923). Watercolor, 19¾" x 25". Museum of Modern Art, New York. Gift of Mrs. Saidie A. May.

in bright color in a manner that led him to join Matisse, Marquet, and Van Dongen as a Fauve. He was deeply impressed by *Luxe, Calme et Volupté* by Matisse, shown at the Salon d'Automne in 1905.

While living with Braque at L'Estaque in 1909, Dufy changed his style, and his palette became more somber. His painting at this time stemmed from late Cézanne and was related to the earliest phase of cubism. He began to make woodcuts as illustrations for books. In 1910 he printed some of these on dress fabrics. The brilliant colors printed on silks so delighted him that he abandoned his cubist manner and began to develop a fashionably decorative style to which he adhered for the rest of his life. Furthermore, he found a ready market for his fabric designs.

By 1920, however, Dufy had abandoned this profitable project and devoted himself completely to painting, drawing, and lithography. He traveled to Morocco and Venice, and lived much of the time on the French Riviera. He did many water colors. In 1936–37 he designed a mural painting (200 ft. by 32 ft.) on the theme of scientific progress for the Electricity Building for the Paris World's Fair. In 1952 he won first prize at the Venice Biennale. A large retrospective was given him in Paris in 1953.

In a sketchy manner, with fragmented brush strokes and flourishes of arabesques, Dufy depicted the carefree world of fashion, luxury, and pleasure. He painted resort centers, such as Nice and Trouville; spectacles, such as parades, horse races, and symphony concerts; and intimate corners of a music room or a studio. With disarming simplicity and yet with breadth and imagination he applied bright, rich color thinly on a white surface so it appeared as luminous as colored glass.

ROBERT REIFF

DURIEUX, CAROLINE. American lithographer and painter (1896–). Born in New Orleans, she studied at Newcomb College there as well as at Tulane University, Louisiana State University, and the Pennsylvania Academy of the Fine Arts under Henry McCarter and Arthur B. Carles. In Europe she studied lithographic printing methods at Desjobert's. Durieux has worked for extended periods in Havana, Mexico, and South America. In 1951, collab-

orating with Dr. Harry Wheeler of Louisiana State University and his wife Naomi, she began experimentation on the electron print, a method of reproducing drawings with inks containing radioactive isotopes. A further extension of this medium has led to color electron prints and color *cliché-verres*. Her works, often penetrating satires of the social scene, are in many public and private collections.

ECOLE DE PARIS. Group of foreign painters who settled in Paris after 1918 without becoming part of the then-current movement in French art. Marc Chagall, Moise Kisling, Amedeo Modigliani, and Julius Pascin were all members of the Ecole de Paris. The term is falsely applied to the whole artistic output in Paris at that time. *See* PARIS, SCHOOL OF.

EICHENBERG, FRITZ. American graphic artist (1901–). Born in Cologne, Germany, Eichenberg studied at the Kunstgewerbeschule in Cologne and the Akademie für Graphische Künste und Buchgewerbe in Leipzig. He worked as an illustrator in Germany and went to the United States in 1933. He has taught widely and in 1956 was made head of the graphic arts department of Pratt Institute in Brooklyn. Large collections of his works are owned by the New York Public Library, the Art Institute of Chicago, and several other institutions. In his commercial work and in the more than sixty books he has illustrated, his most effective medium is wood engraving. With a meticulous technique he has created vivid, if conservative, illustrations that achieve strong effects with tightly knit parallel cuts.

EIGHT, THE. Ultimately a part of the Ashcan school, The Eight was an association of American painters formed in protest against the monopoly that the National Academy held on aesthetic taste and exhibition space. The precipitating spark was the rejection by the 1907 Academy jury of a painting by George Luks, an act symptomatic of the official hostility toward newer tendencies in American art. The protest, which crystallized around the dynamic personality of Robert Henri, culminated in the first and

only exhibition of The Eight at the Macbeth Gallery in New York City in 1908. *See* HENRI, ROBERT; LUKS, GEORGE BENJAMIN.

The men who formed the core of the group around Henri, the ones whose realistic urban genre subjects provoked most of the public outcry, were George Luks, William Glackens, Everett Shinn, and John Sloan. They were originally newspaper artists, whom Henri had met in Philadelphia about 1891, before they moved to New York. Allied to these five by dissatisfaction with the Academy were the impressionist Ernest Lawson; Maurice B. Prendergast, technically the most advanced of all; and the gentle painter of romantic fantasies, Arthur B. Davies. What brought these varied men together was not a common style or technique, but simply a more free and open attitude toward painting than that forcefully advocated by the Academy. It is only against the background of the early-20th-century American art world that the work of The Eight could appear radical. In reality, their painting styles, with the exception of Prendergast, were *retardataire* by contemporary European standards. The most important influences on the early art of the realist members were Hals and Manet, seen through the work of Henri. *See* DAVIES, ARTHUR BOWEN; GLACKENS, WILLIAM JAMES; PRENDERGAST, MAURICE BRAZIL; SHINN, EVERETT; SLOAN, JOHN.

Because they took their subjects from the slums and from fringe elements of society, much was made, especially later, of the "social consciousness" of the realists. This, too, was more apparent than real, although it was the absence of the ideal and the all too strong presence of the immediately perceivable, but hitherto unpainted, city scenes that aroused the harshest criticism. Far from being social reformers, however, the realists were aiming only at a heightened artistic vitality. This meant the use of all possible subjects, with no arbitrary social distinctions. Despite these aims, the sentimentalism of the period is readily seen in many of their paintings. A few years after their exhibition, the eight painters, briefly united mostly by friendship, went their different aesthetic ways. However, they were subsequently absorbed into the larger grouping known as the Ashcan school, and their idea of independence and liberalism became a permanent theme in American artistic life. *See* ASHCAN SCHOOL. JEROME VIOLA

EILSHEMIUS, LOUIS MICHEL. American painter (b. near Newark, N.J., 1864; d. New York City, 1941). He was educated in Geneva and Dresden and at Cornell University. Eilshemius studied painting in New York from 1884 to 1886, at the Art Students League and with Robert L. Minor, and at the Académie Julian in Paris from 1886 to 1887. From 1888 until the early 1900s he traveled in Europe, Africa, the South Seas, and the southern United States. Eilshemius's career began in his twenties with the exhibition of his paintings at the National Academy of Design. This was the first, and only, recognition given him by the official art world during his lifetime.

Many of Eilshemius's early paintings were quiet, sensitively brushed landscapes, comparable in feeling to the Hudson River school in the United States or, in restrained massing of tonal values, to the Barbizon painters in France (for example, *Delaware Water Gap Village*, ca. 1886; New York, Metropolitan Museum). He was also skilled, however, in the evocation of mood through the figure, as in *Mother Bereft* (ca. 1888; Joseph H. Hirshhorn Collection). His native strain of visionary poetry began to appear toward the end of the century; the lack of recognition and the isolation which it caused only served to confirm Eilshemius in the practice of his personal theme: the dreamy and lyrical relationship of the human figure, particularly the female nude, to the surrounding landscape. The floating nymphs and the forest and stream of *Afternoon Wind* (1899; New York, Museum of Modern Art) are, in the relatively firm painting of forms, closer to his early style than to the soft, fluid touches of pigment which he later used.

Despite the contrary evidence of his thorough academic training, Eilshemius has often been called a "primitive" painter, presumably because of the seemingly naïve treatment of his subjects, as in *Figures in Landscape* (1906; New York, Whitney Museum), and his antinaturalistic distortions of anatomy and perspective, as in *Early American Story* (1908; Philadelphia Museum of Art). But the approach as well as the distortions must often be considered part of the attempt to produce a mood or an emotion: sad, as in *The Funeral* (1916, Newark Museum); eerie, as in *The Haunted House* (ca. 1917; Metropolitan Museum); or simply "poetic," as in *The Dream* (1917; Wash-

ington, D.C., Phillips Collection). Discovered for the avant-garde by Marcel Duchamp at the 1917 Independents' exhibition, Eilshemius was given one-man shows by the Société Anonyme in 1920 and 1924, although he had stopped painting about 1921.

JEROME VIOLA

EINFUHLUNG, see EMPATHY.

ELEMENTARISM, see DOESBURG, THEO VAN.

EMPATHY (Einfuhlung). Term coined by Edward Titchener in 1909 as a translation for the German aesthetic term *Einfühlung*, to convey the idea of the artist's projection of self into objects as a result of his response to imagery.

EPSTEIN, JACOB. British sculptor, illustrator, and watercolorist (b. New York City, 1880; d. England, 1959). His first art works were drawings made of people of the East Side of New York City, many of whom were actors. These were used as illustrations for a book on the East Side by N. Hapgood. Epstein studied at the Art Students League, in New York City, under George Grey Barnard while working in a bronze foundry in 1901. He went to Paris and attended the Ecole des Beaux-Arts from 1902 to 1906, where he worked under Thomas. He also attended the Académie Julian and received occasional criticism from J. P. Laurens. In 1906 he went to England, subsequently became a British citizen, and spent almost all of his life thereafter in that country.

In 1907 Epstein received the first of several important and highly controversial commissions, the Strand Sculpture series symbolizing the stages of life. These works were later destroyed. By 1908 he had begun to make portraits, first using his wife as his subject. In 1911 he was awarded the commission for a tomb for Oscar Wilde, and his sculpture created a scandal. In the same year he also met Henri Gaudier. He returned to Paris in 1912, where he met Brancusi and Modigliani, who briefly influenced his work (*Mother and Child*). Epstein's production of this time reflected his interest in primitive sculpture (*O Cursed Be the Day I Was Born*, 1912). He went back to England

in 1912, feeling that he could not work in Paris. In 1913 he executed *Rock Drill* (a result of his brief ardor for machinery), using as a model a pneumatic drill and a visored robot. After this work Epstein quickly recognized that his strength lay in portraits and figure sculpture. In 1917 he began his first statue of Christ; its portraitlike naturalism horrified the public. His many sculptures on religious themes include his most powerful works, *Visitation* (1926; London, National Gallery), *Genesis* (1931; A. C. Bossom Collection), *Behold the Man* (1935), *Consummatum est* (1937), and *Madonna and Child* (1927; a cast of this is in the cloister of the Riverside Church, New York City). His direct carving in stone differed from his modeling in its blockishness, hard angles, and archaic form, as in *Night* (1930), *St. James Park Station* (1932), and *Sun God* (1932).

It was as a reader of human character in portraits that Epstein made his greatest contribution. His brilliant series of busts includes *Bernard van Dieren* (1915–27), *Dolores* (1921–23), *The Ninth Duke of Marlborough* (1923–25; Blenheim), *Joseph Conrad* (1924), *Paul Robeson* (1928), *Einstein* (1933; London, Tate), and *Haile Selassie* (1936). His loosely textured, rhythmically modeled forms are imbued with great emotional power and physical strength. Epstein surmounted unbelievable critical adversity and helped to raise British sculpture out of mediocrity.

ALBERT ELSEN

ERNI, HANS. Swiss painter and graphic artist (1909–). Erni first studied in his native Lucerne and then at the Académie Julian in Paris and at the Berlin Academy. In 1930 he discovered the art of Picasso and Braque. He became part of the Abstraction-Création group in Paris in 1933 and painted for a while in a purely abstract style. During the early 1940s his art went through a rather literal surrealist phase. Most of his work since has been concerned with humanistic themes—with the contemporary issues of scientific advance, man in a technological society, racial prejudice, the struggles of underdeveloped countries, and the prevalence of war.

In treating such themes Erni has developed a wide range of media (oils, mosaic, fresco, lithography, ceramics), styles, and subject matter. Many murals in Switzerland and else-

where treat the human situation on a heroic scale with abiding optimism, as the *In Health There is Freedom* for the United Nations at the Brussels World's Fair (1958). The clinical realism with which figures and their surroundings are depicted follows in the tradition of Swiss 19th-century painting; it sometimes descends to sentimentality, especially in Erni's magazine illustrations and other commercial work. DONALD GODDARD

ERNST, JIMMY. American painter (1920–). Ernst was born in Cologne, Germany. The son of the surrealist painter Max Ernst, he received brief training in Germany in typography and graphics before going to the United States in 1938. Ernst's earlier abstractions depict linear structures set in an uncertainly lit, pulsating, ambiguous space, for example, *A Time for Fear* (1949; New York, Museum of Modern Art) and *Personal History* (1949; New York, Whitney Museum). For a while he experimented with similar forms painted in various tones and textures of black, as in *Blue and Black* (1956; Chicago, Art Institute). The linear structures have more recently become an irregular network, punctuated at points by areas of glowing color and at times hinting at an architectural image. In 1959 Ernst completed a large interior mural for the Continental Bank Building in Lincoln, Nebr.

ERNST, MAX. German painter and sculptor (1891–). Born in Brühl, near Cologne, he studied philosophy at Bonn University; he was self-taught as a painter. He exhibited at the first Herbstsalon in Berlin in 1913, and in 1914 visited Paris, where he met Jean Arp. In 1919 Ernst and Baargeld, joined by Arp, established the Dada movement in Cologne. Ernst was an early practitioner of collage and coeditor of Dada journals. In 1920 the police closed one of his special exhibitions. Ernst joined Tzara, Eluard, and others in Dadaist manifestations in the Tyrol.

Ernst joined the surrealists in 1924, exhibiting in their first major show at the Galerie Pierre, Paris, and in the same year created, with Joan Miró, the décor for *Romeo and Juliet*. A true innovator who demanded of himself new formal approaches for new ideas, Ernst grew tired of the orthodox, unimaginative style of the central group of surrealists and left the movement in 1938 (they were

Max Ernst, *Here Everything Is Still Floating* **(1920). Pasted photoengravings and pencil, 4⅛″ x 4⅞″. Museum of Modern Art, New York.**

to disclaim him, in turn, in the 1950s). He lived in the United States from 1941 to 1949, when he returned to Paris. In 1950 he had an important one-man show at the Galerie Drouin, and in 1954 he received first prize at the Venice Biennale.

Ernst has always met the challenge of both techniques and fantasy of theme. With Schwitters, he was one of the most imaginative practitioners of collage, and he was possibly the first artist to use *frottage,* or rubbings over textured surfaces. Among Ernst's most characteristic paintings, some of them distinctly surrealist in content and others essentially abstract, are *The Elephant of the Celebes* (1921; London, Penrose Collection), *Men Will Make Nothing of It* (1923; Penrose Collection), *Vision Evoked by a Night View of Porte Saint-Denis* (1927; Brussels, private collection), *The Whole City* (1937; Paris, private collection), *A Little Calm* (1939; artist's collection), and *Mother and Children on the Terrestrial Globe* (1953; Mannheim, Municipal Art Gallery). Ernst was among the most in-

ventive and prolific contributors to the development of both Dada and surrealism and is one of the most original members of those groups. *See* FROTTAGE.

ERNST AS SCULPTOR

An untitled carved object in wood, complete with bells, irrelevant additions of other kinds, and an attached hatchet, was one of the sensational three-dimensional works exhibited by Ernst at the renowned Cologne Dadaist show of 1920. This composite sculpture bore a list of instructions as to how to respond to it, one possibility being to attack it with the hatchet. Ernst's sculptures of the middle 1920s, especially those after he joined the surrealists in 1924, consist largely of combinations of plaster with cork, wood, and canvas; most of them are also painted.

While the playful tone of Dada never completely left Ernst's sculpture, an increasing attention to formal completeness and actual sculptural volumes and line occurred after about 1932. His *Oedipus* (1934, plaster; cast in bronze in 1960) and *Lady Bird* (*Femme Oiseau*, 1935; Houston, De Menil Collection) are examples of a serious plastic direction still bearing the wry stamp of Dadaist verbal satire. To this same phase belongs *Lunar Asparagus* (1935; New York, Museum of Modern Art).

Ernst worked frequently with sculpture during his sojourn in the United States between 1941 and 1949, his principal development being a continued and sensitive articulation of actual sculptural statement as distinguished from his earliest, verbally conditioned creations. While many American and European sculptors were exploiting the assemblage of "found objects" during the 1940s, Ernst conceived bronze figural pieces in which modeled forms resemble to some extent discarded materials. To this period belong *Moon Man* (New York, Slifka Collection), *The King Playing with the Queen* (New York, Museum of Modern Art), and *The Table Is Set* (Houston, De Menil Collection).

Ernst's sculpture has seen even more significant growth since his return to Europe in 1949. Disklike faces with radically simplified features, powerfully reduced, compressed volumes suggesting torsos, and schematically arcuated limbs project figural images in which formal, sculptural values clearly take precedence over any programmatic satire. *The Parisian Woman* (1950), *Are You Niniche?* (1956), *Daughter and Mother* and *Bosse-de-nage* (both 1959; New York,

Galerie Chalette) are bronzes of a strength and directness that compare most favorably with the quality of Ernst's painting of the same period. Among his recent works are *A Chinaman Fargone* and *The Spirit of the Bastille* (both 1960). JOHN C. GALLOWAY

EVERGOOD, PHILIP. American painter (1901–1973). He was born in New York City and lived in Southbury, Conn., from 1960. His father was a landscape artist. Evergood graduated from Eton in 1919, then studied with Henry Tonks in England, and, in 1923, with George Luks in the United States. He had his first one-man show in 1927. In 1931 he married Julia Cross, and in the same year went to Spain and discovered El Greco.

After 1932, reacting to the Depression, he featured themes of social protest, more as an affirmation of faith in humanity than as a call for political action. He combined the blunt, forthright character of a primitive in drawing with free fantasy in use of color and a sophistication in treatment of subject. He admired the art of Rowlandson, Hogarth, and Goya. He was given a retrospective exhibition in 1960 at the Whitney Museum of American Art in New York.

EXPRESSIONISM. Movement in early 20th-century art most clearly typified by the painting and graphic art of two German groups, the Bridge (Die Brücke), founded in Dresden in 1905, and the Blue Rider (Der Blaue Reiter), an outgrowth of the Munich New Artists' Association, dating from 1911. The term "expressionism" is much wider in application, however, and is often attached to the styles or individual paintings or sculptures by German artists even loosely affiliated with the two groups just mentioned. It has also been applied to the works of non-German artists (Rouault for example) whose methods denote one degree or another of similarity to the aesthetic of the Bridge or the Blue Rider. *See also* NEW OBJECTIVITY, THE.

The first German group to manifest an explicit style was the Bridge, organized by Ernst Ludwig Kirchner (1880–1938). His first associates, some of them like Kirchner studying architecture in Dresden, were Erich Heckel, Fritz Bleyl, and Karl Schmidt-Rottluff, soon joined by Emil Nolde, Max Pechstein, Cuno Amiet, and Axel Gallén.

Under the informal leadership of Kirchner, the Bridge artists first met to discuss the purposes and nature of their program: the appeal to all German (and, by extension, other) artists to join in revolt against vitiated academic painting and sculpture; to establish a new, vigorous aesthetic linked with the Germanic past but charged with modern emotion and form; and hence to form a "bridge" between artists and cogent spiritual sources. The Bridge artists first exhibited at an improvised gallery in a Dresden lamp factory in 1906, then in 1907 at the Richter Gallery. Two "Albums" were produced in those years, amounting to brief manifestos—the Bridge had no complicated program—in the form of woodcuts. A related document, *Chronik der Brücke*, was published by Kirchner in 1913. *See* AMIET, CUNO; HECKEL, ERICH; KIRCHNER, ERNST LUDWIG; NOLDE, EMIL; PECHSTEIN, MAX; SCHMIDT-ROTTLUFF, KARL. *See also* DONGEN, KEES VAN; MULLER, OTTO.

The second expressionist group, the Blue Rider, was headed by the Russian Wassily Kandinsky (1866–1944); since 1896 he had resided in Munich, first attending the Academy of Art, then in 1901 founding his own school and becoming prominent in artists' organizations including the Neue Künstlervereinigung (New Artists Federation), out of which the Blue Rider was formed in 1911. Kandinsky's associates included Franz Marc, Alexey von Jawlensky, Gabriele Münter, August Macke, and Heinrich Campendonk; and in the first Blue Rider exhibition on December 18, 1911, at the Thannhäuser Gallery, Munich, the Frenchmen Robert Delaunay and Henri Rousseau, the Austrian composer Arnold Schönberg, the Russian brothers David and Vladimir Burliuk, and a very few other artists were also represented. The second Blue Rider show, held in 1912 at the Goltz Gallery, Munich, added Paul Klee, Alfred Kubin, Natalie Gontcharova, Larionov, and several Parisians, including La Fresnaye, Braque, and Picasso. *See* CAMPENDONK, HEINRICH; JAWLENSKY, ALEXEY VON; KANDINSKY, WASSILY; KLEE, PAUL; KUBIN, ALFRED; MACKE, AUGUST; MARC, FRANZ; MUNTER, GABRIELE.

See also BARLACH, ERNST; BECKMANN, MAX; FEININGER, LYONEL; GROSZ, GEORGE; HOFER, CARL; KOKOSCHKA, OSKAR; KOLLWITZ, KATHE; LEHMBRUCK, WILHELM; MODERSOHN-BECKER, PAULA; ROHLFS, CHRISTIAN; SCHIELE, EGON. JOHN C. GALLOWAY

F

FACET CUBISM. The early phase of cubist art in which, through emphasis on the interplay of the planes, the visual effect of faceted jewels is produced. Facet cubism is seen in some works by Braque and Picasso.

FAUTRIER, JEAN. French abstract painter (1898–1964). He was born in Paris of parents from Béarn and brought up in England. He studied at the Royal Academy in London and at the Slade School. His first one-man show was held in Paris in 1927, and André Malraux helped him get a commission to illustrate Dante. During World War II he was active in the French Resistance, and while in hiding, over a period of two years, he painted *Hostages*, a series of abstractions, which was exhibited in 1945. In sympathy with the Hungarian freedom fighters, in 1956 he painted a triptych, *The Partisans*. In 1957 he was given a large retrospective exhibition at the Sidney Janis Gallery in New York and later exhibited widely. In 1960 he won the International prize for painting at the Venice Biennale.

Fautrier's art is linked with that of Wols, Michaux, Soulages, Hartung, and others in a broad movement called "Art Informel," which finds its ancestry in surrealism, Dada, and the art of Paul Klee. It features varieties of psychic improvisation and advances the aesthetic of irrational, lyrical abstractionism. In a characteristic work, Fautrier masses impasto, usually in broad, coarse strokes, as *haute pâté* with a palette knife. He surrounds this island of thick, clotted pigment with a band of a contrasting, thinly washed-on glaze. Gray and pale blue are predominating colors. These small works seem limited and austere, modest and yet forthright and bold. ROBERT REIFF

FAUVISM. First of the several avant-garde movements in art that appeared between the turn of the 20th century

and World War I. Although it was not launched as the result of a definitive program, Fauvism did possess certain collectively shared traits: brilliant, often pure color; rapidly brushed texture, patchlike or with spots of white canvas left bare; ostensibly improvised or random composition; and strongly subjective handling of themes or natural forms. In most Fauve pictures the space is flatly designated. Landscapes, figure compositions, portrait studies (usually informal in arrangement), and still lifes in this exciting style were abundantly created between 1903 and 1908, with 1905–07 being the high phase of Fauve maturation. After 1908 most of these artists developed in other directions, one or two of them turning to cubism, others retaining semblances of Fauvism but refining them (sometimes to less bold clichés of the earlier values).

The first exhibition at which they showed as a (still unnamed) group was the controversial Salon d'Automne held in Paris in 1905. Two such annuals had already been held, in 1903 and 1904; but although certain pre-Fauve painters had participated, their works had not been collectively shown in special rooms, and the full impact of the new style had not been received. By 1905, however, Henri Matisse (1869–1954) had become the leader of a loosely organized group whose turbulent, vividly hued pictures were placed together. The effect was shocking; the exhibition met with public hostility; it was then that the critics called the painters Fauves, or "wild beasts." With Matisse, the exhibitors included Georges Rouault, Othon Friesz, Albert Marquet, André Derain, Maurice Vlaminck, Henri Manguin, Louis Valtat, Kees van Dongen, Charles Camoin, Raoul Dufy, and Georges Braque.

The Fauvist movement has major importance in the history of early-20th-century art: first, for being the primary avant-garde manifestation among various revolutionary happenings in art before World War I; second, for its specific liberation of color and texture; and, finally, for synthesizing some of the formally significant aspects of postimpressionism and bringing them inextricably into the total aesthetic of modern painting. See BRAQUE, GEORGES; DERAIN, ANDRE; DONGEN, KEES VAN; DUFY, RAOUL; FRIESZ, ACHILLE EMILE OTHON; MARQUET, ALBERT; MATISSE, HENRI EMILE; PUY, JEAN; ROUAULT, GEORGES; VLAMINCK, MAURICE. JOHN C. GALLOWAY

Lyonel Feininger, *Ruin by the Sea* (1930). Oil on canvas, 27" x 43⅜". Museum of Modern Art, New York. Gift of Mrs. Julia Feininger, Mr. and Mrs. Richard K. Weil, and Mr. and Mrs. Ralph F. Colin.

FEININGER, LYONEL. American painter (1871–1956). Feininger became a student of music in New York in 1880; he was taken by his parents to Germany in 1887 to study the violin. Determined, however, to become an artist, he studied at the Hamburg Arts and Crafts School and at the Berlin Academy of Fine Arts (1890–91). In 1892 and 1893 he was in Paris and studied at the Académie Colarossi. Living in Berlin until 1906, he worked as an illustrator and cartoonist for German, French, and American journals and newspapers.

In 1911 he met Delaunay and other French cubists in Paris; and cubism, especially its Orphist manner, became a persistent influence upon Feininger's style (early documents of his development are the 1912 *Bicycle Riders*, the 1913 *Sidewheeler*, and the 1914 *Allée*). His prismatic, clear-cut sheafing of planes and his deft handling of light were strongly personal adaptations of Delaunay's more lyrical Orphist style. Feininger's early pictures, which anticipate the development of his whole career, also resemble characteristic works by the futurists and by Franz Marc in his semiabstract phase. Feininger exhibited with the Munich Blue Rider (Blaue Reiter) group and at the Berlin Herbstsalon in 1913.

He was appointed to the faculty of the Bauhaus at

Weimar in 1919 and remained with that school most of the time until, after it had moved to Dessau, it was closed by the German government in 1933. During that period he formed the Blue Four group with Kandinsky, Klee, and Jawlensky (formerly with the Blue Rider in Munich) and gave one-man shows at the Anderson Gallery in New York and the Berlin State Gallery. Outstanding works from this period are Feininger's *Viaduct* (1920) and *The Steamer Odin, II* (1927; both New York, Museum of Modern Art), *Church of the Minorites* (1926; Minneapolis, Walker Art Center), and *Towers at Halle* (1931; Cologne, Wallraf-Richartz Museum). He worked almost exclusively in water color and in graphic media from his earliest period.

Feininger resettled permanently in the United States in 1937, his work having been officially proscribed by the Nazi regime. He lived in New York and Connecticut, painting murals for the New York World's Fair in 1939 and holding a large retrospective show at the New York Museum of Modern Art in 1944. Feininger's style was brought to full maturation with water colors such as *Dawn* (1938; New York, Museum of Modern Art), *The River* (1940; Worcester Art Museum), and *Yacht* (1952; private collection). The last-named work reveals a new, although consistent, attention to looser handling of light and definition of major shapes. Additional important exhibitions of Feininger's works were held in 1950 at the Galerie Jeanne Bucher, Paris, and at Curt Valentin's, New York.

Feininger's major work belongs to the stream of development of French cubism and German abstraction. His style is notable for its delicacy and great finish.

JOHN C. GALLOWAY

FERBER, HERBERT. American sculptor (1906–). Born in New York City, he graduated in 1929 from Columbia University, where he had studied dentistry and oral surgery. From 1927 to 1930 he studied sculpture at the Beaux-Arts Institute of Design, New York City. He began to exhibit sculpture in 1930 at the National Academy of Design, Washington, D.C., and later had several one-man exhibitions. His ... *and the bush was not consumed* (1951) adorns the façade of the Millburn, N.J., synagogue. The Museum of Modern Art, New York, owns

Portrait of Jackson Pollock (1949); the Albright-Knox Gallery, Buffalo, owns *Green Sculpture II*; the Whitney Museum, New York, owns his *Sunwheel* (1956); and the collection of Mr. and Mrs. Victor Riesenfeld contains *Mercury* (1955). Ferber is one of the most inventive of the openwork sculptors in soldered metal. This inventiveness appears also in his space design and in his often aggressive shape formation.

FERREN, JOHN. American painter (1905–1970). Born in Pendleton, Ore., he lived in Europe from 1929 to 1938. He studied in Paris, Florence, and Spain and was at first interested in sculpture, which he left for painting about 1931. A certain sculptural interest is still apparent in the solidly modeled abstract shapes of his compositions from the late 1930s. In the 1940s Ferren painted figures in clean, bright colors and flat designs. His later abstractions, somewhat based on natural appearance, are open in formal structure and high in color, for example, *The Garden* (1954; New York, Whitney Museum). In Ferren's later paintings thick coiling lines of bright pigment are organized against rectangular fields of flat color.

FIENE, ERNEST. American painter and graphic artist (b. Eberfeld, Germany, 1894; d. Paris, 1965). After coming to the United States in 1912, he studied at the National Academy of Design and the Art Students League. He taught for many years in New York. His early works were strongly composed, realistic landscapes and urban subjects; he later showed a tendency toward abstraction in city scenes.

FIORE, ERNESTO DE. Italo-German sculptor (b. Rome, 1884; d. São Paulo, 1945). He studied painting at the Munich Academy (1903–04), and his painting was influenced by Hodler. The sculpture of Maillol attracted Fiore, and he turned to sculpture about 1910. He became a German citizen in 1914 and settled in Berlin. His characteristic works, although related to the aesthetic of Maillol in general interpretation, bear resemblance to the simplified, restrained expressionist forms of Gerhard Marcks and Georg Kolbe, as in the nude, *The Soldier* (1918; Hamburg). Fiore left Germany in 1936 for Brazil. His work was shown at the Venice Biennale in 1950.

FLANNAGAN, JOHN. American sculptor (b. Fargo, N. Dak., 1895; d. New York City, 1942). From 1914 to 1917 he studied painting at the Minneapolis Institute of Arts with Robert Koehler. He was a seaman from 1917 to 1922. Aided by Arthur B. Davies, Flannagan returned to painting and began wood carving, a medium he dropped in 1928. His work in stone began in 1926. Poverty caused him to use fieldstone. He made two visits to Ireland, in 1930 and in 1932–33. After 1934 he began to work in metal, showing at the Weyhe Gallery. The Museum of Modern Art, New York, owns *Triumph of the Egg* (1937) and *Dragon Motif* (1933). The Minneapolis Institute of Arts has his *Not Yet* (1940). Flannagan's strength was in direct stone carving of animals and birds and in his use of the theme of birth.

FONTANA, LUCIO. Italian painter (1899–1968). Fontana moved to Milan from his native Argentina in 1905 and later became a stoneworker there. It was only in 1927 that he began to study painting at the Brera Academy in Milan. From the beginning of his artistic career (1930) Fontana created abstract works that, in the traditional sense, are almost not art, in which shapes and scrawled incised lines appear as spontaneous gestures against roughly painted backgrounds. In 1934 he became part of the Abstraction-Création group in Paris. He spent the war years and some time thereafter (1939–46) in Argentina and at the end of that period issued his *White Manifesto*. It called for a new conception of art (Spazialismo), freed from the materialistic objectivity of the past, and enunciated the need for common cause with scientists in exploring new concepts and creating new materials for their expression. "Motion, evolution, and development" are the basic conditions of matter, and dynamism.

From this period on, Fontana's canvases appear as expanding voids of space, against which holes punched in the surface and shadow-casting projections create a strange spatial ambiguity suggesting infinity. This approach became regularized until 1951, when new irregular elements were added: knife slashes, swirling strokes of paint, larger jagged holes, and colored stones. He also began to get away from the restrictions of the picture format, creating sculptures and entire environments by using neon lights in otherwise black rooms. DONALD GODDARD

FOUGERON, ANDRE. French painter (1913–). Mainly a self-taught artist, he was born in Paris, where he took night courses during 1927–28. He executed small pieces of sculpture and colored lithographs and completed several large decorations, including one for the Students' Sanatorium in Hilaire-du-Touvet, Isère. His search for expressive form and color was similar to that of Pignon and Gischia, except that his style was more realistic. His art is related to some of Picasso's later strong figural canvases. Fougeron's *Les Parisiennes au marché* (1940), shown at the Salon d'Automne that year, was the point of departure for the French neorealistic-socialist school, and it is in this definite style that Fougeron has continued to work. In 1946 he was awarded the Prix National.

FOUJITA, TSOUGOHARU (Tsuguji Fujita). Japanese painter (1886–1968). Born in Tokyo, Foujita lived most of his life in Paris and became a naturalized citizen of France. Sharp, precisely drawn lines and a sensitive, poetic color harmony characterize his work, all of which is European in manner. There are examples in the National Museum of Modern Art in Paris.

FOUND OBJECTS, *see* Objets Trouves.

FRAENKEL, ITZHAK. Israeli painter and stage designer (1900–). Born in Odessa, U.S.S.R., he immigrated to Israel in 1919 after studies at the Odessa Art School and the Ecole des Beaux-Arts in Paris. The founder and director of the Art Academy in Safad, he has won numerous prizes in Israel and has had his work shown internationally, including at the Venice Biennale in 1948.

FRANCIS, SAM. American painter (1923–). Francis was born in San Mateo, Calif., and studied there with David Park and Clyfford Still. Francis has become one of the leading members of the second generation of abstract expressionists. Based in Paris since 1950, he has carried out mural commissions in Tokyo, Bern, New York, and elsewhere. From his better known paintings featuring an amorphous flow of soft forms, he has moved to more violent, centrifugal, and sparse works using acid colors.

FRANKENTHALER, HELEN. American painter (1928–). Frankenthaler lives in her native New York City. Early training with Tamayo at the Dalton School was followed by studies at Bennington College with Paul Feeley and at the Art Students League. Since her first contact with the art of Pollock and De Kooning in 1950, she has painted in an abstract style. In the early 1950s she innovated the staining technique, using thinned paints on unsized cotton duck, which has been taken up by Kenneth Noland, Morris Louis, and a number of other artists. In 1959 Frankenthaler had a one-man show at the Jewish Museum in New York and represented the United States at the São Paulo Bienal.

FRASCONI, ANTONIO. Uruguayan painter and printmaker of Italian parentage (1919–). Frasconi was born in Montevideo and attended the Escuela Industrial de la Construcción. He received formal art training at the Círculo de Bellas Artes in Montevideo, where he had his first one-man exhibition of drawings at the age of twenty-six. He came to the United States in 1945 on a scholarship to the Art Students League. In 1947 he won a second scholarship, to the New School for Social Research, New York City, where he studied under Kuniyoshi and Camilo Egas. Frasconi prefers to work on wood, and produces bold, dramatic compositions, both in color and black and white, some in series, such as *Some Well-known Fables* (1950). He has also done commercial illustrations.

FREUNDLICH, OTTO. German sculptor (1878–1943). He was born in Pomerania, Germany, and died in a Nazi concentration camp in Poland. He first studied art history under Wölfflin, then undertook sculpture in Munich, Florence, and Paris. Between 1910 and 1919 he exhibited in France, Cologne, Amsterdam, and Berlin. He lived in Paris, following visits to Germany, from 1924 until the late 1930s. He was given a retrospective showing at the Galerie Jeanne Bucher in Paris in 1938; by that time his style had become increasingly abstract. His art is notable for its independent assertion of abstract aesthetic, related to cubism and constructivism, and for occasional primitive influences (as in the *Monumental Head* of 1926, reminiscent of Easter Island stone images).

FREYSSINET, EUGENE. French bridge and highway engineer (1879–1962). His masterwork, and one of the important pieces of the century, was the airship hangars at Orly (1916; destroyed during World War II). The structures were a pioneering design of shell reinforced concrete made of folded parabolic arches, spaced apart to admit light, anticipating the work of Robert Maillart and Pier Luigi Nervi.

FRIESZ, ACHILLE EMILE OTHON. French painter and illustrator (b. Le Havre, 1879; d. Paris, 1949). He studied from 1896 to 1899 in Le Havre with Charles Lhullier, in whose classes he met Dufy and Braque. In 1899 he went to Paris, where he studied with Léon Bonnat at the Ecole des Beaux-Arts and with Gustave Moreau. In Moreau's studio he met Matisse, Marquet, and Rouault.

Until this time, Friesz was painting in a manner based upon impressionist style, but he was one of the earliest converts to the new pictorial and coloristic methods of Matisse and he exhibited in the Fauve Salon d'Automne in 1905. His Fauve works were composed of fluid, separated strokes, as in *La Fête foraine à Rouen* (1905; Montpellier, Fabre Museum). For Friesz, as for other artists of the group, the intense color and loose design of Fauvism was a phase through which he passed on the way to a more classical concern for architectural composition and firm spatial construction. The large and relatively darker canvas *Le Travail à l'automne* (1908; Oslo, National Gallery), with its stylized forms and decorative arabesques of figures and landscape, marks the transition to his new interests. Similar tendencies are evident in *Le Printemps* (1909; Fine Arts Museum of the City of Paris), although here the composition is derived from Matisse's *Joie de vivre*.

The natural influence on most of Friesz's post-Fauve paintings was Cézanne, as can be seen in the severe and simplified landscape forms of *Cassis* (1909; Zurich, Art Gallery). JEROME VIOLA

FROTTAGE. Semiautomatic technique by which patterns are made by placing paper or canvas on a figured surface, such as heavily grained wood, a rough fabric, or embossed ceramic tile, and then rubbing the paper or canvas with crayon, pencil, or a roller coated with paint to get an

impression. The surrealist Max Ernst developed the technique in 1925 and used it to make a series of drawings entitled *Natural History*. He was enchanted by the suggestions of images such as faces, clouds, and contours of distant hills and of the human figure to be found by studying these tracings of natural structures. Ernst composed several of these patterns on a single ground and gained further surprising effects through their juxtaposition.

FUJITA, TSUGUJI, *see* FOUJITA, TSOUGOHARU.

FULLER, BUCKMINSTER. American architectural theoretician (1895–). Born in Fulton, Mass., Fuller has applied his own system of geometry to the problems of mass shelter, thus producing revolutionary concepts of structure. He is noted for designs of highly efficient technologically based products, such as the dymaxion house and auto and the geodesic dome. His prefabricated, self-supporting domes, each made of a frame that is a network of aluminum tubes covered by a plastic membrane, are remarkably light (ca. 8¼ pounds per square yard). Of fragile appearance, they are quite resistant. They have been used for hangars, theaters, showrooms, gymnasiums, markets, factories, and offices. Prominent examples are the United States pavilion at Expo 67 in Montreal, Canada, the Alcoa branch office in Cleveland, Ohio, and the Union Dome in Baton Rouge, La. The Union Dome, made of folded and externally braced hexagons of steel sheet, is 384 feet in diameter (the world's largest). Except in the military field, Fuller's innovations have not been widely used; however, he has received many honors for his designs. Among these are the gold medal of the American Institute of Architects and, in 1968, the gold medal for architecture of the National Institute of Arts and Letters.

THEODORE M. BROWN

FUNCTIONALISM. Design concept or attitude in architecture, furniture, and other applied arts that stresses the practical use of the object in determining form. Functionalism is therefore opposed to ornate traditional forms in that even the choice of materials is affected by the object's function. Functionalism became prevalent in the first quarter of the 20th century.

FUTURISM. Italian movement in early modern painting and sculpture. It was announced in a manifesto written by the poet-critic Filippo Tommaso Marinetti and published on February 20, 1909, in the Parisian journal *Le Figaro*. Marinetti, projecting the explosive attitudes of a group of intellectuals and artists in Milan, Rome, and Florence, proclaimed the glories of speed, physical aggressiveness, war, and the modern machine; and, negatively, he decried Italy's lingering affinity with its past archaeological wonders and the tourism that was its chief cultural asset. Marinetti held that the *Victory of Samothrace* was less beautiful than a hurtling automobile, that violence should become in poetry what it was in a modern machine.

The 1909 manifesto was reinforced by an April, 1910, counterpart setting forth the technical manifesto of futurist painters. Its author, Umberto Boccioni, had become, with Marinetti, a leading strategist of early futurism. Boccioni also held one of the first significant one-man shows representing the movement (in Venice, 1910), although most of the pictures were in the Italian divisionist or neoimpressionist style and were not yet fully indicative of futurist connections with cubism. Boccioni's "Technical Manifesto" exhorted painters to interpret the "whirling life of steel" rather than imitate nature, to revolt against prevalent norms of good taste. Also signed by Luigi Russolo, Carlo Carrà, Gino Severini, and Giacomo Balla, this document declared the superiority of science and "universal dynamism" as the latter might be rendered in sensations of an antiharmonious mobility in paintings. *See* BALLA, GIACOMO; BOCCIONI, UMBERTO; CARRA, CARLO; RUSSOLO, LUIGI; SEVERINI, GINO. *See also* STELLA, JOSEPH.

JOHN C. GALLOWAY

G

GABO, NAUM. Russian-American sculptor, painter, and teacher (1890–). He was born in Brainsk, Russia. In 1910 he was a gymnasium graduate at Kursk and then became a medical student at the University of Munich. In 1911 he began the study of the natural sciences and in 1912 went to a Munich engineering school. In 1911–12 he attended the art history lectures of Heinrich Wölfflin in Munich. In 1912 he visited Venice and Florence. He returned to Moscow and saw the Shchoukin and Morosov collections of advanced art. When the war began in 1914 he went to Oslo, where his brother, Antoine Pevsner, joined him in 1916. In 1915 Gabo made his first constructions. *See* CONSTRUCTIVISM.

From 1917 to 1920 he was again in Russia, where he taught with Kandinsky, Tatlin, and Malevich at the Moscow School of Art. Reacting against the use of art as a political instrument, a practice championed by Tatlin and Rodchenko, Gabo and Pevsner published their *Realistic Manifesto* in Moscow during 1920. That same year Gabo had his first public exhibition and produced his *Kinetic Sculpture* as a demonstration of his ideas about movement. From 1922 until 1932 he lived in Berlin. With his brother he did stage sets for Diaghilev during 1926–27 and lectured at the Bauhaus in 1928. In 1931 he returned to architectural design in a theater project that he had begun in 1919, when he worked out ideas for radio stations in Russia.

From 1932 to 1935 he was in Paris and joined the Abstraction-Création group. He went to London in 1935, later editing the magazine *Circle* with Ben Nicholson and J. L. Martin. In 1936 Gabo's sculpture appeared in the New York Museum of Modern Art show "Cubism and Abstract Art." He went to the United States in 1938 and had several exhibitions. In 1939 he went to Cornwall, En-

Naum Gabo, *Spiral Theme* (1941). Construction in plastic, 5½"
x 13¼" x 9⅜". Museum of Modern Art, New York. Advisory
Committee Fund.

gland, and remained there until 1946. He joined the Design Research Unit in 1944.

In 1946 Gabo took up residence in the United States, and in 1953–54 he was a professor at the Harvard University Graduate School of Architecture. He did a number of architectural commissions, such as that for the U.S. Rubber Company, Rockefeller Center, New York City (1956). In 1957 he did his famous sculpture for the Bijenkorf Building, Rotterdam.

The Museum of Modern Art, New York, owns *Head of a Woman* (1916), *Column* (1923), and *Spiral Theme* (1941). The Guggenheim Museum, New York, has *Construction Space "Arch"* (1937) and *Variations of Spheric Theme* (1937). *Construction Suspended in Space* (1951–52) is in the Baltimore Museum of Art. Gabo gave to sculpture the feel and precision of modern science, effectively fusing art and its technological environment in materials invented in the 20th century. His transparent, light-catching forms gave a new elegance and aesthetic range to modern sculpture. ALBERT ELSEN

GARGALLO, PABLO. Spanish sculptor (b. Mailla, 1881; d. Reus, 1934). Gargallo studied drawing and sculpture in Barcelona. He first visited Paris in 1906 and on his second visit in 1911 saw Picasso's cubist paintings. He in turn introduced Picasso to metal sculpture. In 1914 he returned to Barcelona, and in 1917 he was appointed to teach at the Escuela Superior de Artes Oficios. He stayed there until 1923, when he returned to Paris.

His early sculpture was realistic—for example, the head of Picasso in stone (1912; Barcelona Museum)—but his style changed when he turned to ironwork. Examples are *The Prophet* (1933; Paris, National Museum of Modern Art), which is a perforated bronze figure of solids and voids, and the wrought-iron *Picador* (1928; New York, Museum of Modern Art).

Gargallo is important as one of the first sculptors of the 20th century to work in iron.

GARNIER, TONY. French architect (1867–1948). He worked in Lyons. He is best known for his Cité Industrielle project, which he designed while he was a *pensionnaire* at the French Academy in Rome. His later work reflects the progressive use of reinforced concrete and the paring away of superfluous ornament and the academic tinge of his early projects.

GATCH, LEE. American abstract painter (1902–68). Born near Baltimore, he studied with John Sloan and Leon Kroll in New York. In 1924 he went to France and studied with André Lhote and Moïse Kisling. He had his first one-man show at the New Art Circle, New York City, in 1927. His art was represented in the Venice Biennales of 1950 and 1956. In 1960 he was given a retrospective exhibition at the Whitney Museum of American Art in New York.

In the early 1930s his art was influenced by Paul Klee, who was then little known. Gatch painted small, semiabstract landscapes in which natural forms are reduced to geometric patterns without losing their organic character or the scenes their sense of light and atmosphere. Mystical, pantheistic overtones are implied. A series begun in 1960 combined flagstone with paint and collage.

GAUDI I CORNET, ANTONI. Spanish architect (b. near Reus, Catalonia, Spain, 1852; d. Barcelona, 1926). In the 1870s Gaudí associated himself with Juan Martorell, who admired French Gothic architecture. But Gaudí was neither a strict revivalist nor an advocate of the international school of the 1920s. All his life a fervid Catalonian nationalist, he evolved an extraordinarily personal style sometimes vaguely reminiscent of Mudejar architecture, sometimes of Art Nouveau. An apartment house, the Casa Milá (1905–14; Barcelona), with its undulating façade has been likened to the rocks of the Pyrenees.

No straight lines are apparent in the building; even many of the window areas show partial curves. The total effect of its complex composition of supporting elements suggests natural forms, such as caves and grottoes, while its balconies are covered with wrought iron strewn about like seaweed. The galleries of the Güell Park (1900–14; Barcelona) are reminiscent of a natural cavern: columns resembling stalagmites lean inward in places to support a bizarrely irregular vaulted roof.

Undoubtedly, Gaudí's masterpiece is the well-known but unfinished Church of the Sagrada Familia in Barcelona, on which he worked for many years, principally from 1903 to 1926. Although only the transept of this extraordinary building was completed, its exotic forms dominate Barcelona's skyline with their extravagant modulations, which may be compared with the slightly earlier Güell city mansion.

GIACOMETTI, ALBERTO. Swiss sculptor, painter, draftsman, and poet (b. Stampa, 1901; d. Chur, 1966). His first sculpture was done in 1914, and by 1916 he had begun his series of busts of Diego, his brother. In 1919 Giacometti attended the Geneva School of Arts and Crafts, working under Estoppey. He studied Italian painting, notably Tintoretto and Giotto, while in Italy (1920–22). It was then that he became interested in the immobility of archaic art. In 1922 he took up residence in Paris and for the next three years was a student of Bourdelle, whom he disliked. Giacometti continually drew in the museums from Chaldean and Egyptian sculpture and copied a Fayoum portrait.

About 1926 he left his academic style of sculpture for

Alberto Giacometti, *City Square* *(La Place;* 1948). **Bronze, 8½"
x 25⅜" x 17¼". Museum of Modern Art, New York.**

flat figural forms in idol-like and cubist formations. In
1926 he began his *Woman-Spoon* series. Toward the end
of the decade he came to look upon the figure not as a
closed mass but as a transparent construction. In 1929 he
joined the surrealists and became their leading sculptor.
He did his *Reclining Woman* in 1929, *Study for a Sur-
realist Cage* in 1930, *Palace at Four A.M.* in 1932–33
(New York, Museum of Modern Art), *Project for a Square*
in 1930–31, *The Phallic Embryo* in 1931–32, *Object Dif-
ficult to Throw* in 1931, and *Hands Holding the Void*
in 1934 (New York, W. Rubin Collection).

About 1935 he broke with the surrealists, feeling the
need to return to study from the human model, and did
both a cubist *Head* (1935; later destroyed) and a series of
portrait busts of Diego. He destroyed many of his figure
studies and exhibited none. He found that he kept reducing
the scale, detail, and volume of his forms so that they
became thin, attenuated, and increasingly fugitive in pro-
file. He was motivated by the truth of vision, rendering in
sculpture closer approximations of the way the human is
seen from a distance, or, as he put it, "trimming the fat
off of space." With these ideas was mingled his conviction
of an essential human isolation.

Following an accident in 1938, Giacometti was a patient
in a Geneva hospital and was thus permitted valuable time
for reflection on his art. During World War II he was

again in Geneva (1940–45), working from memory rather than from the model and developing his signature style of hermetic figures and busts. He continued to rework this style in Paris after the war, both in sculpture and in painting: *City Square* (1948), *Man Pointing* (both New York, Museum of Modern Art), and *Head of Diego* (Los Angeles, Brady Collection). Among the few themes of his art is the disembodied gesture, for example, *The Hand* (1947).

Giacometti was the strongest European sculptor working after World War II; his importance lies in the visual and philosophic richness of his work, the intensity of his drive to capture that which he felt constantly escaped his vision of the outer world, and the need to render the human in its entirety. ALBERT ELSEN

GIACOMETTI AS PAINTER

Although Giacometti began to paint and draw at an early age, most of his paintings date after 1947. Like his sculpture, they feature human beings who are perilously slender. They are shown standing erect, or beckoning, or striding. Often they appear to move, and then as if with a sense of purpose. He shows them singly and in groups. His portrait busts have decidedly recognizable gestures. His still-life paintings consist largely of clusters of dusty bottles, sculpture tools, and tin cans on a tabletop. The range of his subjects is thus limited. He shows figures in his paintings in a large, empty, cavernous room with a high ceiling. His palette is severely limited to warm grays, blacks, browns, and creamy whites. His paintings are essentially brush drawings. Giacometti has also made lithographs, which are close to his paintings and drawings in theme and conception. ROBERT REIFF

GILBERT, CASS. American architect (b. Ohio, 1858; d. 1934). Trained in St. Paul, Minn., and at the Massachusetts Institute of Technology, Gilbert worked briefly for McKim, Mead and White before returning to the Middle West, where he designed the classically styled Minnesota State Capitol (1896–1903). After moving to New York, he became a major architect of commercial, civic, and utilitarian buildings. In the West Street Building (1905) and the Woolworth Tower (1911–13), both in New York City, he pioneered in accommodating Gothic motifs to the skyscraper building.

A stylistic adapter rather than an innovator, and thorough-

ly competent in the use of eclectic detail, Gilbert was known for his sure sense of design. This is illustrated in the massive, block-square United States Customs House in New York (1901–07) with its Beaux-Arts mixture of Roman and Renaissance forms. He built the state capitols at Arkansas (1912) and West Virginia (1928–32), the United States Treasury Annex (1918), and the Supreme Court Building (1933–35), completed after his death.

MATTHEW E. BAIGELL

GILL, ERIC. English stone carver, engraver, typographer, and author (1884–1940). Typography and lettering were the major themes of Gill's versatile career. In addition to carving letters and painting signs, he designed ten new printing types, among them the well-known Perpetua; wrote an essay on typography; engraved much for the Golden Cockerel Press; and masterfully illustrated the Gospels and other works. As a sculptor, he worked mainly in low relief but also executed figures in the round. The Stations of the Cross, Westminster Cathedral (1918), the wooden altarpiece at Rossal School Chapel, the figures on Broadcasting House, and the giant torso *Mankind*, now in the Tate Gallery, London, are among his finest achievements.

GISCHIA, LEON. French painter (1904–). Gischia was born in Dax. After advanced studies in the history of art and archaeology, he studied art under Friesz and Léger, and in 1926 he visited Spain, Italy, and the United States. In collaboration with Léger and Le Corbusier he decorated the Pavillon des Temps Nouveaux for the 1937 Universal Exposition.

Gischia excels in theater décor and has worked extensively for Jean Vilar and his Théâtre National Populaire. He participated in the foundation of the Salon de Mai (1944) and is a regular exhibitor. His color is decorative and flat with overlapping perspective, as in *The Canvases* (1944). Gischia has written two essays: *La Sculpture en France depuis Rodin* and *Arts primitifs*. A lucid creator of impeccable still lifes, he skillfully combines the lesson of Matisse and that of Léger.

GLACKENS, WILLIAM JAMES. American painter and illustrator (b. Philadelphia, Pa., 1870; d. Westport, Conn.,

1938). He studied at the Pennsylvania Academy of Fine Arts while he worked as an illustrator for the *Record*, the *Press*, and the *Public Ledger* in Philadephia. As a newspaper artist, he met Henri, Sloan, Shinn, and Luks, the most important realist members of the future group, The Eight, which exhibited in New York in 1908. In 1895 Glackens went to Paris, where he remained for over a year. On his return he worked as an illustrator and cartoonist for magazines and New York newspapers. In 1898 he was sent to cover the fighting in Cuba by *McClure's Magazine*, and in 1906 he traveled in France and Spain.

Glackens was only briefly involved with Ashcan-school subjects, which he painted with a humorous approach. He soon left the slums as subject matter for more fashionable scenes of holiday activities, although the depiction of the lower classes had a somewhat longer life in his skillfully observed drawings, such as *Washington Square* (*A Holiday in the Park*, 1914; New York, Museum of Modern Art), where he effectively caught movement and gesture.

Glackens's early works were richly painted and relatively dark in tonality, under the influence of Henri and Manet (for example, *Luxembourg Gardens*, 1904; Washington, D.C., Corcoran Gallery). In subject and in the treatment of the figures and still life, the debt to Manet is obvious in *Chez Mouquin* (1905; Art Institute of Chicago). But Glackens's travel in France had introduced him to impressionism and especially to the light and palette of Renoir. *Nude with an Apple* (1910; Brooklyn Museum) immediately recalls Manet's *Olympia* in pose, but the technical sources are Renoir's brushwork and color. The influence of Renoir was to grow until at times it almost overwhelmed Glackens's individuality, although his colors were seldom quite as hot or his forms quite as full as those of his master. Occasionally, in his later paintings, he more successfully fused his own artistic personality with Renoir's technique, in figures, such as the painting of the girl on a donkey called *Promenade* (1926; Detroit Institute of Arts), or in landscapes, such as *Vence* (1930; New York, Whitney Museum). JEROME VIOLA

GLARNER, FRITZ. American abstract painter (1899–1972). He was born in Zurich, Switzerland, lived as a child in France and Italy, and then lived in New York City. From 1914 to 1920 he studied at the Royal Institute of Fine Arts

in Naples, and, from 1924 to 1926, at the Colarossi Academy in Paris. He had his first one-man exhibition in Paris in 1928. By 1933 he had turned from representational painting that showed the influence of impressionism to abstraction, and he became a member of the Abstraction-Création group.

Glarner called his own work "relational." It is a late development of neoplasticism. Like Mondrian (whom he met in 1943), Glarner limits himself to primary colors, black, white, and gray. He also works for an equivalence of the flat area. He develops planar relationships by introducing the slant or oblique, thus making areas trapezoidal, and frequently composes within a circular format, or *tondo*.

GLASCO, JOSEPH. American abstract and figure painter (1925–). He was born in Pauls Valley, Okla., and now lives in Taos, N. Mex. He studied briefly with Rico Lebrun, in Mexico City, and in New York, and has traveled in Europe. He was included in the Whitney Museum's 1955 show "The New Decade." He frequently composes figures of, or places them before, textured areas resembling richly grained wood or coarse tweed.

GLEIZES, ALBERT. French painter (b. Paris, 1881; d. Avignon, 1953). Gleizes was both a painter and a writer, and he was inextricably linked with the evolution of cubism as a leading theoretician and exponent. His early work (1901) was influenced by impressionism, but beginning in 1906 he sought a simplification of color which reflected his ardent desire to simplify form. He naturally turned to cubism, for it responded to his needs, and in 1910 exhibited at the Salon des Indépendants (*L'Arbre*). In 1911 he was one of the exhibitors in the celebrated Cubist Room in the Salon des Indépendants. At the Salon d'Automne of the same year his *Portrait de Nayral* had a *succès de scandale*. Gleizes belonged to the Section d'Or group headed by Jacques Villon, which often met at his studio or in Puteaux, where Villon lived. In 1912 Gleizes (together with Metzinger) published *Du cubisme*, the most important book at that time on the cubist movement and one which constituted a veritable manifesto.

Gleizes traveled extensively; he went to the United States, where he experienced a religious revelation. Henceforth his artistic researches, while still faithful to cubist prin-

ciples, were influenced by his profound religious interests. He had exhibited in Moscow and Barcelona and at the famous New York Armory Show of 1913. After his visit to the United States he continued his experiments and in 1923 outlined them in *La Peinture et ses lois*. He proclaimed the impending return of the Christian era and endeavored to develop an objective technique easily transmissible as a means of praising God. In 1932 he published *Homocentricisme ou retour à l'homme chrétien* and *Forme et histoire*, a vast work showing the superiority of an art based on religious thought and expressed by symbolic rhythms. From 1939 on Gleizes lived in retirement at Saint-Rémy-de-Provence, exerting in his writings and lectures as well as in his paintings a marked influence on those young artists of the Rhone Valley separated from Paris.

ARNOLD ROSIN

GLICENSTEIN, ENRICO. Polish sculptor (b. Turek, 1870; d. New York City, 1942). After traveling through Europe Glicenstein, at nineteen, entered the academy in Munich. He was awarded the Prix de Rome for his statue *Aryon* and settled in Rome until 1928, when he moved to the United States. Early recognition was accorded Glicenstein by Rodin, who invited him to exhibit in the Salon of 1906 and requested that their works be shown together in the central rotunda of the Grand Palais. Important one-man shows were given him at the Venice Biennale (1926), the Chicago Art Institute (1929), the Palais des Beaux-Arts, Brussels (1932), and the Petit Palais, Paris (1948).

Although Glicenstein was aloof from the movements of modern art, his work exhibits the vitality of engagement. He worked primarily in wood and stone, and his figures from the beginning retain the form of the block.

GLINSKY, VINCENT. American sculptor (1895–). Born near Leningrad, Glinsky received his education in New York City at Columbia University, the City College of New York, and the Beaux-Arts Institute of Design. His first one-man show took place in Paris in 1929. He has since had a number of exhibitions and shows yearly as a member in the Sculptors Guild Exhibition in New York City. He has received awards from the Guggenheim Foundation (1935), the Pennsylvania Academy of Fine Arts

(1948), and the Architectural League of New York (1956), among others. His studies of nude figures are conceived in icy sensuality, emphasizing large forms and sweeping, elegant lines.

GOERG, EDOUARD. French painter (1893–). Born in Sydney, Australia, Goerg went to France at the age of seven. In 1912 he enrolled at the Académie Ranson, where Maurice Denis was teaching; he had his first exhibition in 1924. His art has always been inspired by realism. Goerg greatly admires Goya, Daumier, and Rouault, but unlike them he has accentuated the sentimental, condemning genuine plastic emotions in favor of the anecdotal.

His work soon fell into a kind of soft realism, characterized by the representation of nude, barely adolescent young girls, often accompanied by men in evening clothes, all enveloped in a shadowy atmosphere relieved only by conventional gleams of light. Goerg takes his subject matter from the life around him with no attempt at social realism or at a portrayal of the tragic element as seen in Goya and Rouault, being content to represent people, mostly women and girls, as he sees them (*Les Modèles*, 1954; Mme Goerg Collection; *Le Gourmet*, Art Institute of Chicago; *La jolie fille du bar*, Charles Jacquemart Collection).

ARNOLD ROSIN

GOITIA, FRANCISCO. Mexican painter (1882–). Born in Patillos, Zacatecas, Goitia went to Mexico City in 1898 and for five years attended the Bellas Artes School. He traveled to Europe in 1904, and studied in Barcelona for four years with Francisco Gali. He also spent four years in Italy. On his return to Mexico in 1912, he lived in Zacatecas for six years and came to Mexico City again in 1918. At that time he began working with Gamio on the archaeology of the Teotihuacán Valley and Oaxaca. From a variety of conservative, technically sophisticated early works, Goitia moved into social painting of high aesthetic interest. Distilling a rich Indian and mestizo background, he painted a number of masterful works in thick oil impasto, including the famous *Tata Jesucristo* of 1927, an archetype of human bereavement.

GOLUB, LEON. American painter (1922–). Golub studied with Paul Wieghardt at the Art Institute School in his native Chicago. He has lived in Italy (1956–57) and Paris (1959–64) and now lives in New York City. The colossal figures in his paintings, sometimes drawn from ancient Greek statuary, often have the brutalized power of late Roman art.

GONZALEZ, JULIO. Spanish sculptor (b. Barcelona, 1876; d. Arceuil, near Paris, 1942). He learned metalwork from his father and first exhibited in 1893. He studied painting at the Barcelona Art Academy from 1892 to 1898. In 1900 he went to Paris and met Picasso. Except for sculpture made between 1910 and 1912, he worked as a painter until 1926, when he decided to devote himself to sculpture. Between 1930 and 1931 he instructed Picasso in metalwork and joined the constructivist Circle and Square group. His most imaginative constructs in iron date from the 1930s and strongly influenced metal sculptors such as the American David Smith. He worked more naturalistically in iron and plaster from the late 1930s until his death. The Museum of Modern Art, New York, owns *Standing Figure* (1932), *Head* (1934), and *Woman Combing Her Hair* (1936). González developed the idea of metal sculpture as drawing in space and of forming by free association. He gave an unprecedented range and power to sculpture in iron.

GOODHUE, BERTRAM GROSVENOR. American architect (b. Pomfret, Conn., 1869; d. 1924). Trained under James Renwick between 1884 and 1890, he joined the Boston firm of Cram and Wentworth, becoming a partner in 1899 under Cram, Goodhue, and Ferguson. While a partner, he was responsible for the interior of St. Thomas's Church in New York (1906), considered his finest ecclesiastical interior. Though an ardent Gothicist, after he left the firm in 1914 he helped initiate the Spanish colonial revival in California, particularly with his ornate designs for the San Diego Exposition of 1915. In his skyscraper Nebraska State Capitol (1922), he sought an American style, but in the buildings of this period an eclectic semi-modernism obtained, in which smoother wall surfaces appeared and Gothic detail was shaved clean.

GOODMAN, PERCIVAL. American architect (1904–). He was born in New York City. Noteworthy as a synagogue architect, Goodman designed Temple Beth El in Springfield, Mass. (1953), Temple Beth El in Providence, R.I. (1954), and Temple Beth Shalom in Miami Beach, Fla. (1955). Works by Motherwell, Lassaw, and Lipton decorate Goodman's structures.

GOODWIN, PHILIP LIPPINCOTT. American architect (1885–1957). Born in New York City, he was educated at Yale University and the Columbia School of Architecture (1909–12). Goodwin also studied architecture in Paris (1912–14). After working for Delano and Aldrich (1914–16) and becoming a partner with Bullard and Woolsey, he formed his own office in 1921. He collaborated with Edward Durrell Stone on the design of the Museum of Modern Art in 1939, traveled to Brazil in 1942, and wrote *Brazil Builds* in 1943.

GORKY, ARSHILE. American painter (b. Tiflis, Russia, 1904; d. Sherman, Conn., 1948). A major American abstract artist, Gorky went to the United States in 1920, following two years' study at the Polytechnic Institute in Tiflis, and enrolled as an engineering student at Brown University, Providence, R.I. In 1925 he settled in New York, where he studied briefly at the National Academy of Design and taught at the Grand Central School (1926–32).

Influenced by neoclassicism in the late 1920s, Gorky found inspiration in Picasso's contemporary style during the 1930s, producing cubist still lifes with strong definition and bright colors. His first one-man show was at the Guild Art Gallery, New York, in 1932. During the late 1930s Gorky continued to work under the inspiration of cubism but added the formal devices of Miró. He shared a studio with Willem de Kooning in the early 1940s and the two men interchanged ideas; De Kooning has expressed a debt to Gorky, but the influence was certainly mutual. Another meaningful relationship was that with Stuart Davis, ten years Gorky's senior and an early practitioner of abstraction by way of cubism. It is also probable that Gorky was stimulated to a certain degree by Kandinsky's 1910–13 "biomorphic" abstractions.

These various sources were resolved in Gorky's style shortly after 1940, and by 1943 he was a major figure in

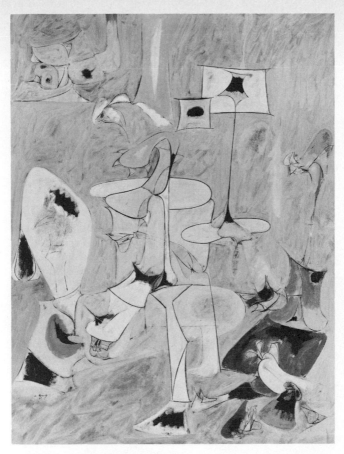

Arshile Gorky, *The Betrothal, II* (1947). Oil on canvas, 50¾″ x 38″. Whitney Museum of American Art, New York.

American abstract expressionist painting. His *Waterfall* (1943), with its fluid, organic shapes and rapid linear accents, is typical of his mature style. The highly personal fantasy of Gorky's imagery led André Breton to classify him as a surrealist, and his last works suggest the indirect influence of Matta's surrealist abstractions.

Among Gorky's finest, most inventive canvases of the 1943–47 phase are *The Liver Is the Cock's Comb, Diary of a Seducer, Making the Calendar*, and *Agony*. These

paintings are remarkably tense and eloquent because of their whipping, cursive line and free spottings of delicate, fluidly handled color. Gorky was represented by one-man shows after 1945 at the Julien Levy Gallery, the Kootz Gallery (1950), the Whitney Museum of American Art (1951), the Martha Jackson Gallery (1954), and the Sidney Janis Gallery (1955). JOHN C. GALLOWAY

GOTTLIEB, ADOLPH. American painter (1903–1974). Born in New York, he studied at the Art Students League from 1919 to 1921 with Robert Henri and John Sloan and at the Parsons School of Design in 1923. Gottlieb's first one-man show was at the Dudensing Galleries, New York, in 1930. In 1947 and in the 1950s he had one-man shows at the Kootz Gallery. He was also represented in many important annuals and international exhibitions, including the Whitney Museum of American Art's "The New Decade," 1955, and the Tokyo International of that year; the 1958 and the 1961 Carnegie International, in which he took a prize; the 1961 Whitney Museum Annual; and the 1963 São Paulo Bienal, at which he won a grand prize.

Gottlieb at first worked in an essentially naturalistic style. In the early 1940s he developed his pictographic semiabstract method with compartmented silhouettes and arcane symbols, combining flatly painted shapes and linear enclosures. His 1946 *Voyager's Return* (New York, Museum of Modern Art) is characteristic. Gottlieb changed in the early 1950s to a fully abstract-expressionist idiom (*The Frozen Sounds 1*, 1951; New York, Whitney Museum) and subsequently became a leading action stylist (*Ascent*, 1958, and *Counterpoise*, 1959; both East Hampton, N.Y., Mrs. Adolph Gottlieb Collection).

JOHN C. GALLOWAY

GRANT, DUNCAN. Scottish painter and designer (1885–). Born in Rothiemurchus, he visited Italy and in 1906 studied with Jacques-Emile Blanche in Paris. Grant was greatly affected by Roger Fry's 1910 London exhibition of postimpressionists, and for several years his paintings reflected their immediate influence as well as that of Matisse and Picasso. In 1913 he designed pottery, furniture, and fabrics for Fry's Omega Workshops, and he was active as a room decorator in the early 1920s. Even in

his later decorative panels Grant always retains some of the feeling for volume and mass evidenced in the *Still Life* (ca. 1912) in the Courtauld Institute of Art, London.

GRAVES, MORRIS. American painter (1910–). Born in Fox Valley, Ore., he now lives in Seattle. From 1928 to 1930 Graves traveled in Japan and China. Mainly self-taught as a painter, he was influenced by Mark Tobey early in his career. He worked with the Federal Art Project in the 1930s and won first prize at the Northwest Annual Exhibition of the Seattle Art Museum in 1933. His first one-man show, at the Seattle Art Museum, was in 1936. In 1938–39 Graves traveled in Europe, and from 1942 to 1945 he served in the Armed Forces. He received a Guggenheim fellowship in 1946, and won first prize at the Art Institute of Chicago in 1948 and a University of Illinois purchase prize in 1955. Graves has had one-man shows in Oslo (1955) and at the Whitney Museum of American Art, New York (1956). He again traveled to the Orient in 1956, when he also visited Ireland.

A serious student of Oriental religion, Graves has long been deeply influenced in his iconography and to some extent in his style by Eastern philosophy. His 1938–40 gouaches, such as *Bird Singing in the Moonlight* and *Blind Bird* (both New York, Museum of Modern Art), are characteristic of his earlier style. The *Flight of Plover* (1955; Whitney Museum) is more nearly abstract; and his pictures of the 1960s, which show an almost completely nonfigurative aesthetic, are less manifestly Oriental in quality.

JOHN C. GALLOWAY

GRECO, EMILIO. Italian sculptor (1913–). Born in Catania, he began exhibiting in Rome in 1933. His early work consists mainly of portraits, but he has since turned to the female nude as his primary mode of expression. His work manifests a lyrical classicism verging, at times, on mannerism, but embodying a sense of fantasy and removal in the elongated linear movements of his figures.

GREENBAUM, DOROTHEA. American sculptor (1893–). Her two best-known works, both in marble and both in the collection of the Whitney Museum of American Art in New York, are *Drowned Girl* (1950) and

Girl with a Towel (1943). Her style is naturalistic with impressionist overtones. Regardless of medium, Dorothea Greenbaum's sculpture reveals a personal application of modeling technique.

GREENE, BALCOMB. American abstract and figurative painter (1904–). He was born in Niagara Falls, N.Y. He was graduated from Syracuse University in 1926 and then studied psychology in Vienna. Greene first began to paint seriously in 1931 and is largely self-taught. He was first chairman of the American Abstract Artists in 1936. In 1939 he executed a mural for the New York World's Fair.

Greene had his first one-man show in 1947 and was given a retrospective exhibition in 1961 at the Whitney Museum of American Art, New York. Starkly geometric abstractions composed of clean-edged, tilting planes were abandoned in 1948 for studies of human figures, which appear transfixed and immobilized by some unnatural light that erodes and disintegrates their flesh.

GREENE, STEPHEN. American painter (1918–). Born in New York City, Greene began studying painting at the Art Students League (1936–37) and later attended the State University of Iowa, where he was a pupil of Philip Guston. The first one-man exhibition of his work was held at Durlacher Brothers in New York in 1947, and subsequent shows were held there in 1949 and 1952; he was also given one-man shows at the Grace Borgenicht Gallery (1955, 1957, and 1958) and at the Staempfli Gallery (1961 and 1964). The last mentioned was the final stop of a retrospective exhibition which had originally opened at the Corcoran Gallery, in Washington, D.C., in 1963.

His work is in the Metropolitan Museum of Art and the Whitney Museum in New York, the Tate Gallery in London, and other museums. Greene's art is personal and expressionistic in its themes; it has evolved from a precise, linear figurative style to one of progressively free, symbolic abstraction.

GRIS, JUAN (Jose Victoriano Gonzalez). Spanish painter (b. Madrid, 1887; d. Paris, 1927). Working in France with

Juan Gris, *Fruit Dish, Glass and Newspaper* (1916). Oil on wood, 21⅝" x 15". Museum of Modern Art, New York. Gift of Abby Aldrich Rockefeller.

Picasso, Braque, and others, Gris became one of the outstanding contributors to cubism. He studied in 1902 at the Madrid School of Arts and Crafts and in 1904 came under the influences of Art Nouveau and Jugendstil. The pseudonym "Juan Gris" was taken in that year. He studied briefly with the academic painter Carbonero in Madrid in

1906 and then went to Paris. Between 1906 and 1910 Gris worked for the journal *Le Charivari* and as a freelance illustrator and designer. He became a friend of Picasso, Max Jacob, André Salmon, Maurice Raynal, Daniel-Henry Kahnweiler, and Gertrude and Leo Stein.

Gris's first significant paintings appeared in 1910; but his assimilation and personalization of the cubist aesthetic was rapid and brilliant. From the time of his 1911 *The Book* and 1912 *Banjo and Glasses* (Paris, Galerie Louise Leiris) he proceeded to form a lucid and severe style even more programmatic than that of Picasso and Braque. He was one of the most inventive practitioners of *papiers collés* (*The Table*, 1915; Philadelphia Museum of Art). See PAPIERS COLLES.

Following his severely structured, quietly colored canvases of 1911–12 and the imaginatively textured works of 1913–15, he began an "architectural" phase about 1916. He composed with fewer fragmentations and overlappings of smaller units, broadening his sharp-edged planes into strongly vertical forms. *The Harlequin* (Chicago, private collection) and *The Guitar Player* (Paris, private collection) are typical of this style, which, with interesting variations, such as opposition of strongly geometric regularity by occasional free curves, obtained until Gris's death.

Gris was widely respected among Parisian artists and critics. In 1924 he lectured at the Sorbonne on his method, which, he insisted, began with the abstract and ended with the concrete, progressing, for example, from the idea of a cylinder to the image of a bottle. He remained throughout his brief life a bona fide cubist. He was represented in the major cubist exhibitions of 1912 and was given large retrospectives by Kahnweiler and Rosenberg. He also designed sets for many ballets and operas and was a prolific book illustrator. JOHN C. GALLOWAY

GROMAIRE, MARCEL. French painter (1892–1971). A native of Noyelles-sur-Sambre, Gromaire at the age of eleven decided to devote himself entirely to painting. Although he took courses in law, he soon abandoned them and began to frequent the different academies in Montparnasse (Colarossi, Ranson, La Palette). He met Matisse's pupils from the short-lived academy which had just been closed. An opponent of theories, Gromaire has remained

outside all schools of painting, acknowledging only the influence of Matisse as draftsman.

Gromaire visited Belgium and Holland and spent some time in Germany and England. His principal artistic formation was derived from the French Gothic and Romanesque, the Flemish and French primitives, Brueghel, the impressionists, Cézanne, and Seurat. His art, however, has generally followed an expressionism far removed from the often pathological form of Scandinavian and German expressionism. After World War I his palette became more somber, his subject matter inspired by peasants and workers (*Les Musiciens mendiants*, 1919; *La Gare*, 1922; *La Loterie foraine*, 1923). Avoiding naturalistic expression, he achieved a great decorative quality.

In 1925 he exhibited his celebrated canvas *La Guerre* at the Salon des Indépendants. In this work he made his art conform to strict rules of composition. Excluding the picturesque and scorning the anecdotal, Gromaire envisioned a rigorously exalted, monumental universe. In 1933 an important exhibition of his work took place at the Kunsthalle, Basel. He was commissioned to decorate the façade of the Pavillon de Sèvres at the International Exposition of 1937. In 1939, together with Lurçat and Dubreuil, Gromaire initiated a movement in favor of a tapestry renaissance (*The Four Elements*; *The Four Seasons*). His colors, adapted to a necessary synthesis, are purposely sober, heavy, and dramatic, with predominating browns, grays, and greens. Gromaire has worked also in water color, lithography, and etching. He has done murals and has illustrated a number of books, including *Macbeth*.

ARNOLD ROSIN

GROPIUS, WALTER. German-American architect, educator, and critic (1883–1969). Born in Berlin, Gropius, the son of an architect, studied architecture at Charlottenburg and Munich Universities during the first few years of this century. He traveled in Spain (1904–05), served in the Imperial Army (1905–06), became chief assistant to Peter Behrens (1907–10), and started private practice in Berlin (1910). He was director of the Weimar Art Academy and Weimar Arts and Crafts School, combining them, in 1919, into Das Staatliche Bauhaus Weimar. He moved the school to Dessau in 1925, and continued as director until 1928,

when he resumed private practice in Berlin. From 1929 to 1957 he served as vice president of C.I.A.M. He was in private practice with E. Maxwell Fry in England (1934–37); became professor of architecture at Harvard (1937); and was chairman of the Department of Architecture in Harvard's Graduate School of Design (1938–52). He has since devoted his time to private practice (with The Architects' Collaborative, or TAC, which he formed in 1946), lecturing, and writing. *See* BAUHAUS; C.I.A.M.

Before World War I Gropius executed two of the key works of contemporary European architecture. In the Fagus Werke at Alfeld on the Leine (1910–11, with Adolf Meyer) skeleton and skin are separated into the now familiar curtain wall formulation, aesthetically exploited here for the first time, even though the technique had been developed earlier in Chicago. In the Werkbund Exhibition at Cologne (1914; destroyed) he designed a model factory consisting of administration offices, garage, and work area. Flanking the administration offices were the famous cantilevered spiral stairs sheathed in glass cylinders, a breathtaking symbol of the technological basis of modern architecture.

Although the years from 1918 through 1928 were taken up almost exclusively with the development of the educational program of the Bauhaus, Gropius did execute some notable works at this time: the prescient project for the Chicago Tribune Competition (with Adolf Meyer, 1922), the classic Bauhaus building itself (Dessau, 1925–26), the unexecuted Total Theatre (1927), and prefabricated housing at the Weissenhof Exhibition, Stuttgart (1927).

During the 1930s Gropius designed his own house at Lincoln, Mass. (1937), and the Chamberlain House at Sudbury, Mass. (1939), both with Marcel Breuer. These were among the first modern European buildings introduced to the United States and were greatly influential in subsequent American domestic architecture. Since World War II Gropius has executed one of his largest commissions (with TAC), the Harvard Graduate Center (1949), a complex of living, study, dining, and recreational facilities. The services of many artists of high calibre, such as Josef Albers, Joan Miró, Herbert Bayer, and Jean Arp, were used in the design of the Graduate Center. In the 1960s Gropius and TAC engaged in the design of the immense University of Baghdad, the culmination of his career.

THEODORE M. BROWN

GROPPER, WILLIAM. American painter, cartoonist, and lithographer (1897–). Born in New York City, he studied with Henri, Bellows, and Giles. He is best known for his skillful political and social cartoons for radical periodicals. His paintings, of similar subjects, are expressionistic in style.

GROSS, CHAIM. American sculptor (1904–). Born in Austria-Hungary, Gross went to the United States in 1921. He has remained essentially independent of the various sculptural developments in American art since his arrival. Although his works are related in a general way to those of Zorach, De Creeft, and Lachaise, Gross imparts a playful rhythm to his figures, often working with superposed forms. He works principally in wood, as in *Acrobatic Dancers* (1942) and *Snake and Birds* (1954). An impressive earlier work is *Mother and Child* (1927; Newark Museum). A compact, semiabstract interpretation of the figure, usually with an attendant sense of offset balances, marks his typical sculptures.

GROSZ, GEORGE. German-American painter and printmaker (1893–1959). Born in Berlin, he went to the United States in 1932. Grosz may be identified with three movements in modern art: Dada, Die Neue Sachlichkeit (New Objectivity), and American social realism of the 1930s and early 1940s. It may be more apt, however, simply to designate Grosz an expressionist with a strongly personal style, especially in his drawings and prints of the late 1910s and 1920s when his style was most incisive.

Grosz trained at the Dresden Academy of Fine Arts and the Berlin Arts and Crafts School and studied briefly in Paris. As a combat soldier in World War I and an observer of the postwar economic chaos in Germany, he was well acquainted with the cynical, often haunting incidents that led to the imagery of his pictures. His lithograph *Memories of New York* (1917), a sharp portrayal of the wartime metropolis, is a Dadaist document. The water color *Café Neptun* (1920; Art Institute of Chicago) and *Trench Warfare* (1923; now lost, formerly Dresden, State Art Collections), lampoon the civilian and the military aspects of world conflict. Another lithograph, *Christmas Eve* (1921), is typical of his satire of middle-class vapidity.

Thought of, above all, as a draftsman, Grosz often worked tellingly in oils, as in the *Funeral of the Poet Panizza* (1917–18; Stuttgart, State Gallery), a consciously catastrophic-looking composition with surging human and architectural movement. His great series *Ecce Homo* (1923) was reissued in the 1960s.

With Otto Dix, Max Beckmann, and other Germans who tired of what in their view was the excessive romanticism of certain Die Brücke artists and the formalism of the Blue Rider, Grosz for a time in the mid-1920s arrived at a strongly realistic method, of which his *The Poet Max Hermann-Neisse* (1927; New York, Museum of Modern Art) is an example.

Grosz left Germany out of disgust with the political situation of the early 1930s, settling in New York in 1932. He was awarded a Guggenheim fellowship in 1937 and won the Carnegie International prize in 1945. For a time in the late 1930s Grosz painted New England landscapes and figure compositions with nudes; but he soon turned again for subjects to socially conscious, topical imagery, as in *The Pit* (1946; Wichita Art Museum), *Peace, II* (1946; New York, Whitney Museum) and *Waving the Flag* (1948). Grosz contributed significantly to the finer tradition of social realism of this century, and his graphic works in that genre are stylistically important to the general history of German expressionist drawing and printmaking.

JOHN C. GALLOWAY

GRUEN, VICTOR. Austrian-American architect and planner (1903–). Born in Vienna, Gruen studied in Berlin under Peter Behrens and worked in Europe before going to the United States in 1938. Today his large office, with main headquarters in Los Angeles and Detroit, deals with such problems as suburban shopping centers and urban design, the best examples of which are Northland, near Detroit (1952), and the plan for Fort Worth, Tex.

GUGLIELMI, O. LOUIS. American painter (b. Cairo, Egypt, 1906; d. Amagansett, N.Y., 1956). He went to the United States in 1914 and studied at the National Academy of Design from 1920 to 1925. His early paintings were tightly rendered realistic studies of urban genre and social themes, such as *Wedding in South Street* (1936; New

York, Museum of Modern Art). Guglielmi's exact depiction was also suitable for subjects with strong surrealistic connotations, as in *Terror in Brooklyn* (1941; New York, Whitney Museum), which places frightened figures under a glass enclosure on a city street. His later paintings of industrial and city scenes, abstracted and purified in form, are related to precisionism.

GULBRANSSON, OLAF. Norwegian draftsman and painter (b. Oslo, 1873; d. Tegernsee, 1958). One of the most famous caricaturists of modern times, Gulbransson is closely identified with the early-20th-century tradition of Munich satire, in spite of his Norwegian birth and training. His caricatures were always masterfully rendered, with economy of line and with acute observation. Like his friend Wilhelm Busch, Gulbransson used his art in the pursuit of truth and equity, and only rarely with biting or cynical criticism.

His output of caricature was largely concentrated in *Simplizissimus* (his earliest contribution appears in vol. 7, no. 38). Most of his other drawings, which include non-caricature, appeared in folio form (*Famous Contemporaries*, Munich, 1905; *Out of my Drawer*, Munich, 1912) or as book illustrations (L. Thoma's *Tante Frieda*, 1907; A. Wohlmuth's *74 Fables*). He painted masks and sets for the theaters of Munich as well.

GUSTON, PHILIP. American painter (1912–). Born in Montreal, Canada, he now lives in New York. Guston studied at the Otis Art Institute in Los Angeles but is mainly self-taught. His works of the late 1930s and early 1940s were executed in the socially conscious style of mixed realism-surrealism then popular in the United States. *Martial Memory* (1941; St. Louis, City Art Museum) is typical, with its masked, enigmatic figures poignantly arranged in a slum setting.

After teaching at the State University of Iowa from 1941 to 1945, Guston took first prize at the Carnegie International, held a one-man show at the Midtown Galleries, and won a Guggenheim fellowship (1948), a Prix de Rome (1949), and an American Academy of Arts and Letters grant (1949). About 1950, a *White Painting* series signaled his development of a more abstract method, which

matured in such canvases as *Dial* (1956), *The Clock* (1957), and *The Tale* (1961). Although Guston is sometimes called an abstract impressionist, his style clearly belongs to the tradition of abstract expressionism, or action painting.

<div style="text-align: right">JOHN C. GALLOWAY</div>

GUTTUSO, RENATO. Italian painter (1912–). He was born in Palermo. Shortly after his arrival in Rome in 1931 Guttuso became a member of the romantic Roman school. His subsequent associations, the Milan Corrente movement and the postwar Fronte Nuovo delle Arti, emphasize the strong social concerns that underlie Guttuso's painting. His earlier style was expressionistic and influenced by Picasso, for example, *Battle with Wounded Horses* (1942; Rome, National Gallery of Modern Art). Although he stresses realistic subjects, Guttuso's awareness of modern abstract design can be seen in *The Mafia* (1948; New York, Museum of Modern Art) as well as in a more recent series of cubistic landscapes.

GWATHMEY, ROBERT. American painter and graphic artist (1903–). Born in Richmond, Va., he studied at the Maryland Institute of Design and at the Pennsylvania Academy of Fine Arts. Gwathmey's subjects are scenes of Southern life, particularly the life of the Negro. The vigorous element of social commentary, only implied in some paintings, for example, *Hoeing* (1943; Pittsburgh, Carnegie Institute), is obvious in others. While his subjects are realistic, his painting style involves the simplified forms of modern abstraction. Objects, figures, and parts of figures are formed of exact, dark outlines and flat areas of color and are composed with a strong awareness of two-dimensional design and pattern, as in *Sowing* (1949; New York, Whitney Museum).

H

HAGUE, RAOUL. American sculptor (1905–). Born in Istanbul of Armenian parents, he went to America in 1921, first living in Iowa and then settling in New York, where he studied at the Art Students League. Typically, Hague's work is directly carved in wood or stone. *Ohio Wormy Butternut* (1948; New York, Museum of Modern Art) and *Sawkill Walnut* (1955; New York, Whitney Museum of American Art), despite their generally abstract appearance, divulge a basic adherence to the human figure. Hague's forms are fluid and sensitively finished in the chosen medium. His later development depends more upon purely abstract images.

HAITIAN PAINTING. The native school of painting in Haiti began to flourish with the establishment of the Centre d'Art at Port-au-Prince in 1944.

The Centre d'Art was started by DeWitt Peters, an American painter and teacher, who managed to gain some small support from the governments of Haiti and the United States. He discovered and brought together a number of artists who, once they were able to devote most of their time to painting and to exhibit and sell their work, became widely known throughout the world. These included Hector Hyppolite, Philomé Obin, Rigaud Benoit, Wilson Bigaud, and many others. Obin started his own branch of the Centre d'Art in northern Haiti at Cap-Haitien. *See* BENOIT, RIGAUD; BIGAUD, WILSON; HYPPOLITE, HECTOR; OBIN, PHILOME.

HALLER, HERMANN. Swiss sculptor (b. Bern, 1880; d. Zurich, 1950). He started as a student of architecture and painting in Munich and Stuttgart. After a trip to Rome

with Paul Klee, and his residence there (1901–05), Haller emerged as a sculptor. His style, although it involved greater delicacy and simplification of form, is essentially in the tradition of 19th-century figure sculpture, as represented particularly by Rodin. Haller was virtually immune to the artistic ferment of Paris during his years there (1907–14). An ethereal quality evolved in his sensitive handling of portraits and slender female figures, particularly in the studies of young, ungainly girls. In 1934 he was awarded the gold medal of the Academy of Florence at the Venice Biennale and, in 1949, the Grand Prix de Zurich.

HALPERT, SAMUEL. American painter (b. Białystok, Poland, 1884; d. Detroit, 1930). He went to the United States at an early age and studied at the National Academy of Design in New York City. In 1902 he went to Paris.

Halpert was among the first American artists to be influenced by modern art in Europe. After a period of impressionistic work, he found the basis of his style in Cézanne and Fauvism. His *Still Life* (1913; New York, Ira Spanierman Collection) exhibited in the 1913 Armory Show, for example, was obviously derived from Cézanne, but the more Fauve *Brooklyn Bridge* (1913; New York, Whitney Museum of American Art) shows the broad color application and simplified forms that were characteristic of his work by 1920.

HARE, DAVID. American sculptor, writer, and photographer (1917–). He was born in New York City and went to school in New York, Arizona, and Colorado. He majored in analytical chemistry until 1936 and worked as a color photographer and commercial artist from 1939 to 1943. Influenced by Giacometti, Hare began sculpture in 1942. From 1942 he collaborated with Breton, Ernst, and Duchamp on the magazine *VVV*. Since 1951 Hare has worked in welded metal and has had several shows at the Kootz Gallery. He made trips to Paris, notably in 1951–52. Until recently he was one of the most active surrealist sculptors in America. His *Sunrise* (1955) is in the Albright-Knox Art Gallery, Buffalo, and *Figure Waiting in the Cold* (1951) is in the Whitney Museum of American Art, New York. He did several architectural commissions, such

as the Eternal Light and Menorah for Temple Beth El, Providence, R.I., and a large relief for the lobby of 750 Third Avenue, New York City. Hare made important contributions in the area of fantastic body imagery and personal interpretations of nature in metal sculpture.

<div align="right">ALBERT ELSEN</div>

HARKAVY, MINNA R. Estonian-born American sculptor (1895–). The bronze *American Miner's Family* (1931; New York, Museum of Modern Art) marked this artist's style as "socially conscious." The forms were essentially naturalistic but marked by romantic simplifications, which, in some later works, border on stylization. The bronze portrait of Leo Stein (1932) is, with its integration of specific likeness and sympathetic interpretation of character, one of Harkavy's finest works.

HARRIS, HARWELL HAMILTON. American architect and educator (1903–). Born in Redlands, Calif., he attended Pomona College and the Otis Art Institute. He collaborated with Richard Neutra (1930–33), was secretary of the American group of C.I.A.M. (1931–33), and established his own office in 1934. Harris has taught at several schools, including the University of Texas, Columbia, and Yale. His architecture is generally associated with the Bay Region Style developed in California. The influence of Frank Lloyd Wright may be seen in Harris's house for Ralph Johnson in Los Angeles (1951). *See* C.I.A.M.

HARRISON, WALLACE KIRKMAN. American architect (1895–). Born in Worcester, Mass., he studied at the Ecole des Beaux-Arts, Paris, traveled on a Rotch Fellowship, and worked as a draftsman for McKim, Mead and White before forming partnerships with Helmle and Corbett (1927–29), Corbett and MacMurray (1929–35), Fouilhoux (1935–41), Fouilhoux and Abramovitz (1941–45), and Abramovitz (1945). Essentially an architectural coordinator, Harrison has been associated with such large-scale and influential works as Rockefeller Center (1931–37) and the United Nations complex (1952), both in New York City, designed by an international team he headed. *See* HARRISON AND ABRAMOVITZ.

HARRISON AND ABRAMOVITZ. American architectural firm of Wallace Kirkman Harrison (1895–) and Max Abramovitz (1908–) in New York City, established in 1945; one of the largest design firms in the country. Their funnel-shaped auditorium at Oberlin College (1953) in Ohio is embellished by an undulating surface at its entrance, expressive of the literary and musical activities within. The Alcoa Building (1952) in Pittsburgh, employing prefabricated curtain walls of pressed aluminum panels, incorporates several technical innovations. The firm has also executed the United States Embassy (1953) in Havana and the C.I.T. Building (1957) and Time and Life Building (1960), both in New York City. *See* HARRISON, WALLACE KIRKMAN.

HART, GEORGE OVERBURY ("Pop" Hart). American painter and graphic artist (b. Cairo, Ill., 1868; d. New York City, 1933). His only formal artistic training occurred in brief periods spent at the Art Institute of Chicago and at the Académie Julian in Paris. A born wanderer, he supported himself in his travels by various odd jobs and always carried portfolios of drawings of the genre scenes that met his eye. These at first were done only for his own amusement and interest, and it was not until about 1921 that his art became paramount.

Hart preferred water color to oil because of the immediacy and spontaneity of its effects, but his search for freedom of expression often involved a mixture of media (for example, water color with pastel, charcoal, or pencil) that sometimes disturbed his critics. A similar technical experimentation can be seen in his etchings and lithographs, where he aimed at the painterly effects of his water colors.

HARTIGAN, GRACE. American painter (1922–). Born in Newark, N.J., she studied with Isaac Lane Muse in Newark and worked as a draftsman in the middle 1940s. In her earlier paintings she applied the technical means of the abstractionist New York school to the figure, for example, *River Bathers* (1953; New York, Museum of Modern Art) and *Masquerade* (1954; Art Institute of Chicago). In other paintings of the 1950s the urban environment is more insistent as subject matter but is still described in rich color and broad, loose strokes, as in *City Life* (1956; New York, Nelson A. Rockefeller Collection) and *Essex*

Market (1956; New York, Mrs. John D. Rockefeller, III, Collection). Hartigan's recent works are more personally lyrical treatments of interiors, landscapes, and still lifes.

HARTLEY, MARSDEN (Edmund Marsden Hartley). American painter and writer (b. Lewiston, Me., 1877; d. Ellsworth, Me., 1943). He studied in Cleveland, at the New York School of Art with F. Luis Mora, Frank V. Du Mond, and William Merritt Chase, and at the National Academy of Design. In his first exhibition, at Stieglitz's Photo-Secession Gallery in 1909, Hartley showed heavily

Marsden Hartley, *Painting No. 5* (1915). Oil on canvas, 39½" x 31¾". Whitney Museum of American Art, New York.

painted mountain landscapes influenced by the style of Giovanni Segantini, whose works he had probably seen in reproduction.

Hartley went to Paris in 1912. He was in Germany in 1913 and 1914, where he met Kandinsky, Marc, and Klee and exhibited with the Blaue Reiter group in Munich and Berlin. During this period he painted strongly colored, expressionistic, abstract compositions based upon the ornamental paraphernalia of German militarism, for example, *Portrait of a German Officer* (1914; New York, Metropolitan Museum). For a whlle, after his return to the United States, Hartley used a form of cubistic abstractions in which he arranged flat, mostly linear shapes, but in the beautifully poised *Movement No. 10* (1917; Art Institute of Chicago) a pear and two bananas betray the still-life source of the composition. In the early 1920s Hartley worked in Paris and in the south of France, painting still lifes and the Provençal landscape in emulation of Cézanne, for example, *Still Life No. 3* (1923; Art Institute of Chicago).

Hartley's mature style began to emerge on his Mexican journey of 1932; in intense, mystical landscapes (including Mt. Popocatepetl) the fructifying effect of his lifelong admiration for Ryder can clearly be seen. In 1936 Hartley revisited Gloucester, Mass., and painted landscapes with less simplified forms and strong, almost violent coloring.

By 1938 Hartley had settled in Maine, determined to become the painter of his native state. He painted the figure in a series of so-called "archaic portraits" of Nova Scotian fishermen done from memory, for example, *Fishermen's Last Supper* (1940–41; New York, Mr. and Mrs. Roy R. Neuberger Collection). His late landscapes and marines, such as the powerful *Evening Storm, Schoodic, Maine* (1942; New York, Museum of Modern Art), were the most personal and fully realized paintings of his career. The stylistic characteristics of these late works, rich coloring and an abstraction from carefully observed natural forms, can be seen in the stylized clouds, deep-blue mountains, and red forest of *Mount Katahdin, Autumn, No. 1* (1939–40; Lincoln, Sheldon Memorial Art Gallery).

JEROME VIOLA

HARTUNG, HANS. French painter (1904–). Born in Leipzig, he began to paint when quite young and was influenced by Rembrandt, then by Kokoschka, Nolde, and

Franz Marc. His early abstractions and water colors date from 1922. While attending classes at the Leipzig and Dresden academies (1924–28), he met Kandinsky (1925). Hartung was one of the first to reject all visible forms and all exterior representation; his painting became entirely abstract. He traveled in France, Italy, Holland, and Belgium. In 1935 he left Germany and settled in Paris. He became a French citizen in 1944. Hartung is one of the most famous exponents of French abstract art. His painting in black sprays and splashes is reminiscent of Japanese calligraphy, as in *T. 56–19* (1956).

HASSAM, FREDERICK CHILDE. American painter, illustrator, and graphic artist (b. Dorchester, Mass., 1859; d. East Hampton, N.Y., 1935). Hassam attended the Boston Art School and worked as a wood engraver and illustrator before 1883, when he went to Paris and studied with Boulanger and Lefébvre. He was a member of The Ten, a group of impressionist artists formed in 1898.

From his first contacts with the works of Monet in Paris, Hassam painted in an impressionist manner, but, perhaps because of his early academic training, he rarely dissolved a scene completely in its light and managed to keep a relatively firm drawing beneath the strokes of pure, bright color. Unlike the personal dissection of light itself that is often found in Monet, the light in Hassam's paintings is inextricable from the objects and scenes it illuminates. Many of his early paintings are of street scenes in New York, Boston, and Paris, for example, *Washington Arch, Spring* (1890; Washington, D.C., Phillips Collection), in which the fleeting impression of the movements of fashionable people is stressed, often with such technical complications as variations in weather or wet pavements. In these pictures the color is bright and the paint handling loose. He painted flag-filled street views during World War I.

Hassam was also concerned with the figure, especially that of women. He painted women either outdoors in full light, as in the painting of a woman leaning against rocks and reading, called *Summer Sunlight* (1892; New York, American Academy of Arts and Letters), or in variously lit interiors, such as the profile half-figure *Against the Light* (1910; Art Institute of Chicago). About 1915 Hassam began to work in lithography and etching.

Hassam's later landscapes and shore scenes are the most broadly painted and perhaps, of all his work, come closest to true impressionism, as in the rough-surfaced *Montauk* (1922; American Academy of Arts and Letters).

JEROME VIOLA

HAYTER, STANLEY WILLIAM. English painter and printmaker (1901–). Born in London, he graduated with honors in organic chemistry and geology from Kings College in 1921, after which he worked for the World Nickel Company and then the Anglo-Iranian Oil Company, traveling in the Near and Middle East. In 1926 he returned from Persia and settled in Paris to devote himself entirely to art. From the age of fourteen he had painted; he had also been interested in the graphic arts for many years and was aware that graphic art, especially the intaglio mediums of engraving and etching, had possibilities that had been either overlooked or undeveloped for generations. The engraved work of Joseph Hecht and Jacques Villon stimulated his interest. At this time he began to teach printmaking techniques. In 1933 he moved to 17 rue Campagne-Première, from which the name "Atelier 17" derived. Atelier 17 was to become the most influential print workshop of the 20th century.

In 1940 Hayter went to the United States to teach at the California School of Fine Arts in San Francisco. Later the same year he set up an Atelier 17 in New York City and taught at the New School for Social Research. An Atelier 17 exhibition was held at the Museum of Modern Art in 1944 (earlier exhibitions of the group had been held in Paris and London in 1934). In 1948 Hayter taught painting and theory at the California School of Fine Arts and then taught printmaking at the Art Institute of Chicago until 1949. During this year he published *New Ways of Gravure*, in which he discussed his theories and experiments in printmaking. He became professor of fine arts at Brooklyn College, New York. In 1950 he returned to Paris to reestablish Atelier 17 there, leaving the New York studio under the direction of his pupils.

Despite his preoccupation with the teaching of techniques, Hayter has said that "Technique is a process which sets the imagination free and makes its action visible; it has no other function." His own work, such as *Tarantelle*

and *Cronos* in mixed intaglio media, shows a freedom of line commensurate with this creed.

The many artists who have worked at Atelier 17 under the inspired guidance of Hayter have set the style of printmaking for this century. They include Picasso, Miró, Lasansky, and Peterdi.

KNEELAND MC NULTY

HECKEL, ERICH. German expressionist painter (1883–1970). He was born at Döbeln, near Chemnitz, and after 1955 lived at Hemmenhofen. Heckel studied architecture at the Technische Hochschule, Dresden, where he began his first paintings, wood sculptures, and woodcuts. As an artist he is largely self-taught. He met Kirchner in 1905 and together with Schmidt-Rottluff and Bleyl founded Die Brücke. After living in Dresden and Oldenburg and visiting Rome, Heckel moved to Berlin in 1911. In 1912 he and Kirchner painted murals on hemp in a chapel at the International Exhibition at Düsseldorf, which was organized by a group of local artists called the Sonderbund. During World War I Heckel was a member of the medical corps in Flanders.

After the war he made his home in Berlin. He was active in the social program of the Arbeitsrat für Kunst (Workers' Council for Art), and he traveled throughout the Continent. In the early 1920s he painted several decorative frescoes for the Erfurt Museum. He was forced to move to Carinthia after his art was denounced by the Nazis as "degenerate."

Heckel seems restrained compared to his colleagues in the expressionist movement. He admired such disparate artists as Poussin and Vermeer for their bright color in broad areas, Munch, and Van Gogh, and particularly liked South Seas sculpture. Like his fellow expressionists, he rejected the finish and detail of academic art in search for the *Urform*, or the initial impulse of creation. His landscapes appear as masses of shattered crystals with paths shooting off to the horizon and spiky trees pointing to a sky heavy with clouds that billow, heave, and subside. His color is naturalistic but heightened for effect. His skies, for instance, are blue, but a blue that is frequently unusually sharp, raw, and acid. His world is a shaken and disturbed one, as if in the wake of cataclysmic forces.

His best-known pictures are of gaunt, tortured women, self-enclosed, withdrawn, and ascetic, as if inhibited or suffering from loneliness or extremes of despair. He made several fine woodcuts, some of which he exhibited at the 1910 Brücke show in Dresden. After World War I his painting underwent a reversal in mood and some loss of power. ROBERT REIFF

HELIKER, JOHN. American painter (1909–). Born in Yonkers, N.Y., he studied in 1928–29 at the Art Students League with Kenneth Hayes Miller, Boardman Robinson, and Kimon Nicolaides. From his early representational work (in which he especially concentrated on drawing) Heliker brought to abstraction a strong feeling for nature. Behind or within the geometric subdivisions of such a painting as *Scava* (1950; New York, American Academy of Arts and Letters) can be seen many allusions to natural processes or forms. Subsequently, Heliker's geometry loosened and his debt to landscape became, quietly, more obvious, as in *Of Maine* (1953; New York, Whitney Museum of American Art).

HELION, JEAN. French painter (1904–). He was born in Couterne, Orne, and now lives in Paris. He studied engineering and architecture in Lille and worked as a draftsman for an architect. Since 1922 he has devoted himself to painting. He never had formal training. In 1926 Torres García introduced Hélion to cubism. His interest in abstract painting led him to Mondrian, and in 1927 Hélion exhibited at the Salon des Indépendants. In 1931 he came to know Theo van Doesburg and helped him edit his publication, *L'Art Concret.* Hélion was active in the Abstraction-Création group at this time. During World War II he escaped from a German prison camp and wrote a book about his adventures, *They Shall Not Have Me.* He has had over 20 one-man shows, and his work is in the Museum of Modern Art in New York, Philadelphia Museum of Art, Museum of Fine Arts in Boston, Art Institute of Chicago, and museums in Beauvais, Lille, and Laon.

Hélion's early work is cubist in character. Prior to 1931 the mark of Mondrian's influence is evident, but thereafter Hélion developed a style very much his own. With pastel

color he combined monumental shapes, recalling machined surfaces, which were mostly flat, but some gently curved and with a slight sheen. These were frequently arranged in sequences against a ground to suggest depth. Hélion favored a vertically accented, upright canvas at this time.

After the war his style changed radically. He went through a surrealist phase and later a somewhat mannered realism. ROBERT REIFF

HENRI, ROBERT. American painter and teacher (b. Cincinnati, Ohio, 1865; d. New York City, 1929). He studied at the Pennsylvania Academy of Fine Arts with Thomas P. Anschutz and in Paris with Bouguereau and Fleury and at the Ecole des Beaux-Arts. Henri's true teachers were the painterly masters of realism: Hals, Velázquez, Courbet, Manet, and, for a while, Whistler.

After traveling in Europe, Henri taught in Philadelphia, where he met Sloan, Glackens, Luks, and Shinn; these five artists were the nucleus of the future group The Eight. In 1901 he settled in New York, painting and exerting enormous influence as a teacher, first in Chase's school, then independently, and at the Art Students League. His early works were street scenes, landscapes, portraits, and full-length studies of women, for example, *Young Woman in Black* (1902; Art Institute of Chicago). In the years before World War I, Henri was fascinated by the portrayal of various human types. Among the results of his wide travels were paintings of Negroes, such as *Willie Gee* (1904; Newark Museum), Irish peasants, such as *Himself* and *Herself* (both 1913; Art Institute of Chicago), and American Indians, such as *Diegito* (1916; Santa Fe, Museum of New Mexico). Most of his last works were portraits and paintings of children.

The basis of Henri's artistic style was the swift and fluent recording in paint of the immediately perceived facts of the subject. In this he was little different from his skillful academic contemporaries. His crucial place in American painting is justified by his teaching, the magnetic power of his personality, and his devotion to his principles. Beyond instruction in facile brushwork, he taught the importance of truth in life and art. For Henri there was no separation between the two; he stressed the painting of contemporary reality in the same breath as

Robert Henri, *Laughing Child* **(1907). Oil on canvas, 24″ x 20″. Whitney Museum of American Art, New York.**

he urged his students to read Whitman and Dostoievsky.

He constantly fought against aesthetic restrictions; the exhibition of The Eight was a protest against the narrowness of the National Academy, and Henri was active in other rebel groups and took part in the 1910 Independents' exhibition and the 1913 Armory Show. JEROME VIOLA

HEPWORTH, BARBARA. English sculptor and draftsman (1903–). She was born in Wakefield, Yorkshire, and had already begun to make clay portraits before attending Leeds Art School in 1920. From 1921 to 1924 she studied

sculpture at the Royal Art College and during this time met Henry Moore. While in Italy (1924–26), she learned direct stone carving from Ardini. Her first show was in 1928. Meeting Arp and Brancusi in Paris in 1932 had a great influence on her style. Her first abstract works date from about 1934. She joined the Abstraction-Création group in 1933. Since 1936 she has lived in Cornwall, working in both wood and stone. Her *Cosden Head* (1949) is in the Birmingham Museum and Art Gallery. Several of her finest works are in her own collection. To a great sensitivity to sensuous closed and open form, Hepworth has wed a poetic consciousness. The Tate Gallery, London, held a retrospective of her work in 1968, and she was one of the two artists who represented Great Britain at the 1968 Venice Biennale.

HERON, PATRICK. English painter (1920–). Heron studied at the Slade School in London and had his first one-man show in 1947 at the Redfern Gallery in London. He was early influenced by Bonnard, Braque, and De Stael but has since developed a style of restrained and controlled abstraction often using carefully adjusted, rough-edged rectangular forms. Heron has also written widely on contemporary art.

HIRSCH, JOSEPH. American painter and graphic artist (1910–). Born in Philadelphia, he studied at the Philadelphia Museum of Art, with Henry Hensche in Provincetown, and with George Luks in New York. From 1935 to 1936 Hirsch traveled in Europe, Egypt, and the Far East. He was an artist-correspondent during World War II. Hirsch's earlier paintings are socially oriented urban genre scenes, sometimes sympathetic, as in *Two Men* (1937; New York, Museum of Modern Art), sometimes satiric, as in *The Senator* (1941; New York, Whitney Museum of American Art). His more recent work is more concerned with subtle brushwork and nuanced color with which he creates vivid compositions of the human figure.

HIRSCH, STEFAN. American painter and graphic artist (b. Nürnberg, Germany, 1899; d. New York City, 1964). He studied at the University of Zurich and with Hamilton Easter Field after his arrival in the United States in 1919.

Hirsch was a painter of figures, still lifes, and landscapes. In the 1920s his paintings were associated with the precisionist style, for example, *New York, Lower Manhattan* (1921; Washington, D.C., Phillips Collection), which depicts skyscrapers and ships on the river in severe and blocklike form. His later works, such as the landscape *Pic of Orizaba* (1932; New York, Whitney Museum of American Art), while more loosely treated, are still formally simplified.

HOFER, CARL. German painter (b. Karlsruhe, 1878; d. Berlin, 1955). He studied with Hans Thoma for two years at the academy in Karlsruhe. At that time he admired the romantic allegorical art of Böcklin. Hofer was in Rome from 1903 to 1908; there he saw the painting of Hans von Marées and was influenced by it. He lived for five years in Paris, where he came to know and was influenced by Cézanne. He became a member of the Neue Künstlervereinigung in 1909, the year of its inception, and was represented in its first exhibition in Munich. He traveled for a year in India before settling in Berlin, and had his first one-man show a year later. During World War I he was interned in France. In 1918 he was appointed a teacher in the Berlin Academy.

It was in the atmosphere of bitterness and disillusionment of postwar Berlin that Hofer evolved the style by which he came to be known. In 1930 he turned to abstract painting, to return a year later to his former style. In 1933 he was dismissed from his teaching position and his art was classified as "degenerate" by the Nazis. In 1934 he won second prize for painting at the Carnegie Institute International in Pittsburgh with *Pastorale* and, in 1938, first prize for *Wind* (both Pittsburgh, Carnegie Institute). In 1943 his studio was bombed and many pictures were destroyed. In 1945 he was appointed director of the Hochschule für bildende Künste in Berlin. He was given a large retrospective in 1946 in Berlin.

Prior to World War I Hofer painted full-size figures like those of Marées, but transposed in the manner of Cézanne. Though he exhibited with the expressionists, he insisted that he was not one of them. After the war his figures lost their warmth and earthiness and became lean and emaciated, with protruding bones and large, dark eyes full of questioning. He painted clowns, sleeping figures, card play-

ers, wan servant girls, and other figures, who, like Picasso's Blue Period creatures, live a marginal existence. Hofer's people look like wooden mannequins. He favored grays with accents of hard, bright color. Contours assume an unexpected and unnatural sharpness, and forms a rigid angularity. The same aura of melancholy and despair appears in the landscapes from Ticino and the stark, rather stiff still-life paintings. In 1950 his works assumed a new freedom of treatment and an increased heaviness of contour. ROBERT REIFF

HOFFMAN, MALVINA. American sculptor (b. New York City, 1887; d. there, 1966). She studied painting with John White Alexander and sculpture with Herbert Adams and Gutzon Borglum in New York and with Rodin in Paris.

She received numerous honors, both professional and academic. One of her earliest awards was accorded at the 1911 Salon in Paris. In 1917 and again in 1921 she received important American medals at National Academy of Design exhibitions. In later years she won a number of decorations from foreign governments, including the French Legion of Honor.

The Harvard University *Bacon Memorial*, dedicated to Harvard students who were killed in World War I, discloses Hoffman's capacity to personify specific, somber sentiment and to reinterpret with sensitivity settings belonging to traditional epochs of the history of sculpture (in this case, the English medieval reclining-knight type). *Russian Bacchanale* (Paris, Luxembourg Museum) and *Pavlova Gavotte* (Detroit Institute of Arts) testify to a certain deftness of interpretation of the figure in space, with a personally directed charm that helps to offset the eclectic approach. *Crusader* heads in the Art Institute of Chicago and the Metropolitan Museum of Art in New York denote Hoffman's considerable technical gifts, although these, like many of her smaller works, convey a graceful sentimentality deriving ultimately from the sterner tenderness of Rodin and much medieval sculpture. JOHN C. GALLOWAY

HOFMANN, HANS. German-American painter (b. Weissenberg, Germany, 1880; d. New York City, 1966). He settled in the United States in 1932. He was a leader of the abstract expressionist school in the United States and

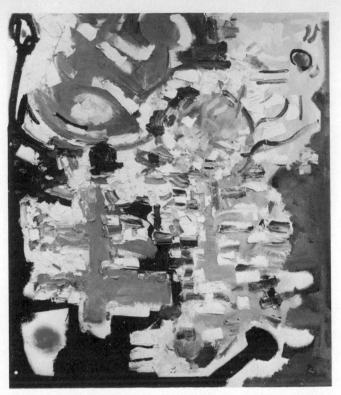

Hans Hofmann, *Fantasia in Blue* (1954). Oil on canvas, 60″ x 52″. Whitney Museum of American Art, New York. Gift of Friends of the Whitney Museum.

the teacher of many outstanding younger painters.

Hofmann studied in Munich from 1904 to 1907. From 1907 to 1914 he painted in Paris, where he met the cubist and Fauvist masters. His first one-man show was at the Paul Cassirer Gallery in Berlin in 1910. From 1915 until 1932 Hofmann directed his own school in Munich, where he attracted an international following. He visited the United States several times, teaching at the University of California (Berkeley) and elsewhere before opening his own school in New York in 1934.

Hofmann's style, not fully abstract until about 1939, was thoughtfully developed out of Fauvist and cubist prin-

ciples and was to some extent conditioned by expressionism. He was always devoted to bold experimentation with color, remarking that painting means building with color.

He was given a one-man show at the California Palace of the Legion of Honor, San Francisco, in 1931. A major retrospective was shown at the Whitney Museum of American Art, New York, the San Francisco Museum of Art, the Walker Art Center, Minneapolis, and the Munson-Williams-Proctor Institute, Utica, in 1957. His works were shown at the Venice Biennale in 1960, and the Museum of Modern Art in New York gave him a retrospective in 1963.

Characteristic works by Hofmann are *The Window* (1950; New York, Metropolitan Museum), *Magenta and Blue* (1950; Whitney Museum of American Art), and *Sanctum Sanctorum* (1962). In 1964 he gave the University of California at Berkeley forty-five of his paintings, together with funds to construct the Hans and Maria Hofmann Memorial Galleries to house these works.

Hofmann typically worked with a notably liberated thrust of vibrant, often pure color, and in shapes that remotely suggest an origin in nature or man-made objects. Certain of his pieces after 1960, however, include with irregular patterns a nucleus of clean-edged rectangles, the result being a powerful synthesis of geometry and free-form abstraction. JOHN C. GALLOWAY

HOLABIRD AND ROCHE. American architectural firm of William Holabird (1854–1923) and Martin Roche (1855–1927). Their partnership was formed in 1883 and lasted until 1923. Best known for business structures, they pioneered the development of the skyscraper. Innovators in structural matters, they also exploited the steel frame to its full architectonic advantage. Their buildings are considered to be among the clearest statements of skeletal architecture of the period and are ranked as major achievements of the Chicago school. The Marquette Building (1894) was the first in a series that was remarkably consistent in style and treatment of the façade. Elements common to these structures include Chicago windows, continuous piers with recessed spandrels, and largely uniform exteriors. Their Tacoma Building (1887–89) is considered the first building whose exterior is completely supported by a skeleton frame.

HOLABIRD AND ROOT. American architectural firm, established in 1927 following the death of Martin Roche of the partnership of Holabird and Roche. Holabird's son, John Augur Holabird (1886–1945), and John W. Root (b. 1887) inherited or secured commissions for some of Chicago's best-known skyscrapers, notably the original Daily News Building, the Palmolive Building, and the Board of Trade Building. In 1935 the firm added a new wing to Richard Schmidt's Henrotin Hospital in Chicago. Holabird and Root also designed the eight-story addition (built in 1960–61) to the Carson, Pirie, Scott Co. Building, which extends the long west elevation by three bays. The façade below the lintel of the second floor, however, does not achieve the brilliance of the cast-iron ornament of Sullivan and Elmslie.

HOOD, RAYMOND. American architect (1881–1934). He was born in Pawtucket, R.I. In association with John Mead Howells, Hood won the international competition for the Chicago Tribune Tower (erected 1923–25), with a rather medievalizing design. Hood's American Radiator Building (1924) in New York City shows a disturbing dependence upon past styles, but his McGraw-Hill Building (completed 1930) in New York City is the first of the new skyscrapers with a horizontal accent. The vertically stripped Daily News Building (1930) in New York City catches the eye with its clean precision. Other works are the Masonic Temple and the Scottish Rite Cathedral (1929) in Scranton, Pa., and the studios of the National Broadcasting Company (1927) in New York City. *See* HOOD AND HOWELLS.

HOOD AND HOWELLS. American architectural team of Raymond Hood (1881–1934) and John Mead Howells (1868–1959). They were associated on only three major building projects during their careers. Hood was the dominant figure on each occasion; he was primarily responsible for designing the winning entry in the Chicago Tribune Tower competition (1922, erected 1923–25), the apartment building at 3 East 84 Street, New York (1928), and the Daily News Building, New York (1930). In their first joint effort, Howells, who had been invited to submit designs, turned the work over to the then largely unknown Hood. At other times in their careers, however, the men prac-

ticed either alone or in partnership with different architects. It appears that little cross-pollination of ideas occurred, for each maintained a distinct style of design despite some collaborations. *See* HOOD, RAYMOND.

HOPPER, EDWARD. American painter (b. Nyack, N.Y., 1882; d. New York City, 1967). Hopper was first trained as an illustrator at a commercial school in New York City (1899–1900) and at the New York School of Art, where he was a student of painting under Robert Henri and Kenneth Hayes Miller until 1906. Between 1906 and 1910 Hopper made three trips to Europe, mostly to Paris and Spain. Painting scenes of the city and its inhabitants in Paris he was unaffected by the current developments of Fauvism and cubism, as he was to remain aloof from other avant-garde movements throughout his career.

Hopper's paintings were first exhibited, with those of other Henri students, at the Harmonie Club, New York, in 1908. Although one of his works was shown and sold

Edward Hopper, *Second Story Sunlight* (1960). Oil on canvas, 40″ x 50″. Whitney Museum of American Art, New York. Gift of Friends of the Whitney Museum.

at the Armory Show in 1913, he did not gain recognition until the 1920s. Working as an illustrator he painted little until 1920; the years between 1915 and 1923 were devoted primarily to etching. In 1923 he took up water-color painting, a medium well suited to his light-filled New England views, but his main output has been in oils.

With his roots in the teaching of Robert Henri, Hopper transformed the realism of the Ashcan school into a vehicle of poetic insight. Almost from the beginning he replaced the loosely painted, picturesque tableaux of the Ashcan artists with a more detached rendering of things as they are according to his own concentrated vision. He was concerned with the appearance of American life and landscape and drew his subjects from his surroundings, mostly in New York City and New England where he lived for part of each year from 1908. Long automobile trips through the United States also provided themes.

Concentrating on formal means, Hopper created compelling and unsentimentalized settings for strikingly solitary figures. Pictorial structure is achieved in terms of the architecture depicted: Victorian houses in New England (*House by the Railroad*, New York, Museum of Modern Art), Cape Cod lighthouses (*Lighthouse at Two Lights*, 1929; New York, private collection), city interiors (*Room in Brooklyn*, 1932; Boston, Museum of Fine Arts) or street façades (*Nighthawks*, 1942; Art Institute of Chicago). The permanent geometry of horizontals and verticals is the framework for still figures, simple but subtle spatial patterns of architectural planes in depth, and planar contrasts of light and shade, atmosphere and mass.

The development of Hopper's style is one of purification rather than basic change. The figures and architecture of his later works are leaner and more monumental. In such paintings as *Second-Story Sunlight* (1960; New York, Whitney Museum) there is a greater clarity of light and a broader treatment of planes. The image is confronted more directly and uncompromisingly, as though to tear away the veil of isolation that characterized his earlier paintings.

Since the 1920s Hopper has been one of the most honored American painters. He was elected to the National Institute of Arts and Letters in 1945 and the American Academy of Arts and Letters in 1955, when he received

the National Institute's gold medal for painting. Among his many exhibitions have been major retrospectives at the Museum of Modern Art in New York (1933) and the Whitney Museum of American Art in New York (1950 and 1964). DONALD GODDARD

HOWE, GEORGE B. American architect (b. Worcester, Mass., 1886; d. Cambridge, Mass., 1955). Howe's major work, the Philadelphia Savings Fund Society Building, built with William Lescaze in 1931–32, presents a striking balance between the horizontals of the cantilevered floors and the vertical rhythms of the columns on the flank. The plan is T-shaped; the service areas are conveniently separated from the office spaces. Other works are his own house in Chestnut Hill, Pa. (1914–16); the Oshland School in Croton-on-Hudson, New York (1929), the first International style building on the east coast of the United States; the Thomas House on Soames Sound, Maine (1938–39), which has walls of wood and stone with cantilevers of reinforced concrete; and the Philadelphia Evening Bulletin Building (1954). *See* HOWE AND LESCAZE.

HOWE AND LESCAZE. American architectural firm of George B. Howe and William Lescaze (1896–1969), active between 1929 and 1934. Among works designed by the firm were the Oak Lane County Day School in Philadelphia and the renowned Philadelphia Savings Fund Society Building (1931–32). This bank represents one of the first examples of the International style of architecture in an American skyscraper. It features a striking balance of horizontal and vertical masses. In the T-shaped plan, services are effectively separated from office spaces. The main banking room, originally in the form of a cube, conveys a certain severity; but the large floor area provides ample space for the customers. The monumental stairhall, however, may today seem overly dramatic. *See* HOWE, GEORGE B.

HYPPOLITE, HECTOR. Haitian painter (b. St. Marc, 1894; d. Port-au-Prince, 1948). As a young man Hyppolite traveled through America and Africa; he was probably subsequently influenced in his painting by the medieval Christian art he saw while in Ethiopia. For many years

the only outlet for his art was in decorating houses and furniture. In 1944 he came into prominence, after being discovered by DeWitt Peters of the Centre d'Art in Port-au-Prince, and began to produce easel paintings on a regular basis. In them he evoked mysterious images from the voodoo rites, the religion that he practiced as a priest. His paintings are decorative in a two-dimensional style that provocatively parallels the styles of many contemporary European artists, particularly Henri Matisse. His work was enthusiastically received by Wifredo Lam and André Breton and was shown in surrealist exhibitions in Paris before his death.

I

INTERNATIONAL STYLE (Architecture). The major European architectural trend of the 1920s and 1930s, as formulated in France, Germany, and Holland. The term was suggested by Alfred Barr of the Museum of Modern Art in New York and first used as the title of an important book by Hitchcock and Johnson (1932), which appeared at the zenith of this European architectural achievement. With an emphasis on space instead of mass, typical International Style architecture is composed of rectilinear volumes defined by light, taut, undecorated planar and linear geometric components asymmetrically balanced by equivalent voids and solids that appear unaffected by gravity.

A description of International Style sources, formation, and influence is tantamount to a survey of the dominant Western architectural tendency of the second quarter of the 20th century; omitted from such a survey, however, are expressionist attitudes and works of the same period. General sources are worldwide: American skyscraper design of the 1890s in Chicago and New York; the early work of Frank Lloyd Wright; futurist projects of Sant'Elia; works by Peter Behrens, H. P. Berlage, Adolf Loos, Joseph Hoffmann, and other Europeans; the Dutch de Stijl movement; and the German Bauhaus. These coalesced after World War I into a widely accepted formal architectural discipline exhibiting the consistency and rigor of previous architectural syntaxes, such as Gothic and Renaissance.

Prophetic of the synthesis of the 1920s was the Fagus Works at Alfeld on the Leine (1910–11) by Gropius and Meyer. Dudok's Bavinck School and Municipal Baths at Hilversum (1921) and Mendelsohn's hat factory at Luckenwalde (1920–23) are quasi-International Style in their compositions of pristine geometric masses. One of the earliest space formulations was the tiny jewelry shop (1920–22)

in Amsterdam designed by Rietveld, an assemblage of glazed, cubical volumes asymmetrically composed within a three-dimensional, rectilinear grid, linking inner and outer space. *See* GROPIUS, WALTER; RIETVELD, GERRIT THOMAS.

Also designed during the early 1920s were a number of unexecuted projects that contributed to the new architectural vision. Mies van der Rohe's revolutionary steel-framed, glazed skyscrapers (1919; 1920–21) were prophetic of his later Lake Shore Drive apartments in Chicago (1949–51), and his design for a reinforced concrete office building (1922), sheathed by a curtain wall, foreshadowed the classic Van Nelle Factory (1927–29) in Rotterdam designed by Brinkman and Van der Vlugt. Mies's project for a country house (1923), with its discontinuous planes, anticipated his Barcelona Pavilion of 1929. *See* MIES VAN DER ROHE, LUDWIG.

Le Corbusier's Citrohan houses (1919–22), extensions of his earlier Domino conception (1914–15), materialized in the architect's contribution to the 1927 Weissenhof Exhibition and embodied elements that recur in his work: open plan, usable roof area, and living spaces elevated on *pilotis*. Notable, too, was the Gropius and Meyer design for the *Chicago Tribune* competition of 1922, a lucid grid composition employing the structural skeleton as the dominant visual element, an architectural expression reminiscent of American skyscrapers of the late 19th century and prophetic of typical works of the 1950s and 1960s. Also important during these years were the pictorial house schemes by Van Doesburg and Van Eesteren, designed for the 1923 de Stijl exhibition in Paris. *See* DOESBURG, THEO VAN; LE CORBUSIER.

After the prophetic stage of the early 1920s a period of realization began. Again Rietveld was early in projecting the spatial nature of the new architecture, as seen in his Schröder House of 1924, composed of discontinuous, colored, planar members hovering in a weightless state of equilibrium. Also realized in Holland during these years was Oud's housing block (1924–27) at Hook of Holland, a typical example of the period. The larger and more complex Bauhaus building (1925–26) is a classic, embodying the essentials of the International Style, and the Van Nelle Factory in Rotterdam gave definitive form to industrial building. *See* BAUHAUS; OUD, JACOBUS JOHANNES PIETER.

At the end of the decade, Mies's Barcelona Pavilion, his Tugendhat House at Brno, Czechoslovakia (1930), and Le Corbusier's Villa Savoye at Poissy (1929–30) added to the list of seminal works of this fruitful era. Le Corbusier's Swiss Dormitory (1930–32) at the Cité Universitaire, Paris, though rooted in International Style principles, points toward the sculptural extensions of the style in mid-century.

The international character of the movement was decisively established by several major events. The Pan-European Weissenhof Exhibition (1927) and the foundation of the C.I.A.M. (1928) underscored the broad social, technological, and aesthetic basis of the International Style, and the literature of the period did much to propagate its attitudes and forms. As early as 1923 Le Corbusier published his prose poem *Vers une architecture*, the most influential architectural literary piece of a century prone to architectural verbalizing. Van Doesburg's doctrinaire "Tot een beeldende architectuur" (*De Stijl*, vol. 6, 1924) was an early articulation of the objectives of the period. Gropius's photo survey, *Internationale Architektur* (1925), emphasized in title as well as in content the breadth of the movement, and Ludwig Hilberseimer's *Internationale neue Baukunst* (1927) further promoted the movement. *Gli Elementi dell'architettura funzionale* (1932) by Alberto Sartoris was also influential. *See* C.I.A.M.

The most critically penetrating of the many works written about 1930 is Hitchcock and Johnson's brilliant essay, *The International Style: Architecture since 1922* (1932), written on the occasion of the first International Exhibition of Modern Architecture (Museum of Modern Art, 1932). They christened the movement and defined it as well.

After the high point of the early 1930s the International Style met with resistance in communist Russia and fascist Germany; yet it found its way to most other parts of the world: Scandinavia, North and South America, Japan, Spain, and England. The period was immensely significant, both in consolidating earlier international tendencies and in establishing the basis of a new architectural vocabulary, attitude, and practice. Despite constantly changing forms, the International Style continues to provide orientation to 20th-century architecture.

THEODORE M. BROWN

J

JACK OF DIAMONDS. Group of Russian artists under the influence of Cézanne, formed in the second decade of the 20th century. The group combined cubism with a form of exotic expressionism derived from native folk traditions of Russian Jewry to create the motifs and forms of their paintings. *See* LARIONOV, MICHAEL; MALEVICH, KASIMIR.

JAWLENSKY, ALEXEY VON. Expressionist painter (b. Kuslovo, Russia, 1864; d. Wiesbaden, Germany, 1941). He went to school in Moscow and St. Petersburg. In 1896 he moved to Munich and studied with Anton Azbé. At that time, he met Wassily Kandinsky, Marianne von Werefkin, and David and Vladimir Burliuk, all fellow students. From 1902 on, he worked independently. He traveled in France and was influenced by Cézanne, Matisse, Hodler, and Van Gogh. In 1909 he joined the Neue Künstler Vereinigung in Munich. In 1912 he met Klee and Nolde and exhibited with them and with Feininger, Kandinsky, and other members of the Blaue Reiter group, but he did not become a member. In 1914 he moved to Switzerland. From 1917 to 1921 he painted a series of mystically Fauvist heads, his best-known works. In 1920 he had a retrospective exhibition at the Gurlitt Gallery in Berlin. He moved to Wiesbaden in 1921 and in 1924, along with Feininger, Kandinsky, and Klee, formed Die Blauen Vier (The Blue Four) group which exhibited in Europe, the United States, and Mexico. From 1934 on he continued to paint small pictures of heads, but more abstractly.

In these last works, Jawlensky appears to have been influenced by cubism and, perhaps, by Dutch de Stijl. His first work, done in Russia, shows the influence of the realist Ilya Repin. During his expressionist period, he painted still lifes, figures, and landscapes in a manner

that recalls Kandinsky. With a minimum of modulation, areas of color—fully saturated carmines, ultramarines, and emerald greens—are outlined by simplified, thickened contours and then juxtaposed for contrast. In his abstracted heads, Jawlensky reduces the features to straight, thick lines. A vertical close to the center of the picture plane represents a nose, while horizontals suggest eyes, eyebrows, and a mouth. The faces are shown close up. The lines are designed to resemble crosses, Russian icons, and the like, thus giving the work strong religious and mystical overtones. ROBERT REIFF

JEANNERET, PIERRE, see LE CORBUSIER AND JEANNERET.

JOHN, AUGUSTUS EDWIN, O.M. British portrait, figure, and landscape painter, draftsman, and etcher (1878–1961). Born in Tenby, Wales, John was one of four children, of whom Gwendolen became a considerable artist in her own right. John studied at the Slade School of Fine Art, London, with William Orpen and Ambrose McEvoy, from 1894 to 1898. In 1898 he won the Slade prize for *Moses and the Brazen Serpent.* His skill as a draftsman gained him a considerable reputation even while at the Slade, where one of his more influential teachers was Henry Tonks, an admirer of Degas. As a young painter, John was somewhat eclectic and borrowed from, among others, Watteau, Rembrandt, Goya, Puvis de Chavannes, and Daumier, but for some years after 1910 he adopted the brighter palette and broader treatment of postimpressionism.

Three years after leaving the Slade, he was appointed professor of painting at Liverpool University and held the post from 1901 to 1904. He became a member of the New English Art Club in 1903. By that time he had embarked upon his career as a portrait painter. He found much of his other subject matter among the underprivileged, for example, gypsies, tramps, and beggars, in whom he found an "absolute isolation" of character and greater inspiration than in his usual patrons.

John's later career was concerned primarily with portraits, of which he was a prolific producer. Early studies of members of his family, particularly those of his children Robin (1909) and David (1918), and oil portraits of

George Bernard Shaw (ca. 1914) and Lady Ottoline Morrell (ca. 1926) are among his best and most skillfully composed. Many of the portraits, however, are of a more formal and sometimes stiff quality in spite of his loose, textured brushwork.

<div align="right">JOHN K. D. COOPER</div>

JOHNS, JASPER. American painter (1930–). Born in Allendale, S.C., Johns attended the University of South Carolina and moved to New York in 1952. His paintings, exhibited at the Leo Castelli Gallery and now in international exhibitions and museums throughout the world, deny the emotional immediacy of abstract expressionism, creating an ambiguous and shielded relationship with the viewer. Starting in 1955 with a series in which the entire canvas is covered by the flat image of an American flag, he has since used such singular images as targets, words, and numbers, which create questions about experience by reducing it to a set of signs. This is most pointedly so of a painting such as *Device Circle* (1959; Connecticut, private collection), which presents the materials of the artist in a pseudogeometric, pseudo-ordered manner. Johns's paintings are raised to an iconic level by their exquisitely painted surfaces and their encaustic technique. His more recent works are freer in technique and often include real objects (*Fool's House*, 1962; New York, private collection). Johns is a leading figure in the "neo-Dadaist" trend in the United States and a forerunner of Pop Art.

<div align="right">DONALD GODDARD</div>

JOHNSON, PHILIP CORTELYOU. American architect (1906–). Johnson was born in Cleveland. He studied architecture at Harvard, and he was director of the Museum of Modern Art's Department of Architecture and Design from 1932 to 1954. In 1932, he published the significant *International Style*, a pioneer work of architectural criticism, and organized the first International Exhibition of Modern Architecture (both with Henry-Russell Hitchcock), held at the Museum of Modern Art. He started in private practice in 1945, working in the meticulous classicism of Mies van der Rohe, and collaborated with Mies on the Seagram Building, built in New York City in 1958. Johnson has been very influential as an architect, writer, and lecturer.

JONES, JOE (Joseph John). American landscape painter, muralist, and lithographer (b. St. Louis, Mo., 1909; d. Morristown, N.J., 1963). Jones was a self-taught artist. His early works are social protest paintings, and for a time he was a regionalist, but his later landscapes are more lyrical in feeling. He did a mural for the ocean liner "Independence."

JORN, ASGER. Danish painter (1914–1973). After working briefly with Léger (1936) and collaborating with Le Corbusier at the Paris International Exposition (1937), Jorn then became one of the major expressionist painters of the period following World War II. Ensor and Klee provided strong early influences. Jorn always remained an advocate—in his painting and writing and as a member of such groups as the Imaginist Bauhaus, the Situationist International, and the Surindépendants—of art as an immediate, existentialist activity and an opponent of the rational, constructivist approach. He was the principal figure in the activities of the influential CoBrA group (1948–51). Jorn's paintings, violently swirling patterns of raw-colored pigment with figurative elements emerging like phantoms, reflect the artist's desire to reach buried levels of human experience and reflect his attachment to Scandinavian myth and folk art. *See* COBRA.

JUDD, DONALD. American sculptor (1928–). Born in Excelsior Springs, Mo., Judd studied at the Art Students League in New York City, William and Mary College in Williamsburg, Va., and Columbia University. At first a painter, influenced by Barnett Newman, Mark Rothko, and others, Judd turned to sculpture in 1961. His works, although made up of simple geometric forms, are not so much concerned with geometric construction as with the qualities of forms under differing conditions of light, the materials used, transparency, repetition, openness, and so forth. The forms are manufactured, usually in plastics, plywood, and particularly galvanized iron.

JULES, MERVIN. American painter and graphic artist (1912–). Born in Baltimore, Md., he studied at the Maryland Institute of Fine and Applied Arts and with Thomas Hart Benton at the Art Students League in New York. Jules is most readily associated with expressionism

and with the satirical social comment of his paintings and lithographs of the 1930s and 1940s. His recent work has become milder and more varied in content and more purely aesthetic in point of view.

K

KAHN, LOUIS. American architect (1901–1974). Kahn was born in Saaremaa (Swedish, Oesel), U.S.S.R., and went to the United States in 1905. He received his architectural training at the University of Pennsylvania, and he worked in Philadelphia from 1921 on as a draftsman, architect, and city planner. He maintained his own practice since 1934. Kahn's efforts as a planner culminated with his unrealized Philadelphia City Plan Project (1956–57). After teaching architecture at Yale University (1947–57), he went to the University of Pennsylvania in 1957.

Kahn at first adhered to the geometric purity of the International Style. His later work was developing toward pictorial boldness, with materials, forms, and structure strongly expressed and contrasted, as in the Yale University Art Gallery (1951–53). In the Richards Medical Research Building (1957–61) at the University of Pennsylvania the towers that contain stairs and exhaust and intake ducts for the laboratories feature prominently as volumetric entities. The Mill Creek Housing Project II (1959–62) in Philadelphia, where red brick and concrete are used, recalls Le Corbusier at the Maisons Jaoul (1952) in Neuilly. The monumental Indian Institute of Management, at Ahmedabad (completed 1966), has massive brickwork. A central education building is ringed with L-shaped fortress-like towers that serve as hostels. In 1966 work started on Kahn's new capital city for Dacca, Bangladesh.

ABRAHAM A. DAVIDSON

KANDINSKY, WASSILY. Russian painter (b. Moscow, 1866; d. Neuilly-sur-Seine, 1944). Kandinsky was one of the greatest innovators in the history of modern art; moreover, his discovery of the possibilities of abstract or nonfigurative painting has amounted to one of the very few fundamental

changes of imagery and form in any epoch. His revolutionary compositions of 1910–14 played a seminal role in the total concept of subsequent nonobjective art.

Kandinsky, whose father was a Russian merchant, lived with his parents in Rome and Florence during his early childhood. He attended Moscow University, taking an advanced degree in social sciences and law, and in 1889 accompanied a scientific mission to the region of Vologda, where he was deeply impressed by Russian folk art. He visited Paris later that year. In 1896, having determined to study painting, he went to Munich, studying first at Anton Azbé's school, then under Franz von Stuck at the Munich Academy of Fine Arts until 1900.

Kandinsky founded the avant-garde Phalanx group in 1901, and in 1902 opened his own art school. Between 1903 and 1907 he traveled extensively in the Near East, Holland, Italy, and Germany and exhibited with Die Brücke in Dresden. He headed the Neue Künstlervereinigung (New Artists Federation) in Munich in 1908–09. Out of this association emerged the illustrious Blaue Reiter group in 1911.

Kandinsky's painting underwent a remarkable, although logical, transformation between 1901 and 1908. He at first worked in an almost academically naturalistic manner, which he applied to portrait studies and landscape. Certain paintings of 1905–06 disclose an interest in Russian folkloristic and religious themes, but the semiabstract landscapes of 1908–09 developed out of the Western tradition of representation, not out of decorative sources. The *Street in Murnau* (1908) and *Bavarian Mountains* (1909) are close to French Fauvism in color and to a lesser extent in touch. His first completely abstract work, a water color of 1910 (usually titled *Composition I* or *Improvisation*), consists of freely brushed shapes of light blues, reds, and greens conjoined by inventive linear scratchings.

Between 1910 and 1914 Kandinsky was incredibly productive. At times he worked totally abstractly, and again he returned to oils and water colors in which references were made to mountain landscapes or street scenes (*Autumn I*, 1911; *Improvisation*, 1912; *Small Pleasures*, 1913). Among the most compelling of Kandinsky's pre-World War I abstractions is *Black Lines* (1913; Munich, Thannhauser Gallery). He referred to the musical connotations of some of his abstractions.

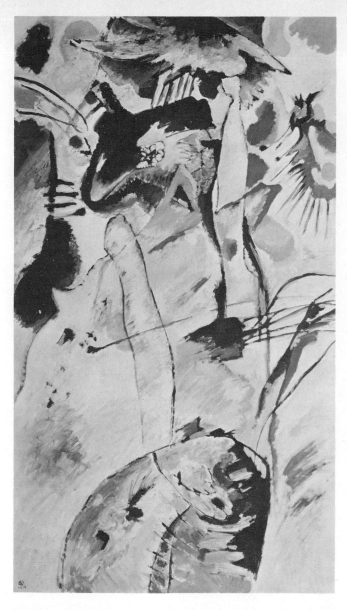

Wassily Kandinsky, *Panel, 3* **(1914). Oil on canvas, 64″ x 36¼″. Museum of Modern Art, New York. Mrs. Simon Guggenheim Fund.**

At the outbreak of war in 1914 Kandinsky went to Switzerland, then to Russia. He was appointed a member of the Cultural Commissariat in 1918, and until 1921 he taught at the Moscow Academy of Fine Arts. He also established some twenty museums in various parts of Russia. He returned to Germany in 1921 and in 1922 was appointed professor in the Bauhaus at Weimar.

After 1921 Kandinsky's abstractions, evidently following a trend that had begun after 1914 during his Russian sojourn, became increasingly geometric in form. The poetic fluidity of the 1910–14 *Improvisation* series was discarded in favor of a new, clean-edged discipline suggestive of the patterns of the architect's French curve and T square (*Improvisation 8*, 1923; *Black Relation*, 1924). Certain later compositions reveal a tendency to soften the precision of the new style, but Kandinsky's aesthetic remained geometrically conditioned until the end of his life.

He formed the Blaue Vier (Blue Four) in 1924 with his Bauhaus associates Paul Klee, Lyonel Feininger, and Alexey von Jawlensky. The group exhibited in Europe, the United States, and Mexico. Kandinsky moved with the Bauhaus to Dessau in 1925. He traveled extensively from 1929 to 1931, meeting James Ensor in Belgium and holding an important one-man show at the Galerie Zak in Paris. When the Bauhaus was closed by the Nazis in 1933, Kandinsky went to Neuilly-sur-Seine, a suburb of Paris, where he lived for the rest of his life. His works, like those of most German expressionists, were labeled "degenerate" by the Nazis in 1937.

Outstanding collections of Kandinsky's works are in the Municipal Gallery and Lenbach Gallery, Munich; the Guggenheim Museum, New York; and the Collection of Mme Nina Kandinsky, Neuilly-sur-Seine. Kandinsky's importance to modern painting was increased by his contributions as a theorist and writer on art. His most important written work, *Uber das Geistige in der Kunst* . . . (*Concerning the Spiritual in Art* . . .), 1912, was translated into many languages and exerted considerable influence on the modern movement.

JOHN C. GALLOWAY

KAPROW, ALAN. American artist (1927–). Kaprow studied at the Hans Hofmann School in New York City

(1947–48) and with the composer John Cage (1956–58). Also trained in art history at Columbia University, he now teaches in that field. Kaprow's first one-man show of paintings and works in other media was given at the Hansa Gallery, New York, in 1952, but he is known primarily for his invention of the "happening." In this form of combined theater and art, first tried by Kaprow in 1958, a total environment is created for a series of actions that are carried out by participants according to a scenario.

KARFIOL, BERNARD. American painter (b. Budapest, Hungary, 1886; d. New York City, 1952). He studied at the National Academy of Design in 1900 and the following year with Jean-Paul Laurens in Paris. Karfiol exhibited in the Armory Show of 1913. He first worked in a manner derived from the precubist Picasso, painting tense, elongated figures whose stylizations revealed an interest in archaic art. In the 1920s Cézanne's volumes and brushwork and Renoir's warm color became the chief sources for Karfiol's tender studies of children and for his nudes, for example, *Seated Nude* (1929; New York, Museum of Modern Art). His later figures are more academic in style.

KAZ, NATHANIEL. American sculptor (1917–). He was born in New York City and studied under George Bridgman at the Art Students League. Kaz has taken several awards and prizes in competitions at the Detroit Institute of Arts, the Audubon Association, and elsewhere. His work is represented in the Brooklyn Museum, the Whitney Museum of American Art in New York, and the Museum of Modern Art in New York. *Cyrano* (1950; Whitney Museum of American Art), one of his best-known works, is a provocative combination of traditional figure pose and bent, twisted nonfigural extensions of body rhythms into space.

KELLY, ELLSWORTH. American painter (1923–). Kelly studied at the Boston Museum School and lived in Paris between 1948 and 1954. He has executed sculptural decorations for the Transportation Building in Philadelphia (1957) and the New York State Pavilion at the New York World's Fair (1964–65). His paintings appeared at the São Paulo Bienal (1961) and received prizes at the Car-

negie International (1962; 1964). Influenced primarily by Arp in his paintings of the 1950s, Kelly used a flat and smoothly but irregularly outlined shape of color on a neutral field, creating an expansive tension with the frame. His recent paintings have depended on luminous color alone to create space, sometimes with several canvases, each a different color, juxtaposed.

KEMENY, ZOLTAN. Hungarian-Swiss metal sculptor, painter, and architect (b. Hungary, 1908; d. Zurich, 1965). Zoltán Kemény immigrated to Paris in 1930 and worked as an architect, but after moving to Switzerland in 1942 he became known as a painter. By thickening paint with sand and plaster, he developed reliefs. He finally became a sculptor, working directly with metal in an abstract style, and in 1964 he received the grand prize in sculpture at the Venice Biennale.

KENT, ROCKWELL. American painter, illustrator, graphic artist, and writer (1882–1971). Born in Tarrytown Heights, N.Y., he studied with William Merritt Chase, Abbott Handerson Thayer, Robert Henri, and Kenneth Hayes Miller. Kent began, on the fringe of the Henri group, as a painter of darkly tonal landscapes, for example, *Road Roller, New Hampshire* (1909; Washington, D.C., Phillips Collection). The characteristics here evident, such as the strong, rhythmic design and the emphasis on simplified and expressive silhouetted shapes, were to be developed in Kent's large production of paintings, especially landscapes, the result of his wide travel and interest in the symbolic treatment of nature, and in his many book illustrations and prints.

KEPES, GYORGY. American designer, painter, educator, and author (1906–). Born in Selyp, Hungary, Kepes studied at the Royal Academy in Budapest (1924–28) and later joined the Bauhaus in Berlin (1931–34). He worked there, and later in London (1935–36), with the effects of light and shadow on photo-sensitized paper and on stage and exhibition design. In 1937 he went to the United States and became head of the light and color department of the Institute of Design in Chicago (1937–43). There he continued his film experiments, for example, *Photomontage* (1937). He has worked in advertising design and interior

design. Since 1946 he has been professor of visual design at the Massachusetts Institute of Technology, and since 1960 the editor of *Visual Arts Today*.

KIENBUSCH, WILLIAM. American painter (1914–). He was born in New York City, where he now lives. In 1936 he graduated from Princeton University and studied with Eliot O'Hara, Mervin Jules, and Anton Refregier. He went to Maine after World War II and came under the influence of Marsden Hartley. In 1949 Kienbusch had his first one-man show in New York. He was given a retrospective at the Carnegie Institute and his work was included in the 1955 Whitney Museum of American Art show "The New Decade."

In his best-known pictures, he abstracts the Maine scene—its islands, buoys, pine trees, and sheds—seizing upon details and expanding them without losing the flavor of rural New England. In 1958 he went to Crete and painted the ruins of Cnossus and Phaistos in a similar manner.

KIESLER, FREDERICK JOHN. Austrian-American architect and stage designer (b. Vienna, 1892; d. New York City, 1965). He studied with Adolf Loos (ca. 1910), was associated with de Stijl in the early 1920s, and in 1926 immigrated to the United States, where he was a scenic designer at the Juilliard School of Music, New York, and director of the Architectural Laboratory at Columbia University. Essentially an architectural experimenter, his most significant work, historically, was La Cité dans l'Espace (Paris Exhibition of 1925), a suspended Cartesian space grid constructed of rails and planes. His last major work (with Armond Bartos) was the poetically conceived Shrine of the Book, housing the Dead Sea Scrolls, in Jerusalem.

KINETIC SCULPTURE. Sculpture incorporating some aspect of motion. Early examples were Duchamp's bicycle wheel of 1913, entitled *Mobile*; Gabo's *Kinetic Sculpture*, exhibited in 1922; Moholy-Nagy's light machine of 1930; and Calder's machine-propelled and later wind-driven mobiles, which appeared from 1932 on. More recently, kinetic sculpture has included movable works, in which the observer can rearrange the sculpture, sometimes to the

extent of a complete redesign, as in Kobashi's *Plumbob IV* (1960; Princeton, N.J., P. J. Kelleher Collection), and machines in diverse forms, usually driven by electric motors, with gears, cams, cranks, and levers, as in Ultvedt's *Construction* of 1961 and Tinguely's *Water Sculpture* of 1960. Tinguely, among others, has introduced the element of sound: some of his machines pound at a rock-and-roll tempo. (See illustration.) *See* CALDER, ALEXANDER; DUCHAMP, MARCEL; GABO, NAUM; MOHOLY-NAGY, LASZLO; TINGUELY, JEAN.

KIRCHNER, ERNST LUDWIG. German expressionist painter and graphic artist and a leading figure in Die Brücke (b. Aschaffenburg, 1880; d. Davos, 1938). His first interests were in early German woodcut artists such as Dürer. In 1901, while in Dresden studying architecture, he began to paint in company with another architectural student, Fritz Bleyl, and in 1903–04 he attended art school. He then returned to architecture school, where he met Erich Heckel, who joined him and Bleyl in their pursuit of art; the three worked in a store converted into a studio. In 1904 Kirchner developed a neoimpressionist style and became influenced also by medieval German art and Japanese prints. At this time he saw African and Oceanic art in the Dresden Ethnological Museum, which proved significant in the development of his future primitivistic leanings and those of Die Brücke. *See* EXPRESSIONISM.

Kirchner's earliest drawings and graphics show a high degree of originality but also reveal strong Jugendstil elements and the influence of Edvard Munch's linear sweep and flat color areas. These sources, together with the flat, brilliant areas of Félix Vallotton, contributed to the decorative and two-dimensional character of Kirchner's early work.

In 1905, with the addition of Karl Schmidt-Rottluff, Die Brücke was organized; and in 1906 Emil Nolde, Max Pechstein, Cuno Amiet, and Axel Gallén-Kallela joined the group. During the summers of 1907 to 1909 on the Moritzburger Lakes they made studies of the nude in nature, and during the winters they worked in the studios of Heckel and Kirchner. As the influence of Van Gogh made itself increasingly felt in the group, Kirchner's color became more spatulated and expressively brilliant. Although they were under French influence, Kirchner and his circle,

unlike the Fauvist painters, leaned toward an erotomania derived from Munch, with symbolic representations of men and women portrayed together in various circumstances. Never content with a "form for form's sake" presentation, Kirchner preferred to convert the form of visible nature into a symbol of life.

In 1910 Otto Müller was the final recruit to Die Brücke; and in that year Kirchner produced the group's annual subscribers' portfolio of graphic works. In 1911 they moved to Berlin, and Kirchner's drawings began to run in *Der Sturm*, Germany's leading avant-garde periodical.

The exciting life of the city added a psychological and dynamic quality to a whole new series of subjects that reveal Kirchner as perhaps the outstanding and typical figurative expressionist. In his nudes outdoors, nature is used as a mirror of the artist's soul; the figures emerge from their background in a state of nature, their emotions heightened by conflicting rather than complementary color, by brutalized forms, and by a tense, distorted space. Similarly, the city scenes of Kirchner and his friends (for example, his *Street Scene,* 1913; New York, Museum of Modern Art) have a philosophical intention in their portrayal of anonymous masklike faces moving aimlessly about the streets. Kirchner is more analytical in these themes than in the representations of nudes outdoors, which were more poetic and universal. But both types of subject convey his interpretive attitude, the basic expressionist quality of searching for some deeper value beyond the outward appearance, which he altered by distortions of form, color, and space.

In 1917 Kirchner settled in Switzerland near Davos, and the rest of his life was spent in a mountain retreat at Langmatt. Now the city philosopher became the poet of the mountains and peasants. His nervous, graphic Berlin style yielded to a more sculpturesque form and a new color quality, no longer stressing dissonances but emphasizing an enamellike brilliance that supports the new formal qualities. This quest for monumentality and serenity is far removed from the spirit of his earlier work. His figures convey the roughhewn feeling of some archaic period, the glorified, symbolic peasants disclosing another philosophical facet of his creativity.

BERNARD S. MYERS

KISLING, MOISE. French painter (b. Cracow, Poland, 1891; d. Sanary, France, 1953). At fifteen he won a competition that gained him entrance to the Cracow academy. His teacher, Joseph Pankiewicz, who had been to France and had met the impressionists and also Bonnard and Vuillard, inspired Kisling to go to Paris, where he arrived in 1910 and soon became a well-known figure in Montparnasse. He made a trip to Brittany; then, in 1911–12, he spent some time in Céret in the company of Braque, Picasso, Juan Gris, and the poet Max Jacob.

Kisling's painting was appreciated by only a few persons until 1919, when he exhibited at Druet's and his work was a great success. He began to free himself from all influences and soon acquired a very personal style. As he was gifted with a Slavic sense of color and a graphic elegance, he became a fashionable portrait painter. Kisling's painting betrays no struggle or anguish but is content to portray well-being and fashionable ease. His color is always warm and creates a joyous enthusiasm for life, which reflected his attitude.

His curves and distorted forms have much in common with Modigliani's art. Like Modigliani also, Kisling was above all interested in portraits and in the nude. He excelled in painting women, content to create a superficial record pleasing to the eye. As a minor representative of the school of Paris, he reflects the era between the two World Wars. ARNOLD ROSIN

KLEE, PAUL. Swiss-German painter (b. Münchenbuchsee, near Bern, 1879; d. Muralto-Locarno, 1940). Klee has been identified with surrealism, Dada, and nonobjective art. His painting, however, belongs, with allowance for a keenly personal aesthetic, to the development of abstract expressionism and his contribution to that history was a distinguished one.

In Bern Klee studied the violin. He chose the visual arts for a career, but his early training in music is clearly evident in his painting. His works often disclose elements affiliated with sound and the principles of musical composition.

Klee left Bern for Munich in 1898, first studying at Knirr's art school, then working under Franz von Stuck at the Munich Academy. He was confronted by a complex of *fin-de-siècle* sources: Jugendstil, impressionist and

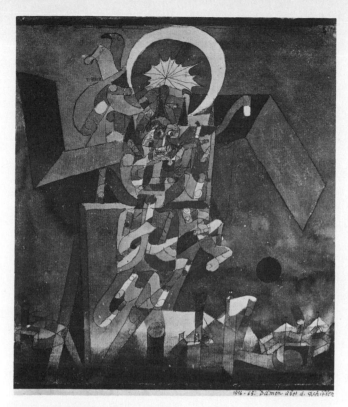

Paul Klee, *Demon above the Ships* (*Dämon über den Schiffen;* 1916). Watercolor, pen and ink, 9" x 7⅞". Museum of Modern Art, New York. Lillie P. Bliss Bequest.

postimpressionist exhibitions, Böcklin's somber allegories, and the academy itself. Klee's protosurrealist graphic works of 1903–05 suggest additional influences as well: Goya, Redon, Ensor, and, in all probability, literary works of a macabre kind. He was also stimulated by the traditional art of Italy during a visit there in 1901 and by the Fauvist style (although he did not immediately respond to it), observed in Paris in 1905.

Given to deliberate rather than spontaneous assimilation of sources, he did not clearly divulge a fully mature method until 1914, after his association with the Blue Rider group in Munich in 1911–12 and his acquaintance with

Delaunay and orphist cubism in 1912. According to Klee's own observation, it was the stimulation of the landscape of North Africa during a visit there with Macke in 1914 that led him to recognize color as his central inspiration.

Klee appears to have found his own way just before he entered the German army in 1914. He continued to paint from time to time throughout his war service, and his work was exhibited by the Dada Gallery in Zurich in 1917. His greatest development occurred after 1919 as he exploited both representational and abstract approaches. He sometimes created works of a poetically sensitive geometry, working during the same period on his unique, personally construed fantasies of plant and animal forms, usually whimsical allegories of creature and environment.

In 1920 Klee had a huge retrospective at the Goltz Gallery in Munich (his first major one-man show had been held at the Thannhauser Gallery, Munich, in 1911), and he was appointed to the faculty of the Bauhaus at Weimar. His intricate teaching theories were published in his *Pädagogisches Skizzenbuch* (*Pedagogical Sketchbook*) in 1925. He was represented in a number of exhibitions during his Bauhaus tenure, including one-man shows at the Kronprinz Gallery in Berlin (1923), the Société Anonyme in New York (1924), and the Galerie Vavin-Raspail in Paris (1925). His work was also shown at the first surrealist exhibition in Paris in 1925.

When the Nazis closed the Bauhaus in 1933 Klee returned to Switzerland. He was given a retrospective in Bern, Lucerne, and Basel in 1935. Klee was seriously ill from a progressive skin and muscular disease during the late 1930s. The style of his painting, once characterized by his remarkably acute linear or fluid nuances, changed to a flat-patterned, broadly drawn, and simplified expression. His imagery, always deeply personal and still whimsical despite the ravages of his illness, was depicted in a bolder but more easily executed manner, sometimes with a single color drawn through with thickly brushed outlines.

It is possible to subdivide Klee's art into many styles, but four major periods may be defined to include the salient changes in his growth. His earliest significant landscape studies in pencil date from the 1890s (*Across the Elfenau*, 1897) and signify a searching, somewhat impressionist, and by all means talented approach. A second

phase includes the pre-World War I etchings and engravings of grotesque themes (*Comedian*, 1904; *Hero with a Wing*, 1905) and brush-and-pen drawings, especially portrait studies and landscapes (*Self-Portrait*, or *Young Man at Rest*, 1911; Bern, Bürgi Collection).

Klee's unmistakably individual style emerges, however, in his smallish water colors dating especially from 1914 (an untitled abstraction, 1914; Bern, Klee Foundation) and in pictures in various media, including such combinations as water color, pen, and rubbed printer's ink (*The Twittering Machine*, 1922; New York, Museum of Modern Art), oil (*Dance-Play of the Red Skirts*, Bürgi Collection), and gouache (*Steamship and Sailing Boats at Sunset*, 1931; private collection), continuing through several linear, geometric, and mosaiclike substyles until about 1935. The fourth period comprises an increasingly simplified, flatly painted and broadly drawn series of gouaches and oils done between 1935 and 1940, typified by *Revolution of the Viaduct* (1937; Hamburg, Art Gallery) and *Locksmith* (1940; Basel, Public Art Collections). The latter is typical of his late style, and consists of a remarkably simple, thickly drawn black line through flat shapes of bright red.

Although his style and personally symbolic content are unique, Klee has been strongly influential for his liberation of the painterly imagination. He was one of the most original technicians and theorists among the earlier abstract expressionist artists of this century. His art inspired the Dadaists and surrealists even though he was not actually a member of either group.

JOHN C. GALLOWAY

KLINE, FRANZ. American painter (b. Wilkes-Barre, Pa., 1910; d. New York City, 1962). He attended Boston University and Heatherley's Art School, London (1937–38). His abstract style developed after World War II, at which time Kline, with Motherwell, Pollock, and other New York avant-gardists, held open discussions in Greenwich Village. His first one-man show was at the Egan Gallery, New York, in 1950. He was represented in "The New Decade" (1955) at the Whitney Museum of American Art, New York; in "Twelve Americans" (1956) and "The New American Painting" (1958) at the Museum of Modern Art, New York; and in the São Paulo and Venice international exhibitions (1957 and 1960).

Kline's action style, strongly personal and influential, is typified in such canvases as *New York* (1953; Buffalo, N.Y., Albright-Knox Art Gallery) and *Siegfried* (1958; Pittsburgh, Pa., Carnegie Institute). He formed powerful, skidding strokes of black in irregular grid patterns on white grounds, sometimes with half-suppressed edges of color appearing alongside the black forms.

KNATHS, KARL. American painter (1891–1971). Born in Eau Claire, Wis., he studied at the Art Institute of Chicago. His early paintings were impressionistic. Most of his later subjects are taken from scenes and activities around Provincetown, where he settled about 1919. About 1930, with the adoption of a theoretical system of painting, Knaths's work became more abstract. The influence of cubism is dominant, either obviously, as in the still life *Mexican Platter* (1946; New York, Whitney Museum of American Art), or more subtly, in the linear framework of the forms, as in *Net Mender* (1957; Washington, D.C., Phillips Collection). Knaths's own lyrical approach to nature at times transcends his theories, as in *The Sun* (1950) and *Pine Timber* (1952; both Washington, D.C., Phillips Collection).

KOERNER, HENRY. American painter (1915–). Born in Vienna, he studied at the Vienna Academy. He went to the United States in 1938. Koerner paints genre subjects with a sharp-focus, photographic naturalism reminiscent of Flemish painters. At times his symbolic themes are treated in a style influenced by the expressionism of Otto Dix and Max Beckmann. The socially satiric intention of Koerner's work can be seen in the panoramic *Vanity Fair* (1946; New York, Whitney Museum of American Art). More recently, he has done many covers for *Time*, in a loosely painted version of Cézanne's modeling.

KOHN, MISCH. American painter and printmaker (1916–). Born in Kokomo, Ind., he studied at the John Herron Art Institute in Indianapolis. He was in Mexico in 1943–44. Kohn was awarded Guggenheim fellowships (1952 and 1955) and a Tamarind fellowship in lithography (1960). He is best known for large wood engravings such as *Tiger* (1949), and more recently for equally large lift-ground aquatints such as *Lion* (1957).

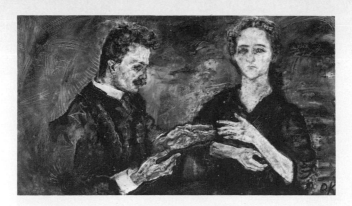

Oskar Kokoschka, *Hans Tietze and Erica Tietze-Conrat* **(1909). Oil on canvas, 30⅛" x 53⅝". Museum of Modern Art, New York. Abby Aldrich Rockefeller Fund.**

KOKOSCHKA, OSKAR. Austrian expressionist painter (1886–). Born in Pöchlarn on the Danube, he now lives in London and Switzerland. He studied at the Arts and Crafts School in Vienna from 1905 to 1908 on a scholarship. His strongest influences were Klimt, Hodler, and Munch, and his early graphic works (the illustrations for his own story, *The Dreaming Boys,* 1908) were conditioned by the Jugendstil and Secession manners then highly influential in Vienna and elsewhere among German-speaking artists. Kokoschka knew Schiele during this period.

Kokoschka was dismissed from the Arts and Crafts School because of the exoticism of his pictures and writings, but he was simultaneously taken up by the Viennese avant-garde. His two exhibitions at the Kunstschau in 1908 and 1909 and two of his plays of 1908, *Sphinx and Strawman* (produced again in the early 1920s by the Dadaists) and *Murderer, Hope of Women,* led to violent public opposition. In 1909 he began to travel; later, his trips were sponsored by dealers or collectors. He was active as a consultant to Herwarth Walden for *Der Sturm* between 1910 and 1914 in Berlin, during which time he exhibited at the Hagenbund show, the Cologne Sonderbund, and at a one-man show at Der Sturm gallery in 1912.

From 1908 to 1914 Kokoschka painted a series of the most remarkable portraits of this century, psychologically

incisive and highly personal in technique: *Hans Tietze and Erica Tietze-Conrat* (New York, Museum of Modern Art), *Peter Altenberg, Frau Lotte Franzos, Ritter von Janikowsky,* all 1909; and *Count Verona, The Duchess of Rohan-Montesquieu,* and *Frau Dr. K.,* all 1910. Kokoschka was wounded in World War I and discharged in 1916 for extreme psychological instability. After treatment, he was appointed professor of art at the Dresden Academy in 1919 but left the position abruptly in 1924, traveling throughout Europe and in the Near East until 1931. This period yielded a series of powerful landscapes, "portraits of cities," including *Paris Opera* (1924; New York, private collection), *Tower Bridge* (1925–26; Minneapolis Institute of Arts), *Lyons* (1927; Washington, D.C., Phillips Collection), and *Dolce Bridge, Scotland* (1929; Los Angeles, private collection).

He settled in Vienna, where a large retrospective of his work was held in 1937. That same year his art was condemned as "degenerate" by the Nazis and he left Vienna. He lived in Britain during World War II, and produced many antiwar canvases on themes of destruction and despair (*What Are We Fighting For,* 1942–43, artist's collection). After the war Kokoschka visited the United States where he painted *Montana*—related to his cityscapes of the 1920s (1947; Zurich, Kunsthaus)—and Switzerland, where the Basel Art Gallery held a large one-man show. He was also represented in the 1947 Venice Biennale and had a major retrospective at the Tate Gallery, London, in 1962. Since 1948 he has lived mainly in Switzerland.

Kokoschka is one of the major expressionist artists of the time. Especially noteworthy are his remarkable portraits preceding World War I and the strong landscapes of the late 1920s.

<div style="text-align: right">JOHN C. GALLOWAY</div>

KOLBE, GEORG. German sculptor (b. Waldheim, 1877; d. Berlin, 1947). Kolbe's first training and practice were in graphic arts and painting. His career was centered in Dresden, Munich, and Leipzig. His influences included Max Klinger, whose sculpture combined certain elements of neoclassicism with Rodinesque contrasts of high finish and unrefined areas of material. This paradox was to characterize much of Kolbe's expression following his con-

version to sculpture in 1900.

Kolbe's favored medium was bronze. He used it in a variety of busts, figures, and memorials dating from the first years of his career. Like Maillol, who with Klinger and Rodin formed the paradoxical sources of Kolbe's basic aesthetic, he preferred the nude figure, especially that of the female, as a vehicle. Movement, sometimes implicitly violent but invariably arrested rather than outgoing, marks his style.

Quieter structuring is more nearly typical, however, as in *Assunta* (1921; Detroit Institute of Arts), a thinly formed female nude with upraised hands at the level of the breast, not yet completing the gesture of clasping. The surface is similar to that of *Grief* and other characteristic bronze works. It appears at first to have a highly polished finish, but it is actually a compromised texture, which in quality lies somewhere between a fully broken exterior, as in Rodin, and cubic, smoothly modeled volumes, as in Maillol. Kolbe's sentiment seldom denotes a maturity of interpretation; rather, it imparts to *Assunta* and related figures a curiously mannered gracefulness.

Kolbe is often grouped with artists of the expressionist movements in Germany, but such a classification is apt only in the most leniently applied sense, since his style fails to reflect the emotive values of expressionism. While Kolbe's aesthetic cannot be criticized as impersonal, it contrasted sufficiently with that of the incisive images of most of Germany's gifted artists to be exempt from official Nazi censure. Kolbe became extraordinarily popular and continued to work in Germany until after World War II. He was commissioned to do more than a dozen public monuments, some of them of large format.

Kolbe's stronger works include, in addition to those mentioned, a bust of Johann Sebastian Bach (1903; Leipzig Museum), *Seated Girl* (1907; private collection), *Portrait of W. R. Valentiner* (1920), and *Seated Figure* (1926; both New York, Museum of Modern Art).

<div align="right">JOHN C. GALLOWAY</div>

KOLLWITZ, KATHE. German graphic artist, painter, and sculptor (b. Königsberg, 1867; d. Moritzburg, 1945). Käthe Kollwitz (nee Schmidt) studied drawing with Rudolf Mauer at the age of thirteen; later she pursued art studies with

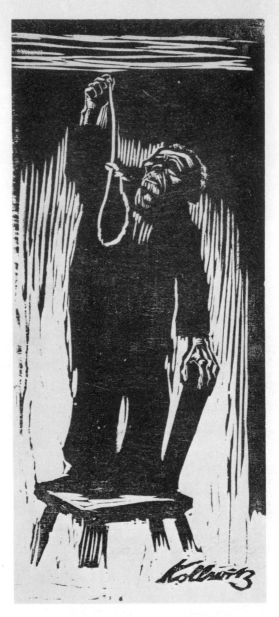

Käthe Kollwitz, *Old Man with Noose* **(1925). Woodcut, 11⅜″ x 5″. Museum of Modern Art, New York. Gift of Edward M. M. Warburg.**

Emile Neide, Stauffer-Bern, and Ludwig Heterich. Her early works were chiefly paintings, but she gradually found graphic arts more suitable to her vision, as she herself has said, "to express the suffering of man which never ends and now is immeasurably great."

In 1891 she married Karl Kollwitz and they moved to Berlin, where he practiced medicine in a poor suburb for workers. She continued with her art and gave her first public exhibition in 1893.

The milestones of her creative life are six great cycles of etchings, lithographs, and woodcuts. The first, *Weavers' Rebellion* (1895–98; three lithographs, three etchings), based on Hauptmann's play *Die Weber*, depicts the plight of indigent Silesian weavers. In 1899 she received an award for this work in the Dresden German Art Exhibition, and in 1900 a prize in London.

At the time of her second cycle, *Peasants' War* (1902–08; seven prints executed in complicated techniques), she was experimenting with the variety afforded by the graphic media. Again, the theme of revolt among the oppressed appears, but on a larger scale. For this she was awarded the Villa Romana prize, which entailed a year's residence in Florence. She sculptured the first version of her memorial for fallen volunteers in 1915; this was later destroyed. In 1925 she made a second version, which was set up in the soldiers' cemetery at Essen-Roggcvcld ncar Dixmuide. It represents a grieving mother and father—portraits of herself and her husband. In 1919 she became the first woman professor elected to the Berlin Academy of Art.

The sequence *War* (1922–23; seven woodcuts) reflects the reactions of a wife and mother. Her fourth cycle, three woodcuts called *Proletariat*, appcarcd in 1925; this was one of her most powerful works. At the beginning of the Nazi regime in 1933 she lost her professorship in the Berlin Academy. From 1934 to 1935 she produced her last great cycle of seven lithographs, *Death*. Käthe Kollwitz spent the last three years of her life at Moritzburg Castle as a guest of the Prince of Saxony.

FRANKLIN R. DIDLAKE

KROHG, PER. Norwegian painter (1889–1965). From 1897 to 1930 he lived principally in Paris. He studied under his father, Christian Krohg, at the Académie Cola-

rossi (1903–07), and with Matisse (1907–09). In 1930 he returned to Norway. Krohg taught at the State Art and Craft School from 1935 to 1946, when he was appointed professor at the State Art Academy, Oslo. A major figure in the renaissance of mural painting in Norway since World War I, Krohg executed several important commissions, including frescoes in the Maritime School and Town Hall, Oslo, and a mural in the Security Council chamber of the United Nations, New York. His style is decorative and expressive with large, flowing rhythms. In his easel paintings (landscape, genre, portraits) there is often a freer, shimmering movement of line and values and, at times, a monumental or decorative character related to the frescoes.

KROLL, LEON. American painter and lithographer (1884–). Born in New York City, he studied at the Art Students League and the National Academy there and in Paris with Jean-Paul Laurens. Kroll's early works are strongly brushed urban and industrial landscapes such as *The Bridge* (1910–11; Baltimore, Union Memorial Hospital), which are loosely related to the style of the New York realists. His later paintings are basically academic in style, despite the sense of plasticity and color derived from Cézanne and Renoir. Their subjects are mostly still lifes and the figure, such as *Nude in a Blue Chair* (1930; New York, Whitney Museum). Kroll has executed murals for the Justice Building, Washington, D.C. (1937), and the War Memorial in Worcester, Mass. (1938–41).

KUBIN, ALFRED. Austrian expressionist graphic artist, illustrator, and painter (1877–1959). In his autobiography, *Sansara* (1913), Kubin described his early life as a series of vivid traumatic experiences with family unhappiness and school failure. He was born in Bohemia and attended the Industrial Art School at Salzburg; he then became apprenticed to an uncle who was a photographer in Klagenfurt. Kubin's stark grim linear distortions embody a fantastic world of visions of haunting immediacy.

Kubin arrived in Munich in 1898, when that city was in the midst of artistic ferment. His drawing *Crushing* (1903) shows a strange animal, half fish, half reptile, about to crush a tiny man situated at the edge of an abyss. Like this drawing, much of Kubin's work is underscored thematically by an imminent catastrophe. In spirit, Kubin is

related somewhat to Ensor; in spite of the uniqueness of his work, he is indebted to artists who were popular around the turn of the century, notably Goya and Beardsley, and he had the greatest respect for the work of Max Klinger.

In 1903 Kubin exhibited with Kandinsky in the Phalanx; found his first patron, Hans von Weber of Munich, who financed his first portfolio; and completed his *War* series. In 1905 in Paris he met Redon and turned toward a more direct symbolism. In his pen drawing, *Night Encounter*, there is no direct threat of violence, but the shadowiness of the background and the dim light seem to presage some sinister turn of events. After 1905 Kubin began a fantastic biological series: in his pictures of mollusks and amoebas, he combined microscopic observation with dream images.

The many books Kubin illustrated seem to have been chosen for their macabre settings. Among these were Poe's *Goldbug* (1910) and *The Beating Heart* (1923), Wilde's *The Ballad of Reading Gaol* (1918), and Barbey d'Aurevilly's *Devil's Children* (1921). In spite of some apparent similarities to Klee, Kubin shows little of Klee's gentle humor but rather a satanic glee. Kubin's art is an imaginative and psychological experience that had considerable influence during the post-World War I era.

ABRAHAM A. DAVIDSON

KUHN, WALT. American painter (1880–1949). Kuhn was born in New York City. In 1899 he took a position as a cartoonist in San Francisco. He contributed to a number of publications in the East, such as the *New York Sun* and the old *Life*. He was thirty when he sold his first picture. Kuhn studied informally in Paris and visited Germany, Holland, and Spain. He taught at the New York School of Art in 1908–09 and at the Art Students League in 1926–27. An important adviser to the lawyer John Quinn in forming a collection, Kuhn also served in a similar capacity to Miss Lillie Bliss, many of whose acquisitions were bequeathed to the Museum of Modern Art in New York.

Kuhn was secretary to the Association of American Painters and Sculptors (1912), when Arthur B. Davies was president. Together, they were significant in organizing and presenting the Armory Show of 1913 in which such modern masters as Matisse, Picasso, Duchamp, Brancusi, and others were first presented to a large public.

Kuhn's earliest paintings recall those of Robert Henri and George Luks; that is, they develop from the Ashcan school tradition. A distinct change occurred after his intimate involvement with the Armory Show; his painting began to show the influence of Matisse, Derain, and Picasso of the Blue Period. In his mature work, for which he is best known, the role Cézanne played in the formation of his style is apparent.

Kuhn's best-known works are those of clowns and acrobats. They are rarely shown performing but appear isolated in a portrait situation, as if they were posing for the artist just prior to or after a performance. Kuhn is fond of showing them partially in costume with grease paint on. He never shows them as comic figures, nor does he sentimentalize them. He often places them in a strong overhead light and defines contours with bold, linear accents. *The Blue Clown* (1931; New York, Whitney Museum of American Art) is a typical painting.

ROBERT REIFF

KUNIYOSHI, YASUO. American painter (b. Okayama, Japan, 1893; d. New York City, 1953). After going to the United States in 1906, he was encouraged by a high-school teacher to study art. He went to the Los Angeles School of Art and Design and later studied with Kenneth Hayes Miller at the Art Students League in New York. His first one-man show was held in 1922 in New York at the Daniel Gallery. In 1925 and 1928 he went to Paris where he saw much modern painting and was influenced by it. In 1931 he returned to Japan for a visit, and in 1935 he went to Mexico on a Guggenheim grant. Kuniyoshi was the first president of Artists Equity and cofounder of the American Artists Congress. In 1948 he was given a large retrospective exhibition at the Whitney Museum of American Art in New York, and in 1952 he was represented at the Venice Biennale.

In the early 1920s, Kuniyoshi took Campendonk and Chagall as models. With whimsical slyness, he depicts mischievous boys, heavy-lidded cows, fantastic landscapes, and the like in a piquant, decorative manner. In the 1930s his painting is more lyrical and naturalistic. He limits himself largely to studies of languid, pensive women and to still lifes composed of such disparate elements as a rose, a dismembered hobbyhorse, a torn poster, binoculars, a vase,

an old umbrella, and so on. Gradated tones suggest atmosphere. Contours are extended and textures exaggerated. Silvery grays, delicate tans, rusts, and olive greens are favored colors.

In his last period, his palette is extended and bright colors—frosty reds, saffron yellows, lilacs, acid greens, and sharp blues—are juxtaposed to lend a posterlike, bittersweet quality somewhat in the manner of Ben Shahn's contemporaneous work. Kuniyoshi's painting assumes an ominous, almost sinister cast. His still lifes are composed of crumpled paper, rent cloth, disjointed mannequins, and so on, shown against a brooding sky or desolate stretch of land. ROBERT REIFF

KUPKA, FRANK (Frantisek). Czechoslovakian painter (b. Opocno, Bohemia, 1871; d. near Paris, 1957). Kupka may be identified with orphist cubism and with the development of nonobjective, geometrical abstraction. He studied at the Prague School of Fine Arts in 1888. In 1891 he lived in Vienna and exhibited at the first Kunstverein; in 1895 he settled in Paris. At the turn of the century Kupka was a prolific illustrator of books, one of which was Elie Faure's *Song of Songs* transposition. He won a prize at the 1902 St. Louis International Exposition.

In 1906 he began a series of exploratory studies which in 1911 emerged as abstractions. His Salon d'Automne entries of 1910 revealed both Fauvist and cubist tendencies and are notable principally for their bright color. To some degree under the influence of Delaunay's orphism, Kupka in 1912 and 1913 exhibited abstract compositions (*Fugue in Red and Blue*; *Philosophical Architecture*) in which rectangles, turned in space so as to have the effect of trapezoids or parallelograms, were brilliantly painted in primary hues.

Kupka's painting received only moderate attention until the 1930s. He was honored by a retrospective at the Jeu de Paume Museum in Paris in 1936. A second comprehensive exhibition was given in Czechoslovakia in 1946, and a museum was founded there in his name. He was a leader of the Salon des Réalités Nouvelles in Paris and was made an officer of the Legion of Honor. An important one-man show was given at the Galerie Louis Carré, Paris, in 1951; and a retrospective was held posthumously at the National Museum of Modern Art, Paris, in 1958.

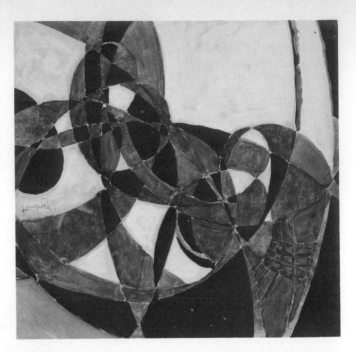

Frank (Frantisek) Kupka, *Fugue in Two Colors: Amorpha* (1912). Gouache, brush and ink on paper, 12⅜″ x 12¾″. Museum of Modern Art, New York. Gift of Mr. and Mrs. Frantisek Kupka.

Additional key works by Kupka include *Black Accents* (1913; private collection), *Red and Blue Vertical Planes* (1913; Carré Gallery), *The Cathedral* (1913–14; private collection), and a series of *Architectural Studies* done in the 1920s. Certain of these compositions bear a distinct similarity to the later geometrical abstractions of Josef Albers and the Op Art of the 1960s.

Kupka is only presently being recognized as a major figure in the early history of nonobjective, geometrical painting. He is without question one of the earliest abstract painters and may have worked in geometrical forms even before Malevich did.

<div align="right">JOHN C. GALLOWAY</div>

L

LACHAISE, GASTON. American sculptor (b. Paris, 1882; d. New York City, 1935). In 1895 he attended the Ecole Bernard Palissy, and in 1898 worked under Gabriel J. Thomas. Lachaise studied at the Ecole des Beaux-Arts until 1905. He went to the United States and worked for H. H. Kitson until 1912. In 1913 he became Paul Manship's assistant. Lachaise's first important work was *Standing Woman* (1912–27), and his first show was in 1918. From 1919 to 1925 he did portraits of contributors to *The Dial*. He made architectural reliefs for the Telephone Building, New York, in 1921, and for Rockefeller Center, New York, in 1931 and 1935. The Museum of Modern Art, New York, owns *Standing Woman* (1932), *Torso* (1934), and *Floating Figure* (1927). *Head* (1928) is in the Whitney Museum of American Art, New York; several works are in the Warburg and Chrysler collections and in the collection of Lachaise's widow. Lachaise gave a sophisticated form to robust sensuality.

LAETHEM-SAINT-MARTIN SCHOOL. School of art of Laethem-Saint-Martin, a village on the Lys River near Ghent, Belgium, founded at the close of the 19th century when Valerius de Saedeleer settled there. The outstanding beauty of this part of Belgium soon attracted a number of Flemish artists who formed a group around De Saedeleer, the three most important being Gustave van de Woestijne, Albert Servaes, and the sculptor Georges Minne. Laethem already had an extremely gifted primitive painter named Van den Abeele, who had a realistic conception of nature.

A few years later a second group of painters, including Albert Saverys, Constant Permeke, Gustave and Léon de Smet, Fritz van den Berghe, Edgar Gevaert, Humbert Malfait, Jules de Sutter, and Piet Lippens was formed at Lae-

them. Strongly opposed to impressionism, they painted villagers and peasant types with a kind of healthy expressionism that was completely Flemish in tradition. They sought to evoke a certain joyousness of life and expressed it in vigorous forms that not only were in contradiction to academic canons but also were attacked by the Royal Academy.

See BERGHE, FRITZ VAN DEN; PERMEKE, CONSTANT; SMET, GUSTAVE DE.

LA FRESNAYE, ROGER DE. French cubist and realistic painter (b. Le Mans, 1885; d. Grasse, 1925). In 1903 he entered the Académie Julian, where he received traditional academic training. In 1908 he transferred to the Académie Ranson, sponsored by Maurice Denis and Paul Sérusier, whose art influenced La Fresnaye. He also came to know and admire Cézanne's painting. In 1910 La Fresnaye traveled extensively in Italy and Germany and then began his first cubist experiments. A year later he met Villon and Gleizes, and with them, Apollinaire, Léger, Metzinger, and others was active in founding the Section d'Or. It was in this period, prior to 1914 when he entered the infantry, that he produced all the work on which his reputation rests. He made a series of cubist drawings and water colors in 1917.

One of La Fresnaye's earliest cubist paintings is *Cuirassier* (1910; Paris, National Museum of Modern Art). He took the theme from Géricault; the color reflects his admiration for Cézanne; and the forms show the influence of Braque and Picasso. In *The Artillery* (1911–12; Chicago, Marx Collection) he suggests the marshaling of armed forces into action by repeating forms in parallel progressions and emphasizing diagonal rhythms. Figures are faceless and severely reduced and geometrized. It is possible that he saw a large exhibition of futurist art held in Paris in 1912. These military themes resulted from his preoccupation with illustrating Claudel's *Tête d'Or*.

Like other members of the Section d'Or, La Fresnaye may be compared to Picasso and Braque; however, he extended their use of color and suggested atmosphere and radiance. He favored figures in a landscape over still life and portrait situations. His innovations are to be found in *Conquest of the Air* (1913; New York, Museum of Mod-

ern Art). In this large canvas Roger and his brother are seen discussing sailing and flying. No airplanes are in evidence; a sailboat is marginal. The scene is given the quality of exhilaration and airiness as the crystalline blues circulate throughout the work.

<div style="text-align: right">ROBERT REIFF</div>

LAM, WIFREDO. Cuban painter (1902–). Born in Sagua la Grande, Lam studied in Havana and Madrid. In 1938 he went to Paris, where his first exhibition attracted the attention and aid of Picasso and led to Lam's association with André Breton and the surrealists. At first his style was strongly influenced by Picasso. Rather than using orthodox surrealist techniques, Lam paints amalgams of organic and sexual forms and the magical fetishes of primitive societies, combining these elements into demonic and frightening figures, as in the closely packed *The Jungle* (1943; New York, Museum of Modern Art).

LARIONOV, MICHAEL. Russian abstract painter (1881–1964). Born in Ternopol in the Ukraine, he studied at the Moscow Academy. He painted his first abstract painting in 1909, and published a rayonist manifesto in 1913. He was a friend of Malevich and a teacher of Tatlin, and was closely associated professionally with Natalie Gontcharova, whom he married. Larionov was the founder of Jack of Diamonds, a group promoting modern art in Moscow. Larionov and Gontcharova moved permanently to Paris and exhibited their rayonist art at Paul Guillaume's gallery. They stopped painting to design décor for the Diaghilev Russian ballet and continued to do so until Diaghilev's death in 1929.

Combining pointillist luminous color and elements from cubism, Larionov reduced landscape elements to rays (hence the name "rayonism"), usually on the diagonal, in a manner suggesting lines of force, as did the Italian futurists.

See JACK OF DIAMONDS; RAYONISM.

LASANSKY, MAURICIO. American printmaker (1914–). He was born of Lithuanian parents in Buenos Aires, where he studied painting, sculpture, and engraving. In 1936 he became director of the Free Fine Arts School, Villa María Córdoba, Argentina. He went to the United

States on a Guggenheim fellowship (1943–44) to study the Metropolitan Museum of Art's print collection and to work with Stanley William Hayter. Three subsequent Guggenheim fellowships have enabled Lasansky to study in Europe.

In 1945 he went as a visiting lecturer to the State University of Iowa, where he created a graphic arts department that has become an important graphics center. In 1967 he was designated the first Virgil M. Hancher Professor of Art at the University.

Lasansky has continued to direct perhaps the most influential print workshop in the United States. His students have won many of the major awards in printmaking. His own work is primarily in the intaglio medium. It is bold, colorful, and full of symbolism, expressing his belief that printmaking is a major art form. KNEELAND MC NULTY

LASSAW, IBRAM. American sculptor (1913–). Born in Alexandria, Egypt, he went to the United States in 1921 and from the age of twelve studied sculpture. He attended the Clay Club, New York City, during 1928–32 and the Beaux-Arts Institute of Design in 1930–31. His first abstract work of 1931 made him a pioneer of abstract sculpture in America. In 1936 he was a founder of the American Abstract Artists group. He has participated in many national and international exhibitions, and his works have had frequent gallery showings in New York.

Working with Percival Goodman, Lassaw did several architectural commissions, including the *Pillar of Fire* at Temple Beth El, Providence, R.I. *Monoceros* (1952) is in the Museum of Modern Art, New York; *Profession* (1956) is in the Whitney Museum of American Art, New York; and *Theme and Variations, I* (1957) is in the Albright-Knox Art Gallery, Buffalo. Lassaw is important for his urban-inspired space cages of soldered metal and for his metaphorical imagery.

LATHEM-SAINT-MARTIN SCHOOL, *see* LAETHEM-SAINT-MARTIN SCHOOL.

LAURENCIN, MARIE. French painter (b. Paris, 1885; d. there, 1956). Marie Laurencin attended the Lycée Lamartine until she was twenty. She received discouraging advice from her drawing teacher but attended drawing

classes at a municipal night school. Later she met Clovis Sagot, a minor art dealer, who spoke to Picasso and Apollinaire about her; soon afterward Gertrude Stein bought one of her paintings. Although Laurencin took an active part in the feverish discussions that gave rise to cubism, she remained strangely uninfluenced by this movement. Her group portraits of Apollinaire and his friends have much simplicity, the bodies and faces are greatly stylized, and the color is applied in a flat, decorative manner.

Laurencin wrote poetry in her youth, and her paintings of graceful, large-eyed, slender-limbed girls have not only a poetic but above all a feminine appeal. She exhibited for the first time at the 22d Salon des Indépendants in 1906. Her art never changed its character. Throughout her career she sought the same dream of gentleness and serenity in the soft or sometimes pathetic faces of women and girls, as in *Portrait* (1913; Paris, Jean Paulham Collection) and *La Femme au chien* (1938; Dinard, private collection). ARNOLD ROSIN

LAURENS, HENRI. French sculptor, painter, and illustrator (b. Paris, 1885; d. there, 1954). Before meeting Braque and joining the cubists in 1911, he worked as a decorator in terra cotta, under the influence of Rodin. His first exhibit was in 1913. His polychromed sheet-iron construction of 1914 is one of the first abstract sculptures. By 1915 his art had evolved into shallow, often painted reliefs and constructions of cubist subject and form. Laurens was a member of the Section d'Or. It was not until the late 1920s that his style acquired the curvacious, sensuous notations by which he interpreted the feminine form. The National Museum of Modern Art, Paris, has his *Siren* (1944) and *The Great Musician* (1938); the Museum of Modern Art, New York, his *Head* (1918). Laurens's most important work was done as a cubist sculptor, with his demonstration that the structure and expressiveness of sculpture need not depend upon a description of the human model.

LAURENT, ROBERT. American sculptor (1890–1970). He was born in Concarneau, France, worked as an apprentice art dealer in Paris in 1905, and was influenced by Gauguin and Picasso. In 1907 he took drawing les-

sons in Rome from Maurice Sterne.

Laurent began carving in the round in 1913 and joined with avant-garde artists in New York. His first exhibit was at the Daniel Gallery in 1916. He rose to prominence with his animal and figure sculptures of the 1920s and 1930s and with commissions such as the *Goose Girl* (1932) for Radio City Music Hall, New York.

LAWRENCE, JACOB. American painter (1917–). He was born in Atlantic City, N.J., and now lives in Brooklyn. In the early 1930s he took free art lessons at a Harlem public library and then at a Works Project Administration school in New York, later receiving a scholarship for the American Artists School. He painted for eighteen months under the Federal Art Project. In 1940 he received the first of three grants from the Rosenwald Fund. He painted his . . . *and the Migrants Kept Coming* series then, a set of sixty pictures, half purchased by the Museum of Modern Art, New York City, and half by the Phillips Collection, Washington, D.C.

Lawrence then did a set of twenty-six gouaches, the *Life in Harlem* series, the *Coast Guard* series, based on his experiences as a steward's mate and officer in the Coast Guard, and the *War* series. He showed his understanding of the mentally ill in the 1950 series on life in Hillside Hospital, *Sanitarium*. In 1955 he began a projected series of sixty tempera paintings entitled *Struggle: From the History of the American People.* In the late 1950s and early 1960s he depicted the struggle for desegregation in the South, and in 1964 he traveled to Nigeria, where he painted the local scene. In 1960–61 he was given a touring retrospective exhibition, which opened at the Whitney Museum of American Art in New York.

Lawrence reduces figures to flat pattern in a manner recalling Shahn, but without the latter's sophistication. He combines bright, often raw color with neutrals and sharp browns and black, giving his social themes a symbolic sense and relieving them of the taint of sentimentality.

ROBERT REIFF

LEBRUN, RICO. American painter (b. Naples, 1900; d. California, 1964). Rico (real name Federico) went to the United States in 1924. Lebrun's remarkable drawings and

paintings derive their visual excitement from the style of the Italian baroque painters. His subjects, however, are modern: the horrors of war, the fascination of slaughterhouses, and rusting farm machinery are all treated with great emotional intensity. Lebrun's sense of tradition and his strong concern for the sufferings of man in the 20th century led him to do an elaborate series of Crucifixion studies (1947–50). These culminated in the large triptych *Crucifixion* (1951; Syracuse University), where the pathos of Grünewald is married to the construction of Picasso's *Guernica*. He also executed a series of paintings based on the concentration camps of World War II.

LECK, BART VAN DER. Dutch painter, graphic artist, and designer (b. Utrecht, 1876; d. Blaricum, 1958). He studied at the Amsterdam Academy. Van der Leck's early paintings were generally realistic, but with symbolic tendencies. About 1910 he became interested in social subjects, for example, *Leaving the Factory* (Rotterdam, Boymans-Van Beuningen Museum), which he painted with a strong emphasis on two-dimensional composition. By 1916 his figures had been rigorously stylized to flat, geometric forms organized entirely on the surface of the picture, for example, *The Tempest* (1916; Otterlo, Kröller-Müller Museum). In 1917, when he was in contact with Mondrian, Van der Leck joined the de Stijl movement and began to work in a nonobjective style, as in *Composition* (1917; Kröller-Müller Museum). After 1919 he returned to his earlier geometric treatment of figures, still retaining, however, his belief in the social utility of art.

LE CORBUSIER (Charles-Edouard Jeanneret-Gris). Swiss-French architect, planner, sculptor, painter, and critic (b. La Chaux-de-Fonds, Switzerland, 1887; d. Cap Martin, France, 1965). He was trained as an engraver in the La Chaux-de-Fonds Art School (1900), and later traveled in Greece and the Balkans (1906–08) and worked in the studio of Auguste Perret (1908–09), an early pioneer in ferroconcrete, the material that became standard for Le Corbusier. He then traveled in Germany (1910–11) and also worked there in the office of Peter Behrens.

In 1920 Le Corbusier founded (with the poet Paul Dermée and the painter Amédée Ozenfant) the avant-garde

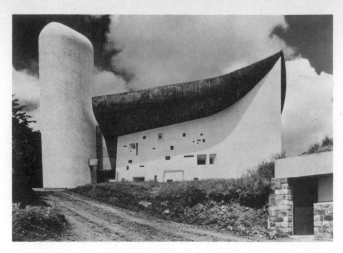

Le Corbusier, Notre-Dame-du-Haut (1950–55). Ronchamp, France.

magazine *L'Esprit Nouveau*, which helped to formulate new attitudes toward city planning, architecture, and many other cultural areas. Some of his articles were incorporated into his most important literary work, *Vers une architecture* (1923), a scorching polemic that called for the burial of the past and the birth of a new architecture based upon the logic of the machine and the necessities of the present. In 1922 Le Corbusier opened a studio at 35 rue de Sèvres, Paris, with his cousin and collaborator, Pierre Jeanneret, where many younger-generation architects worked, among them José Luis Sert and Affonso Reidy. *See* LE CORBUSIER AND JEANNERET.

Some of Le Corbusier's earlier works are unexecuted projects that were seminal for his later executed pieces. The Domino project (1914–15) was a prefabricated, modular unit of ferroconcrete, while the Citrohan projects (1919–22) established many of his major architectural elements: the open plan, the cubic volume suspended on piers, and the usable roof enclosure.

During the 1920s he executed a number of designs for dwellings: the Vaucresson House (1922–23, near Paris), the Ozenfant House (1922–23, Paris), the La Roche House (1923, Paris), the Cook House (1926, Paris), the Garches

House (1927), and housing at Pessac (1925) and at the Weissenhof Exhibition (1927, Stuttgart). All except the La Roche House have been drastically remodeled or have deteriorated. Le Corbusier's classic formulation of this period was the Savoye House (1929–30).

Also during this decade Le Corbusier crystallized his basic attitude toward the city in projects for the reconstruction of Paris (1922–25) and in schemes for a vertically oriented city, consisting of cruciform skyscrapers surrounded by blocks of lower structures, all precisely organized in an open terrain. His book *Urbanisme* was published in 1925, and many planning schemes followed. Le Corbusier's most notable and prescient achievement of the first decade of his active career was the unexecuted design for the Palace of the League of Nations (1927), a work in size and complexity greater than the Bauhaus and prophetic of the best to come in subsequent decades.

During the next decade several important works were executed: the Centrosoyus in Moscow (1929–35), still in good condition; the Salvation Army Building, Paris (1929–33, remodeled); and the Swiss Pavilion at University City, Paris (1930–32), a ferroconcrete box dramatically elevated on sculptured piers, foreshadowing the Ministry of Health and Education in Rio de Janeiro (1937–42; with Lúcio Costa, Oscar Niemeyer, and others) and the Unité d'Habitation in Marseilles (1947–52). The Marseilles project is a residential community housing 1,600 people in a single architectural unit, the apartments ranging from singles to large family complexes. The structure contains shopping, recreational, and nursery facilities in a richly plastic ferroconcrete beehive supported on massive piers. *See* NIEMEYER, OSCAR.

Notre-Dame-du-Haut (1950–55), a pilgrimage chapel at Ronchamp, shocked the architectural world with its expressive sculptural quality and its personal forms, a drastic departure from the architect's earlier classical vocabulary. The building is one of the most impressive objects built by modern man.

As one of his last projects, Le Corbusier (with Maxwell Fry, Jane Drew, and Pierre Jeanneret) was involved in the design of Chandigarh, capital of the state of Punjab in India, the culmination of the sculptural, architectural, and planning efforts of this artistic giant.

THEODORE M. BROWN

LE CORBUSIER AND JEANNERET. French architectural partnership of Le Corbusier (1887–1965) and his cousin Pierre Jeanneret (1896–). The team worked out of a studio in Paris, 35 rue de Sèvres, from 1922 to 1945. During these years Jeanneret, a quiet man who stayed in the background, contributed to the work of his flamboyant and famous cousin, and credit for Le Corbusier's work of this period should technically be shared with Jeanneret. Since 1945 Jeanneret has worked independently, but to date no serious attempt has been made to determine his contribution or to evaluate his work. *See* Le Corbusier.

LEE, DORIS EMRICK. American painter and lithographer (1905–). Born in Aledo, Ill., she studied at the Kansas City Art Institute, with André Lhote in Paris, and with Arnold Blanch and Ernest Lawson. A painter of figures, landscapes, and portraits, she is best known for her rural genre subjects done in a primitivistic, semicaricatural style.

LE FAUCONNIER, HENRI. French painter (b. Hesdin, 1881; d. Paris, 1946). He went to Paris in 1901. About 1909 he became friendly with the group of painters associated with cubism, particularly Gleizes and Delaunay. Le Fauconnier's increasing dependence on cubism can be seen in the progression from the simplified geometric shapes and dull coloring of his basically decorative *Portrait of Jouve* (1909; Paris, National Museum of Modern Art) to the allegorical *L'Abondance* (1910–11; The Hague, Gemeentemuseum), in which, despite the fragmentation of the bodies, he manages not to lose the relatively firm outline of the figures. Le Fauconnier eventually arrived at a personal cubism with landscapes, still lifes, and figures treated in terms of ordered, overlapping planes.

LEGER, FERNAND. French cubist painter (b. Argentan, 1881; d. Grif-sur-Yvette, 1955). Léger was one of the major contributors to the cubist style. He worked for architects in Caen and Paris from 1897 to 1902 and was in military service in 1902–03. Refused regular admission to the Ecole des Beaux-Arts, Léger studied there and at the Académie Julian as an independent, also visiting the Louvre and earning his living as a photographic retoucher. He lived in Montparnasse from 1905 until 1907,

Fernand Léger, *Bargeman* (1918). Oil on canvas, 18⅛″ x 21⅞″. Museum of Modern Art, New York (Sidney and Harriet Janis Collection).

and before 1910 became acquainted with Matisse, Braque, Picasso, and the writers Max Jacob, Apollinaire, André Salmon, and Maurice Raynal. He met with the cubist circle at Jacques Villon's studio in 1910–11 and exhibited at the famous Section d'Or (Galerie de la Boétie) in 1912. He also gave a one-man show at Kahnweiler's gallery that year.

Always an independent-minded artist, Léger in 1913–14 extended his own variety of cubism to include powerfully modeled forms suggestive of mechanical movement (*Contrast of Forms* series). He exhibited in the 1913 Herbstsalon in Berlin (Der Sturm Gallery). From 1919 until the middle 1920s he was associated with the purist movement of Le Corbusier and Ozenfant, sharply clarifying his volumes and color and involving human and machine forms as coordinates within the same canvas (*The Mechanic*, 1920, Paris, Carré Gallery; *Three Women,* 1921, New York, Museum of Modern Art). He collaborated with Dudley Murphy in 1923 on the film *Ballet méca-*

nique, one of the earliest "art" movies, whose content centered on simple, mechanical objects. During the 1920s he knew the de Stijl group. He also conducted his own art school.

Léger visited the United States in 1931 and was stimulated by the environment of New York City. He traveled to Greece and again to New York during the 1930s, decorating Nelson Rockefeller's apartment and creating the décor for the Lifar ballet *David Triumphant* (1937). He also painted a mural on the theme of transportation at the Paris World's Fair that year. Léger lived in New York from 1940 to 1946, at which time his subjects were acrobats and cyclists. During this period his style grew more complex: the powerfully modeled volumes of much of his earlier work gave way to flat patterns of brilliant color upon which he chiefly used strong linear definitions. He was also active in lithography.

Following his return to France in 1946, Léger was active in decorating churches and public buildings (stained-glass windows for the church at Assy in 1948, for the Bastogne Memorial in 1950, and for the Church of Sacré-Coeur, Adincourt, in 1954; murals for the General Assembly Building of the United Nations, New York; and several important mosaics). He also created sets and costumes for the opera *Bolivar* by Milhaud (1950).

Other works by Léger include *Nudes in the Forest* (1910; Otterlo, Kröller-Müller Museum), *The Stairway* (1913; Zurich, Art Gallery; similar canvases in New York, Museum of Modern Art, and Paris, National Museum of Modern Art), *The City* (1919; Philadelphia Museum of Art), *La Danse aux clés* (1930; Paris, National Museum of Modern Art), *Butterflies and Flowers* (1937; Carré Gallery), and *The Great Parade* (1954; New York, Guggenheim Museum).

Léger was a central figure in the development of cubism, although he grew away from the movement and developed a strongly personal expression. The clarity of his modeling and his use of bright color, often depicting machine subjects or rhythms, are a distinctive phenomenon in modern art. JOHN C. GALLOWAY

LEHMBRUCK, WILHELM. German sculptor, graphic artist, painter, and poet (b. Meiderich, 1881; d. Berlin,

1919). Before the age of fourteen he showed a love of carving in chalk and plaster. From 1895 to 1899 he attended the Düsseldorf School of Arts and Crafts. Between 1899 and 1901 he worked as a sculptor's assistant and then entered the Düsseldorf Art Academy, where he studied from 1901 to 1907. While there, he was a master pupil of Karl Janssen. Lehmbruck traveled to Italy in 1905 on prize money won by his sculpture. The Academy purchased his *Woman* in 1905. In 1907 his sculpture *Mother and Child*, which reflected his social consciousness, was successfully exhibited in Paris. He lived in Paris from 1910 until 1914 and was befriended during this time by Archipenko, Matisse, Brancusi, and Modigliani.

Lehmbruck's early style seems to have been formed before he saw the work of Maillol in 1910. His signature style of ascetic, spiritually lean, and angular figures rapidly emerged while in Paris, as can be seen in *Kneeling Woman* (1911) and *Rising Youth* (1913). The dramatic attenuation of his figures may have been the result of the influence of both Gothic sculpture and Picasso's Blue Period. Lehmbruck was consciously seeking a new style by which to interpret modern heroism. At the outbreak of World War I he went to Berlin, where he exhibited at the Secession in 1916 and suffered bitter criticism for his *Man Flung Down*. Like his *Seated Youth* of 1916–18, this sculpture was intended as a personal memorial to German youth killed in the war and to the death of his own hopes. In 1917–18 he had a studio in Zurich, and in 1918 was appointed to the Prussian Academy of Arts.

The most comprehensive collection of Lehmbruck's sculpture is owned by his wife and includes the *Bust of Mme L.* (1910), *Sitting Child* (1910), *The Temptation* (1911), and *Kneeling Woman* (1911; a cast is in New York, Museum of Modern Art). The Lehmbruck Museum, Duisburg, owns *Torso of a Young Girl* (1913–14) and *Rising Youth* (cast in New York, Museum of Modern Art), *Sitting Girl* (1913–14), *Man Flung Down* (1915–16), *Head of a Thinker* (1918), and *Praying Woman* (1918). The Folkwang Museum, Essen, owns *Standing Woman* (1910) and *Mother and Child* (1907). Lehmbruck created some of the last and rare images of pathos and heroism of spirit in modern sculpture in a deeply personal style that meaningfully extended the figure tradition from the medieval period into the 20th century. ALBERT ELSEN

LEONID (Leonid Berman). Russian-American painter (1896–). The brother of the painter Eugène Berman, Leonid was born in St. Petersburg. He went to Paris in 1919 and studied at the Académie Ranson. He exhibited in Paris with the neoromantic group in 1926, and his early work was influenced by the dark, moody atmosphere of neoromanticism. By 1930 he had found his characteristic subjects, the coasts and harbors of Europe (later the northeastern United States as well), which he painted with rich color and a strongly poetic feeling for the deep spaces of sky, shore, and sea bathed in sunlight and atmosphere, for example, *Mussel Gatherers at High Tide* (1937; New York, Museum of Modern Art).

LESCAZE, WILLIAM, *see* HOWE AND LESCAZE.

LEVI, JULIAN EDWIN. American painter (1900–). Born in New York City, he studied at the Pennsylvania Academy of Fine Arts with Henry McCarter and Arthur Carles. After returning from travel in 1927, his paintings, especially still lifes, were influenced by cubist abstraction. In the 1930s, however, he turned to what became his characteristic subjects, seashore and fishing scenes, for example, *Fisherman's Family* (1939; New York, Metropolitan Museum). The isolation of the figures and objects in these paintings at times suggest surrealism, but more often the mood of poignant loneliness is closer to the neoromanticism of Berman and Bérard.

LEVINE, JACK. American painter (1915–). Born in Boston, he studied art at the Boston Museum School. He became a pupil and protégé of Denman Ross at Harvard (1929), and during the 1930s contributed to the Federal Art Project.

He is an expressionist who paints Biblical and social themes. *The Feast of Pure Reason* (1937; New York, Museum of Modern Art) dramatically reveals his biting satire and mordant humor. His manner recalls El Greco's spiritualized lighting, Soutine's rich colors and distorted forms, and Daumier's trenchant caricatures. He has received wide recognition in the United States and abroad, including an honorary one-man show at the 1960 Interamerican Biennial Exhibition in Mexico City.

LEWIS, WYNDHAM. British painter (1884–1957). Born in Nova Scotia, Lewis studied at the Slade School and traveled widely in Europe. Returning to England in 1909, he threw himself into the battle for modern art with explosive force. He was a member of the Camden Town Group and the London Group, and worked in the Omega Workshop before a quarrel with Roger Fry. His close connections with the avant-garde and the influences of cubism and futurism led to the development of vorticism, with which Lewis's name is most associated. He did not confine his activities to painting, for he wrote several satirical novels and produced works of criticism. He also produced a series of incisive pencil portrait drawings. Lewis's paintings clearly show his fascination with the technical and mechanical developments of the 20th century.

LHOTE, ANDRE. French painter and critic (b. Bordeaux, 1885; d. Paris, 1962). Lhote first worked with a sculptor-decorator, then learned painting himself, and exhibited at the Salon des Indépendants beginning in 1906 and at the Salon d'Automne in 1907. He was immediately appreciated by the critics and poets. As an important art critic, Lhote not only contributed to the *Nouvelle revue française* until 1940 but, in his *Treatise on Landscape, Treatise on the Figure, Writings on Art,* and *Egyptian Painting in the Valley of Kings,* raised major questions, analyzing the aims of art from the earliest times to the present and explaining matters of technique. He exercised a lasting influence on the young French generation by his writings and his example and, above all, by his role as a teacher: in 1922 he founded a school and freely gave advice to all who came to him. He had participated in cubist activities yet had not lost himself in the movement. His acknowledged cult of Cézanne and his great admiration for Picasso did not prevent him from developing his own style.

Lhote's canvases are generally pleasing in color and design, reflecting his desire to reconcile traditional painting with cubism. A typical example is *Rugby* (1917; Paris, National Museum of Modern Art). The figures and objects are geometrically transcribed and the planes clearly brought out through contour and color, with emphasis on movement and intelligibility of style.

<div align="right">ARNOLD ROSIN</div>

LICHTENSTEIN, ROY. American painter (1923–). A native of New York City, he studied at the Art Students League there under Reginald Marsh after attending Ohio State University. One of the leading practitioners of Pop Art, he has monumentalized comic-strip sequences and photoreproduction techniques, such as Benday dots, in a deadpan manner. *See* POP ART.

LIONNI, LEO. American graphic artist (1910–). Born in Amsterdam, he earned a Ph.D. in economics at the University of Genoa. He became active in painting, advertising, and design in Milan, at the same time writing on art, architecture, and films. He went to the United States in 1939 and soon had such clients as N. W. Ayer and Son and the Container Corporation of America. But Lionni is most famous as art director of *Fortune,* where he has set a top standard of graphic excellence and sophistication. Lionni has served as head of the Graphic Design Department at the Parsons School of Design, as president of the American Institute of Graphic Arts, and as co-editor of *Print* magazine.

LIPCHITZ, JACQUES. Lithuanian-American sculptor (1891–1973). He was born in Druskieniki, left school in Vilna in 1909, and went to Paris with the intention of becoming a sculptor. He became a student at the Ecole des Beaux-Arts, at first in the studio of Jean Antoine Injalbert. In 1910 he shifted to a direct carving class and became a pupil of Raoul Verlet at the Académie Julian. Lipchitz attended an evening sketching class in Montparnasse and studied primitive, archaic, ancient, and Gothic art in the Louvre.

In 1913 he met Picasso through Diego Rivera. His work at that time, as seen in *Woman and Gazelles,* was moving in a direction different from that of cubism. By 1914 his *Sailor With a Guitar* (Philadelphia Museum of Art), made in Madrid after a summer in Mallorca, showed the beginning of his sympathy with the cubists. This affinity became stronger even before the formation of a close friendship with Juan Gris in 1916. His *Bather* (1915) and brilliant *Man with a Guitar* (1916; New York, Guggenheim Museum) rank with the finest cubist sculptures. The human form has been remade into an imaginative schematic idea,

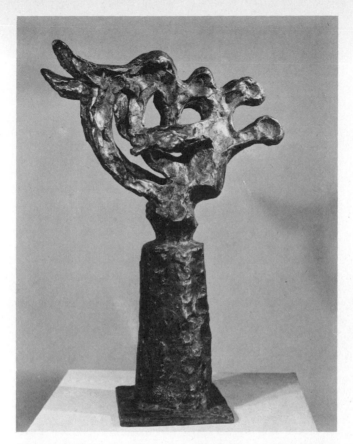

Jacques Lipchitz, *Song of the Vowels* (1931). Bronze (cast 1962 from terra-cotta original), 14⅝" x 10". Museum of Modern Art, New York. Gift of the artist.

a notational system of incomplete and interlocking forms such as we find in the work of Picasso and Braque during that time. Lipchitz's polychromed reliefs of 1918 seem to be developments of the still lifes painted by Picasso. His themes, which include the bather, seated man, and Pierrot, attest to the view that one of the revolutions in modern sculpture first occurred in form rather than in content.

Lipchitz's first one-man exhibition took place in 1920

at the Leonce Rosenberg Gallery in Paris. It was at about this time that his reputation began to increase. He received a commission for five reliefs from Dr. Albert C. Barnes. These reliefs were installed on the exterior of the Barnes Foundation in Merion, Pa., in 1922. That same year Lipchitz joined the Esprit Nouveau group, which included Ozenfant and Le Corbusier and which was concerned with the unification of art and architecture. By now his style had broadened and matured to the extent that he could return to portraiture, and in 1922 he did a striking head of his first wife. His cubist works now oscillated between rigid vertical forms and increasingly curved, faceted volumes.

With *Bather* (1923–25; owned by the artist), which is more than 6 feet in height, Lipchitz increased the scale of his work. He then continued to create very large, medium-size, and small works throughout his career. In 1925 his experiments with small cardboard shapes cast in the lost-wax process led to his "transparents," such as *Pierrot with Clarinet* (1926) and *Acrobats on a Ball* (1926; Baroness Gougaud Collection). In these works he frequently opened up the interiors of his sculptures. In 1927 Lipchitz was commissioned by Vicomte Charles de Noailles to do his first large-scale group composition, *La Joie de Vivre*, and it was set up in the Vicomte's garden at Hyères. In 1960 Lipchitz reworked this monumental sculpture slightly and exhibited it at the Whitney Museum of American Art, New York.

Between 1926 and 1930 he worked on one of his most important sculptures, *Figure*, originally intended for a private garden and now in the New York Museum of Modern Art sculpture garden. *Figure* is one of the most imaginative human metaphors in modern sculpture; its chainlike form is a powerful image of internal tension. By contrast, in 1928 Lipchitz made the more relaxed *Reclining Woman with Guitar* for the garden of Mme de Mandrot at Le Pradet, Toulon. In the same garden he placed his *Song of the Vowels* in 1931 (now in Zurich, Art Gallery).

The early 1930s saw Lipchitz working in different modes and often reworking themes from his earlier period in such works as *Mother and Child* (1922–30; artist's collection) and the moving *Return of the Prodigal* (1931), in which the artist images his feelings of "thirst" for the love of the family. By this time his forms had acquired a more

sensuous volume, and the cubist skeletal armature had been fleshed out. From cubism, however, as well as from his contact with fantastic painting, he had enriched the meaning of his work through free association and through a personal development of the compound image. Good examples of this evocative type of multiple imagery can be seen in the *Harpists* (1930) and *Benediction* (1942; both B. J. Reis Collection). In the early 1930s Lipchitz also began his series of botanical metaphors, which were sometimes erotic evocations of birth and growth such as *Chimène* (1930) and *Spring* (1942; Reis Collection).

In 1936–37, during the Paris World's Fair, an entire gallery was given over to the exhibition of his work, including the prize-winning *Prometheus* sculpture. The Prometheus theme was an important one for Lipchitz, and he reworked it for the Ministry of Education and Health Building in Rio de Janeiro in 1943-44. It was his statement of man's triumph over the forces that plague him and signaled his renewed interest in the modern reinterpretation of older myths. Also in the 1940s he undertook his *Sacrifice* series, a personal commentary on man's spiritual history and rise from human or blood offering to the humane worship of the Virgin. The series includes *Prayer* (1943; Ingersoll Collection).

In 1941 Lipchitz went to live in the United States. During a visit to France in 1946 he was commissioned by Father Couturier to make a baptismal font for the Church of Notre-Dame-de-Toute-Grâce, Assy. Completed in 1954, it is probably the finest religious sculpture in modern art. Casts of the work, known also as the *Virgin of the Inverted Heart*, are in New Harmony, Ind., in the shrine designed by Philip Johnson, and in the monastery on the isle of Iona.

In 1952 fire destroyed his New York City studio as well as important works of art and working models. With funds obtained in part from portrait commissions he built a new studio near his home at Hastings-on-the-Hudson, N.Y., where he lived for many years. In 1959 Lipchitz exhibited a series of small lost-wax cast automatics, a series that was devoted to exploring "the limits of the possible" and recall his earlier work with the transparents. Having pioneered in cubism, surrealism, the return to myths, and spontaneous sculpture, Lipchitz then chose to rework some of his earlier cubist pieces. He has given to

sculpture great dramatic scope and depth as well as a seriousness and excitement that rivals those qualities in the best of modern painting. ALBERT ELSEN

LIPPOLD, RICHARD. American sculptor (1915–). He was born in Milwaukee. His early training was as an industrial designer at the Art Institute of Chicago, and he also studied at the University of Chicago in 1933–34. He worked as a designer until 1941, although he had his first sculpture show in 1938. He decided on sculpture rather than music as a career in the early 1940s.

Lippold is a self-taught sculptor, but his design background is manifest in his thin wire symmetrical constructs (altar sculpture, 1961; Portsmouth, R.I., St. Gregory the Great) and in the impeccable craftsmanship of his elegant space cages. He has taught at the Layton School of Art, Milwaukee (1940–41), at the University of Michigan (1944), at Goddard College (1945–47), and since the early 1950s, at Hunter College. The Museum of Modern Art, New York, owns his *Variation No. 7* and *Full Moon* (1949–50), and the Metropolitan Museum of Art, New York, commissioned *Sun* (1953–56). Lippold's cool, inflexible armatures convey a lyrical feeling for nature and sculpture. ALBERT ELSEN

LIPTON, SEYMOUR. American sculptor (1903–). He was born in New York City, where he lives and works. He was interested as a young man in drawing, in copying old masters, and in work with tools and machines. He attended the City College of New York in 1922–23, and received a degree in dentistry from Columbia University, which he had attended from 1923 to 1927. During those years he read on art and aesthetics and in 1926 became interested in modern art, after seeing the work of Matisse and the cubists. He made small carvings in ivory and gold, principally jewelry, about 1928. Before 1930 he made a 2-foot-high clay statue, *Leonardo da Vinci Holding a Bird*. He first took up sculpture seriously in 1932, but did not attach himself to a teacher. Much of his training came from visits to the Whitney Museum of American Art, the Metropolitan Museum of Art, and the Museum of Modern Art, as well as the former Bucholz-Valentin Gallery.

During the 1930s he did mostly wood carving that sug-

gested the influence of Barlach and Henry Moore and used socially conscious themes, for example, *Lynching* (1935) and *The Dispossessed* (1937). He first exhibited in a group show at the John Reed Club, New York, in 1933–34 and had his first one-man show at the A.C.A. Gallery in 1938. Between 1939 and 1941 he began to open up his forms and to seek a means by which to interpret man's internal life and the powerful dark forces that lie beneath the surface of nature. During the 1940s Lipton evolved a personal metaphorical style that produced some of modern sculpture's most ferocious imagery, such as the *Moloch* series (in lead) of 1948. These are brutal images, often of fantastic mythological hybrids or mutants from biology, endowed with hook or horn—all projections of the sculptor's pessimism about the powers motivating life.

In 1948 he had his first exhibition at the Betty Parsons Gallery, and was recognized as a leading American sculptor. Although he had taught sculpture at the New School in 1938–43 and at Cooper Union in 1943–44, it was not until 1954 that Lipton devoted full time to sculpture. The 1950s saw his signature style develop in bronze and nickel silver on sheet steel and Monel metal. He created a series of strongly designed and dramatic ideographs based on biology, history, and older art. His important architectural commissions included work for a Tulsa synagogue (1953) and for the IBM plant at Yorktown Heights, N.Y. (1960).

His work has been in many national and international exhibitions, notably the 1958 Venice Biennale, and is included in leading American collections.

ALBERT ELSEN

LISSITZKY, LAZAR (El). Russian painter and graphic and exhibition designer (b. Smolensk province, 1890; d. Moscow, 1941). Lissitzky studied at the school of engineering and architecture in Darmstadt, Germany, and traveled (1909–14) throughout Europe. After returning to Russia, he became an architect's apprentice (1915) and an illustrator of Jewish children's books in Vitebsk (1917), along with Chagall and other artists. Under the revolutionary government, Lissitzky became a professor at the Vitebsk School of Art (1918), directed by Chagall. In 1919 he came into contact with Malevich and the suprematist movement, executed the first of a series of abstract paintings known as *Prouns*, and designed posters for the Soviet government

combining abstract shapes and typography.

During the 1920s Lissitzky became one of the most influential typographical and exhibition designers in Europe. Working in the Soviet Union, he had continual contact with the constructivist, Bauhaus, and de Stijl movements, starting with his participation in the constructivist conference at Düsseldorf in 1922. His book designs, such as those for editions of Mayakovsky's poetry, combine suprematist and constructivist principles. In planning exhibitions in the Soviet Union and Europe, he related individual works to an overall design, culminating in the vast photomontage for the Soviet section of the International Press Exhibition in Cologne (1930).

DONALD GODDARD

LONDON GROUP, THE. Group of English artists, founded in 1913, composed of a union of earlier groups, such as the Camden Town Group and the vorticists. Its formation was a reaction to Roger Fry's exhibition of postimpressionism. Harold Gilman was the first president; the group is still in existence. *See* VORTICISM.

LOOS, ADOLF. Austrian architect and critic (1870–1933). Born in Brünn, he worked principally around Vienna, though he spent several years of the 1890s in the United States. Loos returned to Austria in 1897 to become, in the first decade of the 20th century, one of the most articulate leaders of the international revolt against Art Nouveau. He was a powerful spokesman for a new architecture based upon pure, undecorated form and the rational manipulation of materials and spaces. Among his more important works, all in Vienna, are the Steiner and Scheu Houses (1910; 1912) and the Goldman and Salatsch Building (1910), austere cubic compositions, evolved from their inner activities. The best extant example of his work is the interior of the Kärtner Bar in Vienna (1907). Of as great importance as his architectural works to the development of contemporary architecture are his many polemical essays, including *Ins Leere gesprochen* (1897–1900) and *Ornament und Verbrechen* (1908).

LORJOU, BERNARD. French painter (1908–). A native of Blois, Lorjou acquired his artistic education on

his own. His earliest painting was a portrait of his parents; he was then fourteen years old. A trip to Spain (1931) aroused his enthusiasm for El Greco, Velázquez, and Goya. After World War II he contributed to the renaissance of a realistic and popular movement in painting. He exhibited at the Salon d'Automne and at the Salon des Indépendants and, in 1954, at the Galerie Charpentier. In 1948 Lorjou shared the Prix de la Critique with Bernard Buffet, and he became one of France's foremost exponents of the latest version of expressionism. His colorful and often crude forms, the paint thickly and purely applied, are evidence of his indebtedness to Van Gogh, Soutine, and James Ensor.

LOUIS (Bernstein), MORRIS. American painter (b. Baltimore, 1912; d. Washington, D.C., 1962). Louis studied at the Maryland Institute of Fine and Applied Art (1929–33) and worked under the Federal Arts Project during the 1930s. Until he was introduced in New York City to Helen Frankenthaler's method of staining the canvas with thinned paints, Louis created abstract paintings and collages in the cubist tradition. The new technique freed him from traditional drawing and enabled him to use color, in a series of evolving images, to create its own tensions and organic relationships out of an original impulse.

LOZOWICK, LOUIS. American graphic artist (1892–1974). Lozowick was born in Russia. He studied in Paris and Berlin and attended Ohio State University, in Columbus, and the National Academy of Design, in New York City. Industrial complexes, buildings, and bridges in New York provided themes for his early work, which emphasizes strongly simplified structural lines and modeling, sometimes with cubistic overtones. His later work is more textural and romantic. Lozowick was also the author of *Modern Russian Art* (1925).

LUBETKIN, BERTHOLD. English architect (1901–). Born in the Caucasus, he first worked in Paris in Perret's atelier in 1927, at which time he designed, with Ginsberg, 25 Avenue de Versailles. He left for England about 1930, and took part in the formation of the Tecton group. Zoo commissions followed, e.g., the Regent's Park gorilla house

(1933) and the penguin pool (1934), the latter a sculptural essay in reinforced concrete. Using this material Lubetkin is at his best, as may be seen in functional plastic terms at Dudley Zoo and at a bungalow at Whipsnade (both 1937).

His first big jobs were the Highgate Hill flats in two phases (1934 and 1937), each of which set the idioms for his plastic surface values. The phase culminated in a transitional building, the Finsbury Health Center (1938). In postwar work, Spa Green (1951) and Priory Green (1951) show an inward-looking style—a concept negating the prime importance of the façade.

LUKS, GEORGE BENJAMIN. American painter (b. Williamsport, Pa., 1867; d. New York City, 1933). He studied at the Pennsylvania Academy of Fine Arts and in Düsseldorf, Munich, Berlin, London, and Paris. On his return to the United States he worked as a newspaper artist in Philadelphia, where he met Henri, Sloan, Glackens, and Shinn. In 1895 Luks was sent by the *Philadelphia Bulletin* to cover the fighting in Cuba. The next year he was in New York drawing illustrations, caricatures, and comic strips for the *World*. In 1907 the rejection of Luks's paintings by the National Academy led to Henri's withdrawal from the exhibition and to the formation of The Eight, which had its first and only showing at the Macbeth Gallery in 1908. Luks later taught at the Art Students League and at his own school.

His loose spontaneous brushwork and earthy subjects were in keeping with the flamboyance of his personality. The major influences on his style were the Munich school, Hals, and Henri. Luks painted the coal-mining towns of Pennsylvania, but his most important paintings were of scenes and figures of New York City's East Side, typical Ashcan subjects, which stressed a sort of heroic vigor rather than sordid poverty. The vitality and excitement of a crowded shopping street is vividly caught in *Hester Street* (1905; Brooklyn Museum), but in other paintings sympathy for the subject barely covers a strong sentimentality, as in *The Little Madonna* (1907; Andover, Mass., Philipps Academy, Addison Gallery of American Art) or the enchanting smiles of the little girls in *The Spielers* (1905; Addison Gallery). Luks was always overly dependent upon

his powerful, almost virtuoso brushwork, which, at his best, he used in scenes of simple composition or strong action, for example, *The Wrestlers* (1905; Boston, Museum of Fine Arts).

After his Ashcan phase he painted many portraits; one of the most successful is the roguish *Otis Skinner as Col. Bridau* (1919; Washington, D.C., Phillips Collection).

JEROME VIOLA

LURCAT, JEAN. French painter and tapestry designer (1892–1966). A native of Bruyères-en-Vosges, he studied for a short time at the Ecole des Beaux-Arts and at the Académie Colarossi (1912). He founded *Les Feuilles de Mai*, a review that included works by Bourdelle, Rilke, and Ilya Ehrenburg, and associated himself with Lafitte, executing a large fresco for the Académie des Sciences in Marseilles. In 1917 Lurçat exhibited for the first time at the Galerie Tanner in Zurich and executed his first tapestries, *Filles vertes* and *Soirée dans Grenade* (1917).

Lurçat settled in Paris, participated in the Salon des Indépendants, designed the décor and costumes for Remisov's *Celui qui reçoit les gifles*, and joined a group of painters, poets, and writers that included Max Jacob, Louis Marcoussis, and Paul Baudry. In 1922 Lurçat had his first exhibition in Paris, executed his fifth tapestry, *Le cirque*, and painted a large decoration for Edmond Bernheim. Two years later he paid a visit to North Africa and Greece, which resulted in his large tapestry *Les Arabes*. In 1930 he executed a large tapestry *L'Eté*. In 1934 he collaborated with the American Ballet Company, New York, and exhibited oil paintings and gouaches at the Moscow Museum of Modern Art (now a part of the National Museum of Fine Arts).

Lurçat began to concentrate on tapestry and in 1936 was commissioned by the Gobelins firm to execute *Les Illusions d'Icare*, which was offered by the French nation to the Queen of the Netherlands. A second tapestry, *Forêts*, was commissioned in 1937. In 1939 Lurçat settled in Aubusson to supervise four large tapestries entitled *Les Quatre saisons*.

He designed more than 1,000 tapestries and was France's foremost contemporary tapestry artist. His work and writings have influenced two generations.

ARNOLD ROSIN

M

McCULLOCH, ALAN McLEOD. Australian art critic, draftsman, painter, and writer (1907–). Born in Melbourne, he has traveled widely throughout the world and has developed an expressionistic painting style. He is art critic for the Melbourne *Herald* and has been a leader in many progressive activities to benefit Australian art.

MACDONALD-WRIGHT, STANTON. American painter, writer, and teacher (1890–1974). He was born in Charlottesville, Va. In 1907 he went to France and studied in Paris at the Ecole des Beaux-Arts, the Académie Julian, and the Sorbonne. His early works show the influence of various painters, at first Rembrandt and Hals, then the landscape treatment of the Barbizon school, and, lastly, impressionism. He began to experiment with the theories of color and aesthetic expression of Helmholtz, Chevreul, and Rood, and, with the American painter Morgan Russell, founded the synchromist movement in 1912. Much of the rationale and technique of synchromism was derived from the orphism of Delaunay, although both Macdonald-Wright and Russell denied this origin and kept up a steady barrage of propaganda against their French rivals. *See* OR- PHISM.

Synchromism, at first simply the application of new color theories to the traditional subjects of landscape, figure, and still life, evolved into a completely abstract style, using such basic shapes as the circle and the triangle. Macdonald-Wright's synchromist paintings were based on color used not, as by the impressionists, as a vehicle for the depiction of light but as a builder of form; the ultimate source for this was obviously Cézanne. With the help of elaborately constructed charts of the spatial and three-dimensional effects of color, Macdonald-Wright attempted to paint "pure," nonrepresentational, nonanecdotal compositions, or-

ganized solely according to internal aesthetic laws, which would affect the viewer without recourse to the forms of external reality in a manner analogous to that of music. The shifting planes and advancing and receding colors of the style can be seen in his *"Conception." Synchromy* (1915) and *"Oriental." Synchromy in Blue-Green* (1918; both New York, Whitney Museum of American Art).

JEROME VIOLA

McFEE, HENRY LEE. American painter (b. St. Louis, Mo., 1886; d. Claremont, Calif., 1953). He studied in St. Louis and Pittsburgh and with Birge Harrison in Woodstock, N.Y. McFee was first interested in the rendering of volumes in space by the Florentine Renaissance painters. From about 1919 to 1924 he painted still lifes and landscapes under the influence of cubism and Cézanne. These compositions were large-planed with unusual attention paid to surface texture. His later paintings, mostly still lifes and figures, show the same concern for formal structure in a more realistic style.

MacIVER, LOREN. American painter (1909–). Born in New York City, she attended the Art Students League at the age of ten and continued her studies privately. From 1936 to 1939 she worked with the Federal Art Project. She had her first one-man show in 1939, and many of her works are in public and private collections. Summers at Cape Cod and winters at Key West have provided some subjects for her art, but most of her paintings are of simple aspects of city life, stressing the poetic content of a prosaic group of details, such as children's chalk marks for hopscotch or a streaming window, wet with rain. She is a refined colorist, introspective and gently symbolic in the definition of an imaginative, idyllic world half seen, half remembered.

MACKE, AUGUST. German expressionist painter (b. Meschede, Sauerland, 1887; d. France, 1914). He studied at the Düsseldorf Academy in 1904 and afterward traveled widely in France, Italy, and England. In 1911 he was associated with the Neue Künstlervereinigung in Munich and later, as a founder-member, with the Blaue Reiter. Paul Klee and Macke made a trip to Tunisia in April, 1914.

Macke synthesized cubist structure with the orphist color of Delaunay. His art is indebted to Seurat and often has futurist characteristics. His featureless figures with their tubelike limbs appear somber, muffled, and restricted, whether they exist as women looking in shop windows or as nudes in a jungle. His beautiful water colors of Tunisia, composed of interlocking prisms of radiant color, influenced Klee.

MAGIC REALISM (Magischer Realismus). A meticulously rendered, naturalistic style of painting that usually carries an intensity of mood. Although the tendency has existed since the German New Objectivity period of the 1920s, magic realism itself may be identified as a native American surrealism. The juxtaposition of objects does not feature dislocations as extreme as those in the surrealist work of, for example, Dali; but an incongruous and often a haunting effect is produced. The realistic element overrides the magical in most of this painting, and visual facts are usually reproduced in clinical detail.

Such contemporary Americans as Henry Koerner, Andrew Wyeth, and Ben Shahn have worked in a magic-realist style; their careful craftsmanship is often the vehicle for a poignant fantasy. *See* KOERNER, HENRY; SHAHN, BEN; WYETH, ANDREW NEWELL.

MAGRITTE, RENE. Belgian painter (1898–1967). Born in Lessines, he studied at the Brussels Academy from 1916 to 1918. His earliest work was influenced by cubism and futurism. Magritte was a leader of the Belgian surrealists and was active in the Paris group of surrealists in the late 1920s. Throughout his career he used many of the devices of orthodox surrealism, but in a personal manner, refined and philosophical, disquieting but rarely as immediately shocking as others of the movement. He also avoided their automatic techniques and painted in an essentially realistic style.

His early surrealist pictures are governed by the incongruous juxtaposition of unrelated objects. *La Statue volante* (1927; London, private collection), for example, contains, among other things, a classical statue and bits of plumbing. The effect is of a Chirico-like melancholy. In some works painted several years later the incongruity of

the assemblage is heightened by shifts in scale. From the late 1920s until about 1940 Magritte painted pictures that seem more like metaphysical problems in visual form than surrealist projections of the unconscious. His variation on the device of the double image, in which a part of the picture simultaneously functions in two separate contexts, occurs in a series of pictures, for example, *La Belle captive* (1931; Brussels, private collection), which depict a painted canvas on an easel set against a window or in a field. The painted canvas continues without a break the view of the landscape that would ordinarily be hidden by it.

From 1940 to about 1946 Magritte painted gentle fantasy pictures in an impressionistic technique. After 1946 he again painted what appear to be metaphysical or philosophical problems, with brighter, more effective color than previously and more puzzling subject matter. *L'Empire des lumières* (1954; Museum of Modern Art) shows a tree-lined street at night, with a street light shining through the darkness, although there is broad daylight above the roofs. JEROME VIOLA

MAILLOL, ARISTIDE. French sculptor, tapestry maker, painter, and draftsman (b. Banyuls-sur-Mer, 1861; d. near there, 1944). His gift for drawing appeared while he was in college in Perpignan. Between 1880 and 1886 he published in Banyuls a small magazine with his own illustrations. He decided to become a painter after copying works in the Perpignan museum. In 1887 he was in Paris and entered the Ecole des Beaux-Arts as a painting student of Gérôme and Cabanel. Two years later he met Bourdelle and saw Gauguin's work. Also in 1889 he began to make tapestries after study in the Cluny museum.

In 1890, encouraged by Gauguin, he left the Ecole to work on his own. In 1893 he exhibited a tapestry at the National Society Salon. His early work resembled that of the Nabis and of his friend Maurice Denis. In 1896 he started to carve sculpture in wood, after having made woodcuts in 1894. By 1898 he was working in terra cotta and enamel. His decision to become a sculptor was influenced by the impairment of his sight, which was caused by tapestry work.

In 1900 Vollard cast some of Maillol's terra cottas in

bronze and in 1902 gave Maillol his first show, which was also admired by Rodin. That same year he began work on his first major sculpture, *Mediterranean*, for which his wife posed. By 1905 he received important commissions, for which he did *Action in Chains* and *Desire*. With these early works Maillol's style was established; it underwent little change in the next forty years. His style had been formed before a trip to Greece in 1906, and his work thereafter showed no substantial influence from this contact with ancient art.

In 1907 he did a bust of Renoir and a statue of an adolescent male, *Young Cyclist*, both of which are rare in his *oeuvre*, for he favored the ripely mature feminine body above all. After 1910 Maillol's fame was international, and commissions from public and private sources were numerous.

The New York Museum of Modern Art owns *Desire* (1904), *Ile de France* (1910), *Chained Action* (1906), *Seated Figure* (1930), and *The River* (1939–43). His *Mediterranean* is in the Stephen Clark Collection. As an alternative to Rodin's style, Maillol championed emotional and formal restraint, clear and untroubled surfaces, and weighted volumes. Thus his figures serve as reminders of idyllic calm in a time of turbulence.

ALBERT ELSEN

MAITRES POPULAIRES. French term for artists who work at painting as a hobby or on off hours. It is equivalent to "Sunday painters" in English.

MALEVICH, KASIMIR. Russian painter (b. Kiev, 1878; d. Leningrad, 1935). Known as the founder of suprematism, Malevich was probably the first painter to produce purely geometric compositions. He studied at the Kiev School of Art and then at the Moscow Academy of Fine Arts (1900–04). His style came under French Fauvist influence about 1910, when he was active in the Jack of Diamonds group in Moscow. In 1911 he was represented in major exhibitions there and in St. Petersburg. He visited Paris in 1912 and was directly inspired by cubism. The *Scissors Grinder* (1912; New Haven, Yale University Art Gallery) and *Woman with Water Pails* (1912; New York, Museum of Modern Art) disclose his debt to the styles of various cubist painters and, perhaps less obviously, to futurism.

Between 1912 and 1915 Malevich formulated his suprematist style, in which, as he stated in his book *Die gegenstandslose Welt* (*The Non-objective World*; 1927), he sought to free art from all pragmatic associations of subject. His *Suprematist Elements: Two Squares* (ca. 1913; New York, Museum of Modern Art) may be one of the first severely geometric abstractions in the history of modern art.

Suprematism may or may not have been anticipated, insofar as its abstract concept is concerned, by Larionov's rayonist works, the first of which evidently appeared in 1910 or 1911. The utilization of only rectangles and squares, however, is Malevich's own development. *See* SUPREMATISM.

Between 1914 and 1918 he proceeded from black-on-black or white-on-white forms to red rectangles or squares on white grounds and more complex combinations such as trapezoids and partly curved shapes of yellow, violet, green, red, and black (*Suprematist Composition*, 1915–16, Leningrad). In such key works of suprematism of 1914–15 as *Eight Red Rectangles* (Amsterdam, Municipal Museum) Malevich achieved remarkable variety with great economy by subtly making slightly trapezoidal forms rather than precise rectangles, by establishing a diagonal movement rather than the indicated horizontal-vertical arrangement, and by delicately blurring the pristine edges of his shapes. An especially restrained work is his *White on White* (before 1918; New York, Museum of Modern Art).

In addition to showing with the Jack of Diamonds group after 1910, Malevich exhibited with the Blue Rider in Munich in 1912 and at the important suprematist show in Moscow in 1919, where Rodchenko hung his *Black on Black*. Malevich lived in Leningrad after 1921. As the probable founder of purely geometric painting, he was a pioneer of 20th-century abstraction.

JOHN C. GALLOWAY

MALLET-STEVENS, ROBERT. French architect (1886–1945). Born in Paris, he worked in his native city during the 1920s and 1930s in the austere, geometric form of the International Style. Among his buildings are the Alfa-Romeo Garage (Paris, 1925) and the Reifenberg and Martel houses (both Paris, 1927), in the manner of Le Corbusier.

MANESSIER, ALFRED. French abstract painter (1911–). He was born at St-Ouen and has lived in Paris since 1941. In 1935, after studying architecture at the Ecole des Beaux-Arts, he turned to painting and studied with Bissière. Religious themes dominate Manessier's work after 1943. He designed stained-glass windows for churches at Breseux in Doubs and at Basel and Arles and the mosaic marquee of the Chapel of Ste-Thérèse at Hem, France (1958). His art has affinities with that of Bazaine, Estève, and Le Moal, with whom he has often exhibited. In 1955 Manessier won the Carnegie award at Pittsburgh.

In his paintings, shapes are loosely joined in patterns that recall panes of colored glass or mosaic. Although religious and nature themes are more often implied by the title of a picture than by its explicit representation, spiritual and mystical values are expressed by the illusion of light and the immediacy of the color.

MAN RAY, see RAY, MAN.

MANSHIP, PAUL HOWARD. American sculptor (1885–1966). Manship's art is associated with an attempt to carry over into recent times an extension of neoclassicism. From his 1916 *Dancer and Gazelles* in bronze (Toledo Museum of Art) to *Personification of the Elements* (New York, Western Union Building) and later public commissions, Manship revealed the development of an archaizing, prettifying tendency. His leadership in the National Sculpture Society served to influence popular taste toward a traditional approach.

MANZU, GIACOMO. Italian sculptor and draftsman (1908–). He was born in Bergamo and was apprenticed to a carver and gilder in 1919. Later he was an assistant to a stucco worker. While performing military service in Verona in 1928, he attended the art academy there. Although mainly self-taught, Manzù was impressed by Donatello, Rodin, Rosso, and Maillol, as well as by ancient sculpture. He made trips to Paris in 1933 and 1936. In 1941 he was named professor of sculpture at the Turin Albertina Academy. He contributed to international exhibitions from 1931. A series of Crucifixion reliefs done between 1939 and 1943 were censured by both the Fascists

and the Church. His relief *Cardinal and Deposition* (1941–42) is in the R. Gualino Collection, and *Portrait of a Lady* (1946) belongs to Mrs. A. Lampugnani, of Milan. The subjects interpreted in his subtle, naturalistic style range from passive seated women and cardinals in quiet revery to images of brutal execution. In 1949 he executed reliefs for the fifth bronze door of St. Peter's, Rome, and in 1956 he was commissioned to do the central portal of Salzburg Cathedral. He has also worked in etching and lithography.

MARC, FRANZ. German expressionist painter (b. Munich, 1880; d. Verdun, 1916). Marc received his first art training in 1900 at the Munich Academy. In 1903 he spent six months in Paris, at which time he saw his first impressionist pictures. From 1903 to 1907 he made many meticulous studies of animals and their anatomy. From 1907 to 1910 he earned his living teaching human anatomy.

Marc's earliest pictures are moody, lonely landscapes, which, with their flat areas and flowing contours, reveal the influence of Jugendstil. Only after 1909 did his art assume its well-known characteristics. It was then he saw the art of Kandinsky, Von Jawlensky, Macke, and Münter,

Franz Marc, *The Blue Horse* (1913). Watercolor, 6⅜″ x 10⅛″. Museum of Modern Art, New York (John S. Newberry Collection).

and abandoned his academic approach. Like them, he sought to express the spirit of creation and expose the mystery of a primordial nature through abstraction, which he equated with spiritualization.

He first joined the Neue Künstlervereinigung, and in 1911–12 he became a founder-member of the Blue Rider. With Kandinsky he coedited its first publication, *The Blue Rider Almanac*, and helped organize its first exhibition. That same year he went to Paris with Macke and met Delaunay. Once he became a soldier he stopped painting; but he did keep a notebook, in which the sketches suggest that his art was moving toward complete abstraction.

His attitude toward art and life was that of a pantheistic mystic. In a work such as *Blue Horses* (1911; Minneapolis, Walker Art Center), Marc used color symbolically. Blue, for him, signified the masculine principle, robust and spiritual; yellow was feminine, gentle, serene, and sensual. Green represented a reconciliation of these opposites. Though Marc theorized on color use, he never appeared to be bound by such notions. Rather, he used color instinctively. In his *Blue Horses* the horses seem withdrawn and demure. They pull their heads in and close their eyes. The undulating rhythms and soft contours of their enclosed forms are echoed in the shapes of the hills and clouds, trees and foliage. In his later works, deer, horses, and other such animals, which flee from danger rather than fight, are shown enmeshed and merged with their environment, usually a crystalline forest. The prismatic forms and refracted colors found in his pictures of about 1912 reflect the influence of Delaunay and possibly of the futurist Severini. ROBERT REIFF

MARCA-RELLI, CONRAD. American painter (1913–). He studied briefly at Cooper Union and privately in New York City. His barren cityscapes of the 1930s and 1940s show the influence of Italian art, particularly that of De Chirico. After experimenting with an abstract-expressionist approach in the early 1950s, he created the style that continues to typify his work, using cutout shapes of canvas in overall, overlapping patterns of figurative abstraction. Marca-Relli received an award from the Chicago Art Institute in 1954; his work appeared in the Venice Biennale of 1955 and the São Paulo Bienal of 1959.

MARCKS, GERHARD. German sculptor (1889–). Born in Berlin, Marcks worked as an assistant with Richard Scheibe beginning in 1907. He taught at the Berlin School for Arts and Crafts for a year, at the Bauhaus in Weimar between 1920 and 1925, and then at a crafts school near Halle. His position was terminated when the Nazis came into power. Following World War II, Marcks was professor of art in Hamburg at the Academy of Fine Arts. He executed a number of public commissions in Cologne, Hamburg, Lübeck, and Mannheim and has been represented in several important exhibitions abroad. His style is representational with expressionist undertones, generally like that of Georg Kolbe but with additional attention to movement and distortion. His bronze *Runners* (1924; New York, Museum of Modern Art) is characteristic.

MARCOUSSIS (Markous), LOUIS. Polish-French painter (b. Warsaw, 1878; d. Cusset, France, 1941). He went to Paris in 1903 and studied under Jules Lefebvre. His art was influenced by impressionism until 1907, when he turned to cubism. He participated in the Section d'Or group. After World War I his work was strongly influenced by cubism yet was closer to reality. His interest in pure forms, heightened by his poetical temperament, earned him an important place among the cubists with such works as *The Frequenter* (1920; Venice, Peggy Guggenheim Collection). Marcoussis was also an excellent engraver. *La Table devant le balcon* (1936) was included in the exhibition of Fifty Years of Modern Art at the Brussels Universal and International Exposition of 1958.

MARIA (Maria Martins). Brazilian sculptor (1900–1973). She was born in Campanha, Brazil. She studied piano and painting in Paris before turning to sculpture, and worked in ceramics in Japan during the 1930s. Her first exhibition was in Washington, D.C., in 1940. She received one-man shows in Paris and New York City, and she was also represented in Paris at the Surrealist International of 1947. She worked almost exclusively in bronze. The style is surrealist and semi-abstract as in *Eternal Insomnia of Earth* (1956). Her works in American collections include the over-life-size *Christ* (1941) in wood and *The Impossible* (1946) in bronze, both at the Museum of Modern Art in New York.

John Marin, *Sea Piece* (1951). Oil on canvas, 22" x 28". Whitney Museum of American Art, New York. Gift of Friends of the Whitney Museum.

MARIN, JOHN. American painter (b. Rutherford, N.J., 1870; d. Cape Split, Me., 1953). Marin belonged to the first generation of avant-garde 20th-century painters in the United States and developed a keenly individual style, semiabstract and generally expressionistic but always based upon penetrating study of natural forms and their apparent rhythms.

Marin first worked as an architect's draftsman and opened his own office in 1893. At the age of twenty-nine he took up painting, studying at the Pennsylvania Academy of Fine Arts from 1899 to 1901 and with Frank Dumond at the Art Students League in New York City in 1904. Marin traveled in Europe, residing mainly in Paris, from 1905 to 1909. He worked in various ateliers learning engraving and etching and made studies of architectural monuments.

He had his first one-man show at Alfred Stieglitz's "291," or Little Gallery, in 1909. Another was held there in 1910, and the following year he showed several works at the Salon d'Automne in Paris. Marin was also represented in the 1913 Armory Show in New York; his water colors of

Manhattan themes anticipated his future staccato, shorthand fragmentations of landscape. The *Seaside Interpretation* (1914; Columbus Gallery of Fine Arts), *Camden Mountain across the Bay* (1922; New York, Museum of Modern Art), and *Maine Islands* (1922; Washington, D.C., Phillips Collection) show the development of a sturdy, imaginative expression. Marin's oil paintings, such as *Tunk Mountains* (1945; Phillips Collection) and *Sea Piece with a Boat* (1951; New York, Downtown Gallery), convey much the same spirited verve as do his water colors.

After his affiliation with Stieglitz's gallery about 1910, Marin showed at the Daniels Gallery and at the Museum of Modern Art (retrospective, 1936). He was given a large one-man exhibition at the Venice Biennale in 1950, the first time such recognition was accorded an American. He is represented in most major American collections. Marin is a forceful and outstanding water-colorist and a strong contributor to early modern painting in the United States.

JOHN C. GALLOWAY

MARINI, MARINO. Italian sculptor, painter, graphic artist, and draftsman (1901–). He was born in Pistoia. He was a student at the Academy of Fine Arts in Florence, where he studied sculpture and painting under Trentacosta, and was possibly influenced by the work of Medardo Rosso. Marini made several visits to Paris between 1919 and 1938. In 1928 he visited Greece and studied sculpture in Paris. From 1929 until 1940 he taught in Monza at the Villa Reale School of Art. Marini lived in Switzerland from 1942 to 1946. In 1950 he went to the United States and exhibited at the Curt Valentin Gallery. During the 1950s he exhibited internationally, and his work entered many of the leading art museums and finest private collections.

Throughout his career he continued to paint, draw, and make prints. His enthusiasm for color led to its introduction into his sculptures, notably in the equestrian series, *Cavalier in the Form of a Triangle* (1951; Baroness Lambert Collection). His preferred media for sculpture are plaster, wood, and cast metal; he rarely uses stone. His contribution to modern sculpture lies in part in his portraits, such as *Curt Valentin* (1954; New York, Museum of Modern Art), *Igor Stravinsky* (1950; San Francisco Museum of Fine Arts), and his self-portraits. These por-

traits recall late Roman heads and sculpture technique, but they have a unique modernity in the frankness of psychological exploration and in surface handling. Their plastic and spiritual individuality, unself-consciousness, and unheroicized truthfulness make them important developments beyond Rodin's work. Marini's sculptures of women favor static, sensually swollen forms with movement created by the surface excavations of the sculptor. Typical of these works are *Standing Nude* (1945; Antwerp, Fine Arts Museum) and *Dancer* (1949; J. T. Soby Collection).

His most distinguished series, that of the horse and rider groups, was inspired by the Han dynasty tomb horse and was begun in 1936 (for example, *Cavalier*, 1936, Milan, E. Jesi Collection). Ironically, the funereal inspiration is transformed into life-seeking images of man and beast. His variations on the motif have lead to erotic formations of both horse and rider (*Cavalier*, 1951, London, Hanover Gallery). The theme was used by Marini to project his feelings of despair over the tragedies of the war. Not unlike Picasso, he has focused upon the horse alone as a dramatic subject, as in *Great Horse* (1951; Nelson Rockefeller Collection). Marini's art testifies to the vigor and depth of the figural tradition in modern sculpture.

ALBERT ELSEN

MARISOL (Marisol Escobar). American sculptor (1930–). Born in Paris of Venezuelan parents, Marisol has lived since 1950 in New York City, where she studied at the Art Students League and the Hans Hofmann School. The immobility of her genre-like groups of figures, which are composed of blocks of wood and plaster with features and details drawn onto them, expresses a fatalistic humor or melancholy.

MARQUET, ALBERT. French Fauve painter (b. Bordeaux, 1875; d. Paris, 1947). In 1890 he went to Paris, where he attended first the Ecole des Arts Décoratifs and then the Ecole des Beaux-Arts. There he was originally a student of Cormon and later, in 1897, he joined the class of Gustave Moreau. Rouault and Matisse were fellow students. Marquet copied in the Louvre and showed a preference for Corot, Chardin, and Claude Lorraine. By 1899 he began to paint in a pre-Fauve style. He and Matisse, a lifelong friend, frequently painted together. Marquet exhib-

ited at the Salon des Indépendants in 1901 and yearly thereafter for a decade. He had his first one-man show in 1907.

By 1900 Marquet had developed a manner of painting and a repertory of subjects that he kept without considerable change throughout his career. His most characteristic pictures are panoramic views of the quays along the Seine in Paris and the ports of the world with their docks, cranes, tugboats, and ships at anchor. Marquet presents them as if from above, from a hotel room on a top floor. Marquet has in effect transposed late Monets, such as his *Thames* series, replacing the vibrating surfaces with unmodulated, light-reflecting planes derived from Matisse and, ultimately, from Gauguin and the Japanese print.

<div align="right">ROBERT REIFF</div>

MARSH, REGINALD. American genre painter and etcher (b. Paris, 1898; d. New York City, 1954). His family went to America when he was two. Both of his parents were painters. He attended Yale, where he was art editor of the *Record* and drew cartoons. Upon graduation he became staff artist for *Vanity Fair* and then for the *New York Daily News*. He took night classes with Sloan, Luks, and Miller at the Art Students League, and was influenced by his father's friend Boardman Robinson. In 1925 and again in 1928 Marsh went to Paris, where he copied Delacroix and Rubens at the Louvre. He painted murals for the Post Office Building in Washington, D.C., and for the Customs House in New York City. He also made several etchings.

Marsh was attracted by the vitality of city life and the activities of the ordinary people, especially at play. His thinly painted pictures with their baroque compositions and vigorous line, featuring crowds sporting at Coney Island, powdery-white burlesque queens, and drifters along the Bowery, grew out of the liberal realist tradition of Hogarth, Daumier, and the Ashcan school.

MASEREEL, FRANS. Belgian printmaker, illustrator, theatrical designer, and painter (1889–1972). Born in Blankenberghe, he trained under Jean Delvin at the Ghent Academy and attained prominence for his social and political satire in Geneva (1916–21), where he did expressionistic black-and-white drawings and woodcuts for periodicals, books, and his own "novel in pictures," *Mon*

livre d'heures. Masereel lived in Paris (1921–45) and in Nice (after 1949) and traveled extensively. His work, which verged toward the extremes of expressionism in the 1920s, excels in economy of means and projection of fantasy.

MASSON, ANDRE. French painter (1896–). Born in Balagny, he studied in Brussels and at the Ecole des Beaux-Arts, Paris, under Baudoin. From 1918 until the early 1920s he was influenced by the cubists, especially Juan Gris. Masson held a one-man exhibit at the Galerie Simon in 1924, mainly of still lifes and landscapes with figures. At that time he met Ernst, Breton, and Miró and became a member of the surrealist group. He then came under the influence of Kafka and psychological literature and the painting of William Blake, turning to such themes as erotic dream fantasies and the metamorphosis of nature. Masson has been active as an illustrator since the 1920s, making drawings for *Justine* and other works by De Sade, his own *Bestiaire*, and books by André Malraux and Georges Bataille. He was represented in the 1936 International Surrealist Exhibition in London, in a two-man exhibition with Giacometti at the Basel Art Gallery, and in many other shows. Masson lived in the United States from 1941 to 1946. During that period he was especially active in printmaking.

Paintings such as *The Constellations* (1925; Paris, Galerie Furstenberg) indicate his cubist discipline (conditioned by Dada). *The Villagers* (1927; Paris, private collection) shows him close to Miró in both concept and technique, although Masson's touch is lighter and his forms more linear; his *Iroquois Landscape* (1943), painted during his sojourn in America, relates to the surrealist-abstract manner of Matta. A fully characteristic work is the *Summer Frolic* (1934; Paris, private collection), with its transcendental insect forms charging in a lively surface of pale greens, reds, and tans. Masson is distinguished for his imaginative formal treatment of a personalized order of surrealist imagery. JOHN C. GALLOWAY

MATARE, EWALD. German sculptor and graphic artist (1887–1965). Born in Aix-la-Chapelle and initially a painter, Mataré studied with Lovis Corinth and Kampf at the Berlin Academy (1907–14). In about 1920 he turned to sculpture. Working with rich woods, he carved the smooth,

simplified forms of animals, abstracting them but never in terms of pure geometric volumes. Appointed to teach at the Düsseldorf Academy in 1932, he was dismissed the next year by the Nazi regime; he was returned to the post after World War II. Under the Nazis he worked on articles for church use in order to make a living, and after the war he devoted himself in large part to religious sculpture. His major work, bronze reliefs for the south portal of the Cologne Cathedral (1947–54), shows the inspiration of German Romanesque sculpture in the modern terms of reduction to simple forms.

In the graphic media Mataré produced more than 320 works, mostly woodcuts, after 1920. They depict stylized animal shapes, like his sculpture, in the form of simple flat patterns.

MATHIEU, GEORGES. French abstract painter (1921–). He was born in Boulogne-sur-Mer and now lives in Paris. He studied law and philosophy before turning to painting in 1942. His first nonrepresentational art appeared two years later. In 1947 he and Bryen launched the psychic-nonfigurative movement, opposed to geometric formalism and advancing lyrical and informal aspects of abstract art. He had his first one-man show at the Galerie René Drouin, Paris, and succeeding shows at the Stable and Kootz galleries in New York. Inspired by Wols, Mathieu has developed his own variant of spontaneous calligraphy by squeezing paint directly from the tube in a pattern of elegant and graceful arabesques onto a canvas usually covered with a flat wash of a single contrasting color.

MATISSE, HENRI EMILE. French painter and sculptor (b. Le Cateau, Nord, 1869; d. Cimiez, Nice, 1954). One of the most distinguished 20th-century artists, Matisse is historically important as the leader of the first avant-garde movement of early modern art, Fauvism, which made its appearance in 1905 at the Salon d'Automne in Paris.

In his youth Matisse studied classics, and in 1887 he went to law school. While clerking in a law office he secretly attended painting classes in 1890–91 at the Ecole Quentin de la Tour. He later entered the Académie Julian, where he briefly studied under Bouguereau. He then joined the atelier of Gustave Moreau, an academic but encouraging master who also taught Rouault, Marquet, Manguin,

Henri Matisse, *Goldfish and Sculpture* (1911). Oil on canvas, 46″ x 39⅝″. Museum of Modern Art, New York. Gift of Mr. and Mrs. John Hay Whitney.

and others who were to join Matisse soon after 1900 as early Fauves. Matisse was deeply interested in the old masters at the Louvre and became a skilled copyist. He exhibited brownish-toned, traditionally inspired compositions at the Salon de la Société Nationale in 1896 and later; but during the middle 1890s he also found excitement in postimpressionist art, probably seeing the 1895 Cézanne exhibition at Vollard's gallery (he purchased a *Bathers* by that master in 1898). Matisse became interested in sculpture in 1900 and was to create important works in that medium until the 1930s, although painting was consistently his primary field.

With several other artists who were to form the Fauve circle, Matisse exhibited at the gallery of Berthe Weill soon after 1900. He also helped organize the first Salon d'Automne in 1903, joining with Rouault, Manguin, and other former students of Moreau. Matisse was significantly influenced by neoimpressionism in 1904 and 1905; during those years he combined the lessons of Seurat, Signac, Van Gogh, and Gauguin with the stimulus of the sculpture of Negro Africa and the decorative arts of the Near East to break away altogether from his academic background and to develop a brilliantly colored, boldly patterned style known as Fauvism (*Landscape at Collioure*, 1905; Copenhagen, State Museum of Art). See FAUVISM.

The 1905 Salon d'Automne saw the initial presentation of Fauve art, and reaction to it was intensely hostile. As unofficial leader of the group, Matisse was bitterly denounced; nonetheless, between 1905 and World War I he extended his Fauvist method into a number of imaginative, strongly original substyles. The 1905–06 canvases, with their pure areas of rapid, broken touches of color and cursive linear accents, gave way to a manner that involved ample, flat shapes with rhythmic movement, some of them depicting outdoor dance themes (*Le Luxe, I*, 1907; Paris, National Museum of Modern Art). Always a masterful draftsman, Matisse combined powerful linear definition with equally strong color. The influence of Near Eastern arts and of his visits to North Africa was reflected between 1907 and 1920 in certain of his subjects as well as in his formal structure and color. From those years come some of Matisse's most vivid and penetrating canvases (*Harmony in Red*, 1908–09; Moscow, Pushkin Museum). His interest in sculpture was renewed about 1910, and this period was also enriched by his meeting Renoir in 1917.

After 1920 Matisse was also active as an illustrator and as a designer of theater décor, creating, for example, the sets for the Stravinsky-Diaghilev ballet *Le Rossignol*. He won first prize at the Carnegie International in 1927 (for *Le Compotier*) and was given a one-man show in Berlin in 1930. In 1931 he traveled extensively in Russia, Oceania, and the United States. He worked on murals for the Barnes Foundation gallery in Merion, Pa., completing them in 1933. During the late 1930s his style, generally more decorative than before, sometimes recalled his earlier Fauvist manner, although he amplified it with a more graceful,

less blunt technique.

Matisse withdrew to Vence in 1939, intending to retire from painting. He became active in book illustrating, however, and his lavishly colored collages of cut-out art construction paper followed in the mid-1940s. Matisse became a Commander of the Legion of Honor in 1947, and in 1948 he had a large retrospective at the Philadelphia Museum of Art. A similar show followed in 1949 at the Lucerne Art Museum. When he was eighty Matisse undertook the entire decorative scheme for the Dominican chapel at Vence. He designed powerfully simplified Stations of the Cross in black line on white tiles as well as the glass window décor, the altar and altar furnishings, and liturgical garments. He also collaborated with Léger and other artists in decorating the church at Assy.

A museum was established in Matisse's honor at Le Cateau in 1952. In 1953 a retrospective of his sculpture was held at the Tate Gallery in London. After his death in 1954 a large retrospective, including graphic works as well as paintings, was held at the Museum of Modern Art, New York, and at the National Museum of Modern Art, Paris.

Matisse ranks with Picasso, Braque, Kandinsky, Mondrian, and other pioneering masters of 20th-century art. In addition to his remarkable productivity and the originality of his paintings and graphics, Matisse's statements on art were also widely influential, not only upon young painters and sculptors but also upon collectors and critics. Although he invariably painted identifiable objects, Matisse, like the abstract artists, insisted upon the primacy of creative form, upon the painting's being its own subject.

MATISSE AS SCULPTOR

Matisse was a pioneer of formal experimentation in modern sculpture. His sculptural works date almost exclusively from 1899 to about 1935; there are few examples that date from later periods.

The earliest sculptures of the proto-Fauvist phase are usually looked upon either as Rodin-inspired in pose and surface development or as a reaction against Rodin's so-called impressionism and the result of a search for solidity and simplicity. There is little question that Rodin influenced Matisse, who unsuccessfully sought to study with the older master. This influence, however, was less important for the broken treatment of bronze surfaces and pose of

the figure than for the subjective rhythms that transcend subject and material. Moreover, at that time Matisse copied a Barye animal composition, and almost simultaneously he studied sculpture under Bourdelle and developed an admiration for Maillol, who had a fundamentally different approach.

Matisse was always an assiduous student of older traditional painting and sculpture as well as of exotic styles, and seems to have been deeply affected by their aesthetics. In *The Slave* (1903; casts in San Francisco, Chicago, Baltimore, and elsewhere) he may have transmitted, through the general mode of Rodin, an idea that was synthesized from Greek late-archaic bronzes and perhaps very early medieval figures. The forcefully abused surface of *The Slave*, for all its closeness to certain works by Rodin, is not so significant as its extraordinary static quality and ground-rooted compactness.

An even earlier sculpture, the *Madeleine* (ca. 1901; Baltimore Museum of Art), discloses so great an interest in rhythmic, sinuous structure that the facial zone is deliberately rendered vacant. In this work, as in *Torso with Arms Raised* (1906; cast in New York, Metropolitan Museum) and the remarkably advanced *Reclining Nude I* (1907; cast in Baltimore Museum), Matisse is at least apace with the daring painterly vocabulary of his Fauvist canvases.

The *Two Negresses* (1908; casts in Baltimore Museum, New York, private collection), *La Serpentine* (1909/14; New York, Museum of Modern Art), and the startling later examples of the *Heads of Jeannette, I–V* (ca. 1910–11) attest to Matisse's complete dominance over the material and to his preoccupation with a combined emotional and structural involvement in the underlying theme. The curious, if not disturbing, attention to the eyes in *Jeannette III* and *V* has been psychoanalytically interpreted. However, these eyes, the pronounced cheek structure, and the markedly lobelike coiffure show an affinity with specific types of African masks and heads of figures from the Cameroons. The related *Head with Tiara* (1931) similarly suggests the lobed hairdress of, for example, both Baoulé West African heads and the beautiful Balumbo white-faced masks from Gabon. Matisse may not have consciously derived these elements from primitive sources, but he apparently was influenced by them.

In certain instances Matisse's sculptured figures later appeared as themes in his paintings; in others, it is entirely probably that figures originated in lithographs, drawings, or paintings and culminated as sculptural subjects. His *Nude* (or *Venus*) *in a Shell* (1930; casts in Baltimore Museum, New York, private collection) is linked with the odalisque theme of his graphic works and paintings. Bronzes of 1929–30 have been referred to as "pared down" in comparison to the more roughly finished, serpentine early sculpture. Irrespective of the immediate visual impression, Matisse constantly sought the essentials of structure. The small, sparsely limbed, and notably advanced *Serpentine* of 1914, almost certainly motivated by pre-Hellenic Geometric centaurs and related tiny bronzes, is actually more "pared down" than are the economically formed nudes of about 1930.

The decorations for the Vence chapel, dating principally from 1948 to 1951, include the thin, almost elegantly formed crucifix of bronze, which Matisse skillfully adapted to his own design for the simple altar and its other liturgical accessories. This was his last complete sculpture and the most nearly abstract of his three-dimensional works.

Without the use of the color that characterizes his paintings, Matisse's sculptures are, almost without exception, a blunter statement of his aesthetics. Though most of his bronzes and terra cottas are small and intimate in theme, they make a powerful statement of his fundamental concept of form. JOHN C. GALLOWAY

MATTA (Matta Echaurren), ROBERTO SEBASTIAN ANTONIO. Chilean painter (1912–). Born in Santiago, Matta is of Spanish and French parentage. He has lived in Mexico, Italy, England, Spain, and the United States, and now resides in Paris. Matta is identified primarily with surrealism, but his method is abstract. He is an original, provocative imagist and technician.

His first training was architectural; he was apprenticed to Le Corbusier in Paris in 1934. His early paintings (1937–38) were closely linked to surrealism and evolved from his association with the surrealist group. Matta's first one-man show was held at the Pierre Matisse Gallery in New York City (1940) soon after his arrival in the United States. An important retrospective of his work was given at the Museum of Modern Art, New York, in 1957. He has

Matta, *Listen to Living (Ecoutez Vivre*; **1941**). **Oil on canvas, 29½″ x 37⅜″. Museum of Modern Art, New York. Inter-American Fund.**

been represented at the Carnegie International, the Brussels World's Fair, the Kassel Documenta, and other major exhibitions.

Matta's style has progressed from evident surrealist influence (*The Morphology of Desire*, 1938; *Listen to Living*, 1941) to what may be called abstract surrealism (*Untitled*, 1961; Paris, private collection) and relative freedom from subject matter as such. Matta was an influence on Arshile Gorky and other American abstract artists.

JOHN C. GALLOWAY

MAURER, ALFRED HENRY. American painter (b. New York City, 1868; d. there, 1932). Maurer studied at the National Academy and worked as a commercial artist. He lived in Paris from 1897 to 1914. His first style brought him success, for example, the award-winning *An Arrangement* (1901; New York, Whitney Museum). Adoption of more modern idioms after 1904 lost him popular support. His first experiments were related to Fauvism, but he gradually turned toward cubism and abstractions. His cub-

ist still lifes are mild in their analysis of objects; their power is derived from their beauty of texture and pattern. His portraits of the same obsessively repeated face, a girl with huge eyes and a long neck, seem expressive of the inner conflicts which eventually led to his suicide.

MECHAU, FRANK. American painter (b. Wakeeney, Kans., 1904; d. Glenwood Springs, Colo., 1946). He studied in Denver, at the Art Institute of Chicago, and in Paris from 1929 to 1932. Mechau was a painter of horses and Western life. His many artistic interests—Breughel, Chinese landscape paintings, and Italian 14th-century painters—were assimilated into a style in which simplified and stylized forms, especially the graceful silhouettes of horses, were rhythmically and decoratively composed.

MEIDNER, LUDWIG. German painter, writer, and graphic artist (b. Bernstadt, Silesia, 1884; d. Darmstadt, 1966). He studied at the Breslau Academy from 1903 to 1905. The next year he worked as a fashion designer in Berlin. In Paris in 1906, he was painting in an impressionistic manner, but on his return to Berlin in 1907, his tormented and visionary personality began to find expression in his work. In 1912, Meidner began a series of paintings of apocalyptic and cataclysmic subjects—his most important artistic contribution—in which universal agony is rendered by intense color and the dislocated space of exploding cities. His portraits are similar in the psychological intensity of their expressionist distortions.

MENDEZ, LEOPOLDO. Mexican painter (1902–1969). Méndez was born in Mexico City. A graduate of the Mexican Academy and the "open-air" school of Chimatistac, he dedicated himself from the 1920s on to an art of social and political protest. He painted impressive murals (Mexico City, Maternity Clinic #1 and Talleres Gráficos de la Nación), but his prestige rests principally upon his contributions to the graphic arts, particularly through the Workshop for Popular Graphic Art, which he helped found in 1937.
See also TALLER DE GRAFICA POPULAR.

MERIDA, CARLOS. Mexican painter (1893–). Mérida, who is partly Mayan, was born in Quezaltenango,

Guatemala. He studied and traveled in Europe (1910–14). Among the studios he frequented were those of Modigliani, Van Dongen, and Picasso, who encouraged Mérida to seek an aesthetic integration of Indian and avant-garde art.

Mérida's first exhibition in 1919, when he returned to Guatemala, glorified Indian life in romantic and picturesque terms. Failing to win recognition, he emigrated to Mexico the same year. He exhibited at the Academy of Fine Arts in Mexico City (1920), and established himself as a pioneer of the Mexican renaissance.

A second trip to Europe (1927) strengthened Mérida's contacts with painters of the avant-garde, especially Picasso, Miró, Klee, and Kandinsky. From then on his art became more abstract and decorative.

In recent years Mérida has tackled challenging technical problems ranging from "Byzantine" mosaics to sketches on bark fiber à la Indian codices. From Le Corbusier he learned to ally painting to sculpture and architecture. Probably his most successful integration of these three media is found in a multiple dwelling unit named after Benito Juárez (1952; Mexico City), where he painted murals in vinylite on concrete. During the late 1950s he executed murals in several public buildings in Guatemala.

JAMES B. LYNCH, JR.

MERRILL, JOHN O., see SKIDMORE, OWINGS, AND MERRILL.

MERZBILDER, see DADA; SCHWITTERS, KURT.

MESTROVIC, IVAN. Yugoslavian (Croatian) sculptor (1883–1962). Meštrović was born in Vrpolje. He became internationally known and spent his final working years in the United States. His earliest inspiration came from the sculptures and architecture at Split (Spalato) and Sibenik, where Roman and medieval monuments equally impressed him. After a brief apprenticeship in decorative carving, he was sent by a patron to study at the Academy of Fine Arts in Vienna. His teachers were Hellmer, then director of the Academy, and Bitterlich. He exhibited early and was encouraged by the collector Wittigstein.

Meštrović went to Paris in 1910, where he mainly worked independently and exhibited plaster works in the Salon

d'Automne. He won a prize in the 1911 International in Rome, and exhibited in England and France during World War I.

Several of the artist's earlier works (Belgrade, National Museum of Yugoslavia) are clearly of a strong personal quality, for example, *The Artist's Mother* (1907), a reposeful, directly conceived marble portrait, and the marble *Widow and Child* (1912). Of the numerous Crucifixions he carved or cast, one of the most successful is the *Christ on the Cross* (1933; Zagreb, St. Mark's).

JOHN C. GALLOWAY

METAPHYSICAL PAINTING, see PITTURA METAFISICA.

METZINGER, JEAN. French cubist painter (b. Nantes, 1883; d. Paris, 1956). His training before turning to painting was scientific. In 1903 he went to Paris, where he was to live. He first worked in a neoimpressionist manner, then painted as a Fauve before turning to cubism. He was an active member of Section d'Or, a group organized in 1912 with Léger, Delaunay, Picabia, Kupka, Le Fauconnier, and Gleizes. They arranged an exhibition of more than 200 works as a kind of cubist demonstration in 1912, the same year Metzinger wrote a book, *Du Cubisme*, with Gleizes. Metzinger was the first to conceive of combining multiple viewpoints through superposition in a single work. In his *Tea Time* (1911; Philadelphia Museum of Art), he geometricized the human figure in a deliberate and systematic fashion and used many colors, thus rejecting the monochromatic palette of Picasso and Braque.

MIES VAN DER ROHE, LUDWIG. German-American architect (1886–1969). He was born in Aachen. Mies finished his formal education when he was fifteen, spent four years as a designer-draftsman of stucco ornament, and then two years as a decorator and furniture designer in the office of Bruno Paul. From 1908 until 1912 he served as the apprentice of Peter Behrens. In 1912 he designed Schinkleresque projects for the Kröller House in The Hague, where he had opportunities to see the work of Berlage, and for the Bismarck Monument at Bingen.

Mies's early projects strike (for him) a thoroughly uncharacteristic pose, as may be seen in his models of 1920–21 for glass-and-iron skyscrapers. By 1923, however, in

the projects for brick country houses reflecting the influence of de Stijl, it can be seen that Mies brought his latent expressionism under control: here axial walls, in a Wrightian fashion, forcefully extend into the landscape. From 1925 until 1929, Mies characteristically used brick (Wolf House, Guben, Germany), a material other architects shunned because of its handicraft associations. At this time Mies was also capable of extensive projects, for he directed the building of the complexes of the Werkbund Exposition in Stuttgart, Germany, in 1927.

The German Pavilion designed for the International Exposition at Barcelona in 1929 achieved for Mies international prominence. No part of the interior was taken up by any sort of exhibit; there was only the furniture designed by Mies himself. The building, consisting merely of walls and columns arranged on a low travertine podium, was striking in its beauty of materials, in its economy of means, in its well-thought-out grouping of solids and voids. Mies typically used the most precious of materials. The main seating area of his Tugendhat House (1930) in Brno, Czechoslovakia, is defined by a single wall of onyx, and a semicircle of macassar ebony encloses the dining area.

In 1930 Mies was appointed director of the Bauhaus School at Dessau, and in 1937 he left Germany to settle in the United States. Mies's dictum that less is more, and his resultant eschewing of personal eccentricity, found a responsive chord in America: it is no exaggeration to say that Mies was the most influential architect in the United States in the 1950s and 1960s. He is best known for the complex at the Illinois Institute of Technology (begun in 1940) in Chicago, where a predetermined module governs both sizes of buildings and spaces between buildings; the Farnsworth House (1950) in Plano, Illinois; the Lakeshore Drive Apartment Blocks (1950s) in Chicago; and his Seagram Building (with Philip Johnson in 1958) in New York City. His National Gallery (1968) in West Berlin is a templelike glass box, with a steel grid roof, set on a stone base. *See* BAUHAUS. ABRAHAM A. DAVIDSON

MILLER, KENNETH HAYES. American painter, teacher, and graphic artist (b. Oneida Community, Kenwood, N.Y., 1876; d. New York City, 1952). He studied at the Art Students League under H. Siddons Mowbray and Kenyon Cox and at the New York School of Art with William

Merritt Chase. He went to Europe in 1900. Miller taught at the New York School of Art from 1899 to 1911 and then at the Art Students League. He was an important and influential teacher, particularly in regard to artistic theory and technical methods.

Miller's early paintings, perhaps influenced by his strong friendship with Albert P. Ryder, depict sadly poetic or allegorical figures, usually placed in inhospitable settings, for example, *Figures with Landscape* (1914; New York, Metropolitan Museum). After about 1918, however, Miller came strongly under the influence of Renoir. His color deepened and became richer, and he more greatly emphasized a fuller, almost sculpturesque, modeling of forms. The paintings of this period are among his most appealing, for example, those of a sweetly pensive girl (*Day Dream*, 1926; Cleveland Museum of Art) or a young woman at her toilette (*Preparations*, 1928; New York, Museum of Modern Art).

In the late 1920s Miller began to concentrate on painting the scenes about him, especially the women shoppers, shopgirls, and pedestrians on Fourteenth Street. He attempted to recreate, in a modern setting and subject, the three-dimensional construction and solid design of Renaissance artists, with attention paid to texture and with a form-molding generalized lighting. The somewhat idealized, at times overly massive, figures move in a real space with contemporary and realistic accessories, but despite the care with which Miller inserted them into the total design, such obvious details as the costumes now strongly date these paintings. JEROME VIOLA

MILLES, CARL. Swedish sculptor (1875–1955). Born in Uppsala, he first studied as a wood-carver's apprentice and helped support himself by this craft while he was a student at the Technical School in Stockholm. In 1897 Milles went to Paris for independent study, and in the next few years he received almost all the curious combination of influences that marked his style. He was at first guided by Rodin, who personally encouraged him; he was attracted by the more decorative elements of the work of Dalou, Falguière, Gardet, and Frémiet; he assimilated more than a touch of Art Nouveau; and he then acquired certain values—not always fully resolved in his later work—from Bourdelle and Maillol as well as from Adolf von Hildebrand. Ulti-

mately his formulation of the human figure is elongated and linear, accentuating silhouette, upward-thrusting motion, and often mannered gesture.

Milles is best known for his numerous fountain groups, many of them located in the United States, where he settled after 1929.

MILLMAN, EDWARD. American painter (b. Chicago, 1907; d. Woodstock, N.Y., 1964). After studying painting at the Art Institute of Chicago, he worked in fresco with Diego Rivera. Millman painted murals for the Chicago World's Fair of 1933. With Mitchell Siporin he did a large mural for the St. Louis Post Office (1939–41). His earlier style was social realist, but about 1946 he turned toward abstract expressionism.

MINGUZZI, LUCIANO. Italian sculptor (1911–). Minguzzi was born in Bologna. His father, an artist, was his first instructor in sculpture. He also studied at the Bologna Academy of Fine Arts and now lives in Milan and teaches at the Brera Academy. Minguzzi has been represented in many important international showings, including the Venice Biennale and the Rome Quadrennials. He participated also in "The New Decade" exhibition at the New York Museum of Modern Art in 1955 and in the Arnhem (Holland) International Exhibition of 1958. His style is semiabstract, and the forms are taken from the figure and developed into imaginatively interpreted, fluid shapes.

MINIMAL ART. Term coined by the critic Barbara Rose to describe the art of a number of painters and sculptors in the 1960s, particularly in the United States, who seek to reduce the work to its essential abstract elements. In sculpture this means the reduction to simple coordinates, as in the pyramids, cubes, and geometric volumes used by artists such as Donald Judd, Robert Morris, and Larry Bell. In painting it may mean the complete elimination of illusionism in favor of pure structure or color field, as in the work of Frank Stella or Kenneth Noland. The forebears of the movement are the Russian constructivists, Mondrian, Newman, David Smith, and others. *See* BELL, LARRY; JUDD, DONALD; MORRIS, ROBERT; NOLAND, KENNETH; STELLA, FRANK.

MINNE, GEORGES, *see* LAETHEM-SAINT-MARTIN SCHOOL.

MIRKO (Mirko Basaldella). Italian sculptor and painter (1910–1969). Born in Udine, he was a student in Venice, Florence, and Monza. His first one-man sculpture exhibition was in Genoa (1949–50) at the Gallery Cairola. He worked in Rome after 1934. Mirko's first painting exhibition was in Rome (1947) at the Gallery Obelisco. In 1950 he did a bronze gate for the Ardeatine Cave memorial outside Rome, the site of the reprisal slaying of 320 Italians by the Germans in 1944. He did a ceiling decoration for the Food and Agriculture Organization Palace, Rome, in 1951. In 1953 he won a second prize in the competition for the *Monument to the Unknown Political Prisoner.* His *Hector* (1949) is owned by S. Seegar, Dallas, and *Chimera* (1955) is in the V. Kirkland Collection, Denver. One of the strongest Italian sculptors to emerge since World War II, Mirko is at his best in complex, aggressive images.

MIRO, JOAN. Spanish painter, graphic artist, ceramist, and scenic designer (1893–). Miró is identified with the abstract surrealist movement, of which he is one of the most original and sensitive exponents. His highly personalized idiom, filled with great charm and wit, although comparable in a general way to the art of Paul Klee, is entirely and recognizably his own. Born in Montroig, near Barcelona, of Catalan origin, Miró was strongly and poetically affected by the natural environment of his native province as well as by its cultural and artistic heritage. Whereas other Spaniards, such as Picasso and Gris, have felt themselves more at home in other countries, Miró has always needed the milieu in which he was born and brought up.

Miró began to study art in 1907 at the School of Fine Arts in Barcelona under the romantic landscapist Modesto Urgell and under José Pascó, from whom he learned the importance of draftsmanship. In 1910 his parents withdrew him from art school, but he began again at the Galí school, whose director, Francisco de Asís Galí, put Miró in touch with the world of music and poetry, a decisive factor for the young man's career.

In 1917 he met the dealer José Dalmau, who had al-

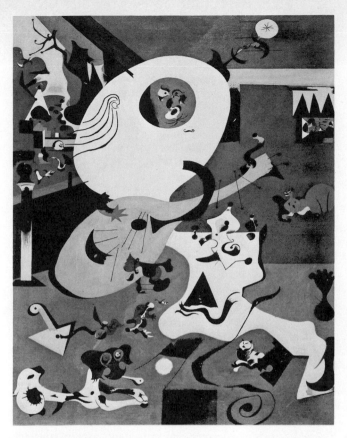

Joan Miró, *Dutch Interior, I* (1928). Oil on canvas, 36⅛" x 28¾". Museum of Modern Art, New York. Mrs. Simon Guggenheim Fund.

ready exhibited the French cubists in Barcelona (1912). From this source Miró also learned of the existence of Fauvism, and his works of the 1917–18 period show better organization than did the previous ones. These new paintings combine Cézanne, Van Gogh, and Fauve influences with occasional evidence of Miró's awareness of facet cubism. Although they are intense formal studies, many of them are filled with a powerful mood and strong subjective analysis of character (for example, *Portrait of*

E. C. *Ricart*, 1917; Chicago, Mr. and Mrs. Samuel A. Marx Collection). From this early period also derive a number of deliberately primitivistic yet highly sophisticated landscapes (for example, *View of a Farm*, 1918; Winnetka, Ill., Mr. and Mrs. James W. Alsdorf Collection). Here, although it is still a long way from his ultimate abstract formulations of nature, Miró's curious, characteristic, and paradoxical combination of gay charm and thoughtful sobriety is already evident.

He had his first one-man show in 1918, and by the end of the war he moved on to Paris (1919), where he first stayed for about a year and visited with his countryman Picasso, through whom he became acquainted with the art of Henri Rousseau. The intense inwardness and primitivism of Rousseau reinforced tendencies already evident in Miró's art and represent another step along the path toward a figurative surrealism. *The Farm* (1921–22; formerly Havana, Ernest Hemingway Collection) is probably the outstanding work of his early career. It exemplifies the combining of his typical freshness of approach with the most intricate calculation of compositional effect. The period 1922–24 marked a continuous application to realism strongly tinted with fantasy and intensity of mood. At the same time Miró moved along the line of abstraction, for example, in the abstractly humorous *Catalan Landscape* (1923–24; New York, Museum of Modern Art).

By the early 1920s Miró was friendly with Dadaist poets, and at this time surrealism itself was about to be launched, a movement whose possibilities of free invention fascinated the painter. Miró became an important part of the surrealist movement from 1924 on. He contributed a delightful freshness of color and imaginativeness of free form and pictorial allusion which, while quite legible, encourage the viewer's interpretation of these images of poetic and musical sensibility. The tiny allusive figures in such works as *The Harlequin's Carnival* (1924–25; Buffalo, N.Y., Albright-Knox Gallery) recall the poetic fantasy of Jerome Bosch, now accommodated to the coloristic needs of the age of Matisse and the abstract automatism of the newly born surrealist movement. In 1925 Miró worked with Max Ernst on sets and costumes for Diaghilev's *Roméo et Juliette*.

During the later 1920s Miró developed a number of increasingly freely organized works with poetic and highly

personalized psychological references, for example, *Dog Barking at the Moon* (1926; Philadelphia Museum of Art). At the same time, however, he applied the techniques of *The Harlequin's Carnival* to a more literal series of Dutch interiors (1928) stemming from a trip to Holland. The collages of 1929–32 reflect to some extent the calculated infantilistic quality of Klee's art. It may be supposed that these collages were important for the execution of such broadly formed masterpieces as the elegant *Painting* (1933; New York, Museum of Modern Art), in which large areas of silhouetted free form dominate in their rich black. During the early 1930s Miró also executed a number of unusual relief constructions parallel in spirit with his pictorial aims. The period is marked by an automatism of technique that involved spilling a quantity of paint on the canvas and then moving a dipped brush around in it. A good deal of effort during this time went into the costumes and scenery of Massine's ballet *Jeux d'Enfants.*

The next few years were marked by various experiments in collage forms, surrealist constructions, and so forth. In 1937, the year of Picasso's *Guernica,* Miró executed his own tragic record of how he felt about the Spanish Civil War, *Still Life with Old Shoe* (1937; New Canaan, Conn., private collection), a rather melancholy and poetic reference to the poverty of Spain's people. In contrast, his mural decoration for the Spanish Pavilion of the 1937 Paris Exposition, *The Reaper,* is a tortured and savage protest, as is the anti-Franco poster of that year, *Help Spain (Aidez Espagne).* During World War II Miró first retired to Varengeville, and then with the fall of France he returned to his native Spain.

During the mid-1940s he was occupied also with ceramics and sculpture, which represent a not inconsiderable part of his *oeuvre.* In 1947 he executed a popularly appealing mural (oil on canvas) for the Gourmet Restaurant of the Terrace Hilton Hotel in Cincinnati. Another such decoration, carried out in 1951 for Harkness Commons in the Graduate Center of Harvard University, is somewhat more serious in tone. Between 1953 and 1956 Miró produced literally hundreds of ceramics; a series of book projects then followed. A ceramic mural, commissioned by UNESCO in 1955 for the outside walls of its Paris headquarters, was completed in 1958. In 1960 a ceramic mural for Harvard replaced the 1951 work, which was

transferred to the Fogg Art Museum in Cambridge.

Miró has clearly devised a vocabulary of free-form, associational, highly colored, and decorative art in which wit and imagination are always present in varying degrees. This vocabulary has served him for the creation of hundreds of outstanding works in various media. It has also served countless other artists, in both the fine and the applied arts, who have profited from the imaginative and decorative possibilities of this artistic language.

BERNARD S. MYERS

MOBILE. An abstract sculpture or construction, usually made of wire and sheet-metal shapes, having parts that move, oscillate, or vibrate, either because of air currents or by mechanical means. Delicately balanced, it is often suspended from a ceiling. Alexander Calder invented the type, named by Marcel Duchamp and first exhibited at the Galerie Vignon (Paris, Feb. 12–29, 1932).

MODERSOHN-BECKER, PAULA. German expressionist painter (b. Dresden, 1876; d. Worpswede, 1907). She took drawing lessons in Bremen, Berlin, and London with academic teachers. In 1899 she moved to Worpswede, an artists' colony near Bremen. There she studied with Mackensen and painted pictures of peasants and the poor in a naturalistic vein with Jugendstil elements added. She made her first trip to Paris in 1900 and saw Cézanne's paintings at Vollard's gallery. She married the academic painter Otto Modersohn in 1901.

About that time, her style changed from a decorative one, similar to that of Bonnard and Vuillard, to a manner which recalls the early work of Van Gogh and the art of Marées and Millet, both of whom she greatly admired. She painted old peasant women and mothers with their children in brownish areas of tone with little or no reference to light and shade. Form was severely reduced to flat areas. These figures appear mute, immobilized, and introspective, as do most of the figures in her later works.

She knew the poet Rilke and the dramatist Hauptmann, and was much influenced by their writing, then considered very advanced. In her own work she aspired to a conception of beauty similar to theirs. As an artist, she depended on her instincts and proved to be amazingly in-

dependent in her preferences in French art. Though she admired Cézanne the most, it was Gauguin's painting, which she saw in a large retrospective memorial show in 1906 in Paris, that provided her with models to clarify her own style.

Modersohn-Becker's *Self-Portrait with Camellia* (1907; Essen, Folkwang Museum) is one of more than twenty self-portraits. In this work she holds a flower in a manner recalling early Flemish portraits of the bridegroom with a pink. Her mouth is slightly open, as if she were about to speak, and her eyes with their oversize pupils look beseechingly at the beholder. The simple background is done in pale blue, which contrasts with the ruddy tans of the figure. Though classified with the expressionists, she was not known by them until some time after her death.

<div align="right">ROBERT REIFF</div>

MODIGLIANI, AMEDEO. Italian painter and sculptor (b. Leghorn, 1884; d. Paris, 1920). He first studied painting when he was fourteen and too ill to continue formal studies. He received training at the academies of Rome, Florence, and Venice before going to Paris in 1906. He took a studio in Montmartre and in 1908 exhibited six pictures at the Salon des Indépendants. His friendship with Brancusi led him in 1909 to make his first sculptures. That year he spent the winter in Italy because of continued illness, considerably aggravated by alcoholism and drugs. He was depressed by poverty and lack of recognition.

In 1913 Modigliani settled in Montparnasse and frequented the Café Rotonde, where he met and became the friend of Soutine and Kisling. At this time his chief patron was Dr. Paul Alexandre. He also sold to the art dealer Paul Guillaume, and Leopold Zborowski became his dealer and champion. Modigliani abandoned sculpture after 1915. His first one-man exhibition of paintings in 1918, organized by Zborowski, was at the Galerie Berthe Weill. The police objected to the nudes as being immodest, and closed the show. The following year he exhibited at the Salon d'Automne and at the Hill Gallery, London.

Except for a few landscapes, mostly early works, Modigliani restricted himself to painting and drawing the human form, particularly portraits and the recumbent female nude. When he first went to Paris, the Fauves were exhibiting and Picasso was just beginning to evolve the

cubist style. Modigliani knew the art of Matisse and of Picasso's Blue and Pink periods. He also saw the art of Toulouse-Lautrec, Gauguin, Beardsley, and Boldini. His admiration for these artists undoubtedly played a part in forming his own distinctive manner of representation. In 1909 he was profoundly impressed with the art of Cézanne. Modigliani's color, his use of the brush, and the quality of his contour bear a relationship to Cézanne.

The period of Modigliani's greatest productivity came in the last two and a half years of his life. He tended to place his figures in a simple setting of broad planes and neutral color. He always preserved some aspects of the sitter's likeness and character, despite the extreme and frequently delightfully outrageous dislocations of form: the elongations, the svelte contours, the wedgelike nose, the tubular neck, the pursed mouth, and the eye that is all pupil. He painted friends, painters, poets, professional models, and servants. His nudes are frankly erotic and animal, yet tempered by a dreamy tenderness, melancholy, and elegance. ROBERT REIFF

MODIGLIANI AS SCULPTOR
Modigliani is better known as a painter than as a sculptor, but there is evidence that he actually preferred working three-dimensionally and abandoned it only because of the cost of materials and because, in his poor state of health, the working of stone became too burdensome. He began making sculptural sketches in line and gouache soon after his arrival in Paris in 1906. His first carved works date from 1909, the year he met Brancusi, Archipenko, and other sculptors and became familiar with African primitive art and the figures of Elie Nadelman.

Only a score of sculptures by Modigliani survive in galleries or private collections, although it is probable that as many more were destroyed or lost. Most are heads, vertically oriented, carved directly in limestone, and approximately 2 feet high (excellent examples in New York, Museum of Modern Art, and Philadelphia Museum of Art).

There can be no doubt that Modigliani's tallish heads of 1909–15 owe something to African tribal styles; examples of these masks and figures were available to him in various places in Paris. However, Modigliani also found inspiration in more than one kind of pre-Romanesque

sculpture, possibly including small Byzantine images. The great linear tradition of his native Italy is sometimes cited as the principal source for his painting style; but as applied to his sculpture, it is mannerist rather than Renaissance concepts that are important. An extraordinarily sensitive combination of the various sources suggested above reinforced Modigliani's own attitude toward three-dimensional art. Although his sculptural output is slight, his style is unique and among the most personal expressions of direct carving in the present century.

JOHN C. GALLOWAY

MOHOLY-NAGY, LASZLO. Hungarian-American designer, painter, sculptor, teacher, and writer (b. Bacsbarsod, Hungary, 1895; d. Chicago, 1946). Beginning as a painter, he became fascinated by the aims of the suprematist painters Malevich and Lissitzky. In Berlin in the early 1920s Moholy-Nagy became associated with the Russian constructivists. In 1923 he was appointed to the faculty of the Bauhaus; and in his first large exhibition, held in the same year, he showed a sculpture, *Space Segments*, in which the abstract forms of the constructivist painting were translated into nickel and glass and mounted on a polished steel plate. Moholy-Nagy sought to uncover the hidden play of tensions and forces arising through the contact of various forms, plancs, and colors. But he knew how to apply his experiments; as director of the metal workshop of the Bauhaus, he designed such things as lighting fixtures and book covers. At this time, too, he worked with Oskar Schlemmer and others on murals, ballet and stage designs, light and color experiments, and typography and layout. See BAUHAUS; CONSTRUCTIVISM; SUPREMATISM.

In the 1920s Moholy-Nagy also formed what was to be a lifelong interest in the dynamic effects of light in motion; he experimented with "photograms," abstract designs on sensitized paper made without the use of a camera. It is not surprising, then, that he should have been an early creator of kinetic sculpture. His *Light-Space Requisite* of 1922–30 is a large construction of perforated chrome disks, wire, and glass, which rotates slowly and casts shadows upon the walls as it revolves.

In 1928 Moholy-Nagy left the Bauhaus. After designing

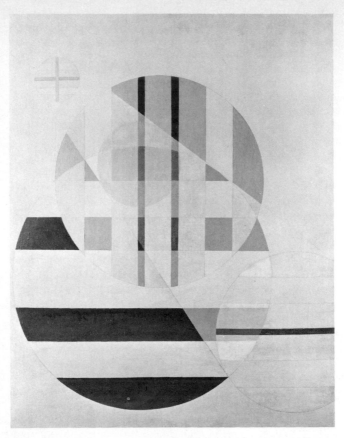

Laszlo Moholy-Nagy, *Z II* (1925). Oil on canvas, 37⅝" x 29⅝".
Museum of Modern Art, New York. Gift of Mrs. Sibyl Moholy-
Nagy.

some strikingly modern stage sets in Berlin and working
on commercial designing in Holland, he was occupied
with displays, typography, and industrial design in Lon-
don from 1935 to 1937. At that time he made documen-
tary films and experimented with the transparent qualities
of glass and plastic. In 1937 he went to Chicago to be-
come director of the "New Bauhaus" (the Institute of De-
sign). Besides his industrial designing, he produced plexi-
glass sculptures, characterized by sweeping curves and the

use of light-reflecting and transparent materials. The first of these, a plexiglass and chromium rod sculpture, was completed in 1943. ABRAHAM A. DAVIDSON

MONDRIAN, PIET. Dutch painter (b. Amersfoort, near Amsterdam, 1872; d. New York City, 1944). A major artist whose contribution to abstract painting is unique, he received his first art lessons from an uncle, Frits Mondrian. Piet Mondrian studied at the Amsterdam Rijksakademie (1892–94), developing a naturalistic, brown-toned manner widely practiced in late-19th-century Holland. This traditional approach, derived partly from Sluyters and Toorop, characterized Mondrian's landscapes of 1895–1906/07 painted at Amsterdam, Ruurlo, and elsewhere in the Dutch countryside. His 1908–09 canvases, for example, those done at Domburg, disclose a broadly handled neoimpressionist influence.

Mondrian's first substantial contacts with contemporary European movements came in 1910 and 1912 when, visiting Paris, he was greatly stimulated first by the work of Matisse, then by that of Picasso, Léger, and Delaunay. Mondrian's series of *Trees* (after 1909) documents with remarkable clarity his gradual, deeply personal assimilation of French Fauvist and cubist aesthetic. By 1914 his style had grown increasingly abstract, and, in a group of works typified by the *Oval Composition (Tableau III)* of that year (Amsterdam, Municipal Museum), the rhythms of landscape forms were reduced to geometric patterns, although these were still technically dependent upon the visual devices of analytic cubism. Mondrian's unremitting quest for an art independent of associative subjects, however, was already apparent in the 1914 canvases. He returned to Holland, and undertook the even more austere rendering of nature in a series of *Ocean and Pier* compositions that, during 1915, became cryptically rhythmic "plus-and-minus" interpretations of the movement of sea against dock. The vibrating small crosses and short horizontal lines present a constantly moving dynamic surface.

Although Mondrian's style had already become strongly conceptual, he then abandoned even the terse, archlike curves of his 1913–14 compositions and the nuances of color and texture that had related those works to cubism. From 1915 on Mondrian's was a rigorous aesthetic in which the straight line prevailed.

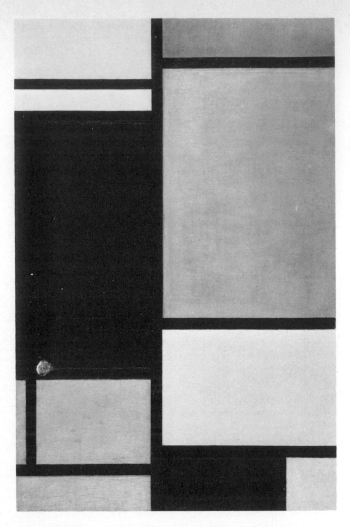

Piet Mondrian, *Composition* **(1921). Oil on canvas, 29⅞″ x 20⅝″. Museum of Modern Art, New York. Gift of John L. Senior, Jr.**

In 1917 Mondrian was a cofounder of the neoplasticist group in Leyden, better known as de Stijl (from the name of the journal, which appeared in October, 1917). *See* DE STIJL; NEOPLASTICISM.

In 1918 Mondrian painted in linear strips, more or less gridlike in pattern, over lightly tinted grounds. In 1919 he used this method with still greater assurance and sometimes applied a quite regular grid. Certain of Mondrian's canvases of 1920, however, revert to a slightly looser manner. The second neoplasticist manifesto, published in 1920, articulated the austere principles of de Stijl. Mondrian visited Paris in 1921, and thereafter, with remarkable consistency, he practiced the style for which he is now best known. Typically, heavy black lines, in effect rectilinear strips, set off in perfectly vertical and horizontal sequences an asymmetrical but balanced grouping of rectangles and squares of various sizes. Primary colors and light grays are used, and the white ground of the canvas also figures prominently in the field of tonalities. More rigorously than Van Doesburg, Mondrian applied the technique of pristine line, plane, and color; any purposive modulation of surface was ruled out.

During the 1930s Mondrian continued to exploit the basic formulas of neoplasticism, which had become internationally known through exhibitions at the Bauhaus and in Paris (Léonce Rosenberg's gallery) in the early 1920s, at the Société Anonyme show of 1926 at the Brooklyn Museum, and elsewhere. The final number of *De Stijl* appeared in 1932, and members of the group were working with increasing independence. Mondrian left Holland for England in 1939, and he proceeded to New York in October of that year. Although he had long since arrived at the perfection of an ostensibly fixed method, Mondrian in the rapid tempo of New York altered the rhythms of his style by using a far greater number of smaller rectangular units alternating with larger ones. He thus developed a final, still highly disciplined aspect of neoplasticism.

Although Mondrian was preceded in geometrically pure abstraction by Kasimir Malevich, the Russian suprematist, and Frank Kupka, the Paris-based Czech, his individual development from naturalistic landscapes through Fauvism and cubism, as well as the severity and consistency of his personal method, were altogether unique. Mondrian has had few direct followers, since his style is not readily adaptable, but the neoplasticist movement has enjoyed great influence upon modern architecture and commercial design.

Among Mondrian's principal works are his *Landscape*

with a Mill (1904; New York, Museum of Modern Art), *The Red Tree* (1909–10; The Hague, Gemeente Museum), *The Tree* (1911; Utica, N.Y., Munson-Williams-Proctor Institute), *Oval Composition (Tableau III)* (1914; Amsterdam, Municipal Museum), *Ocean and Pier* (1915; Otterlo, Kröller-Müller Museum), *Painting I* (1921; Basel, Müller-Widmann Collection), *Composition in Red, Yellow and Blue* (1926; H. M. Rothschild Collection), and *Composition in White, Black and Red* (1936) and *Broadway Boogie-Woogie* (1942–43; both New York, Museum of Modern Art). JOHN C. GALLOWAY

MOORE, HENRY. English sculptor, painter, draftsman, and writer (1898–). He was born in Castleford, Yorkshire, and was first influenced by carvings in a Yorkshire church. By 1909 he was determined to be a sculptor. He was trained as an elementary schoolteacher, but from 1919 to 1921 attended Leeds Art School and then the Royal College of Art, London, where he received a fellowship in 1925 which permitted travel to Paris, Rome, Florence, Venice, and Ravenna. He then took up a teaching post at the Royal College until 1931 and later taught at the Chelsea School until 1939. He had his first exhibition in 1928, at the Warren Gallery, London. In 1928 he was commissioned to do a relief figure, *North Wind*, for the headquarters of the London underground railway. This was the first of many architectural projects.

In 1940 he made drawings of underground shelter scenes and in 1941 did drawings of coal mines, both groups for the War Artists Advisory Committee. In 1944 he did a *Madonna and Child* for the Church of St. Matthew in Northampton. In 1952–53 he did a movable relief for the London Time and Life Building. Later public commissions were a huge reclining figure for the Paris UNESCO headquarters (1959–60) and another for Lincoln Center, New York (1965).

Moore has been an avid collector of primitive art since the 1920s. His work of that decade, *Mother and Child* (1922), *Head of a Girl* (1922; Manchester Art Gallery), and *Mask* (1924; formerly Little Rock, Ark., John Gould Fletcher Collection) shows his interest in pre-Columbian sculpture. The maternal theme and the head as an object of fantasy have been constants in his work. In the late

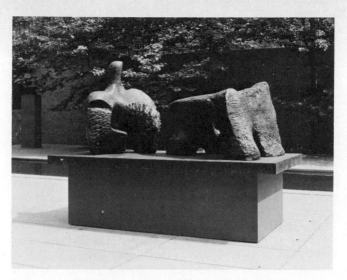

Henry Moore, *Reclining Figure, II* (1960). Bronze, 99" long. Museum of Modern Art, New York. Gift of G. David Thompson, Sr.

1920s he began his series of the reclining woman. (A 1929 example can be seen in the Leeds Art Gallery). In 1930 fantasy entered his treatment of the body, which was rephrased and indented, its separate parts fused and homogenized in surface (*Reclining Figure*, 1930; J. A. Thwaites Collection). In 1932 he introduced holes into abstract compositions such as *Composition* (1932; D. Glass Collection), and by 1933 they appear in the figure itself.

His most abstract pieces date from the 1930s, but they are progeny of the human form. Among these works are *Four-Piece Composition* (1934) and *Two Forms* (1934; New York, Museum of Modern Art). His sculptures of the late 1930s are among the most important figural images in modern sculpture, as can be seen in *Figure* (1938; New York, Museum of Modern Art). In 1938 strings were joined with his forms, creating space cages such as *Bird Basket* (I. Moore Collection). In the 1940s his family groups evolved. Moore's contribution is a humanistic approach to the body, submitting it to his most intimate feelings. ALBERT ELSEN

MORANDI, GIORGIO. Italian painter (1890–1964). He was born in Bologna, where he studied and lived. In 1912 he was associated briefly with the futurists. He joined Carrà and De Chirico and the metaphysical painting movement in the early 1920s and, later, the Valori Plastici. He was a teacher of engraving at the Bologna Academy from 1930 to 1956. In 1948 he received the Grand Prix at the Venice Biennale, and in 1957 the São Paulo prize for plastic arts war awarded to him for a retrospective exhibition of thirty oils.

He is best known for still-life painting in which the subject matter is limited to elegant ceramic, china, and glass vessels, particularly bottles, brought together in the center of a table. His palette was confined mostly to clay whites and brownish tans, with touches of terra cotta and olive green, on neutral backgrounds. Shapes are abstracted and pattern is emphasized. These works have a simplicity and monumental quality that recall the art of Chardin, Corot, and Piero della Francesca, whom Morandi admired and emulated. ROBERT REIFF

MORRIS, GEORGE L. K. American painter and sculptor (1905–). Morris was born in New York City and studied at the Yale University School of Fine Arts, at the Art Students League, and with Léger and Ozenfant in Paris. One of the founders of American Abstract Artists, he has been a consistent exponent of geometrical abstraction. His paintings of the 1930s were compositions of rectangular forms, usually contrasted with a few curved shapes, for example, *Composition* (1938; Philadelphia Museum of Art). The sculptural qualities of his work of the 1940s illustrate the transition to his more recent interest in the spatial problem of advancing and receding forms.

MORRIS, ROBERT. American sculptor (1931–). Morris was born in Kansas City, Mo., and studied at the Kansas City Art Institute and the California School of Fine Arts in San Francisco, among other schools. He was a painter before he became a sculptor in 1960. Like other artists of the "minimalist" tendency, Morris attempts a basic statement of the shape, weight, mass, and space of three-dimensional form, denying all imagery, associations, and even compositional interrelationships. His works in

plywood and plastic, often painted a neutral gray, are cubes, pyramids, and other polyhedrons which stand directly on the floor.

MOSES, GRANDMA (Anna Mary). American primitive painter (b. Greenwich, N.Y., 1860; d. Eagle Bridge, N.Y., 1961). She spent all her life on a farm. Leaving a one-room schoolhouse at twelve, she became a hired girl. She married a farm worker at twenty-seven, moved to Virginia, and then, after twenty years, moved to her permanent home, Eagle Bridge. Arthritis forced her to substitute painting for embroidery when she was seventy-six. Discovered by an art dealer soon after, she acquired an international reputation. Her first paintings were copies of Currier and Ives prints and of postcards. Soon she composed original works based on her memories of earlier life on the farm. She favored panoramic landscapes with many active figures engaged in community endeavors such as harvesting and sugaring.

MOTHERWELL, ROBERT. American painter (1915–). Born in Aberdeen, Wash., he has lived in New York City since 1939. Motherwell studied painting at the Otis Art Institute, Los Angeles, and at the California School of Fine Arts, and trained in the humanities at Stanford, Harvard, and Columbia Universities until 1941. He had his first one-man show at Peggy Guggenheim's Art of This Century Gallery, New York, in 1944 and was represented in the "Fourteen Americans" exhibition and "The New American Painting" show at the Museum of Modern Art, New York, and in the São Paulo Bienal, the Kassel Documenta, and other international and annual exhibitions. In 1965 he was given a retrospective at the Museum of Modern Art in New York.

As one of the early action painters of the New York school and as an exceptionally articulate speaker and author, Motherwell has made a unique contribution to modern American art. A characteristic early work is *Pancho Villa, Dead and Alive* (1943; New York, Museum of Modern Art); a more recent collage, *The French Line* (1960; New York, Mr. and Mrs. Sam Hunter Collection), is an important example of abstract expressionism.

<div align="right">JOHN C. GALLOWAY</div>

MOY, SEONG. American painter and graphic artist (1921–). Born in Canton, China, Moy went to the United States in 1931. Later he studied with Cameron Booth at the St. Paul School of Art and at the Art Students League and the Hans Hofmann School of Fine Arts in New York. He has taught in universities throughout the United States, has operated his own school in Provincetown, Mass., since 1954, and now lives and teaches in New York City. Moy is known primarily for his color woodcuts, which have strong calligraphic and painterly characteristics. Abstracted lines in concerted movement are played against fluctuating areas of brilliant color in his predominantly figurative compositions.

MULLER (Mueller), OTTO. German expressionist painter (b. Liebau, Silesia, 1874; d. Breslau, 1930). From 1890 to 1895 he was apprenticed to a lithographer in Breslau. From 1896 to 1898 he studied art in Dresden, and moved to Berlin in 1908. By 1910 he had rediscovered the peculiar qualities of distemper, a medium which permits the unified application of paint in thin layers over large areas. He exhibited at the Galerie Arnold in Dresden in 1910 with the Brücke group and, a year later, joined them. He was also associated with the New Secession, and Lehmbruck and Heckel were his friends. From 1919 until his death he taught at the Breslau Academy.

In his preexpressionist period, he did classical and mythological nudes, figures such as Lucretia and Cleopatra, in the manner of Franz van Stuck. He was also influenced by Böcklin and the Jugendstil. Kirchner said that Müller's admiration for Cranach led to his being invited to join the Brücke. By 1911 he had begun the paintings of a primitive arcadia for which he is best known. He peopled forests and lake shores with dark-skinned, restrained, and angular female nudes. These have a remote resemblance to Egyptian figures, which Müller admitted admiring.

Müller felt close to his mother, who had been a deserted gypsy child, and many of his pictures are of gypsy mothers transformed into Madonna figures and their children crowned with halos. From time to time he lived around gypsy camps in Hungary. He felt a sympathy for Gauguin, whose art he emulated. Müller's figures are usually heavily outlined and painted with broad, unmodulated areas of bland, earthy color. In his last period, colors became more

somber, forms larger, and universal signs were incorporated to give them symbolic, mystical significance. In 1927 he made a few woodcuts and several colored lithographs on gypsy themes. ROBERT REIFF

MUNTER, GABRIELE. German expressionist painter (b. Berlin, 1877; d. Murnau, 1962). Before turning to painting, Gabriele Münter became an accomplished pianist. By 1902 she was studying in Munich at the Phalanx School, where Kandinsky was her drawing teacher. She was his close companion until 1916. Together, they discovered Murnau and painted pictures of it. In 1909, she joined the Neue Künstlervereinigung and, later, helped found the Blaue Reiter. She lived in Scandinavia from 1914 to 1920. After World War II she gave 143 early Kandinskys from her collection to the Municipal Gallery in Munich. In 1961 she was given a retrospective exhibition at the Hutton Gallery in New York. Her best-known works are landscapes with figures in a manner recalling the charged Fauvism of the early Kandinsky. They are composed of vibrant color in broad, simple, flat patterns, with an emphasis on free, curvilinear contours. Sixty-one of her works are in the Municipal Gallery in Munich.

MURCH, WALTER TANDY. American painter (1907–67). Born in Toronto, Canada, he studied at the Ontario School of Art, at the Art Students League in New York City, and with Arshile Gorky. Murch painted dramatically lit and luminous still lifes of curious objects or intricate machine parts. In 1966 he was given a one-man show at the Rhode Island School of Design and in 1967 at the Brooklyn Museum. He has been variously called a surrealist, a magic realist, and a romantic realist. Although he depicted objects with fastidious precision, he invested them with poetry through a subtle delicacy of light, color, and arrangement.

MYERS, JEROME. American painter and etcher (b. Petersburg, Va., 1867; d. New York City, 1940). He studied in New York City at Cooper Union and at the Art Students League with George de Forest Brush. Myers went to Europe in 1896. He took his subjects from the picturesque life of New York's East Side, ignoring the slum's

sordid aspects in favor of painting colorful street scenes and, particularly, children at play, as in *The Tambourine* (1905; Washington, D.C., Phillips Collection). He often captured the infrequent moments of rest and outdoor pleasure in the lives of poor people, for example, *Evening on the Pier* (1921; Phillips Collection). Myers did not concentrate on oil painting until he was about forty; before that he had worked mostly in pastels, water colors, drawings, and etchings.

N

NADELMAN, ELIE. Polish-American sculptor and draftsman (b. Warsaw, 1882; d. New York City, 1946). He briefly attended the art academy in Warsaw, just before and after 1900. While in Warsaw and Munich in 1903 he was introduced to German romantic art, ancient art, and 18th-century folk-art dolls. He was in Paris by 1904, unattached to any teacher, but influenced by Rodin.

Nadelman began his intellectual analysis of the nature of sculptural volume and its relation to geometry in 1905. For the next ten years he titled his works *Research in Volume and Accord of Forms.* His style became based upon the curve.

Supported by Helena Rubenstein, he went to the United States in 1914 and subsequently exerted a considerable influence on American artists, helping to expand patronage of modern art and interest in American folk art. Much of his work, such as *Head of a Woman* (1909) and *Horse* (1914), was formerly in the Rubenstein Collection.

NAKIAN, REUBEN. American sculptor (1897–). He studied with Manship and Lachaise. Nakian's works of the 1920s, especially the terra-cotta and stone animal studies, are strongly simplified and compact. His style became increasingly liberated afterward, and his bronzes and huge plaster forms of the 1950s and early 1960s are generally abstract-expressionist in character. He often reveals a genuinely baroque, sweeping command of composition.

NASH, PAUL. English painter, designer, illustrator, and writer (b. London, 1889; d. Boscombe, 1946). He studied at the Chelsea Polytechnic and at the Slade School with Henry Tonks. Nash enlisted in the army in 1914, and was appointed an official war artist in 1917 and again in

1940. From his youth his imagination was fed with images and ideas derived from poetry, particularly that of Rossetti and Blake.

In water colors and drawings done before World War I Nash alternated between, and often combined, the rendering of English landscape and subjects of a romantic or symbolic nature in which expressive shape and line took precedence over the literal description of nature. The war matured this aestheticism by giving him authentically emotional scenes to paint. *The Menin Road* (1918; London, Imperial War Museum), a moving, battle-charred landscape, in its slight simplification and vaguely cubic treatment shows some knowledge of the structural aspects of cubism. During the 1920s Nash solidified this pictorial order in a group of broad-viewed land- and seascapes, such as *Winter Sea* (1925–37; York, City Art Gallery), which provided a naturalistic excuse for emphasizing formal construction. In 1933 Nash was one of the founders of the Unit One group.

By the middle 1930s, however, he had returned to his earlier imaginative subjects, this time closer to the surrealists with whom he exhibited in London in 1936. These paintings are mostly landscapes in deep perspective in which unlikely objects are brought together, or, as in *Landscape of the Megaliths* (1937; Buffalo, N.Y., Albright-Knox Gallery), giant rocks engage in soundless conversation. The dreamlike atmosphere of this period lingered on in much of Nash's subsequent work; even his World War II paintings, for example, *Moonlight Voyage: Flying against Germany* (1940; London, Collection of the Air Ministry), seem to share its poetry.

JEROME VIOLA

NAY, ERNST WILHELM. German painter and graphic artist (1902–68). Born in Berlin, he studied with Karl Hofer at the Berlin Academy from 1925 to 1928. Nay's earlier paintings were simplified in style, at times with a surrealistic feeling, for example, *White Cow* (1933; Hamburg, Art Gallery). In the 1930s, influenced especially by Kirchner and Nolde, he painted highly imaginative landscapes with figures in which his already personal use of color was almost completely independent of the object. In the next decade, his work became increasingly abstract,

with color obviously the prime pictorial element. Nay's paintings after the middle 1950s were abstract compositions of roundish areas, freely and rhythmically arranged and sensuously colored, with conscious affinities to music.

NEGRO ART (United States), see BLACK ART: UNITED STATES.

NEOPLASTICISM. Strictly defined, this term refers to the mature aesthetics and painting style of the Dutch artist Piet Mondrian; it derives from the title of an expository statement he published in 1920. Neoplasticism was largely a personal elaboration and extension of the theories of de Stijl, one of the most important movements in 20th-century art. See DE STIJL; MONDRIAN, PIET.

NEOROMANTICISM. Movement in modern painting primarily associated with three artists, Eugène Berman, Christian Bérard, and Pavel Tchelitchew, who met in Paris and exhibited in a group show at the Galerie Drouet in 1926. The neoromantics were opposed to postimpressionism, cubism, Fauvism, and other formally analytic styles. They wished to restore human elements and emotions to art: the undistorted figure, dreams, psychological moods, and sentiment. In certain of these aims they were close to a milder and less histrionic form of surrealism; Tchelitchew, in his later works, moved closer to that movement. See BERARD, CHRISTIAN; BERMAN, EUGENE; TCHELITCHEW, PAVEL.

NERVI, PIER LUIGI. Italian engineer-architect-builder (1891–). Born in Sondrio, he graduated from the Civil Engineering School in Bologna (1913) with a traditional engineering education, worked for the Società per Costruzioni Cementizie in Bologna (1913–15), and was an officer in the Engineering Corps during World War I (1915–18). Nervi then worked with the Società per Costruzioni Cementizie in Florence (1918–23) and established his own construction firm with Nebbiosi in Rome (1920–32). Since 1932 he has led the firm of Nervi and Bartoli, in Rome.

In the tradition of the Perrets, Eugene Freyssinet, and Robert Maillart, Nervi has been a lifelong pioneer of fer-

roconcrete. Among his outstanding works are the Municipal Stadium in Florence (1930–32); a series of aircraft hangars (started in 1935); an exhibition hall in Turin (1948–50); and the Olympic buildings in Rome (1960), all ingenious exercises in concrete. Nervi, Breuer, and Zehrfuss created the UNESCO complex in Paris (1953–58).

NEUE KUNSTLERVEREINIGUNG (New Artists Federation of Munich). Group of artists formed in Munich in 1909 around Kandinsky and Jawlensky. It also included Münter, Werefkin, Erbslöh, Kubin, Bechtejeff, Hofer, Kanoldt, and Girieud. Their art was essentially an expressive, consciously spontaneous extension of Fauvism. The Blaue Reiter seceded from the group in late 1911. *See* HOFER, CARL; JAWLENSKY, ALEXEY VON; KANDINSKY, WASSILY; MUNTER, GABRIELE. *See also* EXPRESSIONISM.

NEUE SACHLICHKEIT, DIE, *see* NEW OBJECTIVITY, THE.

NEUTRA, RICHARD. Austrian-American architect (1892–). Born in Vienna, he graduated from the Technische Hochschule (1917), had contacts with Otto Wagner and Adolf Loos, and collaborated with Eric Mendelsohn (1922). In 1923 Neutra went to the United States, where he worked in the offices of Holabird and Roche, Chicago, in 1924, and with Frank Lloyd Wright at Spring Green in 1925. He started private practice in 1926 in Los Angeles in the office of R. M. Schindler. Neutra was one of the first architects to introduce modern European forms to the United States; he has consistently faced the problem of relating modern technology to human needs.

He published his observations on the United States in *Wie baut Amerika?* (1927), the same year in which he designed the Jardinette apartments in Los Angeles. His first major design, and one of historical importance, is the Lovell House, Los Angeles (1929), the first significant modern European work to be built in the United States and one of the first to utilize standard production techniques. A steel skeleton, prefabricated to accommodate standard steel casements, was transported to the hillside site and welded in place in only two days. Balconies, suspended from the roof frame by delicate steel cables, help create an elegant structure of utmost lightness. Walls are thin

concrete slabs built up in place, the aesthetic result being a three-dimensional assemblage of floating glass and concrete panels, a technological and artistic triumph.

Neutra's second book, *Amerika*, was published in 1930. He built his own house on Silver Lake in Los Angeles in 1933; the California Military Institute and the Von Sternberg House (both in Los Angeles) followed in 1936. These, as well as the Beard House (1935) in Altadena, were conceived as technological and aesthetic experiments and helped produce his reputation as a technical-artistic innovator. In keeping with these interests, prefabrication of housing has been a preoccupation with Neutra since 1926.

During World War II, with metal unavailable for civilian use, Neutra designed the Nesbitt House in Los Angeles (1942) in redwood board-and-batten construction, brick, and glass, a rare combination for the architect, and a very successful design. His famous Kaufmann House in Palm Springs (1946) is built on the desert. Interlocking horizontal planes hover, seemingly weightless, over the volumes defined by them and the glass walls.

In recent years the scope of his work has increased to include community planning, shopping centers, churches, motels, and schools, in all cases marking the careful, consistent expansion and refinement of the technical and aesthetic principles established in the 1920s. Neutra formed a partnership with the architect and city planner Robert E. Alexander in 1949. THEODORE M. BROWN

NEVELSON, LOUISE. American sculptor and painter (1900–). She was born in Kiev, Russia, and arrived in the United States in 1905. She received her art training with Kenneth Hayes Miller at the Art Students League (1929–30) and in Munich with Hans Hofmann (1931–32). Nevelson's first sculpture show was in 1940 at the Nierendorf Gallery, New York. Her archaeological studies in Mexico (1951–52) influenced her terra-cotta sculpture. She began to work in wood during the early 1950s and in 1955 began to use found wooden objects culled from ruined tenements, painting them a uniform color and manipulating them in various combinations. Later, many combinations were done within boxes that, when joined together, grow into entire walls and rooms.

The Museum of Modern Art, New York, owns her

Sky Cathedral (1958), and the white *Dawn's Wedding Feast* (1959) is in the Martha Jackson Gallery, New York. Her work was shown in the Museum of Modern Art's "Sixteen Americans" exhibition in 1959, and she was given a major retrospective by the Whitney Museum of American Art in 1967. Nevelson has brought poetry and a new urban image out of the discards of modern society and has contributed to what is known as "environmental sculpture." ALBERT ELSEN

NEVINSON, CHRISTOPHER RICHARD WYNNE. English painter, etcher, and lithographer (b. London, 1889; d. there, 1946). He studied at St. John's Wood and the Slade School, and in 1911 briefly visited Paris, where he worked at the Académie Julian and at the Circle Russe. He returned to Paris in 1912 and for a time shared a studio with Modigliani. He was appointed an official war artist in 1917 and became a member of the New English Art Club in 1929.

Nevinson was influenced by cubist principles of painting in much of his work, but he was most deeply involved with futurism. He met and became a close friend of Severini in London in 1912 and helped organize a welcome dinner for Marinetti in 1913.

A few of his war period and postwar paintings, for example, *From an Office Window* (1917; Sir Osbert Sitwell Collection), show a relatively mild resurgence of interest in a composition of intersecting planes. Most of his later works are realistic landscapes, portraits, and still lifes. In 1919–20, however, Nevinson visited the United States. The result was a series of paintings which revived the futurist treatment of motion-filled urban scenes with the addition of a satirical point of view. They are, perhaps, the best of Nevinson's postwar paintings.

JEROME VIOLA

NEW ARTISTS FEDERATION OF MUNICH, *see* NEUE KUNSTLERVEREINIGUNG.

NEWMAN, BARNETT. American painter (1905–1970). Born in New York City, he studied at the Art Students League, the College of the City of New York, and Cornell University. His first one-man show was at the Betty Par-

sons Gallery. Newman was represented in "The New American Painting" show at the Museum of Modern Art, New York, and in various group shows in Europe. His series of fourteen paintings, *Stations of the Cross*, was shown at the Guggenheim Museum in New York in 1966. His style is geometrically abstract (*Onement Number 6*, 1953; Beverly Hills, Calif., Collection of Mr. and Mrs. Frederick R. Weisman).

NEW OBJECTIVITY, THE (Die Neue Sachlichkeit). Third branch of German expressionism. It emerged during the 1920s as a product of the disillusionment following World War I. In paintings and graphics, such artists as Max Beckmann, George Grosz, and Otto Dix presented a hard, linear realism. Their work of this period is characterized by stark feeling and mercilessly clear detail. *See* BECKMANN, MAX; DIX, OTTO; GROSZ, GEORGE.

NEW YORK SCHOOL. The New York school reached its highest point in the mid-20th century. At this time abstract expressionism dominated the school and gave an international reputation, perhaps for the first time, to American art. As in 20th-century Paris, many of its leading painters were foreign-born—Hans Hofmann, Arshile Gorky, Josef Albers, Matta, and Willem de Kooning; but native painters of stature —Robert Motherwell, Franz Kline, and Jackson Pollock— soon followed their example. During the 1960s the New York school reacted against abstract expressionism in a violent swing to so-called "pop" art, based on objects of popular commercialism. Shortly thereafter, a new type of geometric abstraction ensued, with "op," or optically illusionistic, art, kinetic or moving sculpture, and minimal art. *See* ABSTRACT EXPRESSIONISM; ALBERS, JOSEF; DE KOONING, WILLEM; GORKY, ARSHILE; HOFMANN, HANS; KINETIC SCULPTURE; KLINE, FRANZ; MATTA, ROBERTO SEBASTIAN ANTONIO; MINIMAL ART; MOTHERWELL, ROBERT; OP ART; POLLOCK, JACKSON; POP ART.

NICHOLSON, BEN. English painter (1894–). Born in Denham, Buckinghamshire, he is the son of the English painter Sir William Nicholson, who is best known for his still lifes. Ben Nicholson studied at the Slade School from 1910 to 1912 and traveled periodically in Europe and the

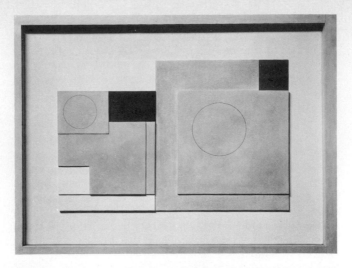

Ben Nicholson, *Painted Relief* (1939). Synthetic board mounted on plywood, painted, 32⅞" x 45". Museum of Modern Art, New York. Gift of H. S. Ede and the artist.

United States until the start of World War I. Apart from his father, from whom he perhaps derived his taste for the purely formal relationships inherent in still-life subjects, Nicholson's mature paintings have been influenced by two main sources: the cubism and linear surface elegance of Braque and the neoplasticism of Mondrian, whom he met in Paris in 1934.

In the late 1920s and early 1930s the bulk of Nicholson's paintings were semiabstract still lifes. In them he used the standard objects of cubism—a jug, a pitcher, a wineglass—but set them as flat shapes on the picture surface. Abstracted still-life forms, sometimes in a severe geometric style with married contours showing the influence of purism, sometimes in a curvilinear synthesis, became the basis for most of his subsequent work.

In 1933 Nicholson began constructing reliefs. These were compositions of rectangles and circles, painted either white or in a limited color range, with various forms slightly projecting. Their shallow depth and the emphasis on color and painted surface texture make the reliefs closer to painting than to sculpture, and Nicholson often used

the same artistic means, composed circles and rectangles in later paintings. While the ultimate derivation of these works is neoplastic, in such a.work as *Painted Relief, I* (1939; New York, Museum of Modern Art) Nicholson's personal treatment—warmer coloring and the organic presence of the circle—humanizes the rigid beauty of this source.

The reliefs and their related paintings dominated his work until the early 1940s, when, in several landscapes, still-life elements were inserted as if lying on the sill of a window overlooking the scene. In 1940, Nicholson moved to St. Ives, Cornwall, with the sculptor Barbara Hepworth, to whom he was then married, and his presence greatly stimulated artistic activity there.　　　JEROME VIOLA

NIEMEYER, OSCAR (Oscar Niemeyer Soares Filho).
Brazilian architect (1907–　). Born in Rio de Janeiro, he studied architecture at the National School of Fine Arts in that city (1930–34), during which time he also worked in the office of Lucio Costa. He began independent practice in 1936, the year that he worked with Le Corbusier. Niemeyer visited New York in 1939 and has been practicing since in Brazil. That country's leading architect and one of the acknowledged masters of the 20th century, he is now chief architect of Novacap, the Building Authority of Brasilia, the new capital.

Niemeyer worked on the team, which included Lucio Costa, that designed the Ministry of Education in Rio de Janeiro (1937–42), where many of Le Corbusier's ideas— he was a consultant—were tried for the first time. For example, sun-breaks, movable slats designed to filter the uncomfortable, intense South American sun, were installed. The building was Brazil's and Niemeyer's first tangible introduction to the new architecture and an important demonstration of its principles for the world.

After designing the Brazilian Pavilion at the New York World's Fair of 1939 (with Lucio Costa and Paul Lester Wiener), Niemeyer's next big work was the group of buildings along Lake Pampulha (1942–43), an artificial lake in Belo Horizonte, a newly developed residential suburb. The Casino is a rather sober alliance of a cubical building, containing the main hall and game room, and an oval building for restaurant and theater. In sharp contrast to

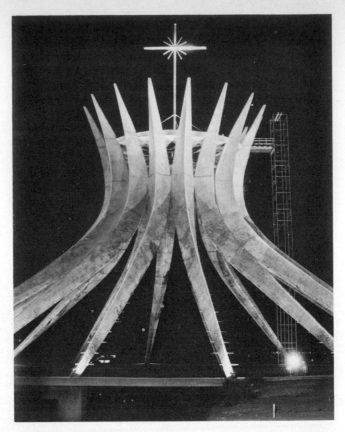

Oscar Niemeyer, Roman Catholic Cathedral (1956). Brasília, Brazil.

the relative sobriety of the Casino is the restaurant "Baile," a lyrical free-form ferroconcrete canopy that undulates across the site to define a circular restaurant and a stage. The greatest challenge of the group is the controversial Church of St. Francis of Assisi. Its nave is a parabolic concrete shell; altar, sacristy, and vestry spaces are smaller parabolas echoing the form of the nave. Light enters the narthex through vertical louvres on the front side and enters the nave in front of the altar. Each building in the group is a separate exercise in architectural form, resulting

in several fine individual buildings that, however, lack unity as a whole.

Niemeyer's major achievement is the design of the principal buildings of Brasilia (begun 1956; planned by Lucio Costa), one of the most ambitious architectural projects ever undertaken. In about two years, and with the assistance of about sixty architects, he designed the buildings, ranging from the sumptuous presidential palace and cathedral to super-block housing and shops, translating the earlier ideas of the 1930s into the huge scale of a substantial city.

Niemeyer came to architecture relatively late (1930); thus, he was not involved in the pioneering work of the 1920s. His earliest work, therefore, has the maturity and assurance that is lacking in some of the first designs of the European masters from whom he derived his ideas. After quickly mastering the new language, he applied it to functionally sound and aesthetically stimulating buildings representative of the best of contemporary design.

THEODORE M. BROWN

NOGUCHI, ISAMU. American sculptor (1904–). Born in Los Angeles, Noguchi resided in Japan from 1906 to 1918. Returning to the United States, he studied medicine at Columbia University, New York City, in 1923. In Paris in 1927 he studied at Brancusi's studio, but was influenced also by Giacometti and Calder. He exhibited his first abstract works in 1928. His pieces, sometimes compact and sleekly polished like many of Brancusi's, sometimes indented, are owned by the Albright-Knox Art Gallery in Buffalo, N.Y., and by the Metropolitan Museum of Art and the Museum of Modern Art in New York as well as by other important public and private collections. An important example of his architectural sculpture is the garden (1956–58) of the Paris UNESCO Building, where roughly hewn stone contrasts with the enclosing smooth glass façade.

NOLAN, SIDNEY. Australian painter (1917–). Born in Melbourne, he is Australia's most internationally recognized artist. He studied at the Melbourne National Gallery and developed his style as a regional painter. He first became known for his "naïve-sophisticate" works based on the exploits of the Australian bushranger Ned Kelly.

These paintings emphasize subject matter, which is handled with a purposeful broadness. His poetic imagery, expressed in vivid colors, often endows old themes with a new vitality; this can be seen in his *Leda and the Swan* series, which scored a major success in the London art season of 1960. Nolan's paintings have represented Australia at the Venice Biennale. Since 1950 he has lived in England, Europe, and the United States.

NOLAND, KENNETH. American painter (1924–). Born in Asheville, N.C., Noland attended Black Mountain College near there and studied with Zadkine in Paris. He now lives in Vermont. Noland's work appeared in the Venice Biennale in 1964 and in 1965 he was given a one-man show at the Jewish Museum in New York City. A leading reductive and deductive painter of the 1950s and 1960s, Noland was associated particularly with Morris Louis in Washington, D.C., where they worked together on the technique of staining with thinned paints. His work is highly formal and depends on the relationship between parallel stripes of color and various canvas shapes.

NOLDE, EMIL (Emil Hansen). German painter and graphic artist (b. Nolde, 1867; d. Seebüll, 1956). Born Emil Hansen, he adopted the name of his birthplace as his surname in 1904. An expressionist artist who was associated with Die Brücke for only a year and a half, Nolde had undergone gradual and strongly personal development before becoming affiliated with that style. He studied and practiced decorative wood carving at Flensburg, and after working in Munich and Karlsruhe, he studied at the Arts and Crafts School in Karlsruhe. He taught art at St. Gall from 1892 to 1898, and in 1899 he once again studied, this time with Adolf Hölzel at Dachau. Visiting Paris in 1900, Nolde worked briefly as an independent student at the Académie Julian. Between 1901 and 1903 he lived in Berlin, Copenhagen, and, again, in Flensburg. During this phase of his career he was under an impressionist rather than postimpressionist influence, and painted landscapes and flower arrangements with strong, although usually darkish, color and a diffused touch.

He exhibited in 1905 at the Galerie Ernst Arnold in Dresden and in 1906 joined Die Brücke for a short time. His first woodcuts and first significant religious themes

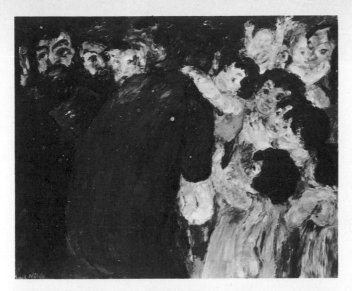

Emil Nolde, *Christ among the Children* (1910). Oil on canvas, 34⅛" x 41⅛". Museum of Modern Art, New York. Gift of Dr. W. R. Valentiner.

were produced that year. In 1909 he lived on Alsen Island, on the north German coast, and in 1910 in Hamburg and later in Berlin, where he helped form the New Secession after his and other Die Brücke artists' works were rejected at the Berlin Secession exhibition. A number of Nolde's powerful religious compositions date between 1909 and 1912, the latter being a highly productive year for him.

Nolde had long been intrigued by primitive art, and this interest was reinforced by his meeting the Belgian artist James Ensor in 1911. In 1913 he joined an ethnological expedition which, after taking him through Russia, Japan, and China, placed him in the South Pacific, where he painted for several months. He returned to Berlin in 1915, living there until 1927 except for visits to England, Paris, and elsewhere. In 1927 a large retrospective honoring him was held at Dresden and elsewhere; the *Festschrift* published for the occasion contained contributions by Klee and other admiring artists. He published a two-volume autobiography in 1931 and 1934. Although he was an ear-

ly supporter of the Nazis, Nolde was among the numerous expressionists condemned as "degenerate" by the Nazi regime; more than 1,000 of his paintings and graphics had been confiscated by 1937, and he was forbidden to paint. Following 1946 he lived at Seebüll, in the north, and began working again. He won the graphic arts prize at the 1952 Venice Biennale.

His characteristic paintings include *The Pentecost* (Bern, private collection), *The Last Supper* (1909; Copenhagen, State Museum of Fine Arts), *Christ Among the Children* (1910; New York, Museum of Modern Art), the controversial triptych *Life of Maria Aegyptica* (1912; Hamburg, Art Gallery), *Three Russians* (1915; New York, Feigen Collection), *Christ and the Adulteress* (ca. 1926), and *The Magicians*, a water color (1934; both New York, Museum of Modern Art). The religious works with their medieval intensity express a violent, almost demonic feeling in brilliant, strongly opposed colors. Nolde was a powerful, productive graphic artist in various media but especially in woodcut (the black-and-white *Prophet*, 1912) and color woodcut.

Despite the independence and unevenness of his development and personal activity after leaving the Brücke, Nolde in his profound emotionalism and "blood and soil" mystique was central to the formation of German expressionism. JOHN C. GALLOWAY

NONOBJECTIVE ART. Term used to designate painting and sculpture in which no trace of a recognizable object is discernible. By extension, the term can be applied to older types of art, such as that in the Muslim East in which geometric decorative forms prevail. Even this definition, however, is flimsy, as in the case of some of Arp's "concretions," in which the observer may easily find allusions to such natural formations as hills and lakes. *See* ARP, JEAN.

NOVECENTO MOVEMENT. Group of Italian figurative artists formed in Milan in 1922. The Novecento (20th Century) movement emphasized a return to the great Italian art of the past and, because of its nationalism, became associated with the Fascist regime. Among its adherents

were the painters Carlo Carrà, Ottone Rosai, Felice Casorati, and Massimo Campigli and the sculptors Arturo Martini and Marino Marini. Various groups of nonobjective artists sprang up in opposition to it during the 1930s. See CAMPIGLI, MASSIMO; CARRA, CARLO; MARINI, MARINO.

NOVEMBER GROUP (Novembergruppe). German cultural organization with Socialist orientation. It was founded by Max Pechstein and César Klein in Berlin in 1918, during the post-World War I Social Democratic republic. The group grew out of the expressionist aspiration for the betterment of man. Many individuals and groups supported it in a spirit of social-intellectual fellowship, and it soon became a cultural focal point of Berlin. Artists, musicians, architects, poets, and theater people combined to deal with problems of creation, dissemination, and understanding of the arts. See KLEIN, CESAR; PECHSTEIN, MAX.

NOWICKI, MATTHEW. American architect (1910–50). Born in Chitai, China, he lived in Poland and the United States and was one of the most promising of the younger generation of architects. He toured the United States in 1947 as a member of the United Nations site-finding committee and later participated in the design of United Nations Headquarters in New York City. While teaching at the North Carolina State College, Nowicki designed the notable Livestock Arena at Raleigh, built after his death (1953–54, with Fred Severud).

OBIN, PHILOME. Haitian painter (1891–). Born in Limbé and essentially self-taught, Obin received his only formal training in drawing under Berthold at the local school in Cap-Haïtien. Working at various jobs to support himself and his family, he produced few paintings until 1944. Then he met DeWitt Peters at the Centre d'Art in Port-au-Prince and began to devote his time exclusively to art. He became prominent both as a painter and as a teacher at his own branch of the Centre at Cap-Haïtien in northern Haiti. Obin paints historical and political events in a primitive style of flattened, simplified forms and distorted perspectives, using a great economy of design and meticulousness in narration that enable him to accommodate large numbers of figures in an orderly and almost epic fashion. His subjects include *The Funeral of Charlemagne Péralte*, *The Cacos of Leconte*, and *Mardi Gras*.

OBJETS TROUVES (Found objects). French term meaning inanimate objects, such as driftwood and stones, that are employed in surrealist and Dadaist constructions. *Objets trouvés* are used in a way that does not impair the viewer's recognition of these objects but emphatically removes them from their natural contexts.

O'GORMAN, JUAN. Mexican painter and architect (1905–). He was born in Coyoacán. From his first architectural success, his father's house (1928), to his masterpiece, the University of Mexico Library (1952), O'Gorman has sought to marry function to tradition. In the latter building, for example, modernist shapes are veneered with patterns of colored stones that evoke memories of ancient codices. His own fantastic house at San Angel (1956) was built around a natural grotto.

O'KEEFFE, GEORGIA. American painter (1887–). Born in Sun Prairie, Wis., she studied at the Art Institute of Chicago in 1904–05, at the Art Students League in 1907–08 with Cox, Chase, and More, at the University of Virginia in 1912 with Alon Bement, and from 1914 to 1916 at Teachers College, Columbia University, with Bement and Arthur Wesley Dow. For the next few years she was active as an art teacher in Texas and New York. Her first exhibition, of abstract drawings, was held in 1916 at the 291 Gallery in New York, directed by Alfred Stieglitz, whom she married in 1924. In these drawings, influenced by the principles of decoration and design taught by Dow, she characteristically discarded all but a few elements of line and color. In the early 1920s O'Keeffe was working with a strongly stylized image, for example, *Lake George, Coat and Red* (1919; New York, Downtown Gallery), and at times with almost complete nonrepresentation, for example, *Abstraction* (1926; New York, Whitney Museum). By the middle 1920s, however, her personal style was established, strongly influenced by the precisionist (cubist realist) clear color and clean-edge treatment of Demuth and Sheeler and the abstract patterns and designs of Paul Strand's close-up photographs of common objects. *See* CUBIST REALISM.

O'Keeffe's first microscopic paintings of flowers were done about 1925. These paintings, which first earned her popular recognition, were not completely literal but were decoratively arranged flower parts rendered with an anonymous, nonexpressive brushwork and a continuously smooth gradation of fresh color, as in *Black Iris* (1926; New York, Metropolitan Museum) or in the long series of variations on calla lilies and roses. O'Keeffe 'has always painted works in series, sometimes over a very long period of time, as if trying to exhaust all the pictorial and decorative possibilities of a given subject. Besides flowers, she has also painted the typical precisionist subject of barns—from the massive forms of *Lake George Barns* (1926; Minneapolis, Walker Art Center) to the more abstract and delicately poised *Stables* (1932; Detroit Institute of Arts) to the rigorously purified *Patio with Cloud* (1956; Walker Art Center).

JEROME VIOLA

OLDENBURG, CLAES. American painter and sculptor (1929–). Born in Stockholm, Oldenburg studied at

Yale University and at the Chicago Art Institute School with Paul Wieghardt. After an initial period of painting in an abstract expressionist manner, he turned to a type of sculptural expression using wood, plaster, or plastic to create oversized artifacts of American culture. These amorphous, unworkable replicas of hamburgers, cakes, telephones, bathroom fixtures, and the like often have a disorienting and ominous as well as a satiric effect. Oldenburg has also been an innovator of happenings.

See also POP ART.

OLITSKI, JULES. American painter (1922–). Born in Gomel, U.S.S.R., Olitski studied in New York City and Paris. He has exhibited since 1950; his work was shown with Kenneth Noland's and Frank Stella's in an exhibition at the Fogg Art Museum, Cambridge, Mass., in 1965. Like Noland, Olitski uses thinned paints in a staining technique but creates effulgent, delicately shaded forms that spread toward the edge of the canvas.

OP ART. Major American nonobjective movement of the 1960s, showing, on the surface, an alliance with the crafts of advertisement, display, and commercial design, but opposing the literal commercialism of Pop Art. Its hard-edged and anonymous aspect may resemble textile patterns or may recall Mondrian, Albers, or sometimes constructivist sculpture. Op Art eschews all forms of representation, even ideograms, signs, and symbols. There is usually an exaggerated emphasis on centrality and symmetry, but the impression produced is one of violent kinetic movement. Uniform patterns of rectangles, squares, circles, dots, stripes, or lines are the rule. Op artists take into account the workings of the human visual apparatus to create striking optical illusions. Through ingenious uses of perspective pull and color contrasts, they provide a powerful and immediate impact. *See* AGAM, YAACOV; ANUSKIEWICZ, RICHARD; RILEY, BRIDGET. *See also* KINETIC SCULPTURE.

OROZCO, JOSE CLEMENTE. Mexican painter (b. Ciudad Guzmán, Jalisco, 1883; d. Mexico City, 1949). Of the "Big Four" of Mexican painting—Orozco, Rivera, Siqueiros, and Tamayo—Orozco is generally considered pre-eminent. His earliest artistic education consisted of nightly

drawing lessons at the Academy of San Carlos and visits
to the shop of the outstanding printmaker Posada. After
three years at the Agricultural School, Orozco returned to
the Academy in 1905. There he fell under the influence
of an older student, Dr. Atl, who was opposed to the cul-
tural anti-Mexicanism of the Díaz dictatorship and preached
a gospel of nationalism. *See* ATL, DR.; POSADA, JOSE GUA-
DALUPE.

In 1911–13, while the Academy was closed by student
strikes, Orozco inhabited the red-light district of the cap-
ital, where he found ample material for some water colors
known as the *House of Tears*.

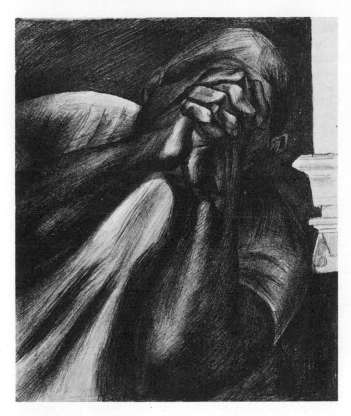

José Clemente Orozco, *Grief* (1926). Lithograph, 12⅛″ x 10⅛″.
Museum of Modern Art, New York. Inter-American Fund.

After the outbreak of civil war in 1914 Orozco served the Carranza forces as an artist-propagandist until he left Mexico for the United States (1917). After several unhappy years he returned in time to found, along with Rivera, Siqueiros, and others, the mural renaissance at the National Preparatory School in the early 1920s. His frescoes (1923–24), some of which he destroyed, are, in general, derivative allegories (for example, the Botticellesque *Maternity*) and on occasion broad caricatures. He and his colleagues were dismissed in 1924; later Orozco was permitted to continue working at the National Preparatory School. During 1926 he frescoed the staircase vaulting and walls of the main patio with scenes of the Spanish conquest and the Mexican revolution. These, unlike the earlier murals, achieve a sustained and heroic monumentality (for example, *Cortes and Malinche*). Two other frescoes from this same period are *Omniscience* (1925) in the House of Tiles (now Sanborn's Restaurant) and *Social Revolution* (1926) in the Industrial School in Orizaba.

In 1927 Orozco revisited the United States, this time benefiting more from its cultural milieu. He frequented the Manhattan salon of Mme. Sikelianos, a patron of the arts. His exhibition at the Marie Sterner Gallery (1928) and his illustrations (1929) for Mariano Azuela's *The Underdogs* earned Orozco further recognition abroad. From Pomona College in Claremont, Calif., he received his first mural commission in the United States (1930). Painted in a large refectory, it represents Prometheus; as interpreted by Orozco, the self-sacrificing Titan generates a Michelangelesque *terribilità*. The gift of fire, held aloft, provides a brilliant relief to the smoldering grays and browns below.

On his return to New York Orozco contracted to fresco another, smaller, refectory, that of the New School for Social Research (1930–31). These murals are among his least satisfying in their rigid symmetry and the mechanical juxtaposition of the compositions, for example, *Struggle in the Orient* versus *Struggle in the Occident*.

In 1932, before decorating the Baker Library of Dartmouth College in Hanover, N.H., Orozco made a brief trip to Europe. He visited England, France (where he enjoyed a Picasso show), Italy, and Spain. When he returned, Orozco began what was then his most formidable project, 3,000 square feet of wall space in the Baker Library, frequently interrupted by doorways, desks, and ventilators.

Dividing his vast scheme into two parts, *The Coming* and *The Return of Quetzalcoatl,* Orozco related the frescoes of one conversely to those of the other. Moreover, Orozco's world view, now matured, polarized this dichotomy around a pagan, aboriginal paradise and a Christian, capitalist hell. Thus, with his spirit lacerated by the cruelties of the Mexican revolution, the miseries of the Great Depression, and the impersonality of urban, industrial society, Orozco turned to a romantic glorification of natural man.

When this work was completed (1934) Orozco triumphantly returned home. For the Palace of Fine Arts he painted *Catharsis* (1934), a fierce struggle among men, with a supine harlot writhing in a debris of cultural symbols.

Summoned to Guadalajara, Orozco executed his masterpieces there in three buildings: the lecture hall of the University (1936), the staircase of the Government Palace (1937), and the chapel of the orphanage called the Hospicio Cabañas (1938–39). In the frescoes of the first two he castigated society with awesome ferocity; Armageddon is at hand, and the earth is a warring plain where men struggle blindly toward their doom. Bodies flayed like the sacrificial victims of Aztec rites lie helpless or dance madly. Distinguished from the false leaders shown below, on the walls above, empyreal, tower the true leaders, Father Hidalgo (in the frescoes at the Palace), who led Mexico to independence from Spain, and Creative Man (on the University dome) in all his aspects.

In general, Orozco's murals after Guadalajara reflect a spiritual *détente,* except, perhaps, in the Chapel of Jesus Nazarene in Mexico City (1942–44; unfinished). No later work rivals the emotional intensity attained there. After 1940 Orozco's world view contracted to more national proportions, perhaps as a result of the reforms and annexations of the Cárdenas administration. The frescoes of both the Ortiz Library (1940; Jiquílpan) and the Supreme Court (1941; Mexico City) reveal this tendency.

A trend toward abstraction, visible at the Supreme Court, is manifest in Orozco's last great mural, *National Allegory* (1947–48; Mexico City, Normal School). Influenced by the experiments of José Gutiérrez, he utilized ethyl silicate, a compound of great durability, to decorate a concrete, parabolic stage wall for an outdoor theater. Inspired by Siqueiros, Orozco designed the concave surface to adjust

pictorial forms to the vision of a widely spaced audience. The painted structure of abstract verticals and horizontals, reinforced by metallic inserts, integrates wall and theater. The whole effect, which is striking, indicates that in the year before his death Orozco may have been on the verge of an artistic breakthrough into an abstract style.

See SIQUEIROS, DAVID ALFARO.

Orozco's murals remain inevitably the criterion of his art and the touchstone of his greatness. His easel paintings vary in quality; few, such as *Zapatistas* (New York, Museum of Modern Art), capture the vitality or grandeur of the frescoes. Compressed within frames of wood, instead of stone and plaster, his monumental forms often weaken. During the 1940s there was a brief unpromising touch of the school of Paris. On the other hand, his graphic art and drawings are uniformly fine, perhaps because the black-and-white techniques lent themselves better to the expression of his uncompromising vision.

JAMES B. LYNCH, JR.

ORPEN, SIR WILLIAM NEWENHAM MONTAGUE. English painter (b. Stillorgan, Ireland, 1878; d. London, 1931). He studied at the Dublin Municipal School of Art from 1892 to 1896 and at the Slade School, where he won recognition for his skill in drawing. He was a member of the New English Art Club in 1900. Appointed an official war artist in 1917, he was knighted in 1918.

Orpen's early works were genre interiors and figures, such as *The Mirror* (1900; London, National Gallery), and portraits, which were to become the principal source of his fame. In 1909 he painted *Hommage à Manet* (Manchester, City Art Gallery), which shows members of the English art world, including George Moore, Philip Wilson Steer, Walter Sickert, and Henry Tonks, seated in conversation beneath Manet's *Portrait of Eva Gonzalez*. Many of Orpen's earlier portraits, in fact, owe much to Manet in the placing of the subject and the handling of paint.

The humor and whimsy which underlie many of Orpen's private paintings hardened into cynicism and satire immediately after World War I. *The Signing of the Peace Treaty at Versailles* (1919–20; London, Imperial War Museum) depicts European diplomats in the Hall of Mirrors. But in *To the Unknown British Soldier in France* (1919;

Imperial War Museum) he painted two corpse-like British soldiers guarding their dead comrade in very much the same setting. After the war Orpen resumed his very successful career as a portrait painter and continued, until his death, to paint in a somewhat hard style, a great number of fashionable or eminent sitters, for example, *Sir William McCormick* (1920; London, National Gallery).

JEROME VIOLA

ORPHISM. Term applied by the French poet Guillaume Apollinaire in 1912 to a style of painting created by Robert Delaunay. Sometimes called orphist cubism or cubist orphism, Delaunay's luminous, spectrum-derived manner of late 1911 appeared in a series of canvases of essentially abstract, lyrically geometric patterns, which had been in part formulated in his earlier cubist studies of *St-Séverin Cathedral* (1909; Philadelphia Museum of Art) and the *Eiffel Tower* (1910; Basel, Art Museum). See CUBISM; DELAUNAY, ROBERT.

See also BRUCE, PATRICK HENRY; FEININGER, LYONEL; KUPKA, FRANK; MACDONALD-WRIGHT, STANTON; MACKE, AUGUST; MARC, FRANZ; RUSSELL, MORGAN.

OUD, JACOBUS JOHANNES PIETER. Dutch architect (1890–1963). He was born in Purmerend, studied at the Technical University at Delft, and worked with the Dutch architects Stuyt and Cuypers and, in 1911, with the German Theodore Fischer. One of the original founders of de Stijl, Oud contributed to the movement until leaving it in 1921. In 1918 he became city architect of Rotterdam and executed the Spangen Housing Estate (1918–19). Among his more important works are the Villa Allegonda at Katwijk (with M. Kamerlingh Onnes) and the Villa De Vonk at Noordwijkerhout (with Theo van Doesburg), both built in 1917; a project for a factory (1919); the Tusschendijken housing at Rotterdam (1920); a housing project, Oud-Mathenesse, in Rotterdam (1922–23); row houses at Hoek van Holland (1924) and at Stuttgart's Weissenhof Exhibition (1927); and Kiefhoek housing in Rotterdam (1928–30). See DE STIJL.

OWINGS, NATHANIEL A., *see* SKIDMORE, OWINGS, AND MERRILL.

OZENFANT, AMEDEE. French purist painter, teacher, and theoretician (1886–1966). Ozenfant was born in Saint-Quentin, Aisne. In 1902 he began to paint and took drawing lessons in Saint-Quentin. In 1906 he went to Paris, where he studied architecture and painting. He attended classes at the Académie La Palette. Ozenfant's art was influenced at this time by Segonzac. In 1908 he exhibited at the Société Nationale des Beaux-Arts. He came to know and admire the painting of Juan Gris. By 1913 he had made three trips to Russia and had visited Italy, Belgium, and Holland. In 1915 he helped found the review *L'Elan* and was its editor for two years. Apollinaire, Picasso, Max Jacob, Matisse, Derain, and Segonzac were contributors.

Ozenfant had been painting as a cubist and knew most of the cubists. Dissatisfaction with trends in that movement led him to evolve purism. He and Le Corbusier published the first purist manifesto, *Après le cubisme*, in 1918, and in that same year the first purist exhibition was given in Paris. Ozenfant and Le Corbusier collaborated again two years later to found the influential review *L'Esprit Nouveau*, which lasted for five years. In 1925 they published *La Peinture moderne*. In 1930 Ozenfant opened his school, which he took to London in 1935; and then, in 1939, he moved to New York City and established a school there. In 1931, he finished an important large painting with more than 100 figures. This picture, done in the purist style, is called *Life*. It took him seven years to paint and is now in the collection of the National Museum of Modern Art in Paris. Ozenfant lectured in many countries over the years, including Egypt, Syria, Turkey, Greece, and, after 1938, the United States as far west as Seattle. In 1955 he returned to Paris to live and work.

Purist theory was critical of the personal expression that gave to cubist art of about 1918 an undirected, varied character. Ozenfant preferred the anonymous nature of the earlier cubist period and advanced the concept of a precise, rational, well-ordered art in harmony with modern machine civilization. He sought a new classicism of constants and saw beauty in technology. He believed that forms in art, like those in an efficient machine, should be standardized, have their basis in mathematics, and yet belong to the objective world. Ozenfant admired Bach and frequently gave titles such as *Fugue* or *Chord* to his pictures. He

rejected complete abstraction as being too close to mere decoration. He limited himself to painting commonplace objects such as bottles, wine glasses, and pitchers, as well as human figures and, later, landscapes. He geometricized them, reduced them to flat areas of color, usually pastel, and then subjected them to a rigid, architectural framework. *See* PURISM. ROBERT REIFF

PANI, MARIO. Mexican architect (1911–). Born in Mexico City, he studied for six years at the Ecole des Beaux-Arts, Paris, and became a professor of architecture at the School of Architecture, University of Mexico. Pani has designed such notable works as the Central Administration Building at the University of Mexico (with Del Moral and Florés); the Music Pavilion at Santa Fé (with Felix Candela); the Ministry of Hydraulic Resources (1950, with Del Moral); the American Embassy in Mexico City (1951, with Collantes); and housing developments in Mexico City (1952 and 1956, with Flores).

PAOLOZZI, EDUARDO. English sculptor (1924–). Paolozzi was born in Leith, Scotland. His parents were Italian. He studied at the Edinburgh College of Art and at the Slade School in London in the mid-1940s. He has exhibited at the Mayor Gallery in London and at the Salon des Réalités Nouvelles in Paris, as well as in large group showings in England and on the Continent. He has lived and taught in London since 1955. He works in concrete, wire, and bronze. His style is totemically figural and relates to the semiabstract conceptualization that is not uncommon among younger British sculptors.

PAPIERS COLLES. Technique used by modern artists by which they paste or glue paper on a surface, frequently integrating it with paint, crayon, or some other medium. Credit for the first *papier collé* is given to Braque, who in 1911 first stenciled letters as a sign painter would on his early, "synthetic" cubist painting, *The Portuguese* (Basel, Art Museum). It followed that he and Picasso, too, would develop this technique further by actually pasting newspaper, wood veneer, marbelized papers, and the like on

their canvases. The inclusion of the commonplace, vernacular, and ephemeral material in a painting gave it an air of insouciance and impertinence. Other artists have developed the technique to suit their own interests. Schwitters, for instance, composed his *Merzbilder* out of discarded subway transfers and bits of trash, while Matisse exploited cutout colored papers as patterns in his series of *papiers collés* called *Jazz*. *See* BRAQUE, GEORGES; MATISSE, HENRI EMILE; PICASSO, PABLO; SCHWITTERS, KURT.

PARANOIAC CRITICISM. Term invented by Salvador Dali to describe the creative process of producing the surrealist object for the purpose of symbolically rendering obsessions, fetishes, and hallucinations.

PASCIN (Pincas), JULIUS. French painter (b. Vidin, Bulgaria, 1885; d. Paris, 1930). Pascin, whose name is an anagram for Pincas, did his early work in Vienna, Berlin, and Munich, where he worked while still very young for the *Lustige Blätter* and for the satirical paper *Simplizissimus*. He went to Paris for the first time in 1905 and made drawings for important Parisian magazines. In 1914 he went to the United States, where he traveled extensively. In 1920 he returned to Paris and settled down in an atelier in Montmartre, where he painted portraits of his friends Salmon, MacOrlan, and others as well as large compositions on Biblical or mythical themes.

Pascin was associated with painters of every school in both Europe and the United States and spent much of his time in cafés. He posed his models in the midst of the greatest disorder, suggesting how they should sit or lie in the least chaste poses (*Ginette et Mireille*, 1929; Paris, Petit Palais). Like Toulouse-Lautrec, Pascin showed himself to be above all a great draftsman, even in paintings, where color only slightly enhances the meaning projected in the drawing. Pascin always demonstrates exquisite restraint and delicacy, and his charm recalls the great 18th-century masters whom he admired. A kind of mystical atmosphere bathes his prostitutes, with their short legs and vague expressions. Alone or in pairs, they give the impression of an existence indifferent to time.

In 1921 Pascin made a trip to Algeria and in 1924 to Tunisia. In 1925 he exhibited at the Flechtheim Gallery in Düsseldorf and visited Italy. He returned to the United

States in 1927 but was back in Paris in the summer of the following year. In 1929 he visited Spain and Portugal.

Pascin always drew with great passion and sensitivity. The brush for him was really a pencil, with modeling achieved by delicate shading. Pascin was a painter of women par excellence, as in *Les Deux amies* (1924; Paris, Robert Ducroquet Collection) and *Femmes* (1925; Paris, private collection). His portraits are among the best witnesses of Parisian life between the two World Wars.

<div align="right">ARNOLD ROSIN</div>

PASMORE, VICTOR. English painter and sculptor (1908–). Born in Chelsham, he worked in the civil service until 1938, when he became a full-time painter. Pasmore began as an impressionist in the English tradition of Whistler and Sickert, with subtly toned still lifes and misty landscapes, such as *Evening, Hammersmith* (1943; Ottawa, National Gallery of Canada). About 1948, beginning with collages, he started to paint in an abstract manner, with light still remaining an important part of his subject, for example, *Spiral Motif in Black and White— The Snowstorm* (1950; London, Arts Council of Great Britain). His recent paintings and painted reliefs are done in a personal version of neoplasticism.

PECHSTEIN, MAX. German expressionist painter (b. Zwickau, 1881; d. Berlin, 1955). He studied at the School for Decorative Arts in Dresden in 1900. In 1906 he met Heckel and Kirchner and became a member of Die Brücke, from which he was expelled in 1910 for having become a member of the Neue Sezession in Berlin. In about 1907 he visited the Ethnographic Museum in Dresden and became enchanted by African sculpture and South Seas carvings. In 1908 he saw the art of Kees van Dongen and Matisse. In 1914 he visited various countries—Italy, India, China, and the Palau Islands in the South Pacific, which were then German. He was taken prisoner by the Japanese, then released and sent to San Francisco. He became a coal stoker on a steamer in order to return to Germany.

In 1917 he did several scenes of the Baltic and designed stained-glass windows and mosaics for Wolfgang Gurlitt in Berlin. In 1926 he did some windows for the International Labor Office in Geneva. In 1923 he became a teacher at

the Berlin Academy. He was dismissed from this position in 1933 by the Nazis, but he returned to it in 1945.

His early expressionist paintings show definite influences of Cézanne, Van Gogh, and, later, the Fauves, especially Matisse. He favored pastel colors, which he loosely applied in dabs and spots. His interest in Gauguin and his discovery of primitive art led him to reject all academic refinements in order to achieve the spontaneity of initial and pure inspiration. He used unmixed color and a vigorous brushstroke. Much of his work suggests hasty execution with its calculated repetitions and obvious decorative effects. His landscapes show a decided similarity to those of Schmidt-Rottluff and of Heckel.

After his Palau voyage, he painted scenes of natives ashore and in canoes. He stressed rhythms with parallel movements and gestures. He also painted the Baltic coast— the shoreline with its dunes, fishermen, and their shacks and boats. His work and ultimately his reputation declined. His painting appeared hard from excessive modeling and detail, as well as from a loss of zeal and conviction brought about by a change in the times.

ROBERT REIFF

PEI, I. M. (Ieoh Ming). Chinese-American architect (1917–). Born in Canton, he came to the United States in 1935 and attended the Massachusetts Institute of Technology until 1939. He also attended Harvard University. In 1955 he formed I. M. Pei and Associates. His firm is noted for its rational and sensitive handling of a large range of problems, for example, the urban complex Place Ville Marie (1960–62), in Montreal, and the standardized Air Traffic Control Towers for installation in Federal Aviation Agency airports (1961–63). In 1966 the firm received a First Honors Award from the United States Department of Housing and Urban Development for the design excellence of the Society Hill skyscraper apartment buildings in Philadelphia. In 1968 Pei was commissioned to design a building to be added to the National Gallery of Art in Washington.

PELAEZ DEL CASAL, AMELIA. Cuban painter (1897–). Born in Yaguajay, Santa Clara Province, Amelia Peláez del Casal studied in the San Alejandro

Academy in Havana and also in Paris, where Kisling and Modigliani influenced her. The colorful semiabstract *Still Life in Red* (1938) is in the Museum of Modern Art, New York.

PEREIRA, IRENE RICE. American painter (1907–1971). Born in Boston, she studied at the Art Students League with Richard Lahey and Jan Matulka. I. Rice Pereira's early works were semiabstract paintings of machine forms. Her first pure abstractions, beginning in 1937, stressed textural variations and in some cases a strict linearity, as in the parchment *White Lines* (1942; New York, Museum of Modern Art). Although these were flat, her later, more geometric work increasingly emphasized deep and ambiguous space. Her experiments with new materials and techniques, painting on parchment and on one or more layers of glass, produced complexities of space and light.

PERLIN, BERNARD. American painter (1918–). Born in Richmond, Va., he studied there at the National Academy of Design in 1936, and at the Art Students League in 1937–38 and again in 1940, when he studied graphics with Harry Sternberg. During World War II he was an artist-correspondent for *Life* magazine. Perlin's earlier work was largely influenced by the style of Ben Shahn. His paintings are seemingly naturalistic renderings of urban genre subjects, landscapes, and portraits, but the delicate treatment, at times unfamiliar point of view, and intense recording of the visual fact give them a haunting, evocative quality, as in *The Jacket* (1951; New York, Whitney Museum).

PERMEKE, CONSTANT. Belgian painter and sculptor (b. Antwerp, 1886; d. Ostend, 1952). He studied in Belgium and was associated with the second Laethem-Saint-Martin school. Before World War I Permeke painted in an impressionist style. His mature paintings are expressionist treatments of landscapes, nudes, workers, and rural life, roughly and thickly painted with bulky figures. In *The Stranger* (1916; Brussels, Museum of Modern Art), a crowded interior scene, the emphasis is on the monumentality of the human forms and individual features are sup-

pressed. A similarly powerful expressiveness is evident in his land- and seascapes, such as *Marine Verte* (1934; Antwerp, Fine Art Museum).

PERRET, AUGUSTE AND GUSTAVE. French architects: Auguste (1874–1954) and Gustave (1876–1952). They worked in Paris. Of the two brothers, Auguste is better known. He was educated at the Ecole des Beaux-Arts, a student of Gaudet and Paulin, but left before receiving his degree to enter his family's building firm, which did contracting and engineering as well as architectural design. There he was associated with his brother Gustave.

Auguste's first work of any consequence was the Municipal Casino at St-Malo (1899), in which reinforced concrete was used in a single span of 54 feet for a slab floor. This building demonstrates not only Perret's early use of ferroconcrete but also his bold simplicity of style. His style developed further in his apartment house at 25 bis rue Franklin, Paris (1902–03), in which the entire structure is conceived as a visibly expressed framework of vertical and horizontal members. The skeletal nature of the building allowed for great freedom in planning and for the development of spatial areas that flowed into the various rooms. In the 1905–06 Ponthieu Garage concrete is exposed, an advance over his earlier work.

However, Perret did not disassociate iron from concrete completely until he designed his forward-looking Church of Nôtre-Dame at Le Raincy (1922–23). This church is designed on a basilican plan. All the supports are freestanding thin shafts, and the entire exterior wall is composed of pierced precast concrete units, separate from the structure, forming a screen.

Typical of his later works is the Ministry of Marine, Paris, designed in 1929, in which the subtle and complex design of the façade is produced entirely by structural elements. His plan for rebuilding Le Havre (1945) illustrates the work of his later years, which was more a realization of his early aspirations for concrete than a progressive design. DORA WIEBENSON

PETERDI, GABOR. American painter and printmaker (1915–). He was born in Budapest, Hungary, and

became a citizen of the United States in 1944. He studied in Budapest, Rome, and Paris, and has taught at the Brooklyn Museum Art School and, since 1952, at Yale University and Hunter College. He is best known for his large intaglio prints dealing with phenomena of nature, including *Germination I* (1951) and *Burning Rocks* (1959).

PEVSNER, ANTOINE. Russian-French sculptor and painter (b. Orel, Russia, 1886; d. Paris, 1962). He was the brother of the sculptor Naum Gabo. From 1902 to 1909 he studied painting, sculpture, and architecture at the Kiev Academy of Fine Arts. Disillusioned with academic art and excited by the advanced French painting seen in Moscow, he went to Paris in 1909 and then returned briefly to Kiev. He became interested in the medieval and folk art of the Kiev area. After one year at the St. Petersburg Academy he felt compelled to return to Paris, and in 1911 he saw the first cubist exhibition at the Salon des Indépendants. He was then in Russia for a year, but returned to Paris in 1913 and saw Boccioni's exhibition and the work of Léger and Duchamp. Under the influence of Archipenko and Modigliani, Pevsner began painting in abstract forms. *Abstract Forms* (1913; New York, Museum of Modern Art) and *Study of a Head* (1914–18) are examples of this phase of his work.

During the war he joined his brother in Oslo (1914–17). While involved in his own painting researches, *Carnival* and *Absinthe* (1915–16; Moscow, Museum of Modern Art), he observed his brother's first sculpture constructions. He returned to Moscow in 1917 and received an official teaching post, along with Tatlin and Malevich, which brought him in contact with suprematism. This influence resulted in the paintings *Harmony in White* (1917) and *Oil Painting* (1917–18), in which he began to consider his works as constructions. In 1920, breaking with the political and artistic views of Tatlin and Malevich, Pevsner and Gabo published their *Realistic Manifesto*. When the Communist government lost sympathy with his art, Pevsner left for Berlin (1923), where he made his first construction, and thereafter concentrated on sculpture.

Later that year he returned to Paris and in 1924 exhibited with Gabo. Between 1924 and 1926 he made his *Bust*, *Portrait of Marcel Duchamp*, and *Torso* construc-

tions (New York, Museum of Modern Art), raising his plastic geometric-shaped planes from a flat surface. In 1927 he worked with Gabo on ballet sets for Diaghilev. He became a French citizen in 1930 and in 1931 was a founder of the Abstraction-Création group. During the 1930s his sculpture assumed the character of elegant machines. Pevsner helped organize the Réalités Nouvelles group in 1946 and did large architectural sculpture in 1950 for the Caracas Cité Universitaire and in 1955 for General Motors in Detroit. ALBERT ELSEN

PEYRONNET, DOMINIQUE PAUL. French painter and lithographer (b. Talence, 1872; d. Paris, 1943). A self-taught artist, Peyronnet began as a commercial printer and started painting about 1920. He is one of the finest modern naïve painters. His subjects are land- and seascapes, still lifes, and figures. In his simple marine scenes, water, land, and clouds are built up by repetition of similar forms and lines, with waves parallel to sand formations, resulting in a strong pattern and a sense of very deep space. His most famous work is *The Ferryman of the Moselle* (ca. 1936; New York, Museum of Modern Art), based upon an incident in the Franco-Prussian War.

PICABIA, FRANCIS. French cubist and surrealist painter of Cuban descent (b. Paris, 1878; d. there, 1953). Picabia began to paint and draw as a boy. He studied at the Ecole des Beaux-Arts with Cormon and also at the Ecole des Arts Décoratifs. When he was seventeen he exhibited at the Salon des Artistes Français. From 1903, for a period of about six years, he painted as an impressionist in a manner similar to Sisley's. He then became interested in cubism. In 1912 he was a founding member of the Section d'Or along with Villon, Apollinaire, Gleizes, Léger, La Fresnaye, and Metzinger. He visited New York and exhibited in the Armory Show of 1913. That year he also exhibited Orphist water colors at Stieglitz's 291. In 1915 he made a second visit to New York and with Marcel Duchamp published a magazine called *291*.

In 1921 he sided with André Breton against Dada and for surrealism. In 1924 he took part in the surrealist film *Entr'acte* and wrote the scenario and designed sets and costumes for the ballet *Relâche*. In 1926 he returned to fig-

urative art. The Rosenberg Gallery in New York gave him his first retrospective exhibition in 1930. During World War II he lived in the southern part of France, and in 1945 he returned to Paris to live. He began to paint abstractly again. In 1949 he had another comprehensive show (at the Galerie Drouin, Paris), for which a catalog, entitled *491*, was issued.

Picabia's cubist pictures suggest a shallow, light-filled area of superimposed and transparent, highly finished segments of enameled metal. These are closer in spirit and nature to early Léger and the Italian futurists than to Picasso or Braque. His Dada works often feature an elaborate mechanism, as sharply defined as an item in a technical handbook, but a mechanism with no apparent 'function or meaning other than to baffle or titillate the beholder. Picabia's transparent paintings of about 1926 feature linear representations of the human figure, one superimposed on the other. At his best, Picabia is ironic, spirited, and outrageous. Many of his paintings indicate, however, an indifference or insensitivity to paint quality and to color and line. ROBERT REIFF

PICASSO, PABLO. Spanish painter, sculptor, graphic artist, and ceramist (1881–1973). Born in Málaga, he later resided permanently in France. Son of an art teacher, José Ruiz Blasco, Picasso took his Italian mother's name soon after 1900. The family moved to Barcelona in 1895. There, after brief but intense study at the academy, where his great talent as a draftsman was immediately apparent, he held his first one-man show at the age of sixteen. His work was reviewed in the Barcelona *La Vanguardia*, and, at the same stage, Picasso published drawings in the journal *Joventut* ("Youth"). He visited the World's Fair in Paris in 1900 and sold his first works in France to the dealer Berthe Weill, one of the first persons to encourage the avant-garde of the 20th century. Returning to Spain, Picasso lived in Madrid; he again went to Paris, and after a second and a third trip home, he settled in Paris in 1904, living for five years at the Bateau Lavoir and meeting various Fauves and other painters and poets who were soon to be associated with the cubist movement. Picasso had already exhibited at Vollard's gallery during a visit to Paris.

His so-called Blue Period, which extended from about 1902 to 1904, was a phase in which he created sad images of destitute persons, some of them almost emaciated, the tonalities of the pictures going to blues, dull whites, and grays. Picasso came under various late-19th-century influences at this time, including Toulouse-Lautrec and, less evidently, Gauguin. (The extreme figural leanness and cool tones of this early style, combined with Picasso's Spanish origin, have caused certain students to detect also the shadow of El Greco.) In 1905, the year Picasso met Guillaume Apollinaire and the Russian collector Schtoukine, the prevalent blue gave way to reddish and pink tones and the subjects shifted chiefly to circus people: pensive acrobats, youths holding or sitting on horses, and serious clowns. In both the Blue and the Rose Periods Picasso's skill in drawing is clearly evident, although both the line

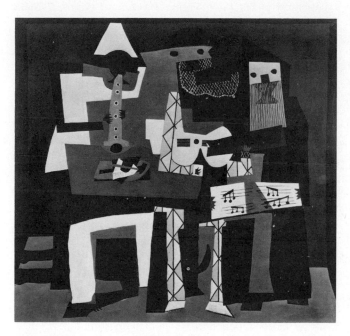

Pablo Picasso, *Three Musicians* **(1921). Oil on canvas, 6'7" x 7'3¾". Museum of Modern Art, New York. Mrs. Simon Guggenheim Fund.**

and the pigmentation are subtler, less assertive, than they were to become in 1906.

Partly under the stimulus of African Negro carvings to which he was introduced, it appears reasonably certain, by Matisse, and otherwise simply because he was developing in style at a phenomenal rate, Picasso in 1906 began to create works which show the unmistakable signs of originality. They also anticipate in their increased formalization of structure and decreased dependence on immediately visual properties of the subject the earliest stages of cubism, which first clearly emerge in the late-1906 and early-1907 studies for the renowned *Demoiselles d'Avignon* (New York, Museum of Modern Art). This great and initial masterwork of cubist style, not yet programmatically geometric like the dissolved images of the analytic cubist phase of 1910–12, was prompted by Picasso's finding in primitive art the affirmation of major tendencies already experienced in his *Pink Nudes, Portrait of Gertrude Stein* (New York, Metropolitan Museum), and *Self-Portrait* (Philadelphia Museum of Art) of 1906. Further, Picasso during 1907 was instructed by the great discipline of Cézanne's painterly geometry and by that master's posthumously circulated theorem about finding in nature certain basic geometrical forms. Encouraged by a contract with Kahnweiler and by the sympathetic companionship of Georges Braque, Picasso, with Braque, proceeded from late 1907 to develop what is called "early cubism." *See* CUBISM.

This phase of the style grew with remarkable clarity through a prolific series of still lifes and landscapes into Picasso's and Braque's 1910 and 1911 analytic studies of the figure. The 1909 *Horta de Ebro Reservoir* and the bronze sculpture *Woman's Head* (New York, Museum of Modern Art) are documents of this early period, with the *Girl with the Mandolin* (1910; New York, Nelson Rockefeller Collection) and *Portrait of Wilhelm Uhde* (1910; London, Roland Penrose Collection) typifying the analytic manner. While Picasso, like Braque, reduced the forms of his subjects to essentially geometrical equivalents, particularly the arc, the plane, the cone or pyramid, and the line, he nevertheless retained more than bare similitude to natural forms. He actually analyzed them so that different sides and parts of forms might be seen simultaneously by the spectator without moving about the object represented. At the same time that Picasso achieved this revolution of

form, he and his colleague Braque used restrained colors; typically, the early and analytic canvases contained only quiet greens, blues, tans, browns, and grays developed from those hues.

Picasso's first synthetic cubist works date from 1912 when he and Braque introduced into their pictures pasted papers, especially clipped numerals and letters from journals and wallpaper or imitation wood graining. Such works are called *"papiers collés"* or "collages." Again, Picasso retained the subject. The synthetic still lifes of stringed instruments, bottles, table tops, and other smallish objects actually reflect the environment of the cubist artists as they sat in cafés discussing their painting. At no time did Picasso create what may correctly be called "abstract" or "nonfigurative" works, although the ordinary visual properties of his subjects yielded to his formalized interpretation. Pictures characteristic of the synthetic cubist manner are his *Still Life with Chair Caning* (1911–12) and *Guitar* (1912). The *Head* of 1913 or 1914, with a pasted, irregular triangle of white and a drawn charcoal arc, comes as near to abstraction as is typical of Picasso. By this time Picasso was recognized in various countries of Europe as well as among avant-garde American painters as the leader of a revolutionary movement in art. However, neither Picasso nor Braque, the actual founders of cubism, regularly participated in the cubist group exhibitions such as the 1912 Section d'Or show.

Between 1914 and 1920 Picasso painted more flatly and decoratively, sometimes using a gay style with confetti-like dots known as "rococo cubism," a name which referred to the tiny touches and forms of that French 18th-century style. Soon after 1920 Picasso, as if to recall the many modes in which he had worked, sometimes created brilliantly hued, flat-patterned compositions such as *Three Musicians* (1921); at other times he used a classicistically monumental, forcefully shaded style, as in *Mother and Child* (1921; Mr. and Mrs. Alex L. Hillman Collection) and *The Race* (1922; New York, Museum of Modern Art). During the late 1920s and into the middle 1930s his paintings and graphic works yielded strongly surrealistic qualities of deformation and fancifulness of imagery, the colors often going to brilliant primary hues. A masterpiece of 1932 and one of his finest canvases is *Girl before a Mirror* (New York, Museum of Modern Art). His 25-foot

portable mural, *Guernica* (extended loan by the artist to Museum of Modern Art, New York), was painted in 1937 in horrified and angry response to the Fascist bombing of that Basque town during the Spanish Civil War. Picasso once stated that this expressive, frightening composition represented his reaction to all brutal, inhuman acts of violence.

By the outbreak of World War II and the Nazi Occupation of Paris in 1940 Picasso had already become the best-known living painter; his enormous productivity was greater than that of any other artist. Certain aspects of cubism had been taken over even by fashion illustrators; and the impact of his several amplifications of the cubist style had been felt by both young and older artists everywhere. He had also created the décor for many ballets and plays, illustrated both contemporary and older books with etchings and lithographs, won the Carnegie International Exhibition prize in 1930, and been honored by many large retrospective shows throughout Europe and America. Picasso was not personally molested by the German Occupation forces during the 1940s, but the humiliation of France and the evils of the Occupation deeply affected him, and his paintings and sculptures of 1940–45 are somber and, for Picasso, restrained. The *Still Life with a Candle* (1944) and *Notre Dame* (1945) are characteristic of this period for their strange containment.

Living mainly in Vallauris after the war, Picasso was once again exuberantly creative, producing many works in a single day and using ceramics as well as painting, graphic media, and sculpture as outlets. Although his style at last ceased to undergo marked change from one year to the next and instead has simply disclosed Picasso's exploitation of modes arrived at before the war, his productivity has continued. He has been especially active in lithography, and in the late 1950s he also completed series of oil paintings based on themes from Velázquez (*Las Meninas*) and Delacroix (*Women of Algiers*).

Picasso's significance in the history of art is vast; he is not only the most influential of 20th-century masters, but his contribution exists in the universal ambiance of all past and present giants of creative expression. His most monumental achievement was the founding of the cubist style, the aesthetic of which has in some measure had impact upon nearly every major artist and movement since

1907. Not the least of Picasso's other significant contributions is the example of his incredible productivity and its inspiration to his contemporaries. JOHN C. GALLOWAY

PICASSO AS SCULPTOR

Picasso is considered first a painter; but his contribution to modern sculpture has been so distinguished and of such a pioneering character that, were he known for his bronzes and constructions alone, he would still be recognized as a giant. There is no existing movement in sculpture that has not been anticipated by some phase of Picasso's personal development as a modeler or assembler of three-dimensional forms.

The earliest significant sculptures by Picasso are a smallish *Seated Woman* (1899) and the better-known *Jester*, or *Harlequin* (1905; Washington, D.C., Phillips Collection), both in bronze. Each piece owes something not only to Rodin but also to Degas, Renoir, and perhaps Daumier as well. The restrained tensions of these works may or may not presage the explosive vigor of his later sculpture; but a close scrutiny of the *Seated Woman* and the *Jester* discloses a peculiarly personal intransigence, less apparent in specific sectors of figure or face than in total flavor, which is to distinguish from this period onward even the slightest of Picasso's images.

In 1906 Picasso was confronted with two sources of inspiration so pervasive in their effect that the whole of 20th-century art has later, in either direct or indirect consequence, been conditioned by them. The first of these forces was ancient Iberian sculpture, a Spanish translation, in a sense primitive, of Greek statues. A number of Iberian stone heads and narrative reliefs were specially exhibited in 1906 at the Louvre, where Picasso had already assiduously studied various older arts: Greek white-ground lekythoi, late Roman art, and Near Eastern sculpture. The second influence upon him at this time was Negro African primitive style, introduced to him most likely by Matisse though earlier admired by others of the Fauvist group, including Derain and Vlaminck.

Picasso's portraits and related paintings of 1906 show an immediate and enthusiastic response to these new stimuli, and the bold concinnity of primitive with Western style in the renowned *Demoiselles d'Avignon* of 1907 is well known. But it is in the 1909 bronze *Woman's Head* (New York, Museum of Modern Art) that Picasso first

profoundly assimilates Negro African formal concepts, both in broad synthesis and in specifics, in an important sculpture. This work is a landmark in the history of modern art as well as one of the greatest documents of early cubist style. Its genesis lies primarily, of course, in the artist's relentless pursuit of conceptualized rather than directly representational form; but this conceptualization owes much to the potently geometricized structure of one particular style of Poro Society mask produced by the Mano and Dan of West Africa.

While numerous Fauvist, expressionist, and other Parisian painters and sculptors had been stimulated by their acquaintance with African art, it remained for Picasso's empathy with it to bring primitive aesthetic tellingly to bear upon subsequent Western sculpture.

The avalanche of canvases and drawings that followed the creation of the *Woman's Head* and that exploited the principles of analytic cubism in painting deterred to a great extent Picasso's attention to sculpture. His next significant three-dimensional work, which anticipated by half a century both the whimsy and the subject content of Pop art, was the *Absinthe Glass* (1912; New York, Museum of Modern Art). This and the canvas-mounted junk reliefs of 1913–14 (*The Mandolin*, 1914; artist's collection) were to be elaborated upon by the Dadaists, as in the *Merzbilder* of Schwitters, and in more fluid and cleancut raised wooden patterns, as in the work of Arp.

Sculpture as such was all but neglected by Picasso from the late 1910s until shortly before 1930. Picasso's vigorous return to sculpture in 1928, his instruction in metalwork techniques by Julio Gonzales in the early 1930s, and the establishment of his sculpture studio at Boisgeloup in 1932 found him at home with this art again. His bronze *Metamorphosis* (1929) is a compelling, grotesque image whose sheer expressionism rivals that of works by Lipchitz of the 1940s. Again basing his work upon conceptualization, Picasso created a nightmarish image in which a woman is being transformed into a nonhuman configuration. His paintings had for some years borne similarly haunting visions. The *Metamorphosis* and similar sculptures, as well as the earlier related paintings, afforded surrealist style much of its substance.

Picasso's several sculptural modes of the 1930s have tellingly affected the development of subsequent styles. The

cagelike compositions of various American, British, and Italian sculptors, largely in the early 1950s, owe their origin to Picasso's welded rod constructions of 1930–32, works which are as nearly nonfigurative as the artist has yet essayed. His 1912 use of an absinthe glass cast in bronze as a sculpture has now been notably amplified; found objects such as plumbing fixtures, sections of pipe, toy airplanes and dolls, and other discarded metallic, wooden, and cloth additives appeared conjoined with coatracklike stands or assembled so as to suggest a whimsical figure. Closer to nature were a bronze, turning *Rooster* (1932) and a *Bull's Head*. Female busts or heads on extremely long necks also issued from this richly productive stage. These women's heads are remarkable for their enormous phallic noses, extruded hemispherical eyes, and lobed coiffures.

Despite the soberness imposed in the 1940s upon Picasso during the German military Occupation of France, he was once again productive in sculpture. While darkish tones characterize his paintings during this unhappy period, Picasso's bronzes and constructions retain occasional humor. A *Bird* (1942), its midsection the treadboard of a child's scooter, its neck the curved-and-vertical post of the steering bar, and its tail a truncated cylinder of pipe from which audaciously extends a sadly drooping feather, is one of the more inventive assemblages of this phase. A number ·of figurines, reliefs of faces, and a cat similarly follow a Picassoesque whimsical spirit.

The crowning example of Picasso's sculpture of the 1940s is the bronze *Man Holding a Lamb* (1943), the plaster model for which, more than seven feet high, is said to have been completed in an incredibly short time. One cast of this monumental statue is in the village of Vallauris, another at Picasso's home, and a third in the collection of Mr. and Mrs. R. Sturgis Ingersoll in Pennllyn, Pa. The composition is sometimes called *Shepherd Holding a Lamb*, this title evoking a more bucolic sentiment.

After the end of World War II Picasso then worked prolifically in ceramic sculpture, approaching new media with bold effect. His more monumental pieces in metal have included a powerful *She-Goat* (1951) and *Woman Diving* (1957). He also continued with the assemblage method, which he devised about 1910 and which has become a widely practiced technique among younger artists. A huge

retrospective exhibition of his sculpture was shown in the Tate Gallery, London, and in several cities in the United States during 1967. Also in that year a 50-foot steel sculpture designed by Picasso was placed in Chicago's Civic Center Plaza. In 1968 another such monumental piece was erected in a Greenwich Village plaza in New York City. JOHN C. GALLOWAY

PICKENS, ALTON. American painter (1917–). Born in Seattle, Wash., he studied at the Seattle Art Institute and the Portland Museum Art School and traveled in Europe. Pickens paints figures in a realistic style, but in the choice of subject and its treatment he shows a symbolic concern for the tragedy of man's social life. Ostensibly genre scenes, his paintings of aged, sinister children, done in the 1940s, transcend the needs of urban realism, for example, the macabre *Blue Doll* (1942; New York, Museum of Modern Art). In other paintings the emotional and symbolic effect of a heightened reality is somewhat more specific in reference, as in the complex allegory on modern freedom called *Carnival* (1949; New York, Museum of Modern Art).

PIGNON, EDOUARD. French painter (1905–). Pignon was born in Marle-les-Mines. After working at various jobs, he took evening courses with Wlérick and Arnold and, encouraged by Picasso, finally began to paint in 1934. He exhibited at the Salon des Indépendants, the Salon des Surindépendants, and the Salon des Tuileries. Like many painters of his generation, Pignon has been influenced by both Matisse's bold use of color and the cubist distribution of space. Nevertheless, he has produced an individual art of great emotional power, using the human figure as a motif of elementary feelings (*The Dead Miner*, 1952). Pignon is one of the best exponents of the artistic-political ideal known in France and elsewhere as social realism.

PIPER, JOHN. English painter, designer, and writer (1903–). He was born in Epsom, Surrey. The son of a solicitor who was interested in art and especially in Ruskin, Piper's early interest in architecture was fostered

by his joining the local archaeological society and by visits abroad with his family. After being articled as a solicitor, he went to the Richmond School of Art in 1926 and then to the Royal College of Art.

This was a seminal moment in English art, when the full impact of cubism and of abstract painting were making themselves felt for the first time, and the Diaghilev Ballets Russes had introduced a new world in the theater. From 1928 to 1933 Piper contributed articles to magazines on painting, architecture, and the theater, and was a member of the 7 and 5 Society, which included Hodgkins, Wood, and Ben Nicholson, the influence of the last being especially strong. This, together with his contacts with the Ecole de Paris, caused a change in his style toward abstract art. His links with the avant-garde movement were strengthened by his collaboration in the magazine *Axis*, edited by Myfanwy Evans (who later became his wife), to which sculptors, painters, and writers contributed.

Paradoxically, in the late 1930s Piper was moving away from abstraction to romantic landscape and topography; there was thus a resurgence of his early love and interest in architecture. Nonetheless his style retained from its abstract phase an expressionist use of colors. Full use of the contrasting textures of buildings gives a dramatic quality to his pictures, which are in the 18th-century tradition. In the tradition of the 19th-century romantic landscape school are the paintings inspired by the grand views of Welsh mountains and *Gordale Scar*. During World War II Piper served as war artist to illustrate the effect of the conflict on the home front. The postwar years saw a new, more structural, geological approach to landscape, based on an awareness of the forces of nature.

By 1950 his reputation was well established and many commissions kept him busy. He was drawn to the theater, designing costumes for Vaughan Williams's ballet, *Job*, and settings for operas at Covent Garden, notably those of Benjamin Britten. A further extension of his activities was the design for the main vista of the Festival Gardens for the 1951 Festival of Britain. He also worked on the "Homes and Gardens" pavilion, using a decoration based on his architectural drawings. In this period Piper turned his attention to stained-glass designs and provided windows for Llandaff and Coventry Cathedrals. His early

experience as an amateur archaeologist and draftsman have led to continuing interest in pen and water-color drawings and graphic art. ROSS WATSON

PIPPIN, HORACE. American primitive painter (b. West Chester, Pa., 1888; d. there, 1946). Before he enlisted in the Army in 1917 he worked as a hotel porter, ironmonger, and junk dealer. He painted his first oil, *End of the War: Starting Home* (Philadelphia Museum of Art), in 1930. Dr. Christian Brinton discovered his work in 1937 and arranged for Pippin's first one-man exhibition at the West Chester Community Center.

In 1940 Pippin attended classes at the Barnes Foundation, Merion, Pa., and had his first one-man show in New York City at the Bignou Gallery.

He painted largely what he remembered. A number of his best pictures use his war experiences as subject matter. These reveal a sharpness and accuracy of detail and a sensitive and powerful sense of design. He has done scenes of his own childhood in his pictures of Negro families in modest interiors. These are always dignified and often touching. His historical and Biblical paintings, as well as his still lifes, to some extent recall Henri Rousseau.

PISIS, FILIPPO DE. Italian painter (b. Ferrara, 1896; d. Milan, 1956). At first interested in literature, he began painting in the 1920s and was associated with Carrà and Chirico in Ferrara. Pisis' style is derived from the painterly bravura of Manet, French impressionism, and the 18th-century Venetians. His subjects, simple still-life objects, Venetian architecture, and landscapes, are rendered with a lyrically loose brush which seemingly transcribes the instantaneous mood arising from the motif.

PITTURA METAFISICA (Metaphysical Painting). Never a group style but rather a common approach, Pittura Metafisica arose out of the meeting and brief friendship of Giorgio de Chirico and Carlo Carrà in Ferrara in January, 1917. Alberto Savinio, a poet and Chirico's brother, and the painters Filippo de Pisis and Giorgio Morandi were also members of the circle. Their artistic ideas were based on the kind of painting Chirico had been produc-

ing since 1911, for example, *Delights of the Poet* (ca. 1913; New York, Museum of Modern Art). By such dream-like means as strangely plunging perspectives of buildings and empty streets, and the evocative association of uncommon or incongruous things, such as the objects and mannequin figures in Carrà's *Mother and Son* (1917; Milan, Dr. Emilio Jesi Collection), they sought to communicate the mystery which they perceived beneath surface reality. In this respect, metaphysical painting was a direct precursor of surrealism.

POLIAKOFF, SERGE. French abstract painter and lithographer (1906–1969). He was born in Moscow and resided in Paris after 1923. He studied in Paris and at the Slade School in London. He supported himself by playing the guitar. In 1937 he met Kandinsky and Delaunay and began to paint abstractly.

In 1952, influenced by the painting of Malevich, Poliakoff developed the style which characterizes his best-known work. Large, simple, angular shapes interlock contingently to form a single layer of paint applied with a palette knife so as to reveal underpainting and thus emphasize the substance of the pigment. In colored lithographs by Poliakoff, as in the paintings, the flattened planes are clearly demarcated from one another; but the forms tend to be even more angular, the colors more intense.

POLLOCK, JACKSON. American painter (b. Cody, Wyo., 1912; d. Springs, N.Y., 1956). He was a leader of the New York action painters and a major contributor to 20th-century abstract tradition. Pollock, who was first interested in sculpture, studied from 1929 to 1931 at the Art Students League in New York City, where Thomas Hart Benton was his instructor. He worked on government art projects in the late 1930s. His first one-man show was at Peggy Guggenheim's gallery in New York, Art of This Century, in 1943. His work was subsequently shown at the McMillan Gallery, the Betty Parsons Gallery, the Sidney Janis Gallery, the Venice Biennale, and the São Paulo Bienal. A number of posthumous retrospectives have been given.

Pollock's early abstract style is seen in *The She-Wolf* (1943; New York, Museum of Modern Art) and *Eyes in the Heat* (1946; Peggy Guggenheim Collection). Pollock's

Jackson Pollock, *Number 27* (1950). Oil on canvas, 49" x 106". Whitney Museum of American Art, New York.

technique, which for several years involved the dripping and spattering of paint upon the surface rather than the conventional mode of brushing, attracted much professional as well as public attention. The critics who understood Pollock's contribution to abstract expressionism pointed out the liberating, object-reducing, and spatially delimiting character of this unique style. The 1952 *Blue Poles* (New York City, Mr. and Mrs. Ben Heller Collection) is a fine example of Pollock's late manner. The wide acceptance of action painting owes much to his efforts.

See also ABSTRACT EXPRESSIONISM.

JOHN C. GALLOWAY

PONTI, GIO. Italian architect and designer (1891–). As a designer, Ponti was probably first influenced by the neoclassical style emanating from Vienna, as may be seen in his drawings and porcelains of the 1920s. Since then he has branched out into all areas of design, including furniture, interior decoration, industrial products, and light fixtures, developing an elegant and functional style. Best known are his light and simply designed chairs.

In architecture, Ponti played an important role in introducing the International Style in Italy. The Faculty of Mathematics building at Rome University City (1934) is his first such work. Collaborating with Pier Luigi Nervi, Ponti produced his most elegant design for the Pirelli building (1955–58) in Milan. The faceted curtain walls of this slender skyscraper taper toward the ends around an ingenious structural core of reinforced concrete.

POONS, LARRY. American painter (1937–). Poons attended the New England Conservatory of Music in Boston and the Boston Museum School of Fine Arts. He has worked in New York City. His work has been associated with Op Art (Responsive Eye exhibition, Museum of Modern Art, N.Y., 1965), minimal art, and the new imagists. The arrangement of ovals and other shapes of color on a monochrome background creates lively optical and temporal effects. The dynamism of this abstract art and the use of an underlying diagonal grid system indicate the influence of Mondrian's late work.

POOR, HENRY VARNUM. American painter and designer (1888–1970). Born in Chapman, Kans., he studied at the Slade School in London with Sickert and at the Académie Julian in Paris. From an early Matisse influence, Poor went on to landscapes, still lifes, and figures, warmly colored and with fluid, decorative brushstrokes which, nevertheless, give expression to the volume of forms, for example, *Bessie* (1939; New York, Whitney Museum). From 1920 to 1930, inspired by Cretan pottery, Poor successfully worked in ceramics and also designed textiles. He completed several murals, including government projects and one at Pennsylvania State College in 1940.

POP ART. A controversial but, paradoxically, very influential avant-garde art movement of the early 1960s. Its focus has been the United States, but its manifestations can be seen in Europe. Formally, it may be said to represent a reaction against the amorphous type of painting generally done by the abstract expressionists; Pop Art, whether in paint or in collage, features a clean, hard-edged precisionism. Thematically, it focuses on everyday, commonplace objects of our commercialized society such as hot dogs, pies, highway signs, comic books, wearing apparel, and can and box packaging. It often becomes a Dadaistic, anti-aesthetic gesture. Some critics maintain that it makes no comment on the objects of commercialism that are portrayed, but Claes Oldenburg as a Pop artist has declared himself committed to an "art . . . that twists and extends impossibly and accumulates and spits and drips and is as sweet and stupid as life itself." *See* OLDENBURG, CLAES.
See also LICHTENSTEIN, ROY; WARHOL, ANDY.

POPE, JOHN RUSSELL. American architect (1874–1937). Born in New York City, he studied at the American Academy, Rome, and the Ecole des Beaux-Arts, Paris, before returning to New York, where he was employed briefly by Bruce Price. During his successful career, he designed many public buildings in the United States and abroad. Pope was a determined neoclassicist, whose style was largely untouched by contemporary influences. His work includes the Temple of the Scottish Rite (1916), a grandiose reconstruction of the Mausoleum of Halicarnassus; the National Gallery of Art (1941; opened after his death); and the Jefferson Memorial (1939–41), all in Washington, D.C.; and the American Battle Monument, Montfaucon, France (1937). As with other American architects who adhered to traditional styles, his buildings are characterized by neatness of execution and reserved elegance.

PORTINARI, CANDIDO. Brazilian painter (b. Brodósqui, São Paulo State, 1903; d. Rio de Janeiro, 1962). Portinari studied in Rio de Janeiro and in Europe. He is known for murals (for example, 1941; Washington, D.C., Library of Congress) and oils of Brazil's northeast (*Retirantes*, 1944; São Paulo, Museum of Art). His romantically nativist works are painted in an individualized realistic style. The powerful figures are presented in a decorative manner influenced by Foujita.

POSADA, JOSE GUADALUPE. Mexican printmaker (b. Aguascalientes, 1851; d. Mexico City, 1913). José Guadalupe Posada arrived in Mexico City in 1887, already an accomplished printmaker. As artist for the publisher A. Vanegas Arroyo, he produced prints on every theme of popular interest, the most famous being the *Calavera* (skeleton) series (for example, *Calavera zapatista*, ca. 1912). Although his prints do not have fine-arts status, their bold line and strong color had an admitted influence on major Mexican artists such as Orozco and Rivera. Later artists in the graphics field, such as those in the Taller de Gráfica Popular, have continued his popular tradition, particularly with the production of *calaveras* and the sensational *corridos* (penny broadsheets).

POUSETTE-DART, RICHARD. American abstract painter (1916–). He was born in St. Paul, Minn., and lives in Eagle Valley, N.Y. Largely self-taught, he began to paint in 1936. In 1951 he was awarded a Guggenheim grant. In several of his pictures a complex of slender uprights of symmetrical design made up of diamond shapes and ovals appears to emerge from a textured, light-flecked ground.

PRAIRIE ARCHITECTURE. Term inspired by the low-lying, horizontal lines of the houses designed by Frank Lloyd Wright in an early phase of his career (1895–1910). Most of these houses are located in the suburbs of Chicago, the most developed example being the Robie House (1908). With long, overhanging eaves, intersecting planes, and informally merging planes and terraces, Wright created for the first time a complete parallel and organic relationship between the house and its surroundings and complex formal relationships not unlike those of the cubists in painting. The widespread popularized effect of this invention is evident in the proliferation of the ranch house throughout the United States. *See* WRIGHT, FRANK LLOYD.

PRECISIONISM, *see* CUBIST REALISM.

PRENDERGAST, MAURICE BRAZIL. American painter (b. St. John's, Newfoundland, 1859; d. New York City, 1924). He went to Europe briefly in 1886, and again in 1891, when he began to study in Paris at the Académie Julian with Laurens and Blanc and at the Académie Colarossi.

His early oils in Paris were influenced by Manet and Whistler, for example, *Dieppe* (1892; New York, Whitney Museum). His Parisian water colors, however, such as *Along the Boulevard* (ca. 1894; Buffalo, Albright-Knox Art Gallery), already show both his mastery of the medium and his awareness of postimpressionist problems of depth and surface pattern. This awareness made him one of the most advanced American painters of the time and much more modern in style than the other members of The Eight, with whom he exhibited in 1908.

In 1898 Prendergast went to Italy, staying mostly in Venice. His paintings became more strongly composed and warmer in color, as in the oil *Ponte della Paglia* (1899; Washington, D.C., Phillips Collection) or the delightful water color *Umbrellas in the Rain, Venice* (1899; Boston, Museum of Fine Arts). In both these works the pattern of his patches of color is further enriched by the repetition of elements in the scene, architectural details or women's umbrellas. About 1904 Prendergast began to concentrate more on oil paintings, usually executed in his studio from water-color sketches made at the scene. He moved closer to an abstract formulation with contrasted color contours and a decorative brushstroke almost independent of the form depicted (as in *Seashore*, 1910; St. Louis, City Art Museum) but a part of the over-all design, as is particularly clear in the loosely worked *Promenade* (1914–15; Detroit Institute of Arts). JEROME VIOLA

PRESTOPINO, GREGORIO. American painter (1907–). Prestopino was born in New York City, where he attended the National Academy of Design. In the 1930s and 1940s his work dealt with social themes and working-class life in a structured manner that shows the influence of Braque and Rouault. In work of the 1950s and 1960s color becomes brighter and shapes, brushstrokes, and compositional relationships more abstract, particularly in a series of landscapes. Continuing to paint social themes, Prestopino produced a series on the Negro community of Harlem (1957) that subsequently became the subject of a prize-winning film at the 1958 Cannes Film Festival.

PROLETARIAN ART. Term associated with an art that gives expression to the aims of the working class, particularly the art of the Soviet Union. It rules out formalistic experiment and seeks to portray the revolutionary struggles and everyday activities of a heroic proletariat in terms of realistic representation. The term also had currency among left-wing American artists of the 1920s and 1930s.

PUBLIC WORKS OF ART PROJECT (PWAP). First art program supported by the Federal government of the United States, begun in December, 1933, and administered

by the Treasury Department under the direction of Edward Bruce. Approximately 3,750 artists were paid daily wages, and their paintings and sculptures (nearly 16,000) were distributed to public institutions throughout the country. By the end of the project, in June, 1934, about $1,312,000 had been spent.

PURISM. Movement formally founded in 1918 with an exhibition at the Galerie Thomas in Paris and the publication of *Après le cubisme* by Amédée Ozenfant and Charles Edouard Jeanneret (Le Corbusier). The purists held that cubism, by moving from its early severe pictorial structure toward an increasing emphasis on subjectivity and decorative qualities (as, for example, in the works of Picasso ca. 1914–18), had relinquished the means for expressing the reality of modern life. For them, the prime modern reality was technology and the concomitant aesthetic based on the machine with its smooth perfection that was cleanly tailored to its function. *See* LE CORBUSIER; OZENFANT, AMEDEE.

PUY, JEAN. French painter (b. Roanne, 1876; d. there, 1960). He studied architecture in Lyons and painting with Jean-Paul Laurens at the Académie Julian and with Eugène Carrière. His early style was impressionist. Puy was attracted to the colorful simplifications of Matisse and exhibited with him at the 1905 Fauve Salon d'Automne. He retained a Fauvist style for the landscapes, portraits, and nudes of his later career, stressing more formal composition in some works and surface pattern and decorative design in others.

RATTNER, ABRAHAM. American painter (1895–). Born in Poughkeepsie, N.Y., he studied art and architecture at George Washington University and also attended the Corcoran School of Art and the Pennsylvania Academy of Fine Arts. In 1920 he moved to Paris where he studied at the Académie Julian and the Ecole des Beaux-Arts. He came under the influence of cubism and of Rouault, with whom he may be compared in emotional intensity. Rattner exhibited at the Salon des Tuileries and the Salon des Indépendants and attained recognition as a member of the Minotaure group. *Springtime Showers* (1939) displays a unique handling of color chords and variations together with the fascinating rhythm of repeated heads and umbrella handles.

Rattner returned to the United States in 1940. During the war his outrage at the monstrous behavior of mankind was shown in such works as *Survivors* (1942) and *City Still Life* (Minneapolis, Minn., Walker Art Center), which portrays the desolation and debris of a mutilated town.

Rattner is best known for his paintings in a semiabstract expressionist style characterized by jewel-like, mysteriously glowing colors and intricate patterns, for example, *The Emperor* (New York, Whitney Museum). The inspiration for such works stems from Romanesque formalism (rather than Gothic stained glass), Byzantine mosaics, and Greek Orthodox icons. His training as an architect is revealed in the monumental quality of the compositions. The figures seem molded in bas-relief against their flat background. Rattner's recent painting has tended toward a more abstract expressionism, though still enriched by his superior painterly technique. BERNARD S. MYERS

RAUSCHENBERG, ROBERT. American painter (1925–). Born in Port Arthur, Tex., Rauschenberg

studied at the Kansas City Art Institute (1946–47), the Académie Julian in Paris (1947), with Josef Albers at Black Mountain College (1948–49), and at the Art Students League in New York City. In 1964 he was awarded the grand prize at the Venice Biennale.

In early works Rauschenberg used newspaper fragments in the manner of the cubist collage. He has since been more concerned with the effect of images in his oddly violent assemblages that merge abstract expressionist painting techniques with real objects, such as stuffed birds and animals, news photographs, buckets, chairs, and hats. A major figure, with Jasper Johns, in the post–abstract expressionist developments toward Pop Art, Rauschenberg has engaged in experiments involving the use of electronics in art, along with engineers from the electronics industry, as a founder of Experiments in Art & Technology, Inc. (1967).

RAY, MAN. American photographer and painter (1890–). He was born in Philadelphia. He studied architecture and engineering before attending the National Academy of Design in New York City in 1908 to study painting. He made his first abstract picture in 1911, and in 1912 had his first one-man show. In 1915 he met Marcel Duchamp; in 1917 Man Ray, Duchamp, and Picabia founded the New York Dada movement.

From 1918 to 1920 Man Ray used an air brush, sometimes on glass, to make his pictures. He produced several Dadaist objects similar to those of Duchamp. One, *Le Cadeau* (New York, Museum of Modern Art), is a flatiron rendered useless by the rows of tacks attached to its smooth side. Duchamp and Man Ray collaborated in 1920 in making rotary glass plates. That same year Katherine Dreier, Man Ray, and Duchamp founded the Société Anonyme.

Man Ray experimented with photography and developed "Rayographs" in 1921 (a collection of his Rayographs is in New Haven, Yale University Art Gallery). To make them he merely placed objects on light-sensitive photographic paper, exposed it to light, and developed it. In 1922 he published a series of Rayographs in a book, *Les Champs délicieux*.

He moved to Paris in 1921, and Duchamp introduced him to the surrealists; Man Ray became a regular con-

tributor to their exhibitions. In 1924 he shot a film, *Anemic Cinema*, using revolving spirals, which he had developed with Duchamp four years earlier. In 1927 he made another film, *L'Etoile de mer*. Many of his works were reproduced in the magazine *La Révolution Surréaliste*. In the 1930s he achieved magical effects in his photographs through solarization, a process of over- and underexposing negatives.

In 1940 he returned to the United States and taught photography in Los Angeles. He directed a portion of Hans Richter's film, *Dreams That Money Can Buy*, in 1944. After 1949, Man Ray maintained a studio in Paris and concerned himself with a new method for developing photographic color prints. ROBERT REIFF

RAYONISM. Abstract Russian movement (Russian, *Lutchism*) developed by Michael Larionov in 1911. In the degree of its denial of everyday reality, it may be compared with the abstract expressionism that another Russian, Wassily Kandinsky, was simultaneously developing in Munich in 1911–12.

Rayonism represented the disintegration of a given form into radiating rays of light, as did futurist art in the latter's lines of force; but the Russian movement went so far as to approach pure abstraction or complete nonobjectivity. Larionov and his wife Natalie Gontcharova are identified with this short-lived movement. *See* LARIONOV, MICHAEL.

READY-MADES. Works of art composed entirely or in part of man-made objects that are produced for some useful purpose and are widely available. Marcel Duchamp was the first to exploit the possibility of employing manufactured articles in art when, in 1913, he "assisted" in the creation of the first ready-made, a bicycle wheel fastened to a stool. A ready-made differs from an *objet trouvé* in that it is entirely manufactured.

REDER, BERNARD. Austrian-American sculptor (b. Czernowitz, 1897; d. New York, 1963). In 1919 Reder enrolled in the Academy of Fine Arts, Prague, first studying graphic art and then sculpture. In 1922 he returned to Czernowitz, where he stayed until anti-Semitic persecution drove him away, and he then settled in Prague in

1930. He admired the work of Maillol and in 1937 moved to France. During World War II he and his wife moved to the United States, and he became a citizen in 1948.

In 1961 a retrospective exhibit of Reder's work was held at the Whitney Museum of American Art in New York. Typical of his sculpture are large bronze figures which extend into the space around them, for example, *Minotaur and Siren* (1955), *Cello Player* (1956), and *Seated Dwarf with Cat's Cradle* (1960). *Lady with House of Cards* (1957) is exhibited in the garden of the Museum of Modern Art in New York.

REFREGIER, ANTON. American painter (1905–). Born in Moscow, he studied in Paris, in Munich with Hans Hofmann, and at the Rhode Island School of Design. Primarily a painter of symbolic social and political subjects, he is known for his many controversial murals.

REGIONALISM. In general, art based on the life and appearance of a particular geographical area; specifically, an American artistic movement (more accurately, point of view) developed in the 1920s and 1930s by such artists as Burchfield, Hopper, Benton, Curry, and Wood. These painters replaced the Ashcan tradition of urban genre with realistic depictions of commonplace rural scenes, mostly of the South and Midwest. Despite the fierce Americanism and anti-European bias of some of its supporters, notably the critic Thomas Craven, regionalism was part of the general reaction against abstraction beginning in the late 1920s. As such, it is related to the New Objectivity painting in Germany and also shared affinities with such contemporary European-derived American styles as cubist realism. *See* Benton, Thomas Hart; Burchfield, Charles; Curry, John Steuart; Hopper, Edward; Wood, Grant.

REIDY, AFFONSO EDUARDO. Brazilian architect-planner (1909–). He was born in Paris. Reidy worked on the influential Ministry of Health and Education in Rio de Janeiro (1937–43); designed the Museum of Modern Art in Rio (begun 1954); and designed the large community projects Pedregulho (1950–52) and Gávea (begun 1954), both in Rio. He is also responsible for many large-scale works still in progress.

REINHARDT, AD (Adolf F. Reinhardt). American abstract painter (1913–67). He was born in Buffalo, N.Y., and educated in New York City; in 1935 he graduated from Columbia College. In the late 1930s he was a member of the Artists Union, the American Abstract Artists, and the Artists Congress. He worked on the Federal Art Project and on décor for the New York World's Fair of 1939–40. He had his first one-man show at the Artists Gallery in 1944.

During the 1940s he favored a rectilinear patterning of sharply contrasting small abstract elements. His work from about 1950 on became lower in color intensity and more rigid in shape. By 1953 his monochrome and symmetrical paintings were done in subtle blues or reds. Reinhardt's later work consists entirely of the "black" paintings for which he is best known. These are composed of large interlocking rectangles of blacks, only slightly varied by deep violet and olive.

RESNICK, MILTON. American painter (1917–). In 1922 he moved from his native Bratslav, U.S.S.R., to New York City, where he later studied at Pratt Institute (1934–35), the American Artists School (1935–37), and with Hans Hofmann (1948). Influenced by Willem De Kooning in the late 1940s, Resnick developed his own lyrical idiom of abstract expressionism in the late 1950s.

RICHARDS, CERI. British painter (1903–). Born in Dunvant, near Swansea, Wales, he studied from 1920 to 1924 at the Swansea School of Art and from 1924 to 1927 at the Royal College of Art in London. The bold color and patterning of his early paintings were derived from Matisse. This was carried over into the surrealist figure and landscape compositions and wood constructions—influenced also by the sculpture and painted forms of Max Ernst—for which Richards is best known. Subsequent works have moved toward total abstraction, as in his recent series of paintings based on the piano music of Debussy.

RICHIER, GERMAINE. French sculptor, painter, and graphic artist (b. Grans, 1904; d. Montpellier, 1959). From 1922 to 1925 she was at the Montpellier School of Fine Arts, and for the next four years she was Bourdelle's as-

sistant. Thereafter she worked on her own and won the Blumenthal Prize in 1934, the year of her first exhibition at the Max Kaganovitch Gallery, Paris. From 1939 to 1945 she lived in Switzerland. She contributed to several international exhibitions, winning the São Paulo Biennial prize in 1951. She exhibited at the Martha Jackson Gallery in New York City after 1957. The Walker Art Center, Minneapolis, owns *Don Quixote* (1950–51), H. Kaye, Great Neck, N.Y., has the *Grasshopper* (1946–55), and the Frumkin Gallery, Chicago, has *Ogre* (1951). Richier contributed aggressive and imaginative mutations of the human form, favoring themes of decay and metamorphosis into vegetal or insectile entities.

RIETVELD, GERRIT THOMAS. Dutch architect and furniture designer (b. Utrecht, 1888; d. there, 1964). The son of a cabinetmaker, and essentially self-taught, Rietveld lived his entire life in Utrecht, where he maintained a large international practice.

After an apprenticeship with his father and a period of working in jewelry design, Rietveld worked as an independent cabinetmaker (1911–19).

Through contacts with some of the members of de Stijl, particularly with Robert van't Hoff, Rietveld joined the group in 1919. His G. and Z. C. jewelry shop, built in Amsterdam (1920 22), was the first mature architectural manifestation of de Stijl aesthetic principles. It is an assemblage of perpendicularly oriented, glass rectangular parallelepipeds, penetrating from the street through to the interior. *See* DE STIJL.

In 1924 Rietveld designed and built the Schröder house in Utrecht, his most important single work, the culmination of de Stijl architecture and one of the pioneering works of modern architecture. Rectangular slabs and linear steel members, asymmetrically organized, are linked like playing cards slotted at their intersections, and these geometric elements define usable volumes. The upper level of the two-story house is a flexible open plan in which living, dining, working, and sleeping areas can be tentatively defined by means of sliding screens, as in the interior of a traditional Japanese dwelling. The building is still in good condition, an unusual circumstance for a modern building of the 1920s.

During the late 1920s and 1930s Rietveld built a number

of shops, dwellings, and chairs; in 1928 he was one of the original founders of C.I.A.M. Among the more creative works of this period was the garage and chauffeur's quarters (Utrecht, 1927–28; remodeled), constructed of prefabricated modular concrete panels assembled on a steel frame which remained a visible aesthetic element. His highly imaginative Zaudy shop (Wesel, Germany, 1928; destroyed), composed of rectilinear space crystals inserted diagonally in a continuous wall of heavy shop fronts, was an innovation in store design.

After World War II, the architect had numerous domestic commissions as well as larger civic works, such as the temporary sculpture pavilion at Arnhem (1954), one of the most imaginative exhibition designs of this era. The Arnhem work and the Netherlands pavilion at the Venice Biennale (1954) called attention to Rietveld as one of the best exhibition designers of our time.

<div align="right">THEODORE M. BROWN</div>

RILEY, BRIDGET. English painter (1931–). She studied at Goldsmith's College and the Royal College of Art in her native London. A figurative and landscape painter until 1960, she adopted a pointillist technique between 1958 and 1960. Riley has since been in the forefront of optical painting, creating exhaustively worked-out and dynamically shifting patterns in black and white. She has taught at the Croydon School of Art and acted as adviser to the J. Walter Thompson Group of advertisers.

RIOPELLE, JEAN-PAUL. Canadian painter (1923–). His early associations were with the "Automatistes" in Montreal, led by Paul-Emile Borduas. Since 1947 Riopelle has lived chiefly in Paris, where he is a leading exponent of nonfigurative painting in general and tachism, or "action painting," in particular.

RIVERA, DIEGO. Mexican painter (b. Guanajuato, 1886; d. Mexico City, 1957). One of Latin America's leading artists, Rivera began his professional education in 1896 at the Academy of San Carlos in Mexico City.

Rivera received a grant from the Governor of Vera Cruz in 1907 that enabled him to go to Europe. With the exception of a brief trip home in 1910, he was not to return

until 1921. In Spain, where he spent his first years abroad, he digested Hispanic variants of realism (Chicharro) and impressionism (Sorolla and Zuloaga). He settled in Paris in 1909. Of particular influence during his next years were the works of Cézanne, Rousseau, Gauguin, Modigliani, and Picasso. From them, in some measure, Rivera learned a new plastic language of simplified forms, decorative lines, and expressive colors. He exhibited at the Salon d'Automne and at the Société des Indépendants. From 1913 to 1917 he passed through a cubist period, marked by a personalized style that can be seen, for example, in his *Paisaje Zapatista* (1915; Mexico City, Marte R. Gómez Collection).

At the end of World War I Rivera deserted the avant-garde. Prompted by fellow-artist Siqueiros and French critic Elie Faure, he went to Italy, where he was stirred by the aesthetic and social aspects of the great frescoes. Rivera returned home in 1921 on the eve of the Mexican mural renaissance.

José Vasconcelos, Minister of Education, assigned Rivera his first mural commission. A derivative allegory entitled *Creation* (1921–22), it was painted in encaustic for the Bolívar Auditorium of the National Preparatory School in Mexico City. In 1923 Rivera painted the walls of the Ministry of Education, an enormous three-storied building with two courts. Rivera consigned the larger (Court of Fiestas) to his assistants, Jean Charlot and Amado de la Cueva; he himself frescoed the smaller (Court of Labor). He eventually took over the larger court also, and all but three of these frescoes are his. By 1926 he had, virtually alone, frescoed some 17,000 square feet.

The three-sided Court of Labor displays a masterful control of space, design, and content. The ground-floor walls depict geographical areas of Mexico's agricultural and industrial wealth. Roof-shadowed at their tops, the walls of each story are pictorially lightened in value and intensity as they rise. Rivera had joined the Communist party in 1921, but the artistic qualities of the murals generally dominate the propaganda, which is softened by the freshness of design and color in the ascension of subject matter from industrial and agricultural activities (ground floor) to the arts (second and third floors).

Everywhere Rivera's excellence of draftsmanship is evident. Even the most overcrowded themes reveal almost unmodeled forms with purity of outline (for example, the

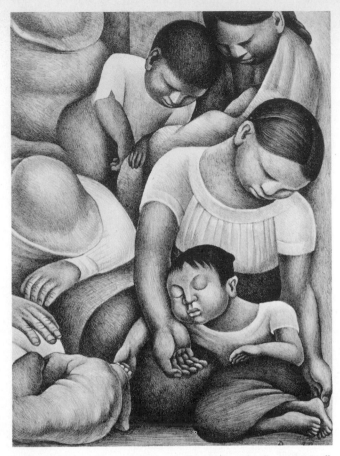

Diego Rivera, *Sleep* (1932). Lithograph, 20⅛" x 14¹³/₁₆". Museum of Modern Art, New York. Gift of Abby Aldrich Rockefeller.

Night of the Poor). Flat but paradoxically solid, these frescoes are memories of his Paris years, now imbued with nationalism and ideology.

Contemporary with the Ministry murals (1923–26) are Rivera's frescoes in the Agricultural School at Chapingo. Often regarded as his finest, they decorate the vaulted interior of a former chapel. Generally they depict, by symbolism and allegory, themes peculiar to nature. Representa-

tions of fertility and growth, enriched by motifs of a generative character, tower over scenes of enslavement or repression. The forms are simpler, larger, and more plastic. Architectural and pictorial harmony is consistent.

After 1927–28, when he was an official guest of Moscow, Rivera's relations with the Communists deteriorated (although he returned to the Party toward the end of his life). In 1929 he accepted a commission from Dwight Morrow, the American ambassador, to fresco Cortés's Palace in Cuernavaca, Morelos. Thematically, his murals there embrace pre-Columbian, colonial, and modern Morelos.

The National Palace staircase murals (1929–35) in Mexico City, like those at Cuernavaca, are narrative and didactic. At the right, Rivera depicted the pre-Cortesian past; on the central wall, colonial and modern Mexico; and at the left, his dream of a Marxist future. Despite passages of brilliance, this vast work is more literary than pictorial.

Cuernavaca and the National Palace brought Rivera international recognition. Between 1930 and 1934 he was active in the United States. His work there, enhanced by notoriety, included frescoes for the San Francisco Stock Exchange (1931), California School of Fine Arts (1931), Detroit Institute of Arts (1932–33), Rockefeller Center (1933), and the New Workers School of New York City (1933).

After his return home, Rivera's murals of the next decade, with few exceptions, continued to decline in quality. Among these were *Man at the Crossroads* (1934; Palace of Fine Arts; copy of his destroyed Rockefeller Center fresco), *Carnival of Mexican Life* (1936; Hotel Reforma), and *Life in Pre-Hispanic Mexico* (1944; National Palace). The last and his Hotel Prado frescoes reflect a momentary upsurge in Rivera's flagging powers. Works of indifferent quality soon followed, among them those at the Insurgentes Theater (1952–53) and the Hospital de la Raza (1953). Among the more interesting projects of these last years were gigantic mosaic reliefs for the Lerma aqueduct (1951) and the University City Stadium (1952–55).

Primarily a muralist, Rivera is also the author of numerous oils, water colors, drawings, and prints. After his Paris years, the years between 1934 and 1940 were especially rich in works in these media. His portraits, so popular and sought after, often sacrifice honesty to shallow charm; occasionally, they capture form and personality

with sensuous grace, as in *Modesta Combing Her Hair* (1940; San Francisco, S. M. Ehrman Collection). Similarly uneven are Rivera's genre paintings; many, in their emphasis upon the picturesque and sentimental, appear aimed at the tourist trade.

Rivera's water colors, prints, and drawings, on the other hand, are remarkably consistent in quality. In these media restrictions of scale enforce aesthetic discipline, and Rivera's calligraphic brilliance shines undimmed. Particularly noteworthy are his studies for the Chapingo murals, the Moscow notebook of water-color sketches (1928), and the beautifully drawn self-portrait in the Karl Zigrosser Collection in Philadelphia. JAMES B. LYNCH, JR.

RIVERA, JOSE DE. American sculptor (1904–). He was born near New Orleans and as a youth worked at an iron foundry. He traveled widely in the Mediterranean area and western Europe. Rivera studied with John Norton in Chicago and held his first one-man show at the Art Institute there in 1930. His style went toward abstraction about 1940. Since about 1945 he has exhibited at the Grace Borgenicht Gallery in New York. He was also represented in the "Twelve Americans" show at the Museum of Modern Art in New York, at the Levitt Gallery, and in Paris. Rivera's recent works suggest a strongly constructivist, geometric influence anticipated by his *Yellow-Black* (aluminum) of 1947. He works in New York.

RIVERS, LARRY. American painter (1923–). Rivers, who lives in his native New York City, studied with Hans Hofmann in 1947–48. Rivers often painted the human figure in the round, the line integrated with large patches of thinly applied, naturalistic color. During the 1950s he went through a phase of abstract expressionism, employing broad areas of lambent color in imaginative compositions. The figure returned in his works when he adopted a mode of harsh naturalism in both painting and sculpture, a forerunner of Pop art. He was represented at the 1956 Museum of Modern Art exhibition "Twelve Americans." A retrospective show of his works in 1965 at the Jewish Museum in New York featured his 33-foot-long *History of the Russian Revolution* assemblage of painting, sculpture, and collage.

ROBINSON, BOARDMAN. American cartoonist, illustrator, and mural painter (b. Somerset, Nova Scotia, 1876; d. Stamford, Conn., 1952). In 1894 he went to the Massachusetts Normal Art School to study with E. Wilbur Dean Hamilton. After four years there he went to Paris to study and later traveled in Italy.

In 1915 he published his *Cartoons of the War*. He went to Europe with John Reed as war correspondent for *Metropolitan Magazine*. He then illustrated Reed's *The War in Eastern Europe*. In 1916 he had his first exhibition and began to illustrate for *The Masses*, for which he did some of his finest work.

His first murals, a series on the history of commerce, were executed for the Kaufmann Department Store in Pittsburgh in 1927. From 1930 to 1944 he was director of the art department of the Fountain Valley School for Boys in Colorado Springs. In 1932 he painted a series of murals, *Man and His Toys*, for the Radio City Music Hall, New York City. The next year he illustrated Dostoevski's *The Brothers Karamazov* and in 1935, *The Idiot*. During the next six years he made illustrations for *King Lear, Moby Dick, The Spoon River Anthology*, and *Leaves of Grass*. In 1935 he painted frescoes for the then recently opened Colorado Springs Fine Arts Center, and he became its director a year later. In 1937 he did the murals for the Department of Justice building in Washington, D.C. He had a comprehensive one-man show at the Colorado Springs Fine Arts Center in 1943, and in 1946 he was given exhibitions in Dallas and at the Kraushaar Gallery in New York.

In spirit and manner, Robinson's early art parallels much of that of the Ashcan school—of Henri, Luks, and Sloan—but he is quite independent of the group. His cartoons and illustrations constitute his best work.

ROBERT REIFF

ROBUS, HUGO. American sculptor (1885–1964). Born in Cleveland, he studied at the Cleveland School of Art, working summers as an apprentice to the craftsman Henry Potter in the design of jewelry and furnishings. In 1912 he traveled in Italy and studied with Bourdelle. He taught at Columbia University and Hunter College in New York City and at the Brooklyn Museum School. He won the Widener

Gold Medal at the Pennsylvania Academy in 1950. He had one-man shows at the Munson-Williams-Proctor Institute in Utica, N.Y., the Corcoran Gallery of Art in Washington, Grand Central Galleries in New York, and elsewhere, and in 1960 he was given a retrospective exhibition at the Whitney Museum of American Art in New York. Robus's style, from the date of *Girl Washing Her Hair* (1933; New York, Museum of Modern Art) through that of *Mother and Child* (1958), suggests Art Nouveau influence combined with Bourdelle's and Maillol's respective visions.

RODCHENKO, ALEXANDER. Russian painter, sculptor, designer, and photographer (b. St. Petersburg, 1891; d. Moscow, 1956). He studied at the Kazan School of Art in Odessa and the Strogonov School of Applied Art in Moscow, but gave up academic training in 1913 to work on his own. Until 1919 he was primarily a draftsman and painter. In his early works Rodchenko adopted a busy futurist style, but he soon turned to complete abstraction, creating geometric forms with ruler and compass, under the influence of Malevich in 1914–15. Then, following the lead of Tatlin, in whose exhibition "The Store" he showed drawings in 1916, Rodchenko began to stress contrasts of textures and the reality of the object. He painted a series of black-on-black canvases in 1918 as a response to Malevich's *White on White*.

One of the most fervent supporters of the Russian Revolution, Rodchenko sought an end to traditional forms of art, opposing Kandinsky, Malevich, and others, and the creation of new forms suitable to the new society. He proclaimed the ideal of the artist-engineer and fully accepted the machine age and the artist as a technician working with abstract materials. In 1919 he began to produce three-dimensional constructions, some of them mobiles, using wood, metals, and other materials, as part of the purpose of making art real, again influenced by Tatlin. In them he used geometric configurations—cubes or circles—in rugged, dynamic, and asymmetrical compositions. From 1921 on Rodchenko was one of the leading voices of the new constructivist movement and attempted to create closer ties between art and industry. During the 1920s and through much of the remainder of his career he turned to more practical arts, applying constructivist principles to typog-

raphy, furniture, theatrical sets, and posters as well as to photography. *See* CONSTRUCTIVISM. DONALD GODDARD

ROHLFS, CHRISTIAN. German expressionist painter (b. Niendorf, Holstein, 1849; d. Hagen, 1938). In 1874 he was a student at the Weimar Art School. That year one of his legs was amputated, a misfortune that caused him to avoid people and traveling. He eventually taught at the Weimar School. In 1897 he saw Monet's paintings for the first time. A year later he met Edvard Munch, who strongly influenced him. Van de Velde came to Weimar to teach and introduced Rohlfs to the art of postimpressionism and to late Monet.

Criticized for his modernist tendencies, Rohlfs left Weimar after thirty years and accepted a position from Karl Osthaus to teach at the Folkwang School at Hagen. There he first saw the art of Seurat, Signac, Cézanne, Gauguin, and Van Gogh. He met Nolde in 1906; they spent summers in the medieval town of Soest, where Rohlfs forged a new style and also began to make woodcuts. He knew little or nothing of the Brücke group or other expressionist movements before 1912, when he went to Munich, and he was unaware of Marc and Kandinsky even then. He continued to teach at the Folkwang School, which had since moved to Essen.

He began to use tempera paint and returned to Soest and to the themes of cathedrals and medieval towns. In 1925 he was given a retrospective exhibition at the National Gallery in Berlin. He received several honorary degrees. In 1927 he moved to Ascona, Switzerland, for his health. The Nazis denounced his work and had him expelled from the Prussian academy. Some 400 of his pictures disappeared at this time. He died in his studio at the old Folkwang Museum, and a Barlach statue was placed on his grave, according to his request.

His first paintings were landscapes. As early as 1880 he began to paint out of doors. At the turn of the century, an intimate realism gave way to modest impressionism, which developed into a pointillism similar to that of Henri Cross. About 1910 he painted in a style recalling Van Gogh. Two years later he began to paint medieval towns with a heavy dark line and pure bright colors. He favored primary colors and sought effects of vibration by crossing

and intermingling the tones. At this stage in his development his work was expressionist. His tempera paintings, done from 1919 on, frequently have a luminous effect because he scraped areas down to the paper with a steel brush. ROBERT REIFF

ROSENQUIST, JAMES. American painter (1933–). He studied at the University of Minnesota under Cameron Booth and at the Art Students League in New York City. One of the major artists of Pop Art in New York, Rosenquist paints monumental works resembling billboard art in technique and effect that place magnified images of popular culture in jarring relationships, often with overtones of social commentary.

ROSENTHAL, DORIS. American painter and lithographer (b. California; d. 1971). She studied with Bellows and Sloan at the Art Students League in New York City and received Guggenheim fellowships in 1932 and 1936. She painted colorful and rhythmic figures reflecting Mexican and Central American sources.

ROSSO, MEDARDO. Italian sculptor, painter, designer, and writer (b. Turin, 1858; d. Milan, 1928). He studied as a painter at the Brera Academy, Milan, in 1882–83, but did his first sculpture group in 1881. This was the beginning of his series of impressions of groups of figures seen in gardens (*Conversation in a Garden*, 1893; Milan, private collection), in buses (*Impressions of an Omnibus*, 1883–84, destroyed), and on the streets (*Street Singer*, 1882; Rome, Gallery of Modern Art). They marked a deep social awareness and a respect for Daumier's sculpture. In 1884 he went to Paris and worked for Dalou. There he met Rodin and Degas. Through exhibitions in Paris and in London, and only after 1920 in Italy, his work brought him considerable attention. His favored themes were of sensitive, withdrawn women and of children experiencing illness. In 1909 the futurists admired his dematerialization of form and his fusion of substance with light and space. The Museum of Modern Art, New York, owns *La Portinaia* (1883) and *Bookmaker* (1894), while the University of Nebraska, Lincoln, owns *Jewish Boy* (1892). Rosso showed the disintegrating power of

light on form and achieved a precarious evocation of the interpenetration of a subject with its environment.

ALBERT ELSEN

ROSZAK, THEODORE. American sculptor, painter, and draftsman (1907–). He was born in Poznan, Poland, and now lives and works in New York City. The family went to Chicago in 1909, and he won an award in a National Art Contest for Public Schools in 1920. His formal training as a painter was at the Chicago Art Institute, under Schroeder and Reynolds, and at the National Academy of Design, with Hawthorne and Luks in 1926. He also took courses briefly at Columbia University, New York. In 1927 he returned to Chicago and had his first exhibition of lithographs. He taught drawing and lithography at the Art Institute there.

Roszak returned permanently to New York in 1931 and did sculptures in clay and plaster. His work was first shown in 1932 at the Whitney Museum's first painting biennial. From 1935 on, he exhibited at the gallery of Pierre Matisse in New York. From 1937 to 1939 he was an art instructor for the Works Progress Administration. In 1936 he began work on three-dimensional, machinelike constructions, such as *Amorphic Form* (1937) and *Chrysalis* (1937), both of which are in the collection of the artist. When he became a constructivist in sculpture, he gave up his romantic painting. In 1938 he was an instructor in design and composition with Moholy-Nagy in the Design Laboratory. In 1941 he joined the faculty at Sarah Lawrence College, Bronxville, N.Y.

In 1946 Roszak gave up his constructivist sculpture in favor of a technique that involved welded, hammered, and brazed open compositions, as can be seen in *Anguish* and *Surge* (both 1946) as well as in *Scavenger* (1946–47), *Thorn Blossom* (1947; New York, Whitney Museum), and *Specter of Kitty Hawk* (1946–47; New York, Museum of Modern Art). His images are sharp and pessimistic; they are multiple evocations of predatory forms, forceful commentaries on the brutal destructive power of man and nature. His interest in myths led to *The Whaler of Nantucket* (1952–53; Chicago Art Institute), based on *Moby Dick*.

His sculpture is rich with compound imagery, such as the bird and pelvis forms of *Raven* (1947). Roszak helped

reunite sculpture and literature. His *Sea Quarry* (1949; Florida, Norton School of Art) and *Recollections of the Southwest* (1948) are significant demonstrations of the metal sculptor's means of interpreting nature in an unprecedented way.

ALBERT ELSEN

ROTHKO, MARK. American painter (1903–1970). Born in Daugavpils, Latvia, he went to the United States in 1913. He was raised in Portland, Ore., and studied at Yale University and at the Art Students League, New York City, with Max Weber. In 1933 he had his first one-man show at the Portland Art Museum. His style at that time was essentially realistic. In the 1940s he was influenced by surrealism. He exhibited at several galleries in New York, his style becoming increasingly abstract with a diminution of surrealist imagery in late 1940s. About 1948, he developed a completely abstract expressionist

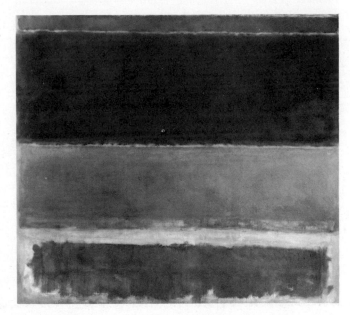

Mark Rothko, *Four Darks in Red* (1958). Oil on canvas, 102" x 116¼". Whitney Museum of American Art, New York. Gift of Friends of the Whitney Museum.

style, with two or three forceful, rectangular shapes, somewhat blurred at the edges, and a limited color range (*Number 14*, 1949; *Earth Red and Green*, 1955; *Tan and Black on Red*, 1957; and *Orange Red and Yellow*, 1961).

Rothko has been represented in shows at the Museum of Modern Art, New York ("Fifteen Americans," 1952, and "The New American Painting," 1958) and at the Venice Biennale and the Carnegie International. His style is unmistakable among abstract expressionist idioms; founded on severely economical units of form and color, it is extraordinarily rich within those limitations. *See* ABSTRACT EXPRESSIONISM.

JOHN C. GALLOWAY

ROUAULT, GEORGES. French painter and printmaker (b. Paris, 1871; d. there, 1958). He received some drawing lessons from his grandfather, an amateur painter who admired Rembrandt, Courbet, and Manet. From 1885 to 1890 Rouault worked as an apprentice to a stained-glass repairer and designer, collaborating on new windows for St-Severin in Paris. He took evening courses at the Ecole Nationale des Arts Décoratifs, and in 1891 entered the Ecole des Beaux-Arts with Elie Delaunay as his teacher. He then studied with Gustave Moreau and came to know Matisse, Manguin, Marquet, Camoin, and others who were to become Fauves soon after 1900.

Moreau died in 1898, and Rouault, as one of his leading pupils, was named director of the museum founded in Moreau's honor. At that time, however, Rouault underwent a severe psychological strain and reacted aesthetically against his academic manner. Convalescing in 1902 and 1903, he developed the blunt, forceful style that connected him with the Fauvist circle, and he helped to found the first Salon d'Automne in 1903, becoming a target for the invective of the academicians of whom he had only recently been a colleague. Rouault's personality was increasingly shaped by religious and sociological considerations, and his subjects, interpreted in bold washes of darkish reds and blues with powerful linear definitions, became correspondingly somber—images of corrupt jurists, prostitutes, and disenchanted clowns and acrobats. Rouault was represented in the renowned and controversial 1905 Salon d'Automne, although his canvases were not placed with the Fauvist collection.

His first one-man show was held at the Galerie Druet

in 1910. He continued his religious and morally conscious paintings until 1916, when his dealer, Ambroise Vollard, persuaded him to turn to printmaking and illustration. The French government in 1919 purchased his painting *The Child Jesus* (1893). The Galerie Druet held a retrospective of his works in 1924. He worked chiefly in graphic media until about 1927, occasionally producing paintings of a somewhat more varied and richer coloration.

Turning to painting again after 1927, Rouault developed the thickly crusted, richly toned style with thickly outlined images for which he is best known. His themes repeated the clowns and religious figures he had done earlier, but he seldom painted his aggressive indictments of judges and prostitutes of about 1903–16. Rouault's manner, especially his persistent use of heavy black outlines as well as his sometimes luminous encrustations of grainy blues, reds, greens, and yellows, has frequently been related to the effect of medieval stained-glass technique. While he may have retained some affinity for that medium, this analogy is only superficially pertinent. Rouault's outlines are specifically applied to definitions of silhouette and main bodily divisions, whereas Gothic tracery joins together the irregular

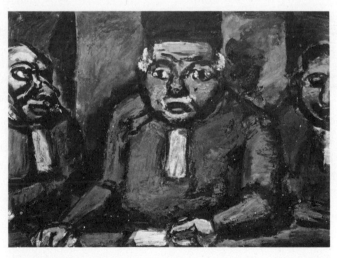

Georges Rouault, *The Three Judges* **(1913). Gouache and oil on cardboard, 29⅞″ x 41⅝″. Museum of Modern Art, New York. Sam A. Lewisohn Bequest.**

pieces of glass irrespective of whether or not the line marks off a particular sector of form. Nonetheless, the general effect of Rouault's color and line are not without a certain medieval flavor, the more so because of the gravity of his subjects.

Rouault's art after 1930 became internationally famous through showings in Munich, London, Chicago, New York, and elsewhere; and his style also won recognition through tapestry designs. His pictures following the early 1930s are difficult to date precisely because he seldom designated the year of completion with his signature. Moreover, he often reworked or finished canvases he had started from about 1910 through the 1920s. His works increased in richness of color and texture, however, from about 1932 on.

A retrospective of his work was held in 1945 at the Museum of Modern Art in New York. In 1947 Rouault won a lawsuit against the heirs of his dealer, Vollard, for the right to reclaim some 800 unsold and unsigned works, which he regarded as unfinished. Rouault burned more than 300 of these before witnesses. Universally acclaimed as one of the major French artists of the 20th century, he was made a Commander of the Legion of Honor in 1951. In 1952–53 major retrospectives of his paintings and graphic art were held in Brussels, Amsterdam, Paris, Cleveland, New York, and Los Angeles.

Rouault's important paintings include *The Child Jesus among the Doctors* (1893; Colmar, Unterlinden Museum), *Le Chahut* (1905; Paris, private collection), *The Mirror* (1906; Paris, National Museum of Modern Art), *Head of a Clown* (1908; Washington, D.C., Dumbarton Oaks Collection), *Mr. X* (1911; Buffalo, Albright-Knox Art Gallery), *Three Judges* (1913; New York, Museum of Modern Art), *Small Family of Clowns* (1933; Paris, private collection), *The Old King* (1936; Pittsburgh, Carnegie Institute), *Head of a Clown* (1948; Boston, Museum of Fine Arts), and *Twilight* (1952; Paris, private collection).

Rouault is one of the most distinguished modern printmakers; he worked in various media including wood engraving, color lithography, and etching. His first important series was the famous *Miserere*, some sixty etchings and aquatints finished in 1927 but not actually published until 1948. His *Fleurs du mal*, based upon Baudelaire's poems, were partly done in 1926–27 and were completed in the 1930s. Another significant group is *Les Réincarna-*

tions du Père Ubu (1928), consisting of eighty-two wood engravings and seven color etchings.

A close associate of the Fauvist group between 1903 and 1907, Rouault may only inexactly be classified as an exponent of the Fauve style. He somewhat better fits the designation of expressionist; but, despite his sharing of religious themes with Nolde and certain other members of Die Brücke, Rouault's expressionism is only generally related to that of the Germans. JOHN C. GALLOWAY

ROUSSEAU, HENRI. French primitive painter (b. Laval, Mayenne, 1844; d. Paris, 1910). From 1864 to 1868, according to Rousseau himself, he went as a regimental musician in the French army to Mexico in the campaign of Napoleon III to aid Maximilian. In 1869 he went to Paris, first to work as a lawyer's clerk, then as a *douanier*, a minor customs official. He was to bear the name "Le Douanier" thereafter. He often went to the Louvre to copy; such study was the only form of instruction he received. In 1886 he exhibited at the Salon des Indépendants. That year he left his work in customs and lived on a small pension and income from music lessons.

In 1889 he wrote a play called *A Visit to the Exhibition of 1889*. In 1890 he met Gauguin, Seurat, Pissarro, Redon, and the critic Gustave Coquiot. The following year Rousseau began to paint the first of many pictures with tropical themes. He was inspired by a visit to the Paris Botanical Gardens, which presumably evoked memories of Mexico. In 1895 he painted the large canvas *War* (Paris, Louvre). He also painted a portrait of Alfred Jarry, author of *Ubu Roi*. In 1898 Rousseau offered his celebrated *The Sleeping Gypsy* (New York, Museum of Modern Art) to Laval, his home town, for a small amount, but the offer was refused. The next year he wrote another play, *A Russian Orphan's Vengeance*. In 1905 he exhibited three paintings, among them *The Hungry Lion*, at the Salon d'Automne.

He became acquainted with Picasso, Delaunay, Vlaminck, Max Jacob, Apollinaire, Raynal, and Salmon in 1906 and, the next year, with the American Max Weber and the critic Wilhelm Uhde, who was to write the first monograph on Rousseau. Uhde also acquired a number of his paintings. Mme. Delaunay commissioned Rousseau

Henri Rousseau, *The Sleeping Gypsy* (1897). Oil on canvas, 51″ x 79″. Museum of Modern Art, New York. Gift of Mrs. Simon Guggenheim.

to paint his *Snake-Charmer* (Paris, Musée du Jeu de Paume), and the dealer Joseph Brummer sold a number of Rousseau's works. In 1908 Picasso gave a banquet in Rousseau's honor at the Bateau-Lavoir studio on rue Ravignan. In 1910 he was given his first American showing, arranged by Max Weber at the "291" Gallery in New York.

Rousseau's lack of a formal art education, although evident in his drawing of ambitious subjects, freed him from all academic convention and permitted instinct to have full reign. His unerring sense of pattern, his imaginative use of color, and his taste for lyrical and exotic themes give credence to his painting because he had, as a primitive, unquestioning conviction in his vision of nature and in the efficacy of his art. ROBERT REIFF

ROUSSEL, KER-XAVIER. French painter and decorator (b. Lorry-les-Metz, 1867; d. L'Etang-la-Ville, 1944). He studied with Maillart, Fleury, and Bouguereau and was a member of the Nabis group. Many of Roussel's early works are fluid, skillful still lifes. Under the influence of the Nabis, he turned to figure painting, at first with closed silhouettes and linear emphasis and later in a broader style. He eventually concentrated on decorative paintings and

murals of figures in landscape, often based on mythological subjects. With Vuillard, Roussel executed the large decorative panels of the Palais des Nations, Geneva, in 1938.

ROY, PIERRE. French painter and graphic artist (b. Nantes, 1880; d. Milan, 1950). He studied with his father, Donatien Roy, and with Jean-Paul Laurens at the Académie Julian. Although he was often associated with the surrealists, the air of mystery which Roy's meticulously realistic works, mostly still lifes, evoke is produced more by a free association of objects than by a strict use of the principle of incongruous juxtaposition. His often reproduced painting of the snake on the landing, *Danger on the Stairs* (1927–28; New York, Museum of Modern Art), is simply and immediately frightening. In his compositions of the 1930s, often with visual plays on the real, involving painted shadows cast on painted frames, the combination of objects, rarely strange in themselves, seems to hint at a perpetually inaccessible deeper meaning, as in the interior with calibrated instruments and a deep landscape view called *Metric System* (ca. 1933; Philadelphia Museum of Art).

RUDOFSKY, BERNARD. American architect and designer (1905–). Rudofsky has designed posters, billboards, textiles, furniture, rugs, china, glass, and wallpaper, among other things. His work usually stresses comfort and simplicity, avoiding the stamp of high fashion; hence he prefers to design sandals rather than dress shoes. An outdoor house on Long Island, N.Y., features a breakdown of the barrier between indoor and outdoor space. The hub of the plan consists of an exposed cooking terrace.

RUDOLPH, PAUL MARVIN. American architect and educator (1918–). Born in Elkton, Ky., he studied architecture at the Alabama Polytechnic Institute (1935–40) and at Harvard in the 1940s. He was associated with Ralph S. Twitchell at Sarasota, Fla., before establishing practice in New Haven, Conn., where until 1965 he was chairman of the Department of Architecture at Yale. His Jewett Art Center in Wellesley, Mass. (1959), is an imaginative contemporary work that harmonizes well with an existing collegiate Gothic environment. The bold forms of his Art and Architecture Building at Yale (1963) have

influenced many younger men. In 1966 he received a first honor award from the U.S. Department of Housing and Urban Development for the design excellence of his elegantly conceived Crawford Manor, a housing development for the elderly in New Haven, Conn.

RUSSELL, MORGAN. American painter (b. New York City, 1886; d. Broomall, Pa., 1953). He studied with Robert Henri and in 1906 went to Paris, where he met Matisse. There, in 1912, Russell and Stanton Macdonald-Wright founded synchromism, a movement similar in theory and result to its rival, orphism. In his paintings in this style, Russell aimed at the creation of form and space by means of rhythmic, nonobjective arrangements of arcs and segments of contrasted colors. After 1920 Russell returned to figurative painting.

RUSSOLO, LUIGI. Italian painter and musician (b. Portogruaro, near Venice, 1885; d. Cerro di Laveno, 1947). A self-taught artist, he was one of the founders of futurism in 1910. Russolo's personal mysticism of universal forces, expressed in paintings such as *Synthesis of the Actions of a Woman* (1912; Grenoble, Museum of Painting and Sculpture) or *Interpenetration of Houses + Light + Sky* (1912; Basel, Art Museum) fitted well with the movement's emphasis on the depiction of motion. He experimented with the incorporation of noise into traditional music and published a manifesto, "The Art of Noises," in 1913. In his later paintings, Russolo worked in a more representational style.

S

SAARINEN, EERO. Finnish-American architect (b. Kirk-konummi, Finland, 1910; d. Ann Arbor, Mich., 1961). The son of Eliel Saarinen, Eero studied sculpture in Paris (1930–31) and architecture at Yale (until 1934). He worked in his father's office in Bloomfield Hills, Mich., from 1936 to 1950, when he formed Eero Saarinen and Associates, which still carries on his work.

Saarinen's first recognition came when he won the competition for the Jefferson National Expansion Memorial (1948–65) in St. Louis, Mo. After that he designed such large-scale works as the General Motors Technical Center

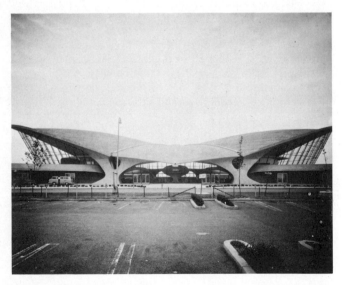

Eero Saarinen, TWA Flight Center (1956–62). Kennedy International Airport, New York.

in Warren, Mich. (1948–56), and the Auditorium and Chapel at the Massachusetts Institute of Technology, Cambridge, Mass. (1953–56), the first major shell construction in the United States. He gained world attention with the United States Chancellery buildings in Oslo (1955–59) and London (1955–60) and with his soaring shapes in reinforced concrete in the Ingalls Hockey Rink, Yale University (1956–59), and the TWA Flight Center, Kennedy Airport, N.Y. (1956–62).

One of Saarinen's last, and probably most mature, works is the Dulles International Airport Terminal Building in Chantilly, Va. (1958–62), a vast complex designed specifically for jet travel, where everything from the magnitude of the planning to the minutiae of the details seems appropriate to the task. THEODORE M. BROWN

SAARINEN, ELIEL. Finnish-American architect and planner (b. Rantasalmi, Finland, 1873; d. Bloomfield Hills, Mich., 1950). He studied painting and architecture simultaneously in Helsinki (1893–97) and started architectural practice in 1896 with H. Gesellius and A. E. Lindgren.

His European reputation was established by his designs for the Finnish Pavilion at the Paris Exposition (1899–1900), the National Museum (Helsinki, 1902), and the Helsinki Central Station (1904; constructed 1910–14). In 1922 Saarinen became known in the United States with his design for the Chicago Tribune competition, which took second prize. A *succès d'estime*, it influenced skyscrapers in the United States for years to come.

After immigrating to the United States about 1922 he undertook many large-scale works, such as the Cranbrook School for Boys (1926–30) and the Cranbrook Academy of Art (1926–41), both in Bloomfield Hills, Mich.

His more structurally expressive, later works include the Kleinhans Music Hall (1938) in Buffalo, done in collaboration with his son Eero, and the Tabernacle Church of Christ (1940) in Columbus, Ind., a large complex of blocks interlocking around a tower and water pools. *See* SAARINEN, EERO. THEODORE M. BROWN

SAEDELEER, VALERIUS DE, *see* LAETHEM-SAINT-MARTIN SCHOOL.

SALEMME, ATTILIO. American painter (b. Boston, 1911; d. New York City, 1955). A self-taught artist, he began to paint in the late 1930s, and by the early 1940s had developed the mysterious, flatly colored forms whose enigmatic characters and relationships were to be the subjects of his paintings. These forms—geometric, mostly slim rectangles with occasional references to hats, limbs, and facial features—are statically and evocatively set in an ambiguously clear space, as in *The Oracle* (1950; Philadelphia Museum of Art) or *The Inquisition* (1952; New York, Whitney Museum). In his late works some of the tension is dispelled by the use of softer color, less ritualistic composition, and playfully constructed abstract organic shapes.

SAMARAS, LUCAS. Greek-American sculptor (1936–). He went to the United States in 1948. First studying at Rutgers University under George Segal and Allan Kaprow, he later studied Byzantine art with Meyer Schapiro at Columbia. Although Samaras denies that he is part of the surrealist tradition, the fact remains that his art—filled with visions of pain, cruelty, and destruction, and using pins and other perforating and cutting objects—evokes, if nothing else, the "theater of cruelty." He works completely out of himself and his own personal background, probing into his own most intimate emotions. His art is also "irrational" in the surrealist sense, for example, the pin-covered chairs or boxes. Yet his constructions are far less literary than many surrealist works and far more intense in feeling, more enigmatic, and fiercer.

SANTOMASO, GIUSEPPE. Italian abstract painter (1907–). He was born in Venice, where he studied and now lives. A founder-member of Fronte Nuovo, he joined The Eight in 1953. Influenced by Braque and Jean Lurçat, Santomaso reduced still-life objects to flat patterns, translating their contours into arabesques. Recently, he has emphasized painterly values through texture.

SCHAMBERG, MORTON. American painter and photographer (b. Philadelphia, 1881; d. there, 1918). Schamberg studied with Chase in Europe and was in Paris in 1906. Influenced by Duchamp, he painted mechanical objects, preserving their forms but using a cubist-derived compositional scheme.

SCHIELE, EGON. Austrian expressionist painter (b. Tulln, 1890; d. Vienna, 1918). Schiele attended the Vienna Academy of Fine Arts, where he studied under Gustav Klimt and knew Kokoschka, from 1907 to 1909. His style was strongly influenced by Art Nouveau-Jugendstil arabesque, but to this idiom he added a remarkably intense, nervous linearity and spotting of his own original fashioning. This manner was applied to an extraordinary series of male and female nudes, as well as to landscapes, between 1908 and the year of his death; and into those ten years he pressed an incredible creativeness. He was drafted into the Austrian army in 1915 but managed to continue painting at a fairly productive level.

Although his talent did not receive adequate recognition, he was not altogether unnoticed in his time. He was befriended by the critic Rössler, who encouraged several patrons to collect his work; he exhibited at the Vienna International in 1909, the Mietke Gallery Kunstsalon in 1911, the Cologne Sonderbund in 1912, the Goltz Gallery, Munich, and the Folkwang Museum, Hagen, in 1913, and, rather successfully, in a special room accorded him at the Vienna Secession exhibition of 1918. Moreover, he published a number of lithographs. Despite its general relation to Klimt and Kokoschka, Schiele's style is unique among expressionist idioms. JOHN C. GALLOWAY

SCHLEMMER, OSKAR. German painter, sculptor, stage designer, teacher, and writer (b. Stuttgart, 1888; d. Baden-Baden, 1943). He studied at the Stuttgart Academy with Adolf Hölzel and taught at the Bauhaus (1920–29), at the Breslau Academy (1929–32), and at the Berlin Academy (1932–33). His early paintings, influenced by Cézanne and related to cubism, exhibit in essence his lifelong concern for pictorial structure and the realization of form. During and after World War I he began to experiment with the organizational possibilities of space, both two-dimensional, in abstract paintings of geometric shapes, and three-dimensional, in architectural reliefs of cement and wire.

In the 1920s Schlemmer began to paint his most characteristic subject, the human figure in space. Schlemmer's treatment of this theme was extraordinarily complex. Ultimately humanistic in derivation, it yet allowed expression of his strong mystical feelings in paintings of stiff and seem-

ingly mechanized figures whose formal handling owed much to archaic Greek sculpture and to the abstracting principles of purism, for example, *Concentric Group* (1925; Stuttgart, State Gallery) or *Group of Fourteen in Imaginary Architecture* (1930; Cologne, Wallraf-Richartz Museum). In these paintings, severe control carefully adjusts the free perspective depth of figures and architectural settings to the surface tension of two-dimensional composition, as in *Bauhaus Staircase* (1932; New York, Museum of Modern Art). JEROME VIOLA

SCHMIDT-ROTTLUFF, KARL. German painter (1884–). Born in Rottluff, he attended the Gymnasium in Chemnitz (1897–1905). He painted his first oils at the local Kunstverein while still in school. In 1904 he met Kirchner, whose encouragement of his early woodcuts Schmidt-Rottluff gratefully acknowledged later. The technique of his first efforts in this medium, for example, *Cityscape* (1904), was impressionistic. In 1905 he began to study at the Technische Hochschule in Dresden, and in the same year his woodcuts tended more toward abstract patternization of blacks and whites. Although his *Woman with Hat* (1905) recalls the work of Munch and Toulouse-Lautrec, it is as far removed from impressionism as possible. Here, shape and line have been disengaged from the subject matter, achieving an almost independent existence.

In 1905 Schmidt-Rottluff, Heckel, Kirchner, and Bleyl formed what Schmidt-Rottluff called Die Brücke (The Bridge), ". . . the bridge which would attract all the revolutionary and surging elements" (letter to Nolde, 1906, inviting him to join Die Brücke). The group followed no formal program, but its general tendency was an expressionism very close to Fauvism. It disbanded in 1913.

Schmidt-Rottluff's paintings about 1908 were characterized by simplified color that gained in effect through expressive contrasts. By 1910 he had arrived at a decorative style reminiscent of Gauguin. In *Firs Before a White House* (1911; Cologne, Wallraf-Richartz Museum) contours and surfaces take on the structure of the picture space. *Rising Moon* (1912; St. Louis, City Art Museum) seems to summarize the concise and definite form achieved thus far.

Between 1917 and 1919 he produced twenty important woodcuts on New Testament themes, of which the *Road*

to Emmaus (1918) is justly famous. In these he strove for rigidity of gesture and movement and the total contrast of the black-and-white areas. The influence of woodcut technique, cubism, and African sculpture converged in *Self-Portrait with Hat* (1919; Detroit Institute of Arts), the head hewn, as it were, out of slabs of color.

Schmidt-Rottluff visited Italy in 1923, Paris in 1924, and Rome in 1930 (a visit of several months). These travels may have contributed to the transformation of his style into something more gentle and picturesque. The vibrance of color and life began to have ever-increasing significance for him.

During World War II he was proscribed by the Nazis as a decadent artist and was forbidden to paint. After the war he set to work anew. The salient characteristic of his late style is the large-scale simplicity apparent in *Full Moon in the East* (1951; collection of the artist).

FRANKLIN R. DIDLAKE

SCHOLZ, WERNER. German painter (1898–). He was born in Berlin and studied there. An expressionist, Scholz was strongly influenced by Die Brücke group, especially Emil Nolde, in his figures, landscapes, and religious subjects of very simplified forms and colors.

SCHRIMPF, GEORG. German painter and graphic artist (b. Munich, 1889; d. Berlin, 1938). Before he was twenty, Schrimpf had traveled through Germany, Holland, and Belgium, and in 1909 he returned to Munich. In 1913, on Lake Maggiore, Schrimpf copied nudes from Raphael and Michelangelo. In 1915 he was in Berlin, where he was impressed with the work of Franz Marc. Before 1917, Schrimpf's work featured flat patterns and forms that were delineated by sharp contours, as may be seen in *Girl with Cat* (1916).

By 1918, Schrimpf had combined his powerfully outlined figures with a deeper perspective. The starkness of the figures, combined frequently with wide-eyed stares (*Self-Portrait*, 1918; *Portrait of Oskar Maria Graf*, 1918), contribute to the spectator's awareness of tension. Yet Schrimpf wedded his monumentality to a meticulous precisionism, which might justify the application of the term "magic

realism" (an extreme factualness from which emanates a certain haunting intensity).

Historically, Schrimpf is important as a member of Germany's New Objectivity group, which flourished after World War I. Schrimpf's references to social injustices and postwar suffering, however, are more obliquely made than those of Dix and Grosz and contain little of the caricature and morbid observation that color much of their work.

Schrimpf's grandiose figures frequently suggest something of the Italian Renaissance. His Madonnalike women, often shown looking off toward a distant landscape with their backs to the observer, convey ultimately a feeling not of despair but of poetic nostalgia.

ABRAHAM A. DAVIDSON

SCHWITTERS, KURT. German artist specializing in collage (b. Hannover, 1887; d. Ambleside, Eng., 1948). He attended the Dresden Academy for six years, and it was there that he received a sound background in traditional art theory and technique. He painted portraits in an academic manner throughout his life to make a living. Schwitters saw the art of Kandinsky and Franz Marc after World War I and was so impressed that he went through an expressionist phase.

Schwitters painted his first abstract pictures about 1918, and a year later made his first collage. About this time, while making a collage from a newspaper advertisement with the heading *Kommerz und Privat Bank*, he cut off the first three letters of *Kommerz* and was left with the term *Merz*, which he exploited as a label to specify his kind of art and as the title of a magazine he published in 1923. The name actually connotes nothing; it was merely the product of chance. Schwitters was connected with avant-garde movements as early as 1918, when he exhibited at the Berlin art gallery Der Sturm along with Mohlzahn and Klee. By 1919, he began to write the poem *Anna Blume*. He was active in Dada demonstrations, especially in Holland, by 1920. (See illus., vol. 4, p. 236.)

In the same year he constructed his first *Merz-bau* in his home in Hannover. It was a giant construction made of trash, which he found fascinating. It grew and grew until it consumed so much space that one could not enter the room that held it. This first *Merz-bau* was destroyed in the bombing of World War II. Schwitters made two

Kurt Schwitters, *Merz 22* (1920). Collage, 6⅝″ x 5⅜″. Museum of Modern Art, New York. Katherine S. Dreier Bequest.

more *Merz-bau* constructions, one in Norway, the other in Ambleside.

Schwitters's magazine was to go through twenty-four issues, the last in 1932. Such notables as Jean Arp, Hannah Hoch, Francis Picabia, and Theo van Doesburg contributed to it. In 1925 Schwitters composed a *Lautsonate* (phonetic poem), to be read and placed on a phonograph record. His works were exhibited widely. In 1932 he became a mem-

ber of the Paris Abstraction-Création group. In 1935 he was represented in the New York Museum of Modern Art's exhibition "Cubism and Abstract Art" and, later, in their "Fantastic Art, Dada, and Surrealism" show. In 1937 his work was shown in the Nazi-promoted show of so-called "degenerate" art. He went to England in 1940.

Schwitters's best-known works are his small collages, composed largely of such evanescent bits of commonplace trash as subway tickets, bus transfers, newspapers, shreds of cloth, and the like. He exploited their color and texture, their power to evoke associations, and the surprise which comes from discovering the vernacular in an essentially poetic context.

ROBERT REIFF

SECTION D'OR. French term meaning "golden section." It refers to the ideal proportion between the side and the diagonal of a square, a proportion present in many natural as well as man-made forms and therefore of great interest to the cubist painters who participated in the Section d'Or Exhibition at the Galerie La Boétie in Paris (1912). They were Jacques Villon (promoter of the movement and one of the organizers of the exhibition), Marcel Duchamp, Gris, Léger, Duchamp-Villon, Picabia, Lhote, Delaunay, La Fresnaye, Marcoussis, Gleizes, Dumont, Metzinger, Herbin, Segonzac, and others. The importance of the exhibition and the short-lived magazine of the same name lay in the fact that this was the largest grouping of cubist artists to exhibit together up to that date. The exhibition itself was in nature of a tribute to Cézanne, in admiration of the great influence he had exercised on the cubist movement.

SEGAL, GEORGE. American sculptor (1924–). Segal was born in New York City and attended New York University. He later studied at Rutgers University where he became associated with Allan Kaprow, Lucas Samaras, and other artists, and participated in the early staging of "happenings" (1959). It was then that Segal turned to sculpture from figural painting. In characteristic works he creates entire scenes, in which figures produced by taking plaster casts of living people are placed in desolate settings, such as gas stations, diners, and buses. The anonymous white

figures, with their features smoothed over, are pictorially united by the physical and emotional consistency of enervation and isolation.

SEGALL, LASAR. German-Brazilian painter (b. Vilna, Lithuania, 1891; d. São Paulo, 1957). Segall attended the Berlin Academy (1906–09) and taught at Dresden. He developed an expressionist style, often depicting Jewish themes. In 1913 he visited Brazil and exhibited the first modern art seen there (São Paulo, Campinas). He participated in the expressionist movement in Dresden (1914–23) and settled in Brazil in 1923. Suffering emigrants were a main theme (for example, *Navire d'émigrants*, 1939–41; São Paulo, Museum of Art).

SEGONZAC, ANDRE DUNOYER DE. French painter and engraver (1884–). Segonzac was a native of Boussy-Saint-Antoine. He showed such an early passion for drawing that in 1901 he was admitted to Luc-Olivier Merson's personal academy in Paris. Segonzac frequented the School of Oriental Languages and later met Boussingault and Luc-Albert Moreau. In 1905 he entered the Académie Julian, where he studied with Jean-Paul Laurens, and in 1906 he shared a studio with Boussingault.

After World War I he regularly submitted his work to the Salon des Indépendants and the Salon d'Automne. His early work (*Les Buveurs*, 1910) is a kind of homage to Cézanne's *Joueurs de cartes*, but already in *La Vénus de Médicis* (1913) he shows that geometry in space is not incompatible with the refined expression of a sensuality that is no less abstract. Segonzac's art developed toward maturity and revealed his sensitive and poetic realism rooted in the countryside (*La Maison blanche*, 1919; *Le Printemps*, 1920; *La Ferme dans les terres*, 1923). The forms are simply and boldly treated, and the warm colors reflect the painter's love of nature. Although he is not considered a Fauve, Segonzac may be classified as generally in that area.

In his water colors Segonzac, like Signac and Jongkind, willingly lets the drawing appear beneath the color, and in his etchings and drypoints he produced a number of superb prints that alone grant him a first-rank place in

modern art. His forms are serious but never sad. The still lifes, portraits, nudes, and landscapes reveal great taste and sensitivity (*Fernande les mains croisées*, etching, 1925; *Le Pont de Couilly*, water color, 1925).

ARNOLD ROSIN

SELEY, JASON. American sculptor (1919–). Born in New Jersey, Seley studied architecture at Cornell University and sculpture with Zadkine at the Art Students League in New York City (1943–45). He traveled to Haiti in the late 1940s on a U.S. Department of State grant and to Europe in 1950 on a Fulbright fellowship. Seley's work is represented in many New York collections, including that of the Museum of Modern Art. He works chiefly in welded steel, creating abstract compositions utilizing automobile parts, as in *Baroque Portrait* (1961) and *The Boys from Avignon* (1963).

SEPESHY, ZOLTAN. Hungarian-American painter (1898–). Born in Kassa, Sepeshy studied in Budapest, Paris, Prague, and Venice, and went to the United States in 1920. He paints landscapes, figures, and urban genre in an original tempera technique. His recent works have been semiabstractions.

SERT, JOSE LUIS. Spanish-American architect, planner, writer, and educator (1902–). Born in Barcelona Sert was educated there at the School of Architecture. He worked in Paris for Le Corbusier and Jeanneret (1929–30), and was in private practice in Barcelona until 1937. He went to the United States in 1939 (naturalized 1951). Sert was professor of city planning at Yale (1944–45) and, since 1953, has been professor of architecture and dean of the Graduate School of Design at Harvard University.

Among Sert's architectural works are the apartment houses in Barcelona (1931), the housing group for the government of Catalonia (1933–36), and the Spanish Pavilion at the International Exposition, Paris (1937). He also designed master plans for several Latin American cities, the United States Embassy in Baghdad, Iraq (1955–60), the Married Students Dormitories at Harvard University, Cambridge, Mass. (1962–64), and the Charles River Campus of Boston University (1960–65).

Sert has published *Can Our Cities Survive?* (London, 1942; 3d ed., 1947) and (with J. Tyrwhitt and E. N. Rogers) *The Heart of the City* (London, 1952).

<div align="right">THEODORE M. BROWN</div>

SERVAES, ALBERT, see LAETHEM-SAINT-MARTIN SCHOOL.

SEVEN AND FIVE SOCIETY. Loose society of English artists (originally seven painters and five sculptors) formed in 1919 in London to promote impressionism in England. With the election of many members and under the influence of Nicholson (elected in 1924) the group became more oriented toward nonrepresentational art. Members included Hitchens, P. J. Jowett, David Jones, Hepworth, and Moore. They last exhibited as a group in 1935 or 1936. *See* HEPWORTH, BARBARA; MOORE, HENRY; NICHOLSON, BEN.

SEVERINI, GINO. Italian painter (1883–1966). Born in Cortona, he lived chiefly in Paris after 1906. Severini was instrumental in formulating the Italian futurist movement, although he remained in Paris during its advent and development. He was responsible for the first publication of Marinetti's general futurist manifesto of 1909 in the Parisian journal *Le Figaro.*

Severini studied with Balla in Rome (1900–01), where he met Boccioni; both were influenced by Balla's Italian divisionism, or neoimpressionism. Severini went to Paris in 1906, where he met Braque and the writer Max Jacob. Severini's first characteristic works date from early 1910, concurrently with his signing of the "Technical Manifesto of Futurist Painting." He was especially productive during 1912, the year of the initial Parisian showing of futurist works (Galerie Bernheim-Jeune) and the spread of the movement to London, Berlin, and elsewhere. The cubist influence upon his work, which had been evident in lesser degree from 1910, became more firmly assimilated from 1915 and lasted until about 1921, the year of publication of his *Du Cubisme au classicisme.* During the 1920s Severini sought an individual neoclassical idiom, invoking elaborate mathematical analyses of figural proportions.

Like most futurists, Severini paid verbal homage to the machine, but in fact more often than not he used the human figure as the source of image and rhythm. His 1912

works on the Bal Tabarin dancer theme (such as the characteristic version in the Museum of Modern Art, New York) are cases in point. These are, moreover, relevant to the concern of certain cubists, especially Duchamp, Picabia, and Léger, with simultaneous or sequential mobility of similar subjects. *The Armored Train* (1915; New York, private collection) is one of the relatively few works by Severini in which the futurist glorification of war and the machine is made obvious. His *Harlequin* series of the 1920s totally abandoned the futurist style.

JOHN C. GALLOWAY

SHAHN, BEN. American painter (1898–1969). Born in Kaunas, Lithuania, he went to the United States in 1906. A major advocate of politically significant art but also an individual stylist, Shahn studied at the National Academy of Design. He visited Europe in 1925 and 1927, practicing book illustration during that period. His first one-man show was held at the Downtown Gallery in 1930. Shahn's art attracted much attention in 1931–32, when he painted a series of twenty-three gouaches on the theme of the Sacco-Vanzetti trial, a politically significant case which found Shahn taking the side of the condemned defendants. These pictures are striking for their primitivizing, although essentially realistic, imagery and great economy of pictorial elements. A similar series followed in 1933 on the Tom Mooney case. Shahn was by that time an artist of established reputation, by no means exclusively because of the topical nature of his themes but also because of his peculiarly personal style.

Shahn was assigned to several mural designs under the Federal Art Project of the mid-1930s and early 1940s; an important example is located in the Federal Security Building in Washington, D.C. (1940–42). (His composition *Handball*, 1939; New York Museum of Modern Art, relates to that mural.) Shahn worked with the Office of War Information during the 1940s, executing a series of dramatic posters. His style became increasingly imaginative, more colorful, and more evidently based upon some principles of abstract design; but that tendency, even when carried further in paintings of the 1950s and 1960s, has served to corroborate rather than obscure the impact of his socially conscious themes. His *Father and Child* (1946), the ironic *Epoch* (1950; Philadelphia Museum of Art), and

The Physicist (1960; New York, Downtown Gallery), with its grim, symbolical overtones of nuclear threat, remain, despite their charm of technique, as characteristically provocative as Shahn's early commentaries on the inequities of society.

Shahn has had retrospectives at the Museum of Modern Art, New York, in 1947, and at the Municipal Museum in Amsterdam, and has been represented in major exhibitions at the Whitney Museum of American Art, the São Paulo Bienal (with awards), the Carnegie International, and elsewhere. JOHN C. GALLOWAY

SHEELER, CHARLES. American painter and photographer (1883–1965). Born in Philadelphia, he studied there at the School of Industrial Art and at the Pennsylvania Academy of Fine Arts with William Merritt. Chase, whom he twice accompanied to Europe. Sheeler began professional photography in 1912. He exhibited paintings at the 1913 Armory Show and in 1920 collaborated with Paul Strand on the film *Mannahatta*. Sheeler did several series of photographs: African Negro masks (1918), Ford Plant, River Rouge (1927), Chartres Cathedral (1929), and Assyrian reliefs in the Metropolitan Museum (1942).

Sheeler's early paintings, mostly still lifes, were influenced by Cézanne. For a few years after the Armory Show, he experimented with cubism, as in *Landscape* (1915; Leominster, Mass., William H. Lane Foundation). He derived from cubism a feeling for the formal order implicit in abstraction, but he sought this order in the painting of recognizable objects.

In the 1920s he concentrated on the clean depiction of the surfaces of subjects that already contained an abstract structure (interiors, stairways, architecture, and barns), for example, *Bucks County Barn* (1923; New York, Whitney Museum). The characteristics of Sheeler's painting—simple presentation of volumes, clean edges, and sharp images—which, along with his subjects, he shared with such other artists as Demuth and O'Keeffe, led to the application of the terms "precisionist" and, later "cubist realist" to their work. See CUBIST REALISM.

The first phase of Sheeler's mature work culminated in *Upper Deck* (1929; Cambridge, Mass., Fogg Art Museum), where each bit of nautical apparatus takes its place in the strong design. *Upper Deck* also marked the transition to

machine and industrial subjects and those paintings most generally associated with Sheeler and precisionism, such as *River Rouge Plant* (1932; Whitney Museum), loosely based on the Ford photographs of 1927, and *City Interior* (1936; Worcester Art Museum). In the best work of this period Sheeler managed to fuse exact painting with his basically abstract vision.

Abstraction predominates in his later paintings, where even industrial forms are vigorously purified of naturalistic detail and just as rigorously arranged, as in *Incantation* (1946; Brooklyn Museum). JEROME VIOLA

SHINN, EVERETT. American painter, illustrator, and decorator (b. Woodstown, N.J., 1876; d. New York City, 1953). He studied at the Pennsylvania Academy of Fine Arts. First interested in mechanics, he worked as a draftsman. Later he did newspaper illustrations, in Philadelphia from 1896 to 1901 and then in New York City. A member of The Eight, Shinn began as a realistic painter of urban genre and theatrical scenes, such as *The Hippodrome, London* (1902; Art Institute of Chicago). Subjects from the theater became more important in his work, and his less realistic style was increasingly influenced by Degas. His decorations for theaters and private homes were in the French rococo style.

SHREVE, LAMB AND HARMON. American architectural firm of Richard H. Shreve (1877–1946), William Lamb (1883–1952), and Arthur Loomis Harmon (1901–). Shreve, who was the senior member, joined with Lamb in 1920; Harmon became affiliated in 1929. They designed the world's tallest skyscraper, the Empire State Building (1929–31) in New York City.

SICKERT, WALTER RICHARD. English painter (b. Munich, 1860; d. Bath, 1942). He studied briefly at the Slade School, London. For a time he was a friend and studio assistant of Whistler, through whom he met Degas in Paris in 1883. Sickert was in Dieppe from 1900 to 1905 and was a founder of the Camden Town Group in 1911. Inspired by the impressionists, he borrowed some of their technique. His early paintings, subdued tonal studies of urban scenes, were influenced by Whistler. However, Sick-

ert's lifelong admiration for Degas can be seen in the solid compositional structure and cutoff views of many of his paintings, for example, *Ennui* (ca. 1913; London, Tate).

SIMULTANEITY. Concept of the spatio-temporal element in painting embodied in orphism and futurism. Toulouse-Lautrec, Seurat, and Munch had attempted dynamic expression of movement in their work, and Picasso and Braque anticipated the problem of simultaneity in analytical cubism. But it remained for a small group of dissenters, including the three Duchamp brothers and Robert Delaunay, to formulate the problem clearly and to find solutions. Color was a primary factor in orphism's realization of movement—Fauve color combined with cubist form. Delaunay's *St. Severin* series (1909) and *Eiffel Tower* series (1910), Marcel Duchamp's *Nude Descending a Staircase* (1912), and Jacques Villon's *Marching Soldiers* (1913) are typical products of the movement. Their aim is to present simultaneous views of different aspects of the same object, either at the same moment in time or at successive moments in time.

SINGIER, GUSTAVE. French painter and graphic artist (1909–). Born in Warneton, Belgium, he went to Paris in 1919 and later became a French citizen. Singier first worked as a decorator and designer while painting in an expressionistic manner. His more recent abstractions, grounded in natural forms, consist of well-defined, linear, flatly colored shapes in strong, often large decorative compositions with patterned effects derived from Miró and Klee. In style, he is associated with the French artists Jean Le Moal and Alfred Manessier.

SINTENIS, RENEE. German sculptor (b. Silesia, 1888; d. Berlin, 1965). She studied with Von Koenig and Haverkamp at the Arts and Crafts School in Berlin. Although Sintenis interprets the human figure with sensitivity (as in her bronze *Daphne* in the Museum of Modern Art, New York), she is at her best in sympathetic studies of animals of various kinds, usually in the medium of bronze. Her style is a personal blending of impressionist and expressionist values with a strong basis in naturalism. Following a dislocated life during the Nazi ascendancy of the 1930s

and World War II, Renée Sintenis was appointed professor of art at the Berlin Academy, where she was deeply influential as a teacher.

SIPORIN, MITCHELL. American painter (1910–). Born in New York City, he studied at the Art Institute of Chicago. Siporin is a well-known muralist and painter of social subjects. With Edward Millman he did the large St. Louis Post Office mural (1939–41).

SIQUEIROS, DAVID ALFARO. Mexican painter (1896–1974). He was born in Chihuahua. A political activist and technical innovator, this pioneer of the Mexican mural renaissance was one of the so-called "Big Three": Orozco, Siqueiros, and Rivera. Siqueiros's youthful participation in strikes at the Mexican Academy was followed by military service under Carranza. Posted to Europe (1919–22), Siqueiros drew from his studies there the conviction that Mexico needed a democratic, public art adapted to its revolutionary mood.

Among those presiding over the birth of the mural movement at the National Preparatory School (1922–24), only Siqueiros, with his *Burial of a Worker*, achieved true monumentality and social significance. He helped to organize his colleagues into a unionlike "Syndicate" and to publish its fiery organ, *El Machete*. After this group dissolved, Siqueiros concentrated on union activities in Guadalajara until 1930, when, at Taxco, he resumed painting wholeheartedly.

During the 1930s he further developed his concepts of proletarian art by organizing assistants into mural teams who sprayed pigment on outdoor concrete. Their works included the Plaza Art Center in Los Angeles (1932). In 1933, in Argentina, he applied weather-resistant plastics, such as Duco and ethyl silicate, to the problem of externalizing murals so as to achieve maximum communication. In 1937, after having established his Experimental Workshop in New York City for diffusion of these new techniques, Siqueiros consummated his antifascist activities by service with the International Brigades as divisional commander in Spain.

After returning to Mexico in 1939, he devoted increasing time to art. Since then his major works (in Mexico City)

David Alfaro Siqueiros, *Echo of a Scream* (1937). Duco on wood, 48″ x 36″. Museum of Modern Art, New York. Gift of Edward M. M. Warburg.

have been the *Trial of Fascism* (1939; Electrical Workers Union), *Cuauhtemoc against the Myth* (1944; Sonora ♯ 9), *New Democracy* (1945; Palace of Fine Arts), *Patricians and Patricides* (1945; ex-Customs House), *Ascent of Culture* (1952–56; University of Mexico), and *Future Victory of Medical Science against Cancer* (1958; Medical Center). During this period his most distinguished mural outside Mexico was *Death to the Invader* (1941; Chillán, Chile).

Meanwhile Siqueiros executed many easel pictures, including portraits, and prints. At the Venice Biennale of 1950 he won second prize. From 1960 to 1964 he was imprisoned by the Mexican government for the crime of "social dissolution," but he subsequently completed a government commission for a mural at Chapultepec Castle.

Film projectors, airbrushes, spray guns, and cinematic techniques all enabled Siqueiros to implement his theories of "dynamic realism" and "kinetic perspective." Thus, he resolved the conventional divisions of wall, corner, and ceiling into a spatial unity (unparalleled even in baroque frescoes) which envelops the spectator in an all-embracing visual experience. Ingenious foreshortenings of simplified, "Indianesque" forms, lacquered on concrete or on masonite surfaces of concave profile, correct the visual distortions of traditional murals, at the same time projecting illusions of shifting images.

JAMES B. LYNCH, JR.

SKIDMORE, OWINGS, AND MERRILL. American architectural firm of Louis Skidmore (1897–1962), Nathaniel A. Owings (1903–), and John O. Merrill (1896–). Founded in Chicago during the 1930s, Skidmore, Owings, and Merrill (SOM) is today one of the largest design offices in the world, with branches in New York, Chicago, and other cities, serving primarily American big business. Gordon Bunschaft (1909–), who became a partner in 1945, has designed many of their major buildings.

SOM first gained international recognition with its design for Lever House (1951–52) on Park Avenue in New York City. The prototype of postwar, glazed, curtain-wall commercial buildings, Lever House is not only important for its elegant aesthetic quality; it also began a new era in urban planning of the skyscraper. Only one-quarter of its expensive site is occupied by the vertical slab; the balance is covered by a horizontal rectilinear volume suspended above a pedestrian plaza, resulting in a humanized pedestrian environment without sacrifice of functional efficiency.

The Manufacturer's Trust (1953–54) in New York is a cubical, glazed open volume that established a new form for banks. Among the firm's more successful large-scale works is the Connecticut Life Insurance Company office buildings (1954–57) in Bloomfield, Conn., a 280-acre administrative village outside the insurance city of Hartford.

Another large composition is the United States Air Force Academy, completed in 1962, in Colorado Springs, Colo., a coldly efficient complex, which culminates in a 17-spired chapel designed to accommodate three faiths. One of the other significant SOM works is the Chase Manhattan Bank (1957–61) in New York, a masterfully coordinated urban pedestrian-commercial-office complex in the Lever House tradition.

SOM manipulates a contemporary idiom with skill and sophistication to produce large quantities of consistently high-quality work.

THEODORE M. BROWN

SLOAN, JOHN. American genre painter (b. Lock Haven, Pa., 1871; d. New York City, 1951). He studied with Anschutz at the Pennsylvania Academy of Fine Arts and worked as an illustrator for Philadelphia newspapers. He moved to New York in 1905, where he was employed by *Collier's*, *The Century*, and *Harper's Weekly* and was art editor of the old *Masses*. His earliest drawings show the influence of the then fashionable Art Nouveau style. He changed his style after Robert Henri introduced him to the drawing of the English illustrators Leech and Keene and to the art of Daumier, Guys, Gavarni, and Goya.

About 1907 Sloan began to paint seriously. He joined Luks, Glackens, Shinn, and Henri, all from Philadelphia, to form a group that was dubbed the "Ashcan school," because its members painted scenes of New York slums, among other things. In 1908 Sloan exhibited as a member of The Eight at the Macbeth Gallery. This group, composed of the Ashcan artists plus Ernest Lawson, Maurice Prendergast, and Arthur B. Davies, was opposed to the dominant role played by the National Academy and was in favor of representing the contemporary scene realistically. In 1913 The Eight played an active role in organizing the celebrated Armory Show, which introduced modern art to the United States. Sloan was elected president of the Society of Independent Artists, and was reelected several times. He taught at the Art Students League in New York from 1914 to 1938, and was its president in 1931. In 1938 he wrote *The Gist of Art*, in which he reminisces and gives his philosophy of art.

Sloan is generally considered the most vital and gifted

of the Ashcan painters. He reveals his sympathy for the workingman and -woman and his interest in social reform without bitterness or sentimentality. He never preaches, nor does he use his art as a weapon. His shop girls are seen drying their hair on a rooftop not far from a clothesline, scurrying under the El, or entering a popular theater such as the Haymarket. His laborers drink their ale in the cool dark of their neighborhood saloon, feed pigeons, and gorge on Chinese food while keeping their hats on. Sloan reduced detail, softened contours, and depended on tone to define his forms. ROBERT REIFF

SLUYTERS, JAN. Dutch painter (b. 's Hertogenbosch, 1881; d. Amsterdam, 1957). He studied at the Amsterdam Academy and won the Prix de Rome in 1904. Sluyters began as an impressionist. About 1916 his style became more expressionistic, in paintings of religious subjects, landscapes, and figures. For a time his formal treatment was influenced by cubism, probably his nearest approach to abstraction, although he retained a personal use of color, ultimately owed to the Fauves. His later work, mostly figures and nudes, became freer and more simplified in paint handling and composition, for example, the soft and airy *Maternité* (1948; Amsterdam, Municipal Museum).

SMET, GUSTAVE DE. Belgian painter (b. Ghent, 1877; d. Deurle, 1943). He studied at the Ghent Academy and in 1901 went to Laethem-Saint-Martin, where he was associated with the second group of Belgian expressionists. He painted simplified and stylized landscapes and portraits, for example, *Paysage de neige au clair de lune* (1918; The Hague, Gemeentemuseum) and *Béatrice* (1923; Brussels, Fine Arts Museum). In his later paintings, the flat treatment sometimes gave way to a greater volume and solidity, as in *Still Life with Herrings* (1938; Antwerp, Fine Arts Museum).

SMITH, DAVID. American metal sculptor and painter (b. Decatur, Ind., 1906; d. Albany, N.Y., 1965). He lived and worked at Bolton's Landing, N.Y. Smith was an important innovator in contemporary American sculpture, creating monumental abstractions in welded iron and steel. In 1925 he was a riveter in the South Bend, Ind., Studebaker plant,

an experience that was important for his later metalwork. In 1926–27 he became a painting student at the Art Students League, New York City, studying with John Sloan and Jan Matulka. From the latter he became aware of Mondrian, Picasso, and Kandinsky. In 1930, partly influenced by Stuart Davis and Jean Xceron, he worked in an abstract surrealist style. In 1931 he attached objects of various materials to his paintings. In the Virgin Islands that year he made constructions with found and carved coral forms and did his initial freestanding wooden and

David Smith, *Lectern Sentinel* **(1961). Stainless steel, 101¾″ x 33″. Whitney Museum of American Art, New York. Gift of Friends of the Whitney Museum.**

painted constructions. He sustained these experiments the following year, adding soldered lead and iron forms to a wooden base.

Seeing a *Cahiers d'Art* reproduction of Picasso's metal sculpture in 1933, Smith made his first welded iron sculpture. The following year he acquired studio space in the Terminal Iron Works in Brooklyn, where he worked for six years. In 1935 he traveled to London, Paris, Greece, Crete, and Russia, becoming interested in ancient art and numismatics. Between 1937 and 1940, during the Spanish Civil War, he did his *Medals for Dishonor* series. His first show was at the East River Gallery, in New York, in 1938. He exhibited with the American Abstract Artists and worked for the Works Progress Administration. After 1940 he built a studio at Bolton's Landing. During World War II he was a machinist and worked on tanks and locomotives. He taught at several schools: Sarah Lawrence College, Bronxville, N.Y., in 1948; the University of Arkansas, Fayetteville, in 1953; and Indiana University, Bloomington, in 1954.

David Smith was perhaps the first and most influential American sculptor to realize the potentials of openwork in iron. His imagery was tough but molded by a strong fantasy that produced uncanny figural conceptions (*Head,* 1938, New York, Museum of Modern Art; *Detroit Queen,* 1957, Connecticut, private collection) and lyrical landscapes (*Hudson River Landscape,* 1951; New York, Whitney Museum), as well as militant birds (*Royal Bird,* 1948; Minneapolis, Walker Art Center), witty still lifes (*The Banquet,* 1951; New York, private collection), and foreboding totemic images (*Tank Totem* series, mid-1950s). He did several surrealist compositions, for example, *Song of an Irish Blacksmith* (1950) and *Oculus* (1947; New York, Mr. and Mrs. R. John Collection).

Smith's metaphorical imagery comes from machines and machine-made parts as well as from botanical nature. The *Agricola* series of 1951–52 is an example of the latter source. His materials lose their distinct identity through Smith's wit and through his power to fuse them into a new art object. In 1959 Smith returned to painting and to painting his sculpture. In 1964 he received a Brandeis University medal for lifetime achievements in the creative arts.

ALBERT ELSEN

SMITH, MATTHEW. British painter (1879–1959). Smith was born in Halifax. His parents were strict nonconformists; his father was a prosperous industrialist. Smith went into business, and only after a struggle against family opposition was he able to go to the Manchester School of Art. He later went to the Slade School in London, but as a result of poor health was sent to Pont-Aven in 1908; he moved to Paris in 1910. The influence of Gauguin, especially his emphasis on strong colors, was of the greatest importance to the maturing Smith. In Paris he exhibited at the Salon des Indépendants and enrolled in Matisse's academy. The influence of these two great colorists led to Smith's adoption of Fauvism, which he was to retain throughout his career, adding his own vigorous brushwork. He spent many years in France, mainly in Provence, and was an important channel of influence for French art in England.

SMITH, TONY (Anthony Peter). American sculptor, architect, and painter (1912–). After studying at the Art Students League in New York City and the New Bauhaus in Chicago, Smith supervised a number of architectural projects as an assistant to Frank Lloyd Wright. Between 1940 and 1960 he became an influential teacher and designed a number of houses in his own architectural practice. He produced his first sculptures in Germany in 1953–55 and, after 1960, evolved one of the most original forms of sculptural expression in the United States. In 1966 he was given a one-man exhibition split between the Wadsworth Atheneum in Hartford, Conn., and the Institute of Contemporary Art in Philadelphia. Made of plywood painted black and meant to be translated into steel, his works use a modular system and basic geometric shapes, but evoke a primordial power, especially when set in a landscape. Smith has also painted since the early 1930s, using the medium as a means of experimentation with space, shape, and formal relationships.

SOCIAL REALISM. American art movement of the 1930s. Largely as a result of the Depression and the increasing involvement of the United States in global affairs, some leading artists, notably Shahn, Soyer, Gropper, Grosz, and Evergood, used art as a vehicle for messages of social

protest. Since the works produced were narrative and exhortative, all the artists worked in a representational idiom, although there was a variety of personal styles. Outstanding works within this loosely constructed category are Shahn's *The Passion of Sacco and Vanzetti* (1930–31; series of 23 paintings) and Evergood's *Lily and the Sparrows* (1939; New York, Whitney Museum). More recently, as in the work of Jack Levine, social realism has been infused with more overtly imaginative forms. *See* EVERGOOD, PHILIP; GROPPER, WILLIAM; GROSZ, GEORGE; LEVINE, JACK; SHAHN, BEN; SOYER, ISAAC.

SOULAGES, PIERRE. French abstract painter (1919–). He was born in Rodez, Aveyron, and now lives in Paris. While a student at the lycée in Rodez, he painted and took an interest in local Romanesque art. In 1939 he saw the art of Cézanne and Picasso in Paris. In 1946 he began to paint regularly, and exhibited in the Salon de Mai in 1947 and every year thereafter. In 1949 he had his first one-man show and in 1951 he designed decor for Louis Jouvet's production of *The Power and the Glory*. Soulages's first New York one-man show was at the Kootz Gallery in 1954.

Soulages composes by piling up, one on the other, large rectangles that resemble close-up views of brushstrokes and that are usually as black and shiny as patent leather. These appear to hover before a brightly colored luminous ground.

SOUTINE, CHAIM. Russian-French painter (b. Smilowitchi, near Minsk, Russia, 1894; d. Paris, 1943). His style is an individual form of expressionism. Although born into a poor family, Soutine managed to study at the Vilna art school in 1910 by assisting with photographic work. He went to Paris in 1913 after the sale of several of his earliest pictures and attended the Ecole des Beaux-Arts, studying with Cormon and independently acquiring an admiration for Courbet and Rembrandt.

Although Soutine knew Chagall, Lipchitz, Modigliani, and the poet Cendrars, he was too introverted, or perhaps too independent, to seek help from them. He became severely undernourished, and at one point he attempted suicide. He met the dealer Zborowski through Modigliani,

Chaim Soutine, *Chartres Cathedral* (1933). Oil on wood, 36″ x 19¾″. Museum of Modern Art, New York. Gift of Mrs. Lloyd Bruce Wescott.

however, and the resulting sale of several paintings enabled Soutine to paint from 1919 to 1922 in Céret, in southern France. The landscapes of this period are unexcelled in intensity of feeling; their violently distorted forms and vivid colors express an almost irrational emotionality. Soutine had produced some 200 canvases by the time he returned to Paris, and, in 1923, the American collector Dr. Albert Barnes bought half of them. Many of Soutine's admirers hold that this sudden prosperity adulterated the spirit of his art, although several forceful landscapes, still lifes with butchered meats (harking back to a theme he had painted soon after arriving in France), and the famous *Choir Boy* series of 1927 attest to his fundamentally superior talents.

Among these talents was his great gift for portraiture. Soutine's *Self-Portrait* (1918; New York, private collection) and *Child with a Toy* (Geneva, private collection) are among his major works of the earlier period. These match in turbulence of brushwork and disquietude of psychological content the stronger portraits by Kokoschka, the Austrian expressionist. Soutine frequently used brilliant reds and greens with powerful echoes in his gray tonalities, the handling often being violently expressive. Rouault may have been an influence, but there is a decided empathy with the most vigorous of the German Brücke styles. In later works, pictorial design plays a stronger part than before, with relatively more equilibrium between design and emotional power.

JOHN C. GALLOWAY

SOVIET REALISM. The official style of painting adopted by the Soviet government soon after the Revolution. The government insisted that the function of art was social: to glorify the state and its leaders or to teach the virtues of hard work and other Soviet aims.

SOYER, ISAAC. American painter and lithographer (1907–). The younger brother of Moses and Raphael Soyer, Isaac was born in Tambov, Russia. He studied at Cooper Union, the National Academy, and the Educational Alliance, all in New York City. Soyer paints primarily working-class genre subjects, for example, *Employment Agency* (1937; New York, Whitney Museum).

SOYER, MOSES. American painter (1899–). The twin brother of Raphael Soyer and older brother of Isaac, he was born in Tambov, Russia, and studied in New York City. He paints sympathetic urban genre, dancers and models, and figures, such as *Girl in Orange Sweater* (1953; New York, Whitney Museum).

SOYER, RAPHAEL. American painter and lithographer (1899–). He was born in Tambov, Russia, and was the twin brother of Moses Soyer and older brother of Isaac. He studied at the National Academy and the Art Students League in New York City. His subjects are melancholy urban genre and figures.

SPEICHER, EUGENE. American painter (1883–1962). Born in Buffalo, N.Y., he studied there and in New York City with DuMond and Chase and, in 1908, with Robert Henri. Speicher's work consists mostly of portraits and figure paintings of girls and women, but he has also painted nudes and still lifes of flowers. Despite his early association with American realism, his paintings exhibit little that is specifically modern, except for a certain monumentality of composition and a simplified treatment of planes, both remote echoes of Cézanne. These elements can be seen in the sturdy *Lilya* (1930; Cincinnati Art Museum).

SPENCER, NILES. American painter (b. Pawtucket, R.I., 1893; d. Sag Harbor, N.Y., 1952). He studied in Rhode Island and at the Art Students League in New York City with Henri and Bellows, and was in Europe in 1921–22 and 1928–29. Spencer was associated with the precisionist (cubist realist) group, which painted industrial or urban landscapes with smoothly simplified geometric forms, as can be seen in his *City Walls* (1921; New York, Museum of Modern Art), where a structural order is imposed on an urban scene.
See also CUBIST REALISM.

SPENCER, STANLEY. English painter (1891–1959). Born in Cookham, he studied at the Slade School, London (1909–12). Although he also painted realistic landscapes and portraits, his main interest was religious scenes, usually

with his native village as the ultimate source for their setting. In these works, expressively distorted massive figures and realistic detail are combined for an almost mystical effect. His murals (1926–32) for a chapel at Burghclere, Berkshire, depict the resurrection of soldiers. His late work was increasingly personal and savage in symbolism.

SPRUANCE, BENTON MURDOCH. American painter, lithographer, and educator (1904–1967). Born in Philadelphia, he studied at the University of Pennsylvania and at the Pennsylvania Academy of Fine Arts. He was professor of fine arts at Beaver College, Glenside, Pa., from 1933 until his death. He was also director of the Division of Graphic Arts at the Philadelphia Museum College of Art. Spruance is primarily known as a color lithographer of social, religious, and mythological subjects; the *Anabasis* series (1959) is an outstanding example of his work. Many of his lithographs are in museums and library collections in the United States.

SPRUCE, EVERETT FRANKLIN. American painter (1908–). Born near Conway, Ark., he studied at the Dallas Art Institute. Although he has painted other subjects, such as still lifes, Spruce is best known for his regional landscapes of Texas and the Ozark country, tightly painted in a simplified and stylized manner, for example, *The Hawk* (1939; New York, Museum of Modern Art). Since the 1940s, in landscapes, genre, and figures, he has used brighter color and looser handling, as in *Pigeons on a Roof* (1947; New York, Metropolitan Museum), at times approaching expressionism.

STABILE. Stationary abstract sculpture or construction of a type created by Alexander Calder and first exhibited at the Galerie Percier (Paris, April 27–May 9, 1931). It is typically made of wire and sheet metal or wooden forms attached to a base. Jean Arp is credited with inventing the term to describe Calder's work.

STAEL, NICOLAS DE. French painter (b. St. Petersburg, Russia, 1914; d. Antibes, France, 1955). After his parents' deaths in 1922, De Staël attended Jesuit schools in Brussels. He studied at the Brussels Academy of Fine Arts and

in 1936 with Léger in Paris. By 1942 he had begun to paint abstractly. In 1944 he became a friend of Braque and of Lanskoy and exhibited with Kandinsky, Domela, and Magnelli at the Galerie L'Esquisse, where he had his first one-man show that same year. In 1948 De Staël became a French citizen. He traveled widely, visiting North Africa, the United States, Italy, Spain, and England.

His somber, blocky abstractions in a tachist manner with thickly troweled-on paint were abandoned in 1952 for broadly abstracted figures of athletes, musicians, nudes, and still lifes. Forms were reduced to color spots and bright reds and electric blues and blacks were favored.

<div align="right">ROBERT REIFF</div>

STAMOS, THEODOROS. American abstract painter (1922–). He was born in New York City, where he studied at the American Artists School in 1948–49. He had his first one-man show in 1953. In his recent work, biomorphic shapes, hovering over an atmospheric ground, have lost their similarity to vegetation, fossils, sea anemones, and the like through further abstraction.

STANKIEWICZ, RICHARD. American sculptor (1922–). Born in Philadelphia, he studied with Hans Hofmann in New York (1948–49), at Léger's school in Paris (1950), and at the Atelier Ossip Zadkine in Paris (1950–51). With eleven other artists, he opened the Hansa Gallery, in New York, in 1952. The Museum of Modern Art, New York, owns his *Instruction* (1957), and *Diving to the Bottom of the Sea* (1958) is in the Rubin Collection, New York. Stankiewicz is one of the best and most influential of the "manipulators" working with junk and objects of his own manufacture to produce a witty, urbane art.

STEER, PHILIP WILSON. English painter (b. Birkenhead, 1860; d. London, 1942). He studied in Paris from 1882 to 1884 under Bouguereau and Cabanel and was influenced by impressionism, but not consistently. His landscapes after 1900 are broadly painted views in the English tradition.

STEINBERG, SAUL. American painter and graphic artist (1914–). Born in Romania, he studied in Milan,

Italy, and served in the United States Navy during World War II. In drawings and cartoons, he uses an incisive, graphic wit to illustrate the fantasies and follies of humanity. Several collections of his drawings have been published in book form.

STELLA, FRANK. American painter (1936–). Born in Malden, Mass., he studied painting with Stephen Greene and William Seitz while at Princeton University, but in his early work Stella was influenced primarily by Hans Hofmann. In 1958 Stella turned from abstract expressionism to a drastically reduced and severely ordered style that has been in the forefront of minimal art in the 1960s. Adopting an uncompromising approach to abstraction, he first painted only concentric rectangles of white line that echo the frame of the canvas against a black background, but in more recent works he uses a searing range of colors and a variety of canvas shapes.

STELLA, JOSEPH. American painter (b. Muro Lucano, near Naples, 1877?; d. New York City, 1946). Stella went to the United States in 1896 and studied for a while at William Merritt Chase's New York School of Art. From 1905 to 1910 Stella produced illustrations for the magazines *Outlook* and *Survey*. His *Pittsburgh, Winter* (1908) is an aerial view of the city subsumed in a Whistlerian haze. But early drawings of miners, steelworkers, and immigrants are hard and linear and done with a meticulous realism.

In Europe in 1910–12, Stella came into contact with several of the Italian futurists, and upon his return to America he became, in effect, America's leading futurist painter. A landmark was the *Battle of the Lights, Coney Island* (1913; Lincoln, Nebr., Sheldon Memorial Art Gallery), a work suggesting an assimilation of Severini. Here, amid the fragmented objects, one finds an occasional bit of a printed word. Usually, however, Stella preferred to show, not the kaleidoscopic effects of much of European futurism, but a crystallized, frozen aspect of industrial forms, as may be seen in *The Bridge* (Newark Museum), done for his *New York Interpreted* series of 1920–22. In work of about 1915 Stella was forecasting the shiny surfaces of the precisionists. In spite of the quiet, jeweled

mood that *The Bridge* evokes, Stella spoke of "the steely orchestra of modern constructions."

Stella spent the years 1926–35 mostly abroad, in Naples, North Africa, and especially Paris. In 1936 he was back in New York; in 1937–39 he was in Europe again and in Barbados, but after 1939 he remained in New York. In Barbados he painted landscapes abounding in lush and exotic vegetation with occasional phallic centralized images. His *Full Moon (Barbados)* (1940; Sergio Stella Collection) features a fully saturated, almost perfectly circular yellow moon above a strange blue thistle flanked by tropical birds. Stella's transformations of plants and fruits might prompt a surrealist classification. The forms are heavily outlined and rendered without modeling. The earlier gouache *Sunflower* (1929; Terner Collection) similarly features a powerfully centralized form and lush, intense, cool color. Stella also produced assemblages of bits of paper rubbish from 1920 on, which anticipated much abstract art of the 1950s and 1960s.

ABRAHAM A. DAVIDSON

STERNBERG, HARRY. American graphic artist (1904–). Born in New York City, he studied at the Art Students League and with Harry Wickey. Sternberg is one of the leading graphic artists in the United States, as an etcher and lithographer and in the mass medium of silkscreen printing. Sternberg's early etchings are eclectic and show the influence of Marsh in crowded, vigorously drawn city scenes, Goya in incisively caricatured parables, and Blake in cosmological themes. During the depression and World War II his work developed toward a more direct expression of social commentary in terms of simplified and monumental forms. After the war he turned increasingly to serigraph, woodcut, and mixed media, stressing lyrical themes, decorative effects, and flat areas. Sternberg has taught widely in New York and has written several books on the graphic arts.

STERNE, MAURICE. American painter and sculptor (b. Libau, Latvia, 1878; d. Mount Kisco, N.Y., 1957). He went to the United States in 1889 and studied mechanical drawing at Cooper Union. From 1894 to 1899 he studied painting at the National Academy, where he also took anatomy classes with Eakins. Sterne won a traveling fel-

lowship in 1904 and for the next ten years traveled in France, Italy, Greece, and the South Seas, spending three years in Bali. His early paintings were influenced by Whistler. The Gauguin-influenced Bali paintings, ambiguous in space and decoratively composed, for example, *Bali Bazaar* (1913–14; New York, Whitney Museum), were well received. His later paintings, landscapes, figures, and still lifes, are strongly composed and are influenced, on the whole, by Cézanne.

STILL, CLYFFORD. American painter (1904–). Born in Grandin, N. Dak., Still attended Spokane University and Washington State College at Pullman and has taught at Hunter College, Brooklyn College, and elsewhere. His first one-man show was held at the San Francisco Museum of Art in 1941. He has been represented in major exhibitions at the Museum of Modern Art, New York ("Fifteen Americans," and "The New American Painting"), the Walker Art Center, Minneapolis, and Seattle (1962 World's Fair). A retrospective of his work was held in 1959 at the Albright-Knox Art Gallery, Buffalo. Still's compositions, usually executed on enormous canvases, are of large, ragged shapes of few colors, totally abstract and at first glance reposeful; but subtle overlappings of contrasting light and dark tones or hues afford an intriguing tension. Characteristic paintings are *Number 1* (1951; Utica, N.Y., Munson-Williams-Proctor Institute) and the similar *Painting* (New York, Museum of Modern Art). Still's work is central to the establishment of the New York school's action aesthetic.

STONE, EDWARD DURRELL. American architect (1902–). Born in Fayetteville, Ark., he attended the University of Arkansas (1919–23), studied architecture at Harvard (1925–26) and the Massachusetts Institute of Technology (1926–27), traveled in Europe on a Rotch Fellowship (1927–29), and started independent practice after working in several offices (1933).

An important early work is the Museum of Modern Art in New York (with Philip Goodwin, 1939). Later, he designed the United States Embassy in New Delhi, India (1958), and the United States Pavilion at the Brussels World's Fair (1958).

STONOROV, OSCAR. German-American architect (1905–1970). Born in Frankfurt am Main, he studied in Florence and under Karl Moser at the Polytechnic Institute in Zurich. He worked in the Paris office of André Lurçat before moving to the United States in the late 1920s. In partnership with A. Kastner (1932–35), he won second prize in the competition for the design for the Palace of the Soviets.

STUEMPFIG, WALTER. American painter (1914–1970). Born in Germantown, Pa., he studied at the Pennsylvania Academy of Fine Arts in Philadelphia. Although the fine detail with which Stuempfig paints his genre figures and urban landscapes is more usually associated with magic realism, the loneliness and bleak isolation of the scenes appear closer to the sad moods of the neoromantics, by whom he was influenced. Their effect on his work can be seen in the near-surreal atmosphere of *Cape May* (1943; New York, Museum of Modern Art) and the empty beach scene called *Thunderstorm II* (1948; New York, Metropolitan Museum).

STYLE MECANIQUE, LE. Style of the 1920s and 1930s deriving from angular, machinelike forms employed in painting and sculpture of the time and applied to architecture and interior décor. Called by Ozenfant "the style of the typewriter," it took on a debased character as *le style jazz* in industrial design, where triangles, half circles, and zigzags were used in a superficial manner.

SULLIVAN, LOUIS HENRI. American architect (b. Boston, 1856; d. Chicago, 1924). Regarded as the first great modern architect, Sullivan rejected historic eclecticism in favor of an attempt to understand the social requirements of architecture in an industrial society. To that end, he sought to mirror the needs and ideals of people within a modern technological framework.

He studied at the Massachusetts Institute of Technology in 1872, and during a stay in Philadelphia in 1873 was a draftsman for Furness and Hewitt. A year later he worked for William Le Baron Jenney in Chicago and then studied at the Ecole des Beaux-Arts in Paris. Rebelling

Louis Sullivan (with D. Adler), Wainwright Building (1890–91). St. Louis, Mo.

against traditionalist instruction, he returned to Chicago in 1876, entered the office of Dankmar Adler in 1879, and became a partner in 1881, remaining until 1895. Their Borden Block (1879–80), with its narrow piers and wide bays, was an early attempt to break away from solid-wall

construction. In other buildings of this period, however, Sullivan emphasized the vertical (perhaps influenced by Philadelphia commercial architecture of the 1850s) or Richardsonian elements, as in the Walker Warehouse (1888-89). The firm's reputation was considerably enhanced by the Auditorium Building (1887-89), one of the largest and most complex buildings in the country at the time, in the interior of which Sullivan's highly personal and vaguely Celtic ornamental vocabulary appeared.

The Wainwright Building in St. Louis (1890-91), the firm's first skeletal structure, represented a major attempt, which can be termed expressive functionalism, to create a special form appropriate to the skyscraper. The building was erected around a U-shaped court, and Sullivan employed a system of closely ranked piers, every other pier in front of a structural member, to give the exterior a pronounced vertical effect in order to make it the "proud and soaring thing" he thought a tall building ought to be. This effect is seen also in the Guaranty Building in Buffalo (1894-95) and the Condict Building in New York City (1897-99). On the other hand, in the Carson Pirie Scott and Company Store in Chicago (1899-1904) the structural grid is revealed and dictates the cell-like appearance of the façades. At the street level there is profuse ornamentation designed by George G. Elmslie, who was also largely responsible for much of Sullivan's putative later work, including the National Farmers' Bank in Owatonna, Minn. (1907-08).

Sullivan's never-erected Odd Fellows' Temple, designed in 1891, and perhaps the first cruciform skyscraper plan, demonstrated his concern for the skyscraper as a plastic problem. He said that the Chicago World's Columbian Exposition of 1893 set American architecture back fifty years, but he contributed the design of the Transportation Building, its only fresh and original building. Unfortunately neglected in his later years, he turned to writing and produced two books, *The Autobiography of an Idea* and *Kindergarten Chats*.

MATTHEW E. BAIGELL

SUPREMATISM. Name given by Malevich to his version of extreme geometric abstractionism derived from cubism. *See* MALEVICH, KASIMIR.

SURREALISM. Movement in art and literature which is concerned with giving expression to the poetry of the subconscious. Such surrealists as De Chirico, Dali, Tanguy, and Magritte composed pictures based on the kind of images experienced in dreams, nightmares, or a state of hallucination. They attempted to present them in as graphic a manner as possible. In order to make the bizarre or fantastic believable, they favored a sharp-focus realism. They frequently depicted a dream situation in a deep vista totally free of any beclouding atmospheric effects, revealing the improbable in a late-afternoon light which renders objects clearly and with long-cast shadows, suggesting the palpability of weight and substance.

Dali exploited the shock value of combining the mechanistic with the obscene, convulsed, and tortured. De Chirico evoked dream states of longing, anguish, and despair. Another group of surrealist artists, such as Arp, Miró, and Masson, painted works of a more abstract nature. The forms in their pictures are the products of a self-induced automatism.

See also MAGIC REALISM.

ROBERT REIFF

SUTHERLAND, GRAHAM. English semiabstract painter (1903–). He was born in London and now lives in Trottiscliffe, Kent. He entered Epsom College in 1914. From 1919 to 1921, he served as an apprentice at the Midland Railway Works. He then became a student, until 1928, at the Goldsmiths' College School of Art of the University of London, where he specialized in the graphic arts. In 1925 he had his first exhibition of prints in London. The next year he was elected a member of the Royal Society of Painter-Etchers and Engravers.

Sutherland turned from etching to teaching and took a post at the Chelsea School of Art in 1930. Three years later he began to paint. He made some posters for Shell Mex and London Transport. He exhibited his paintings for the first time in 1938 at the Rosenberg and Helft Gallery in London. He had a second show at the Leicester Gallery two years later. In 1941 he was appointed an official war artist, a post he held throughout the war. In 1946 he had his first one-man show in New York, at the Buchholz Gallery. That year he painted a *Crucifixion* for

St. Matthew's Church, Northampton.

He painted Somerset Maugham's portrait in 1949 and, later, portraits of Sir Winston Churchill and Lord Beaverbrook. These works brought a fame which his more austere pictures never attained.

Sutherland's early etchings and book illustrations bear the mark of Blake's influence and that of Blake's follower Samuel Palmer. From about 1935 to 1940 he made a number of water colors in a semiabstract manner of landscapes with rocks, tree trunks, craggy ledges, and the like. His color choice was arbitrary, brilliant in treatment and palette, and yet suggestive of nature. His techniques recall those of Henry Moore in some cases. By 1944, under the influence of Picasso, Sutherland supplanted his lyrical animistic landscapes with views of horny, spiked shapes which protrude from a vinelike tangle. These hostile plants have claws, teeth, and animal parts. In 1949 Sutherland did a series of *Standing Forms*, which are column-like yet appear to be potentially alive.

ROBERT REIFF

SYNCHROMISM, see MACDONALD-WRIGHT, STANTON; ORPHISM; RUSSELL, MORGAN.

SYNTHETIC CUBISM, see CUBISM.

SZYSZLO, FERNANDO DE. Peruvian painter (1925–). Born in Lima, Szyszlo studied there and in France and Italy. He has exhibited widely (for example, at the Guggenheim International of 1964, in New York). *Cajamarca* (1963; Lima, Walter Gross Collection) is a subtly colored abstraction with Peruvian regional content.

T

TACHISM. Name derived from the French *tache*, meaning "spot" or "blob," and given to a mid-20th-century style of painting that is not concerned with natural representation (portrait, figure, nude, landscape, still life) or composition (perspective, light, and shade). Tachism seeks above all to create a suggestion of nonstatic construction and relies essentially on unconscious, accidental manipulations of color, including dripping. In France tachism has become synonymous with gestural painting (where the gesture or movement is more important than the technique of drawing). The leading exponents of tachism are Wols (*Composition en vert*) in France, Pollock (*No. 21949*) and Francis (*Eté No. 1*; New York, Martha Jackson Gallery) in the United States, K. R. H. Sonderborg in Denmark, Schultze in Germany, and Davie in England. Tachism with its roots in Japanese calligraphy has become the favorite means of expression of a whole group of French painters, exemplified by Hartung. *See* DAVIE, ALAN; FRANCIS, SAM; HARTUNG, HANS; POLLOCK, JACKSON; WOLS.

See also ABSTRACT EXPRESSIONISM.

TAEUBER-ARP, SOPHIE. Swiss sculptor (b. Davos, 1889; d. Zurich, 1943). She studied at the School of Applied Arts in St. Gall and at the Debschitz School in Munich and taught in Zurich at the School of Arts and Crafts (1916–29). Active in the Dada movement, she was married to Jean Arp. Her best sculptures are of the 1935–38 period.

TAL COAT, PIERRE. French painter (1905–). A native of Clohars-Caoët, Brittany, Tal Coat was influenced by the French and foreign painters who frequented this fishing village. In 1931 he participated in the activities of the Forces Nouvelles group. The Spanish Civil War left

a deep impression on his art and was reflected in his violent colors and tortured forms. In 1940 he settled in Aix-en-Provence, where he continued his experiments in light and movement. From 1947 onward his painting, influenced by his interest in old walls and surrounding vegetation, acquired the flavor of Oriental painting, especially that of the Sung dynasty. Tal Coat seeks above all to express the hidden mysteries of nature. Typical of his technique of dripping colors on a neutral background is *Souvenir de Dordogne* (1955; Paris, private collection).

TALLER DE GRAFICA POPULAR (Workshop for Popular Graphic Art). Contemporary Mexican graphic artists' group formed in 1937 for purposes of communal activity. These artists were influenced strongly by Posada (as in the *corridos*) and by the dynamic expressionism of Orozco. Beginning under the leadership of Méndez, O'Higgins, and Arenal, with the encouragement of Siqueiros, the group soon had sixteen members and has since attracted other artists from Mexico, the United States, and Europe. Individually and collectively, Taller members have turned out a large amount of graphic work, much of it political or social in nature (*Deportation to Death*, 1943; by Méndez) and some in the fine-arts print tradition (*Estampas de Yucatán*, 1945; series by Zalce).

TAMAYO, RUFINO. Mexican painter (1899–). Tamayo was born in Oaxaca and went to school in Mexico City, where he also learned to draw. He attended the Academy of San Carlos for three years, but, like others of his generation, he was uninspired by the traditional academic art program and later studied intensively on his own. In 1921 he became head of the department of ethnographic drawing in the National Museum of Anthropology. The association with Aztec, Maya, and Toltec sculpture was to have a deep impact on his later work.

His first show was held in an empty shop in Mexico City in 1926, and in the fall of that year he took the exhibition to New York, where he sold several pictures and received much acclaim. In 1929 a show of his work was one of the first gallery exhibitions of younger artists in Mexico City. Throughout his career he has held various official posts connected with the arts and has divided his

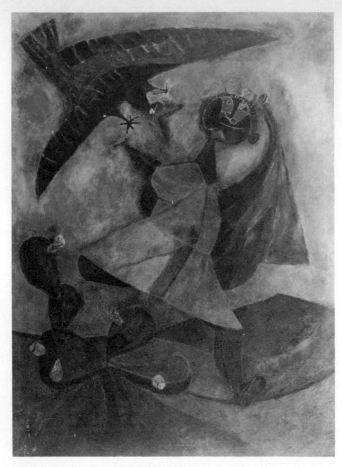

Rufino Tamayo, *Girl Attacked by a Strange Bird* **(1947). Oil on canvas, 70″ x 50⅛″. Museum of Modern Art, New York. Gift of Mr. and Mrs. Charles Zadok.**

time, working in Mexico City, New York, and, more recently, Paris.

Early in his development Tamayo reacted against the domination of the prominent Mexican muralists and sought a more modernist technique. He first created small, intimate canvases. Influenced by Matisse and later, more lastingly, by Braque, his low-keyed early work has a decided

personality of its own. In 1929 he began to paint brighter pictures and to deal with social themes, for example, the portrait of Juárez (1932; Mexico City, private collection). Spatial relationships became a preoccupation, as in the *Women of Tehuantepec* (1939; private collection). His drawings and paintings of animals achieve real power through calculated dislocations. Tamayo's paintings were shown at the Venice Biennale in 1950.

It was not until 1933 that he turned to murals; in 1943 he painted a fresco for the Hillyer Art Library of Smith College in Northampton, Mass. His two most celebrated Mexicanist murals were done in 1952 and 1953 in the Palace of Fine Arts in Mexico City. Executed in vinylite on canvas, they are the *Birth of Nationality* and *Mexico Today*. A *Prometheus* mural for the library of the University of Puerto Rico was completed in 1957.

FRANKLIN R. DIDLAKE

TANGE, KENZO. Japanese architect (1913–). His interest in large community projects found a dramatic expression in the designs for the gymnasium and annex built for the Tokyo Olympics of 1964. Although the influence of Le Corbusier is evident, particularly in the handling of natural concrete, his works exhibit the grace and drama of the native architectural tradition. His works include the Hiroshima Peace Center and town halls in Kurashiki, Shimizu, and Tokyo. In 1966 his designs for office and broadcasting centers initiated his plan for reorganizing Tokyo.

TANGUY, YVES. French-American painter (1900–57). Tanguy was born in Paris. His father was a naval officer from Brittany, and Tanguy sailed with the merchant marine in his youth. He saw a painting by De Chirico in Paul Guillaume's gallery and at once, self-taught in painting, began his career as an artist. After joining the surrealists in 1925, he participated in their major exhibitions, including the 1936 London and 1938 Paris International Exhibitions. He lived in the United States after 1939.

Despite his lack of formal training in art, Tanguy was one of the most orthodox of stylists in the surrealist group. His was a smooth, painstakingly modeled and lighted naturalism, not at all in sympathy with the technical innovations of Ernst, Miró, Arp, and others who came to sur-

realism by way of Dada. The quality of fantasy in his themes is distinctly more advanced than his aesthetic.

Among Tanguy's characteristic paintings, all of them executed in a mode related to that of Dali, Magritte, and Delvaux, are *Extinction of Useless Lights* and *Mama, Papa is Wounded!* (both 1927; New York, Museum of Modern Art), *Untitled Landscape* (1927; France, private collection), and *Four O'Clock in Summer: Hope* (private collection). His *Fear* (1949; New York, Whitney Museum) and a few later works disclosed Tanguy's potential—never fully exploited—as a more liberated and provocative stylist.

<div align="right">JOHN C. GALLOWAY</div>

TAPIES, ANTONIO. Spanish abstract painter (1923–). He was born in Barcelona and now lives in Madrid. In 1943 Tápies began training for the law at the University of Barcelona, but in 1946 abandoned it to paint. He is largely self-taught. In 1948 he became a founding member of a group, Dau Al Set (The 7th Side of the Die), which published a magazine of the same name. He had his first one-man show in Spain in 1950. In that year he also visited Paris and saw the art of Dubuffet. Tápies visited Belgium and Holland in 1951 and New York City in 1953, when he had his first New York show. In 1962 he was given retrospective exhibitions at the Hannover Landesmuseum and the Guggenheim Museum in New York.

His art prior to 1950 shows the influence of Klee and Torres García. In his better-known, starkly spare "matter" abstractions, he frequently scratches into neutral, earth-colored layers of oil or latex paint to which grit or sand has been added.

TATLIN, VLADIMIR EVGRAFOVITCH. Russian sculptor (b. Moscow, 1885; d. Novo-Devitch, 1956). He studied at the School of Painting and Sculpture in Moscow. His figurative style yielded to the influences of cubism, futurism, and other abstract tendencies peculiar to the first decade of the 20th century. In 1912 he visited Picasso's studio in Paris, and upon returning to Moscow he enthusiastically began experiments with various nonaesthetic industrial materials, which played a major role in Russian constructivism. *See* CONSTRUCTIVISM.

From 1918 to 1920 Tatlin taught at the Studios for

Training in the Liberal Arts and Techniques. He sought the utilitarian in art and proclaimed the productive role of the artist in society. A *Monument for the Third International* was projected by him in 1919; the model for this huge structure was astonishingly abstract and revolutionary, but the decline of nonfigurative art resulting from government policies in Russia prevented the construction of the building. During his last years Tatlin was employed in an aircraft factory.

CHARLES MC CURDY

TCHELITCHEW, PAVEL. Russian-American neoromantic artist (b. Moscow, 1898; d. Frascati, Italy, 1957). As a child he was fascinated by the book illustrations of Gustave Doré. In 1918 his family fled to Kiev because of the Revolution, and there he received his first art lessons.

In 1920 he left Kiev for Odessa, and then for Istanbul, Berlin, and finally, in 1923, for Paris, where, nearly at once, he renounced his cubist-derived style. He first painted landscapes and then did a series of portraits in highly keyed color of certain friends such as Glenway Westcott, Nicolas Nabokov, and Margaret Anderson. Gertrude Stein was struck by his work, which she saw in the 1925 Salon d'Automne, and sought him out. Tchelitchew saw her collection and the Picassos of the Blue and Pink periods; he was very much moved by them, and they influenced his art. By 1925 he reduced his palette to earth colors, black, and white.

His painting, with its somber themes and mood of revery and despair, was in accord with that of another group of artists who were to be known as "neoromantics." They exhibited at the Galerie Druet in 1926. Included in the group were Eugène Berman, his brother Léonide, Kristians Tonny, and Christian Bérard. It was at this time that Tchelitchew began to combine several views of a single face simultaneously in a single image.

In 1926 he moved to the south of France and then to Algiers. He began to paint circus figures there and to achieve textured effects by adding sand and coffee grounds to pigment. In 1928 he started to use extremes of foreshortening and perspective. He would, for instance, show a reclining figure with the feet close to the beholder so that they would appear abnormally large. That same year he had his first one-man show, in London, and a year

later his second, in Paris. In the late 1920s he painted a number of still lifes which were evocative of the human figure by the selection of objects and their arrangement.

In the early 1930s he did a series of paintings of tattooed circus figures, then tennis players, then bull fighters. Julien Levy gave him his first American one-man show in 1934. Tchelitchew also designed sets for the ballet.

ROBERT REIFF

TECTON GROUP, *see* LUBETKIN, BERTHOLD.

THOMPSON, BOB. American painter (b. Louisville, Ky., 1937; d. 1966). He studied at the University of Louisville and Boston University. He met a post–abstract expressionist group of painters at Provincetown, Mass., in 1958, including Red Brooms, Mimi Gross, and Mary Frank, who influenced him toward a figurative expressionism, as did Jan Muller's work. Thompson began to adapt various Renaissance masters to this purpose, especially Piero della Francesca, who gave him the kind of brilliant patterning to which he aspired. His many compositions dealing with the figure in nature reflect the tight logic of Poussin. Motif after motif shows the lavish borrowing and adaptation that mark Thompson's work. His deeply and aggressively sensuous art, however eclectic, reflects Thompson's own private problem, the black man against the world. He would seem to be a truly black artist in the same sense as the black musicians he admired so much. With his wild curves, his often fiery colors and bold diagonals, this genuinely natural man bent on destroying himself evokes the same tragedy seen in many of their lives.

TINGUELY, JEAN. Swiss sculptor (1925–). Born in Fribourg, Tinguely studied under Julia Ris at the Art School in Basel, where he was exposed to Schwitters, Klee, and the Bauhaus school. In the late 1940s he began to incorporate motion into his work, using small motors to drive wire sculptures. He has since produced highly complicated and eccentric machines, some of which have been self-destroying, including the famous *Homage to New York*, performed at the Museum of Modern Art (1960). In the 1950s Tinguely became one of the New Realists, a group led by the French painter Yves Klein.

TOBEY, MARK. American painter (1890–). Born in Centerville, Wis., he lives in Seattle and in Switzerland. Except for brief study with Kenneth Hayes Miller after he had already begun his career, Tobey is a self-taught artist. His delicately spun "white writing" abstractions, indirectly related to the more vigorously handled works by Jackson Pollock (which they precede), are thought by many authorities to derive from his study of fine calligraphy during his visit to China and Japan in the early 1930s. Actually, the total effect of these nonfigurative, handsome temperas and gouaches is closer to the Western tradition of Anglo-Celtic manuscript illuminations of the 8th century; but Tobey has been a serious student of Oriental religion (he converted to the Bahá'í World Faith in 1918) as well as of Eastern art, and there can be no doubt of a linkage, at least philosophically.

TOMLIN, BRADLEY WALKER. American painter (b. Syracuse, N.Y., 1899; d. New York City, 1953). He studied at Syracuse University from 1917 to 1921 and in Paris in the middle 1920s. Tomlin practiced an essentially realistic art until about 1939, arriving slowly but with distinctive purpose at abstraction about 1946. His style, identifiable as abstract expressionist, or action, painting, consists of rapidly brushed, long strokes, either interwoven or giving an overlaid effect, enlivened by a quick, darting line. *Number 9: In Praise of Gertrude Stein* (1950; New York, Museum of Modern Art) is characteristic of his late manner. Tomlin received special mention in the 1946 Carnegie International and won a Tiffany fellowship the same year.

TOOKER, GEORGE. American painter (1920–). Born in New York City, he studied at the Art Students League with Reginald Marsh, Kenneth Hayes Miller, and Harry Sternberg, and received lessons in tempera technique from Paul Cadmus. Tooker paints haunting imaginative scenes in a realistic style, for example, *The Subway* (1950; New York, Whitney Museum).

TOTALITARIAN ART. The official art of totalitarian governments. Almost invariably, such art takes the form

of realism that glorifies the state and its rulers. Frequently, as in the case of German art under the Nazi regime and of early Soviet art, there is a preference for a severe and grossly monumental neoclassicism, particularly in architecture.

TRAJAN, TURKU. Hungarian-American sculptor (1887–1959). He went to the United States in 1908 and studied at the Chicago Art Institute and at New York's Beaux-Arts Institute and Art Students League. He was a solitary who cared nothing for current artistic values (and who supported himself by occasional work as a chef). Trajan created an entirely personal poetic idiom in which color as well as form functioned expressively, as in the "angelic beauty" of his nudes. Almost completely unknown at the time of his death except for a few artist friends, Trajan was given a major exhibition at the New School in New York in 1966. Hilton Kramer's "An Apology to Trajan" in the *New York Times* summed up the bitterness felt by so many people that a fine artist—"absolutely original" in the words of Jacques Lipchitz—could die unknown.

TROVA, ERNEST. American sculptor (1927–). Self-taught as a painter, Trova began his "Falling Man" series of sculptures in 1960. These present man as the modern enigma who dominates yet is dominated by his mechanical environment. Although his robotlike, faceless men are mechanical to the highest degree, they owe their actual forms to the Leonardo-Dürer tradition. Their emotional content, however (and their facelessness), relate them to the surrealist persons in De Chirico's otherwise empty squares and streets. Trova's men have neither faces nor arms—nor sex for that matter—and suggest some alien creature that has dropped onto Earth from another world. He has no individuality, he cannot act since he has no arms, and he cannot reproduce himself. The fact that these figures are always characterized as "falling" men whether they are standing, sitting, or lying down would seem to indicate the philosophical direction of Trova's thinking.

TSCHACBASOV, NAHUM. American painter and graphic artist (1899–). He was born in Baku, Russia, and went to the United States in 1907. Originally an accoun-

tant, he began painting about 1930, studying at the Lewis Institute, at the Armour Institute of Technology, and in Paris with Leopold Gottlieb, Gromaire, and, briefly, Léger. His paintings of the 1930s, apart from a short excursion into abstraction, were satiric treatments of social subjects in an expressionistic, at times naïve, style, with rich color and surface. Beginning in the 1940s, his subjects became more imaginative, often including fantastic animals, in a manner comparable to that of Chagall. Tschacbasov is also known for his experiments in encaustic painting.

TUNNARD, JOHN. English painter and lithographer (1900–). Born in Sandy, he studied at the Royal College of Art, London, and worked as a textile designer before devoting himself to painting. Tunnard's paintings, although nonrepresentational, are based upon the traditional receding space of landscape, for example, *Fugue* (1938; New York, Museum of Modern Art). He sets subtly colored mechanical or abstracted natural forms against a background of land or sea and sky, at times playing upon perplexing positional relationships, as in *Project* (1946; London, British Council).

TYTGAT, EDGARD. Belgian painter, book illustrator, and graphic artist (b. Brussels, 1879; d. there, 1957). He studied at the Brussels Academy. At first Tytgat worked in an impressionistic style. Such a painting as the nude in a hammock, *Le Reveil du printemps* (1921; Rotterdam, Boymans-Van Beuningen Museum), appears transitional between his early works and the Vuillard-like interiors he painted about 1920. After the middle 1920s he painted in a naïve, primitivistic style derived from Henri Rousseau and popular European prints, at times with great charm and humor, as in the circus subject *Le marchand de coco* (1927; Brussels, Museum of Modern Art). From the 1940s on he showed a lightened palette and a looser technique in landscapes, interiors, and such fables and legends as the *Embarquement d'Iphigénie* (1950; Brussels, Fine Arts Museum).

UMLAUF, CHARLES. American sculptor (1911–). Born in Michigan, he studied at the Art Institute of Chicago and at the School of Sculpture in Chicago, and became professor of art at the University of Texas in Austin. He has received prizes from the Art Institute of Chicago, the University of Illinois at Urbana, the Ford Foundation (1960 purchase), and others. His style is based on a modified, sometimes almost schematic, interpretation of the human figure. He frequently interprets religious subjects.

UTRILLO, MAURICE. French painter of street scenes (b. Paris, 1883; d. Dax, Landes, 1955). His mother was the artist Suzanne Valadon, who had once been a traveling acrobat and later a model for such artists as Degas. By the time he was nineteen Utrillo had become an alcoholic and was unable to hold a job. At his mother's insistence he began to paint. She thought it would occupy him and possibly have some therapeutic value, but he sold his works cheaply to maintain his drinking.

His first pictures reveal a debt to the impressionists, notably Pissarro. From the beginning he represented scenes of Paris, particularly Montmartre. He had no formal training, but it can be assumed that he received criticism from his mother, an able draftsman. From 1908 to 1910 he went through his White Period. He painted from illustrated postcards as early as 1909. He exhibited for the first time in the Salon d'Automne in 1910 and two years later had his first one-man show, at Libaude's. He was very prolific despite the fact that his work was interrupted by drinking bouts and stays in hospitals and nursing homes.

In 1913 he designed sets for a Diaghilev ballet, *Barabau*.

and blue-grays, in strong contrast with rich blacks and browns and surprising touches of rust and vermilion. The breadth of conception lends a monumentality to his modest themes.

ROBERT REIFF

Maurice Utrillo, *The Church of Blevy*. Oil on canvas, 25½″ x 19½″. Museum of Modern Art, New York.

In 1928 he was made Chevalier of the Legion of Honor. After his marriage in 1935 he gave up drinking, took an interest in religion, and continued to paint prolifically. In fact, he tended to overproduce, and, although his pictures sold well, they fell off considerably in quality.

Utrillo's best-known pictures belong to his White Period. He depicted the deserted streets of Montmartre in subtle harmonies of milky and oyster whites, warm grays, olives,

VALADON, SUZANNE. French painter (b. Bessines, 1865; d. Paris, 1938). Her life was as tempestuous and dramatic as the famous era in French art in which she played an important role. As a young girl, Suzanne Valadon was the queen of the balls and studios of Montmartre and attracted the attention of many artists. Renoir admired her lustrous skin, Puvis de Chavannes her slenderness, Toulouse-Lautrec her features, already catching a glimpse of sadness and depravity in spite of her radiant youth. When she was eighteen, her son Maurice Utrillo was born.

Rather than invent forms, she sought to observe humanity to the point sometimes of biting cruelty. She admitted only to having been influenced by Gauguin's technique and that of his Pont-Aven friends, whose decorative style she had seen and admired at the Universal Exposition in 1899.

She usually painted nude figures, generally choosing as a model someone from the working class or a servant. Yet she painted some landscapes and still lifes and a few portraits, mostly of her son but also of her friends and of herself (*Autoportrait*, 1927). All her work is characterized by great power of expression and sharpness of observation, but the color is not always in agreement with the emphasis of her line, with the result that the canvases often give the impression of colored drawings. When she controlled her passion for crude colors and too obvious contrasts, she produced such superb work as *Chambre à coucher bleue* (1923; Paris, National Museum of Modern Art).

<div align="right">ARNOLD ROSIN</div>

VAN DOESBURG, THEO, *see* DOESBURG, THEO VAN.

VANTONGERLOO, GEORGE. Belgian sculptor, architect, painter, and theorist (1886–1965). Born in Antwerp,

he received instruction in painting, sculpture, and architecture at the Antwerp and Brussels art academies. In 1914 he met Theo van Doesburg in Holland, where he had been sent after joining the army. He attached himself to the de Stijl movement and collaborated on a publication of that name with Van Doesburg and Mondrian in 1917. During 1914–17 he was active in designing architectural projects. From 1919 to 1927 he resided in Menton, France, where he did his first abstract sculpture constructions and developed his theories on the relation of design to modern society. The latter led to the publication in 1924 of his *Art and Its Future*. From 1932 to 1935 he participated in the Paris Abstraction-Création group. He later lived a withdrawn existence in Paris. The Museum of Modern Art, New York, has *Construction in a Sphere* (1917), and Peggy Guggenheim owns *Construction in an Inscribed Square of a Circle* (1924). Vantongerloo was one of the most influential constructivists, combining ideas about science, architecture, painting, and sculpture.

ALBERT ELSEN

VASARELY, VICTOR DE. French painter (1908–). Born in Pécs, Hungary, he studied in Budapest and went to Paris in 1930. His paintings, influenced by Bauhaus and constructivist aesthetics, explore the spatial and optical possibilities of geometric shapes and flat, interactive color in what has come to be called Op Art.

VERISM (Veristic Surrealism). The post-World War I surrealistic representation of dream images with photographic precision in an illusionistic space. Unlike such practitioners of abstract surrealism as Miró and Masson, who created images through psychic automatism, veristic painters drew on objective reality for images to express subjective states. Ernst initiated this tendency; Tanguy and Dali have been two of its greatest exponents. Its method is illustrative, and its subject matter includes neoromantic idylls, constructed objects, and dream figures. *See* DALI, SALVADOR; ERNST, MAX; TANGUY, YVES.

VIEIRA DA SILVA, MARIA-HELENA. French abstract painter (1908–). Born in Lisbon, she studied sculpture under Bourdelle and Despiau and attended the studios of Dufresne, Friesz, and Léger and William Hayter's

"Atelier 17." She traveled extensively in Europe, remained in Brazil during World War II, and in 1947 returned to Paris, where she has been living ever since. Beginning with colored spots on a neutral background, she soon developed a personal style through dimensionless space. The painting of 1953 in the Guggenheim Museum, New York, is an excellent example of her infinite labyrinths and collapsing perspectives.

VIGAS, OSWALDO. Venezuelan painter (1926–). Born in Valencia, Venezuela, Vigas abandoned medicine to devote himself entirely to art. He studied at the School of Fine Arts, Valencia, and adopted abstract painting in 1952. In 1953 he went to Paris, where he has been living ever since. Vigas is interested in images of the earth, which he expresses in thick paint, mostly black and white. His paintings have been exhibited at the Salon de Mai, the Carnegie International (1955, 1957), the Venice Biennale (1954), and at the São Paulo Bienal (1953, 1955). In 1952 he was awarded the Venezuelan National Painting Prize and was commissioned to paint a large mural for the University of Caracas. Typical of his recent work is *Pierres fertiles* (1960), which reflects his obsession with earthly objects transposed into abstract forms.

VILLON, JACQUES (Gaston Duchamp). French painter (1875–1963). A brother of Marcel Duchamp and Raymond Duchamp-Villon, the sculptor, he was born in Damville and went to Paris in 1894. He earned a living from satirical and humorous drawings for the newspapers *Le chat noir*, *Gil Blas*, *L'Assiette au beurre*, and *Le courrier français*. Villon devoted the first fifteen years of his artistic life to this minor form of art, unable to liberate himself from it. He also made posters for Parisian cabarets and did lithographs. In 1903 he exhibited at the first Salon d'Automne. Toward 1906 he was able to devote himself primarily to painting.

Like many artists of his generation, he was at first influenced by Degas and Toulouse-Lautrec, but he was then seized by the spirit of Fauvism and determined to carry color to its highest intensity. In 1911 he adopted analytical cubism, composing his paintings according to strict principles and in a range of very refined colors.

His first abstract period was from 1919 to 1922 (*Le vol*; *Les chevaux de courses*). Overlapping planes are used to render a diversity of values, the artist seeking to express the essence of things rather than their exterior attributes. From 1922 to 1930 Villon was obliged, in order to earn a living, to devote himself almost entirely to engraving, and he executed a series of color reproductions of works by Braque, Picasso, Matisse, and others. After another period of abstractionism (*Le Théâtre*, 1933) he turned to pure colors. From 1914 on, he achieved a synthesis of all his ideas and feelings (*Entrée au parc*, 1948). Villon's painting, however, never completely nonfigurative, has retained a pyramidal constructive element and relies on color for spatial effects. His art continued to develop, ever faithful to the spirit of his early cubist works, as in *La Seine, au val de la Haye* (1959; Paris, Galerie Louis Carré), *Les grues près de Rouen* (1960; private collection), and *Au val de la Haye* (1960; private collection).

<div style="text-align: right">ARNOLD ROSIN</div>

VILLON AS GRAPHIC ARTIST

Between 1895 and 1907 Villon produced more than thirty lithographs, mostly in color, showing the gay life of bohemian Montmartre. Eight posters date from this period, among them the *Guinguette fleurie* of 1899, in which broad unmodulated planes recall the posters of Lautrec. Between 1899 and 1910 Villon made 175 etchings and aquatints, independent of his work for the *journaux amusants*, or illustrated newspapers, for which he periodically drew little vignettes of street and café life. In 1899 he executed his first color aquatints under the supervision of Eugène Delâtre, who had helped Mary Cassatt with this difficult technique. The tender relationship between mother and daughter in *Autre temps* (1904; Boston, Museum of Fine Arts) may derive from Cassatt.

Villon's version of cubism was sometimes geometrically calculated, as can be seen in his preliminary pencil, ink, and water-color drawings (1924; New Haven, Yale University Art Gallery) for the painting *The Jockey*. Profile, top, and side views are superimposed, and then Villon embarks upon a process of methodical dissection. The etching *Table d'échecs* (1920; New York, Museum of Modern Art) is composed of a series of overlapping pyramids. But Villon could record also states of emotion: the etching *Tête de fillette* (1929; Boston Public Library) shows a

young girl's face frozen in terror. He was a sensitive portraitist.

Villon illustrated, among others, Racine's *Cantique spirituel* (1945), in which the crucified Christ seems to float away from the restraining Cross; Hesiod's *Les travaux et les jours* (1962), in which the linear drawings are remarkably free and delicate; and Max Jacob's *A poèmes rompus* (1960). ABRAHAM A. DAVIDSON

.VLAMINCK, MAURICE. French painter (b. Paris, 1876; d. Rueil-la-Gadelière, 1958). His parents were musicians and led a Bohemian existence, so that the young Vlaminck received little schooling. He knew Derain as a boy, and the two artists were lifelong friends. In 1895 he took a few drawing lessons. After 1899 he earned his living as a violinist, but he and Derain set up a studio at Chatou, and he came to know impressionist art. When he saw the Van Gogh exhibition at Bernheim-Jeune's in 1901, he was overwhelmed, and his own painting began to show

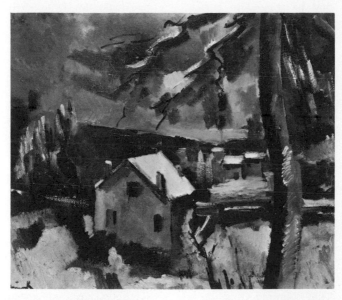

Maurice Vlaminck, *Winter Landscape* (1916–17). Oil on canvas, 21¼" x 25½". Museum of Modern Art, New York. Gift of Mr. and Mrs. Walter Hochschild.

the influence of Van Gogh. He met Matisse the same year and exhibited for the first time at the Salon des Indépendants. He wrote his first novel in 1901, and two others followed shortly.

By 1905 he and Derain began to frequent a favorite café of avant-garde artists, the Azon in Montmartre. There they met Picasso, Max Jacob, Kees van Dongen, Apollinaire, Matisse, and others. Vlaminck exhibited with a group at Berthe Weill's and at the Salon d'Automne. It was at the latter that a critic referred to the art as that of wild beasts, or *fauves*, a name which the painters themselves then adopted and which has since been used to designate the art of the group at that time. Vollard purchased all the pictures in Vlaminck's studio in 1906.

In 1908 Vlaminck changed his style radically. He moved away from Fauvism and closer to the late Cézanne. In 1919 he was given an extensive exhibition at Drouet's in Paris. In 1925 he moved to Rueil-la-Gadelière, where he was to spend most of the rest of his life.

Vlaminck was rebellious by temperament. He proudly announced that he had never been inside the Louvre and that he wanted to burn down the Ecole des Beaux-Arts with his cobalts and vermilions. He favored brilliant color, straight from the tube. He would combine bright reds with full oranges and heighten their intensity with bright blues and greens. Like Van Gogh, he favored the pull of forced perspective. Despite all his anarchical intent, he developed little as a Fauve. He chose landscape subjects not unlike those of the impressionists. His art appears limited and brash compared to Matisse's, but almost restrained compared to that of the German expressionists.

ROBERT REIFF

VORTICISM. Variety of cubist futurism, exclusive to England, that was invented by Wyndham Lewis (1884–1957). *See* LEWIS, WYNDHAM.

VUILLARD, EDOUARD. French decorative painter (b. Cuiseaux, Saône-et-Loire, 1868; d. La Baule, 1940). At the Académie Julian in Paris, Vuillard's fellow students included Bonnard and others who were founder-members of the Nabis. They admired Gauguin, and his synthetist ideas influenced their thinking. They exhibited as a group until 1899.

Vuillard, however, exhibited regularly at the Galerie Bernheim-Jeune, the Salon des Indépendants, and the Salon d'Automne. He taught at the Académie Ranson in 1908. In 1913 he and Bonnard made a trip to England and Holland. That year he also produced the decoration for the foyer of the Théâtre des Champs-Elysées. In 1937 he designed decorations for the Palais de Chaillot and two years later for the League of Nations Palace in Geneva.

Vuillard's painting is in close accord with that of Bonnard. They were both influenced by the late art of Monet and by Gauguin, Seurat, the Japanese print and the then-fashionable Art Nouveau movement. Their subject matter and the treatment of it are similar, and they were termed "intimists." They both were fond of representing the restricted, quiet, and cultivated life of the upper-middle-class French family, always in a peaceful, offhand moment in the routine of its existence. Vuillard would show a woman musing over a teacup or seated in the corner of a large sofa embroidering. These simple scenes are often transformed into a tapestry of impressionist color.

ROBERT REIFF

VYTLACIL, VACLAV. American painter (1892–). Born in New York City, he studied at the Art Institute of Chicago, the Art Students League, and with Hans Hofmann in Munich. Vytlacil was a founding member of American Abstract Artists. At the beginning of his career he was influenced by cubism and by the orphism of Delaunay. In the late 1930s Vytlacil was painting figure compositions derived from Picasso's classical phase. By the early 1950s he had moved into strongly painted, semiabstract sea- and landscapes, in which the formal structure was nearly hidden by the emotional expression, as in the vigorous and improvised *Forest* (1949; Washington, D.C., Phillips Collection).

WADSWORTH, EDWARD. English painter (b. Cleckheaton, Yorkshire, 1889; d. Uckfield, Sussex, 1949). He studied in Munich and at the Slade School, London. Wadsworth exhibited with the vorticists and was a member of the London Group and Unit One. As an official artist during World War I, he became known as a painter of camouflaged vessels, for example, *Dazzle Ships in Drydock at Liverpool* (ca. 1918; Ottawa, National Gallery of Canada). In the early 1920s he was painting still lifes of sea shells and flowers with a cubistic formal structure. Shortly thereafter, he evolved his characteristic combination of semiabstract machine forms seen against a view of sea and sky, as in *Marine* (1928; Leeds, City Art Gallery).

WALKOWITZ, ABRAHAM. American painter (b. Tumen, Siberia, 1880; d. New York City, 1965). Walkowitz went to the United States in early childhood. He studied with Walter Shirlaw at the National Academy of Design and with Laurens at the Académie Julian in Paris. He exhibited at the 1913 Armory Show. An early champion of modern art in the United States, Walkowitz held his first important exhibition at Stieglitz's avant-garde "291" in 1912 and was associated with that gallery until 1917. The basis of his style is a lyrical use of Cézanne-derived treatment of figure and landscape, with an emphasis on strong rhythm most readily apparent in his innumerable Rodinesque water colors and drawings of the dancer Isadora Duncan.

WARD, LYND. American graphic artist (1905–). Ward was born in Chicago. Since attending Teacher's College of Columbia University in New York City and

the Academy for Graphic Arts in Leipzig, he has illustrated more than 100 books with woodcuts, wood engravings, and lithographs. He also invented the novel in woodcuts, examples of which are *God's Man* (1929) and *Vertigo* (1937).

WARHOL, ANDY. American painter, film-maker, and commercial artist (1929–). Warhol was educated at the Carnegie Institute of Technology in Pittsburgh and spent the first part of his working life as a commercial artist (about 1947 to 1959). To this completely depersonalized work may be traced both the techniques and the general approach of the Pop painter of the next few years (1960–1968), after which Warhol abandoned painting for film-making.

During his commercial art days Warhol had developed a blotting technique from which pictures could be reproduced impersonally by others, just as during his "fine art" period he utilized silk-screen technique for his portraits of famous people such as Jacqueline Kennedy and Marilyn Monroe. With the later silk screens the hand of the artist had almost no function, either on the screen itself or on the canvas to which the design was transferred. The artist limited himself to choosing a ready-made image from a commercial medium, such as a picture in the newspapers, an advertisement, or a piece of movie publicity, and after adding brilliant commercial color to it, turned it over to his assistants for cumulative and continuous silk screening so as to achieve maximum impact. This machinelike reality contains, in addition to the mechanically produced portraits, such themes as Campbell soup cans, Brillo boxes, and similar items that reflect the Pop culture. BERNARD S. MYERS

WARNEKE, HEINZ. American sculptor (1895–). Born in Bremen, Germany, he studied at the Academy of Art in Bremen and at the Academy of Art in Berlin. He went to the United States in 1923. Warneke has received awards and prizes from the Art Institute of Chicago, the Pennsylvania Academy of Fine Arts, the Washington Artists Association, and others.

Warneke's style is one of simplified, sometimes semi-abstract figural treatment based on the essential planes, volumes, and movement of his subjects (often animals). He has worked in granite, marble, bronze, and brass, sometimes actually carving the last substance from a rough-

ly cast block. Many of his statues have a finely polished surface. Among his characteristic works are *Startled Deer*, *Boar*, *Cat*, and *Stallion Rearing*.

WAROQUIER, HENRY DE. French painter, sculptor, and graphic artist (1881–). Born in Paris, he had some early training in architecture but is self-taught as a painter. The two sources of his painting can be seen in his early Bretagne landscapes which combine impressionism with the formalization of Japanese art. His first trip to Italy in 1912 resulted in a more sober palette due to the influence of primitive landscapes and Italian frescoes. Waroquier has been more concerned with the linear and volumetric elements in painting than with color; for a period after 1932 he concentrated almost exclusively on the figure, particularly the female nude, and, more recently, he has concentrated on sculpture.

WATKINS, FRANKLIN CHENAULT. American painter (1894–1972). Born in New York City, he studied at the Pennsylvania Academy of Fine Arts and traveled in Europe in 1923. Watkins first attracted attention when his overly dramatic *Suicide in Costume* (1931; Philadelphia Museum of Art) won a prize at the Carnegie International of 1931. The violent pose and fitful painting and lighting reveal a debt to El Greco. Similar expressionist means appear in *The Fire-Eater* (1933–34; Philadelphia Museum of Art), where twisted figures, turbulent setting, and excited brushstrokes effectively parallel the subject. Much of Watkins's later work is of a religious or symbolic nature, for example, *The Angel Will Turn a Page in the Book* (1944; Washington, D.C., Phillips Collection).

WEBER, MAX. American painter and sculptor (1881–1961). Weber was born in Bialystok, Russia, and went to the United States in 1891. His first formal art education was at the Pratt Institute in New York City (1898–1900), where he was influenced by Arthur Wesley Dow's principles of design. Weber was in Europe from 1905 to 1908; during these years he absorbed the ideas of the crucial early movements in modern art which were later to fuse with his own expressive means in his work. He became a

close friend of Henri Rousseau and studied with Matisse in 1907.

Weber's early paintings, executed after his return from Europe, are mostly Fauve in inspiration, but in such a work as *The Geranium* (1911; New York, Museum of Modern Art) the angular treatment of faces, limbs, and drapery is close to early cubism. For the next few years Weber's paintings were dominated by a cubism combined with a futurist concern for the depiction of speed and objects in motion. *Chinese Restaurant* (1915; New York, Whitney Museum) is a synthetic cubist composition of textures and forms derived from the motif with moving figures treated as an essential pattern. In this period Weber also produced sculptures, some completely abstract, others representational in a primitive style. From 1917 on Weber began to paint less abstractly, with more individuality in subject and treatment, and to develop his coloristic gifts. Most of his paintings of the 1920s and early 1930s were classic Cézannesque figure, landscape, and still-life compositions, often poetic in subject and contemplative in mood.

In the late 1930s, Weber became increasingly concerned with religious subjects. They had sporadically appeared earlier but now emerged fully developed. Their themes are of Jewish life, richly and emotionally painted. Some of Weber's finest paintings have been of the Hassidim, a mystical Jewish sect which had impressed Weber during his boyhood in Russia. Their religious intensity found expression in paintings of their joyous dances as well as in more restrained scenes, such as *Adoration of the Moon* (1944; Whitney Museum), where four men in distinctive Hassidic dress are engaged in a moon-struck discussion. Weber continued to use these religious subjects in later work, in near-expressionist paintings of strong color and free linear design. It is noteworthy that he was strong enough to discard abstraction when it no longer served his artistic needs. JEROME VIOLA

WINTER, FRITZ. German painter (1905–). Winter studied at the Bauhaus in Dessau (1927–30) and worked with Kandinsky. He was prevented from painting by the Nazi regime in 1933 and served in the German army during World War II. Taken prisoner by the Russians, he was not released until 1949. He has received awards

at the Venice Biennale (1950), the Milan Triennale (1954), and the São Paulo Bienal (1955). His work has always been abstract, complex in regard to the use of brushstroke and line, levels of space, and effects of light, and highly disciplined in the Bauhaus tradition.

WOESTIJNE, GUSTAVE VAN DE, see LAETHEM-SAINT-MARTIN SCHOOL.

WOLS (Wolfgang Schulze). German painter (b. Berlin, 1913; d. Paris, 1951). He studied briefly at the Bauhaus. In 1932 he moved to Paris, where he was associated with the surrealists. He began to paint seriously after World War II and had his first one-man show at the Galerie Drouin in Paris. Influenced by Klee, Kandinsky, and Fautrier, Wols's free improvisations of line and color exemplify what has become known as *art informel* or *art autre.*

WOOD, CHRISTOPHER. English painter (b. Knowsley, Lancashire, 1901; d. Salisbury, 1930). He studied at the Académie Julian in Paris and traveled widely on the Continent and around the Mediterranean. He was a friend of Cocteau and Nicholson and of Picasso.

Wood's "primitivism," like that of Henri Rousseau, is merely on the surface, more the product of a personal method of vision than of a lack of technical skill. His fine sense of color enabled him to paint playfully, at times inserting a spot of seemingly discordant color that yet keeps its place, adds excitement, and works with the total design. At first Wood borrowed from Modigliani, Matisse, Seurat, and Picasso, but borrowings became fewer as his work progressed. His subjects include mostly still lifes, landscapes, beach scenes, and a few portraits, such as *Max Jacob* (1929; Paris, Louvre). In his best works, harbor scenes and fishing villages in Cornwall and Brittany, he used color schemes of white, brown, gray, and green with his characteristic grayish crosshatching for areas of sky and foam. Within the limits of his style, Wood was remarkably successful at depicting conditions of weather and light. JEROME VIOLA

WOODRUFF, HALE. American painter (1900–). Born in Cairo, Ill., he was educated in art at the John Herron Art

Institute and the Fogg Art Museum. He also worked in Paris at the Académie Moderne and the Académie Scandinave. He was art director at Atlanta University from 1931 to 1946 and subsequently taught at the New York University School of Education. His first one-man show was held in New York at the Bertha Schaefer Gallery in 1952. Woodruff's painting consists of strong compositions in quiet earth colors based on landscape themes but semiabstract and angular in form. They are often worked out in terms of a precise calligraphy that suggests one side of the abstract expressionist movement. But Woodruff retains an original approach. It has been said that his paintings are "permeated with a sense of fate" as though inspired by more than aesthetic purpose alone.

WORKSHOP FOR POPULAR GRAPHIC ART, *see* TALLER DE GRAFICA POPULAR.

WOTRUBA, FRITZ. Austrian sculptor (1907–). He studied at the Vienna School of Arts and Crafts and lived in Switzerland and Paris from 1937 to 1945. He exhibited in many international expositions including those at Arnhem, Venice, London, and Amsterdam. His style, which is semiabstract, refers to figural forms.

WOUTERS, RIK. Belgian painter, sculptor, and draftsman (b. Mechlin, 1882; d. Amsterdam, 1916). He studied at the Mechlin Academy, then at the academy in Brussels, where he settled in 1905. He participated in the so-called Brabançon Fauvism. Wouters went to Paris in 1912, and was strongly influenced by impressionism. He endeavored to reconcile Cézanne's constructiveness, Renoir's interest in life, and Matisse's decorative composition. Wouters's best paintings and sculpture date from that period (for example, *Fleurs d'anniversaire*, 1912; *Soucis domestiques*, 1913). In less than seven years he made a remarkable contribution to Belgian art and was its principal representative of Fauvism; his work prepared the way for Belgian expressionism.

WRIGHT, FRANK LLOYD. American architect (b. Richland Center, Wis., 1869; d. Scottsdale, Ariz., 1959). One of the great artists of our time, Wright was largely self-taught—about three semesters of civil engineering at the

University of Wisconsin was the extent of his higher education. He went to Chicago in 1887, first to work for Lyman Silsbee and, in the same year, for the firm of Adler and Sullivan, the leading architectural office in Chicago at that time. Throughout his life Wright expressed his artistic indebtedness to Louis Sullivan, and he formally acknowledged the debt in *Genius and the Mobocracy* (New York, 1949), a romantic biography of Sullivan. Their association lasted until 1893, when Wright started an independent career. He traveled to Japan in 1905; visited Europe in 1910–11; and returned to Japan in 1916, remaining until 1922. After a decline in his practice during the 1920s and early 1930s he began, at the age of sixty-six, what amounted to a second lifetime, which spanned the next 2½ decades.

While working for Sullivan, Wright handled most of the firm's domestic jobs: the Charnley House (Chicago, 1891) was the most notable of this period. Up to 1910 his independent work, which was largely domestic, was for a wealthy clientele, located mostly in the suburbs of Chicago. The Winslow House (River Forest, 1893) was his first major building, its horizontal emphasis and broad, hovering roof suggestive of the mature Prairie houses yet to come. Its massive form is like that of H. H. Richardson and its intricate ornament similar to Sullivan's.

By about 1900 Wright's personal style had matured. With the River Forest Golf Club (1898; demolished), the Husser House (Chicago, 1899; demolished), and the Waller House (River Forest, 1899), the beginnings of his characteristic open, centrifugal plans emerged. During the first decade of the 20th century the definitive Prairie house was formulated in the Bradley and Hickox Houses (Kankakee, Ill., 1900); the *Ladies' Home Journal* projects (pub. February and June, 1901); the Willits House (Highland Park, 1902); the Roberts House (River Forest, 1908); and the Robie House (Chicago, 1909), the latter culminating Wright's Prairie house phase. Aligned on a suburban street and lavishly decorated with polychrome brick, leaded windows, and flower vases, the home is typical of 19th-century well-to-do American suburbia. Yet its flexible spaces, loosely defined by screens, and its planar elements, centrifugally oriented about a massive vertical chimney, are decidedly 20th century. (See illus., vol. 4, p. 425.)

The two important nondomestic works of Wright's early

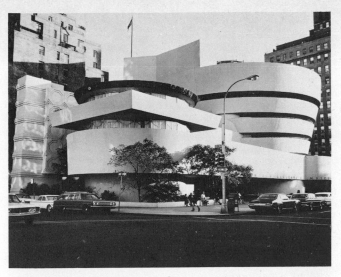

Frank Lloyd Wright, Solomon R. Guggenheim Museum (1956–59). New York, N.Y.

period are Unity Church (Oak Park; designed 1904, built 1906–07) and the Larkin Building (Buffalo, N.Y., 1904; demolished). The church, an early example of the architectural application of reinforced concrete, consists of two major spaces—worship and living—linked by a common entry space. The cubic auditorium, with galleries on three sides, is defined by the three-dimensional interlocking of structural and spatial elements, with corner blocks used for circulation and utilities.

The Larkin Building was like a contemporary office building turned inside out. Open work spaces were arranged around an inner court, glazed overhead and supported by corner piers, which were again used for mechanical activities. The massive, sculptural bulk of this building attracted the attention of the architectural world at the beginning of the century, where it ranked with such key commercial and industrial works as Sullivan's Carson Pirie Scott and Company Store (Chicago, 1899–1904); Peter Behrens's AEG Turbine Factory (Berlin, 1909); and Gropius's Fagus Factory (Alfeld an der Leine, 1911–16). Wright's influence spread abroad through first-hand con-

tacts with architects such as the Dutch H. P. Berlage and by two publications of his major early works (*Ausgeführte Bauten und Entwürfe von Frank Lloyd Wright*, Berlin, 1910; and C. R. Ashbee, ed., *Frank Lloyd Wright: Ausgeführte Bauten*, Berlin, 1911).

On his return from Europe in 1911 Wright undertook several large projects. He started construction on his own home in Spring Green, Wis., which suffered two fires and underwent countless expansions and variations until the time of his death. Like Thomas Jefferson's Monticello, it has the quality of a self-contained plantation, with production handled on the premises and with a design worked out empirically over a lifetime. Midway Gardens (Chicago, 1913–14; demolished) was an outdoor dining-entertainment area, a kind of beer hall organized by a series of terraces. Wright's chief work of this period was the Imperial Hotel (Tokyo, 1915–22; demolished 1967), a massive, brooding, ornamented pile on an H plan, organized around water pools.

Aside from some small houses in the early 1920s (Hollyhock House, Los Angeles, 1920; Millard House, Pasadena, 1923), Wright's practice went into a total decline until the mid-1930s.

In the 1930s Wright renewed his production with the Willey House (Minneapolis, Minn., 1932–34) and a series of Usonian houses, including the Jacobs House (near Madison, Wis., 1937); the Schwartz House (Still Bend, Two Rivers, Wis., 1939); and the Winkler-Goetsch House (Okemos, Mich., 1939). Taliesin West, in Scottsdale, Ariz., was also started at this time (1938) and, like Spring Green, continued to be built until the time of the architect's death. The classic of this period, Falling Water (Bear Run, Pa., 1936), dramatically hovers above a waterfall. Intersecting concrete planes are cantilevered from a central tower of rough, natural stone.

In the industrial realm, Wright built the S. C. Johnson Wax Company Administration Building (Racine, 1937–39). Curvilinear forms enclose a city block; myriads of mushroom columns of various heights support everything from the tight, low parking garages below to the soaring, imaginative offices above. As in the Larkin Building, the offices dramatically embrace a central space; the building turns its back on its surroundings. The research tower (1950), a concrete trunk supporting cantilevered floors, is

the focal point of the composition. Like a precision machine in action, the building symbolizes 20th-century industry.

Wright's work proliferated after World War II. Of small dimensions but immense quality is the Morris Gift Shop (San Francisco, 1948–49). A blank brick wall, pierced by a yawning Richardsonian arch, invites the pedestrian to enter a dreamworld of curvilinear forms organized within a cubical volume. Inside, the spiral ramp foreshadows the totally curvilinear form and completely continuous space of the Guggenheim Museum (New York; completed 1959), one of Wright's last and most provocative buildings.

A giant figure historically, Wright stems from the 19th-century romantic tradition of Thoreau, Whitman, and Sullivan. Yet his masterful handling of space, his intuitive engineering, and his poetic sense of modern industry are decidedly of this century.

THEODORE M. BROWN

WRIGHT, JOHN LLOYD. American architect (1892–). The son of Frank Lloyd Wright, John was born in Oak Park, Ill., and educated at the University of Wisconsin and the Chicago Art Institute. He was chief draftsman in his father's office between 1913 and 1919, and established his own practice in 1926, doing mostly domestic works in the Midwest and Far West. Wright has also written several books, including *My Father Who Is on Earth* (New York, 1946) and *Appreciation of Frank Lloyd Wright* (London, 1960).

WURSTER, WILLIAM WILSON. American architect (1895–1973). Born in Stockton, Calif., and educated at the University of California, afterward he worked in the office of J. Ried in San Francisco (1920) and of C. F. Dean (1921–22) and Delano and Aldrich in New York (1923–24) before starting his own office (1926). He developed an influential practice with T. Bernardi and D. Emmons in San Francisco; the firm of Wurster, Bernardi, and Emmons was founded in 1945. Wurster was dean of architecture at the Massachusetts Institute of Technology (1944–50) and at the University of California (1950–59); in 1959 he became dean of environmental design at California.

WYETH, ANDREW NEWELL. American painter (1917–). Born in Chadd's Ford, Pa., he is the son of the painter and illustrator N. C. Wyeth, with whom he studied. Wyeth is a skilled water-colorist but is best known for his microscopically detailed tempera paintings of Maine and Pennsylvania landscapes and rural subjects. The minutely depicted surfaces rarely become cloying because Wyeth combines his realism with unusual angles of vision and strong design and surrounds his subjects with a seemingly symbolic atmosphere all the more powerful because it is vague, as in the often reproduced *Christina's World* (1948; New York, Museum of Modern Art).

XCERON, JEAN. Greek-American painter (b. Isari, 1890; d. New York, 1967). Xceron was a pioneer of nonobjective painting in the United States, where he first went in 1904. In 1912 he began to study at the Corcoran Art School in Washington, D.C., but he soon became interested in Cézanne and in cubism and increasingly concerned with the geometric structure of objects and the use of color as a means of modeling. During the 1920s in Paris he met Arp, Braque, and Picasso, and in 1931 Xceron's first one-man show brought critical acclaim. He returned to the United States in 1937, joined the staff of the Guggenheim Museum in New York in 1939, and exhibited widely. A number of his works are owned by the Guggenheim Museum, which gave him a one-man exhibition in 1965. His art is characterized by clarity of outline, austerity of means, and structural design.

YAMASAKI, MINORU. American architect (1912–).
Born in Seattle, Wash., he was educated at the University
of Washington (graduated 1934). He traveled to Japan
(1933) and worked in several New York offices before
practicing in Detroit. A well-known work is the St. Louis
Airport (1953–55; with Hellmuth and Leinweber), a large
space dramatically defined by three shell concrete groin
vaults. In 1966, at Princeton University, he constructed a
building with a lacy concrete façade, for the Woodrow
Wilson School of Public and International Affairs.

YEATS, JACK BUTLER. Irish painter (b. Sligo, 1871;
d. Dublin, 1957). He was the son of the painter John B.
Yeats and brother of the poet William B. Yeats. Jack was
first influenced by impressionism, but even some of his
dark-toned early works show the ease with which he could
catch a likeness or render a scene. By the middle 1920s,
however, Yeats had adopted a spontaneous, loose, expres-
sionistic manner of painting. This technique of bright color
and excited, slashing strokes was applied to landscapes,
figures, and scenes from Irish daily life or Celtic mythology,
not with ironic social intent but rather as an expression of
abundant life and immense vitality.

YUNKERS, ADJA. Latvian-born American printmaker,
painter, and pastelist (1900–). Born in Riga, he studied
in Leningrad, Berlin, Paris, and London before going to
the United States in 1947. From 1942 to 1945, in Stock-
holm, he edited and published *Creation*, *ARS*, and *ARS-
Portfolios* containing original prints by Scandinavian art-
ists, and in 1950 published *Prints in the Desert* in Albu-
querque, N.Mex. He has been awarded two Guggenheim

fellowships and a Ford Foundation grant. His most ambitious print was published in 1953, a polyptych of large color woodcuts, with a center panel entitled *Magnificat*. It has been described as his personal ontology, combining symbolism and abstraction.

Z

ZADKINE, OSSIP. French sculptor and teacher (1890–1967). He was born in Smolensk, Russia, and lived and taught in Paris. In 1906 he studied at the Polytechnic School of Art, London, and in 1909 he was at the Ecole des Beaux-Arts, Paris. He began stone carving in 1911 and was influenced by Rodin, African art, and cubism, as can be seen in *The Prophet* (1915; Grenoble Museum) and *Woman with a Fan* (1918). His first exhibition was in Belgium, in 1919, and after 1922 he had several other shows in Holland, where his work is especially highly regarded.

From 1946 to 1953 he was professor of sculpture at the Grande-Chaumière Academy in Paris; he also taught at his own school. In 1951–53 he worked on a commission from Rotterdam for a memorial to the victims of the Nazis' destruction of that city. *Orpheus* (1928) is in the Petit Palais Museum, Paris; *Stag* (1927) is in the Stedelijk Museum, Amsterdam; and the 1949 version of *Orpheus* is in the National Museum of Modern Art, Paris. One of the pioneering cubists, Zadkine was an influential teacher.

ZAO WOU-KI. Sino-French painter and printmaker (1921–). Born in Peking, he studied at the School of Fine Arts in Hangchow and taught there until 1947. By the time of his first exhibition in Shanghai (1941), his work already showed the influence of Western artists, notably Picasso, Matisse, and Modigliani. After settling in Paris (1948) he achieved great success with both his paintings and graphic work, exhibiting there for the first time in 1951. His paintings, etchings, and lithographs of this period are highly imaginative evocations of landscapes, animals, and other forms, which drew inspiration from the delicate and concise meanderings of Paul Klee. He has since developed a nonfigurative style using clusters of brushstrokes that resemble a kind of calligraphy.

ZEHRFUSS, BERNARD H. French architect (1912?–). He collaborated with Marcel Breuer and Pier Luigi Nervi on the design of the important UNESCO complex at the Place Fontenoy in Paris (1953–58). His style expresses the contemporary idiom, as in the exhibition building of the Centre National des Industries et Techniques (1958; with J. de Mailly and R. Camelot). One of the most significant structures built in France since World War II, it is conceived in bold parabolic planes.

ZERBE, KARL. German-American painter and teacher (1903–1972). Born in Berlin, he studied with Joseph Eberz and Karl Caspar in Munich and in Italy. Zerbe went to the United States in 1934. Throughout his career he had worked in several variations on his basic expressionism: early, colorful landscapes and flower pieces; the incorporation of influences from Kokoschka, Lehmbruck, and Grosz in the early 1930s with a treatment akin to that of Beckmann; and his mature and more personally expressive figures and symbolic paintings. Zerbe most successfully experimented with different media, including encaustic, where the potentially richly colored and worked surface led to particularly happy results, for example, *Harlequin* (1943; New York, Whitney Museum), and later with polymer tempera. In his latest paintings his expressionism approached abstraction.

ZORACH, WILLIAM. American sculptor (1887–1966). Born in Lithuania, he was brought to the United States as a young child. He studied in Cleveland and at the National Academy of Design from 1906 to 1908 and with Fergusson and Blanche in Paris in 1910–11. He then worked mainly as a painter and exhibited at the Salon d'Automne in Paris in 1911 and at the New York Armory Show in 1913. He did direct carving before 1920. About 1922 he began to devote his energies exclusively to sculpture. Much of his work was in very hard stones, and other work was in wood; he also did some modeling.

Zorach's painting had been influenced by the earlier 20th-century avant-garde movements, but his sculptural style was more restrained. Using Egyptian sculpture, archaic Greek sculpture, and to a lesser extent the sculpture of primitive peoples as referents, he developed a full-volumed, modified naturalistic expression tending toward great stability and quietness. From the 1930s he was con-

cerned with themes of tenderness—animals in repose, children with animals, motherhood, and so on. He sometimes used natural boulders in his animal compositions, carving out the form with great economy and with resultant monumentality even when the physical scale was small.

<div align="right">JOHN C. GALLOWAY</div>

BIBLIOGRAPHY

GENERAL WORKS

Arnason, H. H., *History of Modern Art,* New York, 1969.

Baur, John I. H., *Revolution and Tradition in Modern American Art,* New York, 1967.

Brown, Milton W., *American Painting from the Armory Show to the Depression,* Princeton, N.J., 1970.

Cassou, J., E. Langui, and N. Pevsner, *Gateway to the Twentieth Century,* New York, 1962.

Goldschmidt, Ernst, *Art since Mid-Century* (2 vols.), Greenwich, Conn., 1971.

Goodrich, L., and John I. H. Baur, *American Art of Our Century,* New York, 1961.

Gray, Camilla, *The Great Experiment: Russian Art 1863–1922,* New York, 1962.

Haftmann, Werner, *Painting in the Twentieth Century* (2 vols.), New York, 1965.

Le Corbusier, *Towards a New Architecture,* New York, 1970.

Licht, Fred S., *Sculpture: The Nineteenth and Twentieth Centuries* (vol. 4, *History of Western Sculpture*), Greenwich, Conn., 1967.

Lucie-Smith, Edward, *Late Modern: The Visual Arts since 1945,* New York, 1969.

McCurdy, Charles, et al., *Modern Art: A Pictorial Anthology,* New York, 1958.

Myers, B. S., ed., *Encyclopedia of Painting,* 3d rev. ed., New York, 1970.

Myers, B. S., and S. D. Myers, eds., *McGraw-Hill Dictionary of Art* (5 vols.), New York, 1969.

Myers, B. S., *Mexican Painting in Our Time,* New York, 1956.

Roh, Franz, *German Art in the Twentieth Century,* Greenwich, Conn., 1968.

Rose, Barbara, *American Art since 1900,* New York, 1967.

Schmutzler, Robert, *Art Nouveau,* New York, 1964.

Sharp, Dennis, ed., *A Visual History of Twentieth Century Architecture,* Greenwich, Conn., 1972.

Trier, Eduard, *Form and Space: Sculpture of the Twentieth Century,* rev. ed., New York, 1968.

MAJOR 20th CENTURY MOVEMENTS IN ART

Abstract Expressionism: Hess, Thomas B., *Abstract Painting,* New York, 1951. Sandler, Irving, *The Triumph of American Painting: A History of Abstract Expressionism,* New York, 1973. Tuchman, Maurice, *New York School: The First Generation,* Greenwich, Conn., 1971.

Bauhaus: Roters, Eberhard, *Painters of the Bauhaus,* New York, 1969.

Cubism: Fry, Edward F., *Cubism,* New York, 1966. Rosenblum, Robert, *Cubism and Twentieth-Century Art,* New York, 1968. Schwartz, Paul W., *Cubism,* New York, 1971.

Dada: Richter, Hans, *Dada: Art and Anti-Art,* New York, 1970.

Expressionism: Myers, B. S., *The German Expressionists: A Generation in Revolt,* New York, 1957. Selz, Peter, *German Expressionist Painting,* Berkeley, 1957. Sotriffer, K., *Modern Graphics: Expressionism and Fauvism,* New York, 1972.

Fauvism: Duthuit, Georges, *Fauvist Painters,* New York, 1950. Muller, Joseph-Emile, *Fauvism,* New York, 1967.

Futurism: Taylor, Joshua C., *Futurism,* Greenwich, Conn., 1961.

Mexican Revolution: Myers, B. S., *Mexican Painting in Our Time,* New York, 1956.

Minimal Art: Battcock, Gregory, ed., *Minimal Art: A Critical Anthology*, New York, 1968.

Pop Art: Lippard, Lucy R., *Pop Art*, New York, 1966.

Social Realism: Agee, William C., *The 1930's: Painting and Sculpture in America*, New York, 1970.

Surrealism: Waldberg, Patrick, *Surrealism*, New York, 1966.

MAJOR MASTERS

Aalto: Aalto, Alvar, *Alvar Aalto: Complete Works, 1922–1960*, New York, 1970. Gutheim, Frederick, *Alvar Aalto*, New York, 1960.

Albers: Bucher, F., *Joseph Albers: Despite Straight Lines*, New Haven, 1961.

Arp: Read, Herbert, *The Art of Jean Arp*, New York, 1968.

Barlach: Carls, Carl D., *Ernst Barlach: Sculptor, Craftsman and Playwright*, New York, 1969. Werner, Alfred, *Ernst Barlach*, New York, 1966.

Beckmann: Selz, Peter, et al., *Max Beckmann*, Greenwich, Conn., 1964.

Bonnard: Fermigier, André, ed., *Bonnard*, New York, 1969. Vaillant, A., *Bonnard*, Greenwich, Conn., 1965.

Brancusi: Brogza, G., *Brancusi*, Bucharest, 1965. Geist, Sidney, *Constantin Brancusi*, Greenwich, Conn., 1969.

Braque: Ponge, Francis, and Pierre Descargues, eds., *Georges Braque*, New York, 1971. Russell, John G., *Braque*, London, 1959.

Calder: Arnason, H. H., and P. E. Guerrero, *Calder*, Princeton, N.J., 1966. Sweeney, J. J., *Alexander Calder*, New York, 1951.

Chagall: Cassou, Jean, *Chagall*, New York, 1966. Meyer, Franz, *Marc Chagall*, New York, 1964.

Chirico: Far, Isabella, ed., *Giorgio Di Chirico*, New York, 1971.

Dali: Descharnes, Robert, *The World of Salvador Dali*, New York, 1968. Gerard, Max, ed., *Dali*, New York, 1968.

Davis: Smithsonian Institution, *Stuart Davis Memorial Exhibition,* Washington, D.C., 1965.

De Kooning: Hess, Thomas B., *Willem De Kooning,* Greenwich, Conn., 1969.

Delaunay: Vriesen, Gustav, and Max Imdahl, *Robert Delaunay; Light and Color,* New York, 1967.

Demuth: Ritchie, A. C., *Charles Demuth,* New York, 1950.

Derain: Sutton, D., *André Derain,* New York, 1959.

Doesburg: Jaffé, H. L. C., *De Stijl, 1917–1931: The Dutch Contribution to Modern Art,* Amsterdam, 1956.

Duchamp: Schwarz, Arturo, ed., *Complete Works of Marcel Duchamp,* New York, 1970.

Dufy: Werner, Alfred, ed., *Dufy,* New York, 1970.

Ernst: Russell, John, ed., *Max Ernst,* New York, 1967. Spies, Werner, *Max Ernst, Nineteen Fifty to Nineteen Seventy,* New York, 1972.

Feininger: Scheyer, Ernst, *Lyonel Feininger: Caricature and Fancy,* Detroit, 1964.

Gabo: Gabo, Naum, *Gabo: Constructions, Sculpture, Paintings, Drawings [and] Engravings,* with introd. essays by H. Read and L. Martin, Cambridge, Mass., 1957.

Giacometti: Hohl, Reinhold, *Giacometti,* New York, 1971.

Gorky: Levy, Julien, ed., *Gorky,* New York, 1968. Schwabacher, E., *Arshile Gorky,* New York, 1957.

Gris: Kahnweiler, D. H., *Juan Gris,* New York, 1969.

Hartley: McCausland, E., *Marsden Hartley,* Minneapolis, 1952.

Henri: Read, H. A., *Robert Henri,* New York, 1931.

Hofmann: Hunter, Sam, ed., *Hans Hofmann,* New York, 1964.

Hopper: Goodrich, Lloyd, ed., *Edward Hopper,* New York, 1971.

Kandinsky: Grohmann, Will, *Wassily Kandinsky, Life and Work,* New York, 1958.

Klee: Di San Lazzaro, Gualtieri, *Klee: A Study of His Life and Work,* New York, 1964. Haftmann, Werner, *Mind and Work of Paul Klee,* New York, 1968.

Kokoschka: Hoffmann, E. K., *Kokoschka: His Life and Work,* London, 1947. Wingler, H. M., *Oskar Kokoschka* . . . , Salzburg, 1958.

Kollwitz: Nagel, Otto, *Kaethe Kollwitz,* Greenwich, Conn., 1971.

Kupka: Vachtova, L., *Kupka,* New York, 1968.

Le Corbusier: *Le Corbusier, 1910–1965,* ed. W. Boesiger and H. Girsberger, New York, 1967.

Léger: Rosenblum, Robert, *Cubism and Twentieth-Century Art,* New York, 1968.

Lipchitz: Hammacher, A. M., *Jacques Lipchitz, His Sculpture,* New York [1961?].

Marc: Lankheit, K., *Franz Marc,* Berlin, 1960. Schmidt, Georg, *Franz Marc,* Bern, 1957.

Marin: Boston, Institute of Contemporary Art, *John Marin: A Retrospective Exhibition,* Boston, 1947.

Matisse: Aragon, Louis, *Henri Matisse,* New York, 1972. Barr, Alfred H., Jr., *Matisse: His Art and His Public,* New York, 1951. Elsen, Albert, ed., *Sculpture of Henri Matisse,* New York, 1972.

Matta: Frumkin, Allen, *Matta Drawings,* Greenwich, Conn., 1972.

Miró: Rowell, Margit, *Joan Miró,* New York, 1970. Soby, James, *Joan Miró,* Greenwich, Conn., 1959.

Moholy-Nagy: Moholy-Nagy, Sibyl, *Moholy-Nagy: Experiment in Totality,* Cambridge, Mass., 1971.

Mondrian: Jaffé, H. L., ed., *Mondrian,* New York, 1970. Seuphor, Michel, *Mondrian,* New York, 1957.

Moore: Sylvester, David, *Henry Moore,* New York, 1968.

Nicholson: Read, H., introd., *Ben Nicholson: Paintings, Reliefs, Drawings,* vol. 1, London, 1948; *Ben Nicholson,* vol. 2: *Work since 1947,* London, 1956.

Niemeyer: Papadaki, Stamo, *Oscar Niemeyer,* New York, 1960.

Nolde: Haftmann, Werner, *Emil Nolde,* New York, 1972. Selz, Peter, *Emil Nolde,* Greenwich, Conn., 1963.

Orozco: Helm, MacKinley, *Man of Fire: J. C. Orozco*, Westport, Conn., 1953.

Picasso: Elgar, Frank, *Picasso*, New York, 1956. Leymarie, Jean, *Picasso: The Artist of the Century*, New York, 1972. Los Angeles County Museum of Art, *Picasso: 60 Years of Graphic Works*, Los Angeles, 1966. Penrose, Roland, ed., *The Sculpture of Picasso*, Greenwich, Conn., 1967.

Pollock: New York, The Museum of Modern Art, *Jackson Pollock*, New York, 1967. Robertson, B., *Jackson Pollock*, London, 1960.

Rivera: Wolfe, B., *The Fabulous Life of Diego Rivera*, New York, 1963.

Rothko: Selz, Peter, *Mark Rothko*, New York, 1961.

Rouault: Courthion, P., *Georges Rouault*, Paris, 1962.

Rousseau: Bouret, J., *Henri Rousseau: Le Douanier*, New York, 1961.

Saarinen: Temko, Allan, *Eero Saarinen*, New York, 1966.

Schwitters: Janis, Harriet, and Rudi Blesh, *Collage: Personalities, Concepts, Techniques*, rev. ed., Philadelphia, 1962.

Siqueiros: De Micheli, Maria, ed., *David Alfaro Siqueiros*, New York, 1971.

Smith: Cone, J. H., *David Smith, 1906–1965, A Retrospective Exhibition*, Cambridge, Mass., 1966. McCoy, Garnett, *David Smith*, New York, 1973.

Soutine: Castaing, M., and J. Leymarie, *Soutine*, New York, 1964. Leymarie, Jean, ed., *Soutine*, New York, 1964. Tuchman, M., *Chaim Soutine*, Los Angeles County Museum of Art, 1968.

Sullivan: Morrison, H., *Louis Sullivan*, New York, 1952.

Tamayo: Goldwater, Robert, *Rufino Tamayo*, New York, 1947.

Utrillo: Jourdan, F., *Maurice Utrillo*, Paris, 1948.

Vlaminck: Sauvage, M., *Vlaminck, sa vie et son message*, Geneva, 1956.

Wright: Scully, Vincent, Jr., *Frank Lloyd Wright*, New York, 1960.